HOUSTON 175

A Pictorial Celebration of Houston's 175-Year History

HOUSTON ★ CHRONICLE
chron.com

ACKNOWLEDGEMENTS

A number of individuals and entities contributed photos to help make this book possible. Special thanks go to the Houston Metropolitan Research Center at the Houston Public Library, specifically Joel Draut and Elizabeth Sargent; Michele Reilly at the University of Houston Digital Library; and Story Sloane III (The Sloane Collection/www.sloanegallery.com).

CREDITS

Houston Chronicle
chron.com

Jack Sweeney
Publisher and president

J.R. Gonzales
Houston 175 book editor

Mike Tolson
Writer

Jeff Cohen
Editor

Susan Barber
Art director

Larry Lovelace
Copy editor

Scott Clark
Senior editor

Steve Gonzales
Director of photography

Pediment Publishing
Design and production

FOREWORD

Tucked somewhere inside your closet or on a bookshelf is a collection of photos.

Maybe you have them nicely arranged in a photo album. Or maybe they're in a shoebox.

They remind you of loved ones long gone and of joyous days long past. The photos may hold little value to much of the world, but to you, your friends and family, they might as well be bars of gold.

What you're holding in your hand is Houston's photo album.

Many of the familiar faces are here. There's Glenn McCarthy – the brash oilman who envisioned a luxury hotel outside of Houston's city center – having a chat with Jesse H. Jones. There's Selena, thrilling rodeo audiences, unaware of the tragedy that would befall her more than a month later. There's Barbara Jordan, beaming in a photo outside her campaign headquarters, the national stage just ahead of her.

The triumphs are here, too. Hakeem Olajuwon, with his daughter, taking in the celebratory atmosphere after the Houston Rockets won an NBA title. Howard Hughes glancing up at the crowds of Houstonians gathered to welcome him home after a record-setting flight.

But – unlike what you'll find in most photo albums – there's tragedy, too. A devastated Fifth Ward after a blaze that scorched many city blocks. The rubble left in the wake of Hurricane Ike. An outpouring of grief over the loss of the space shuttle Columbia.

Over the last 175 years, the people and places in these photos have contributed to the story of Houston. It's a story of hard work, a story of growth and, sometimes, a story of moving ahead in the face of tragedy.

Though this book might be a photo album of Houston, think of it as yours, too.

J.R. Gonzales
Houston 175 book editor

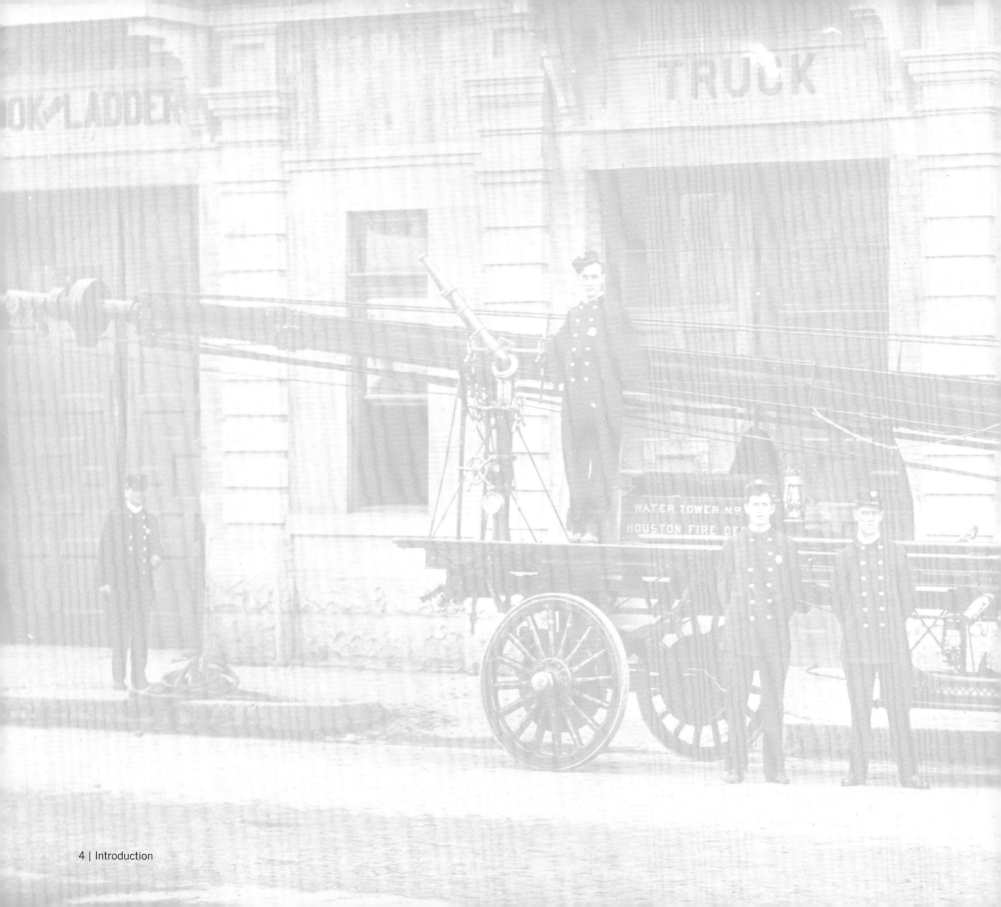

TABLE OF CONTENTS

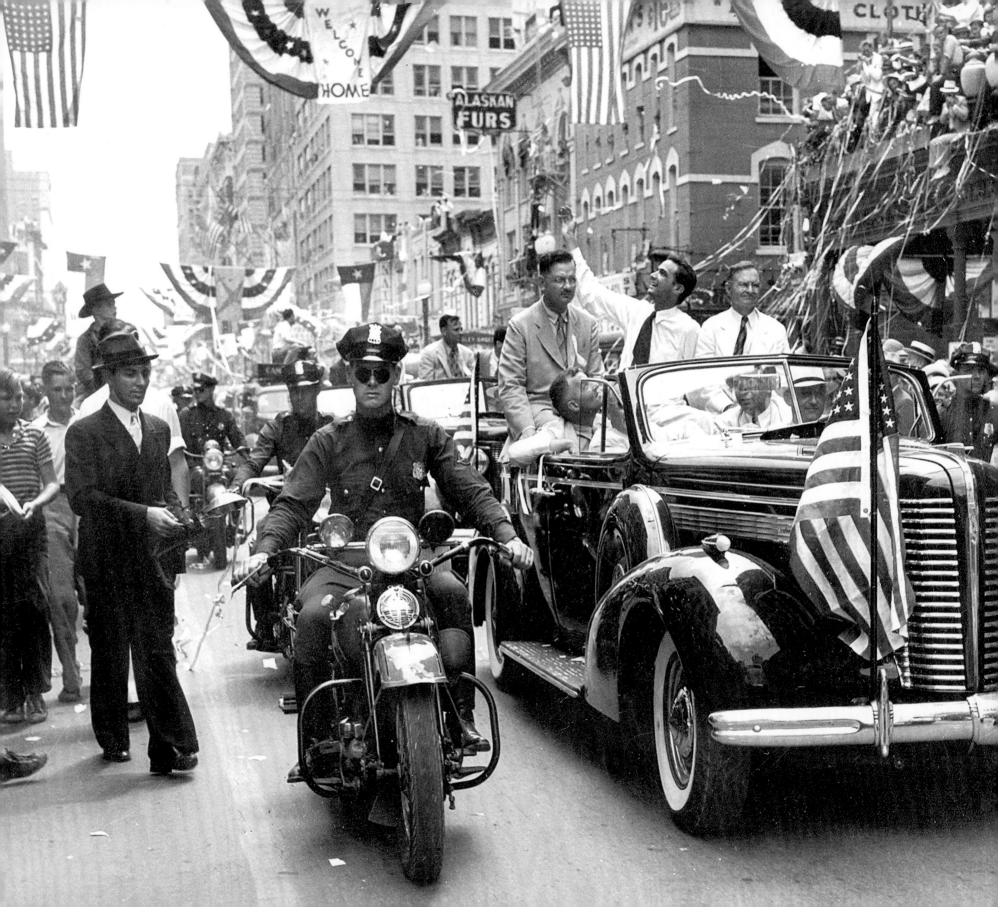

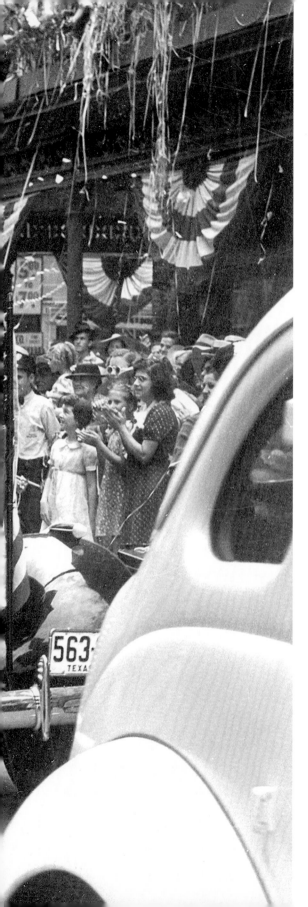

NEWS & EVENTS

In some ways, what passes for news in the Houston area is no different than the news in any other large city. Tragedies happen, achievements are reached, life goes on.

But then there are those moments when it seemed like Houston and the surrounding area became the center of the universe. That's when — long after the story has fallen off the front page — the memories will remain.

Houstonians young and old are quick to recall some of these events. For example, there was the day in 1947 when the SS Grandcamp exploded at Texas City. More than 500 were killed in that disaster, which in the days and weeks to come would put the spotlight on this region. To listen to the stories of those who were there to experience it is to get a sense of ourselves and our heritage that can't be found in a history book or newspaper microfilm.

Where were you that Saturday night in 1986, when more than 1.3 million of us turned out to see our downtown skyline become a concert stage? *Rendez-Vous Houston: A City in Concert* was French composer Jean-Michel Jarre's love letter to our city, delivered at a time when Houston was caught in the grip of an economic slide.

Then there are those times when we were a witness to history, but didn't realize it. Where were you when President John F. Kennedy visited Houston on Nov. 21, 1963? Some welcomed him here at Houston International Airport while others crowded the Gulf Freeway just to wave at the president and first lady Jacqueline Kennedy.

It certainly wasn't Kennedy's first visit to Houston, but, because of the tragic events that would occur in Dallas the next day, many have held on to the moments — however instant — they shared with him.

It's those events that transcend that of being a typical news story to a moment that etches itself into the history of our city — and ourselves.

LEFT: Howard Hughes Jr. receives a hero's welcome on July 30, 1938, during a return home following his record-setting around-the-world flight.
COURTESY HOUSTON PUBLIC LIBRARY, HOUSTON METROPOLITAN RESEARCH CENTER

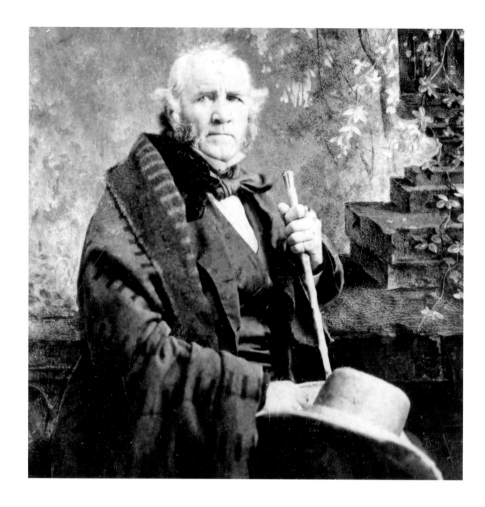

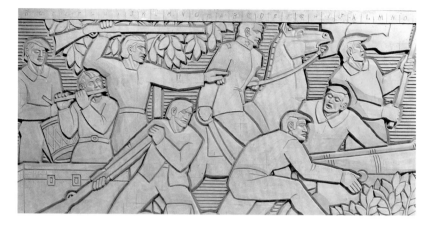

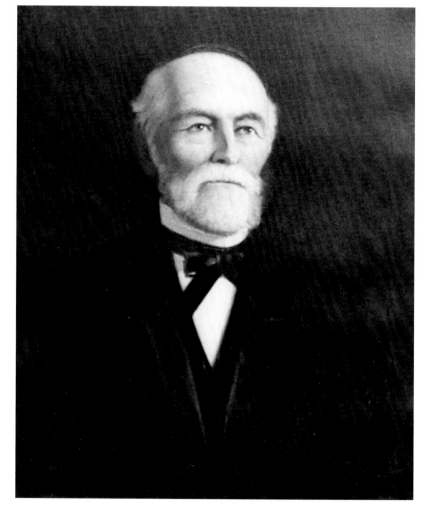

ABOVE: Virginia native Sam Houston, seen here in this circa late-1850s photo, led the charge to secure Texas' independence at the Battle of San Jacinto. The prominent lawyer and politician was president of the Republic of Texas twice and also served as governor.
COURTESY HOUSTON CHRONICLE ARCHIVES

TOP RIGHT: This engraved panel at the base of the San Jacinto Monument is one of eight that depict Texas' struggle for independence. The monument itself is 15 feet taller than the Washington Monument.
COURTESY HOUSTON PUBLIC LIBRARY, HOUSTON METROPOLITAN RESEARCH CENTER

RIGHT: Through various enterprises, philanthropist, merchant and financier William Marsh Rice was able to acquire a fortune that allowed him to establish what is now Rice University.
COURTESY HOUSTON CHRONICLE ARCHIVES

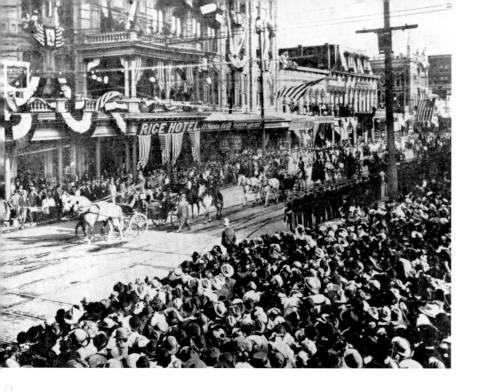

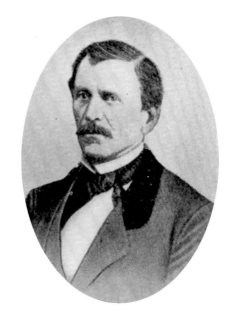

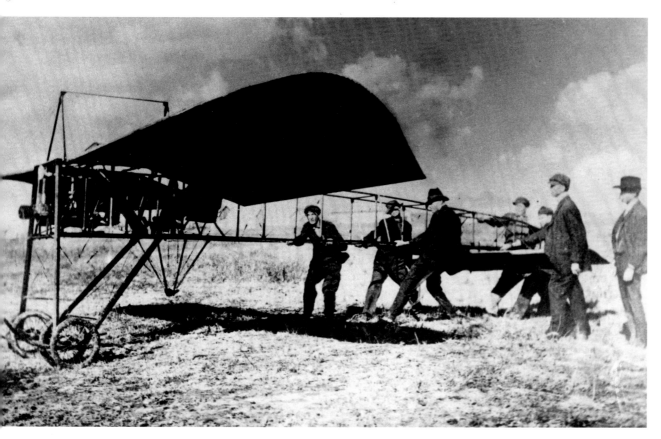

TOP LEFT: Huge crowds turn out outside the Rice Hotel for a parade honoring President William Howard Taft, who visited the city in late 1909.
COURTESY HOUSTON PUBLIC LIBRARY, HOUSTON METROPOLITAN RESEARCH CENTER

TOP RIGHT: The idea of a town called Houston sprang from the creative minds of brothers John Kirby Allen, left, and Augustus Chapman Allen. Financed by the inheritance of Charlotte Allen, Augustus' wife, the New York land speculators were able to put in motion what would eventually become the nation's fourth-largest city.
COURTESY HOUSTON CHRONICLE ARCHIVES

LEFT: L.L. Walker, the first Houstonian to pilot an aircraft, prepares for a flight to Galveston in a self-constructed Bleriot-type airplane in 1910. He only made it as far as La Marque.
COURTESY UNIVERSITY OF HOUSTON

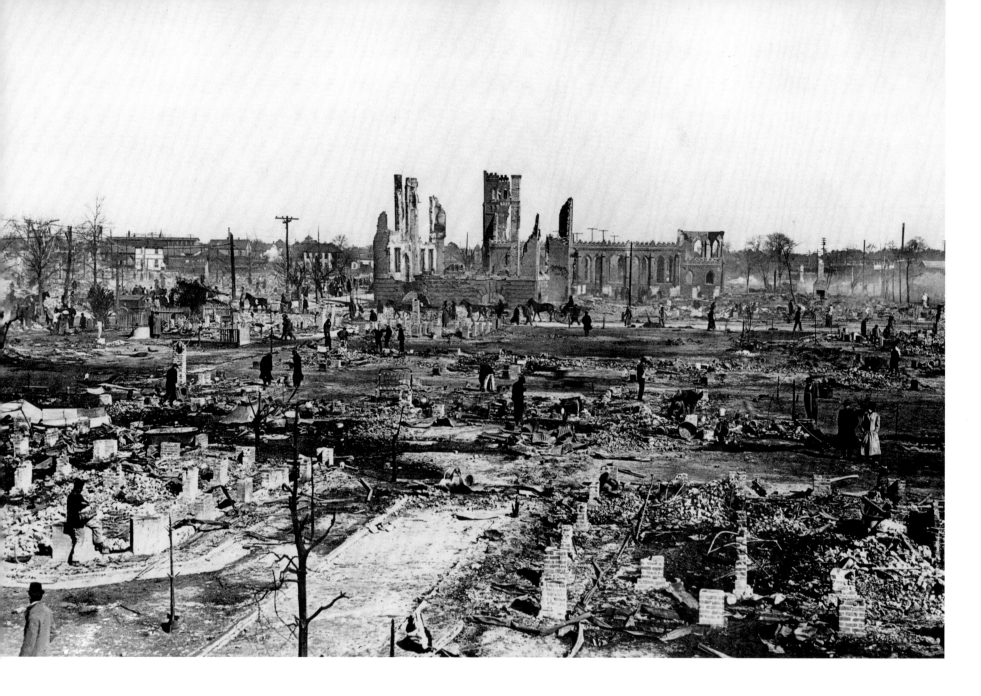

ABOVE: The largest fire in Houston's history swept through the Fifth Ward on Feb. 21, 1912. Fortunately no one was killed in the blaze, which is believed to have started in an abandoned house. COURTESY UNIVERSITY OF HOUSTON

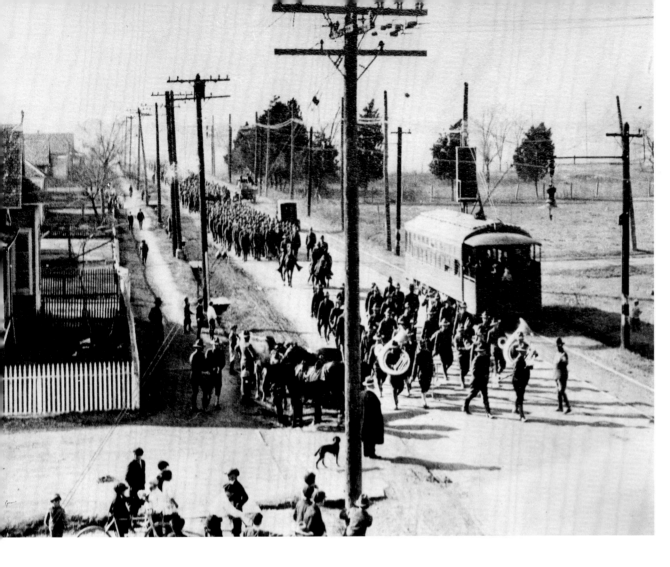

LEFT: A military band leads a line of World War I-era soldiers down Washington Avenue from Camp Logan into Houston, 1917.
COURTESY UNIVERSITY OF HOUSTON

BOTTOM LEFT: Camp Logan, an Army training camp established during World War I, was located where Memorial Park is today. Black soldiers guarding the construction of the site rioted on Aug. 23, 1917, as racial tensions boiled over. More than a dozen were killed, including several Houston police officers.
COURTESY HOUSTON CHRONICLE ARCHIVES

BELOW: About 15,000 turned out for a victory sing in front of the Rice Hotel on Dec. 17, 1918, to pay tribute to allied forces for their recent victory in Europe during World War I.
COURTESY HOUSTON PUBLIC LIBRARY, HOUSTON METROPOLITAN RESEARCH CENTER

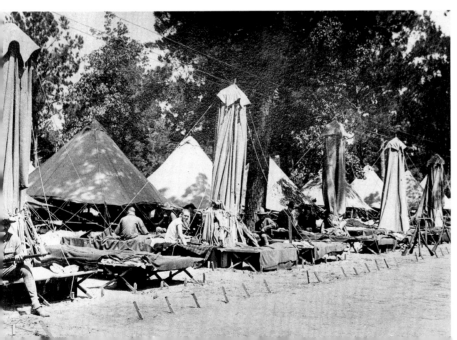

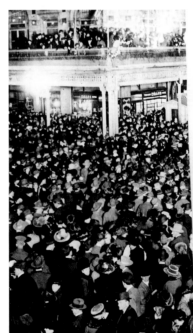

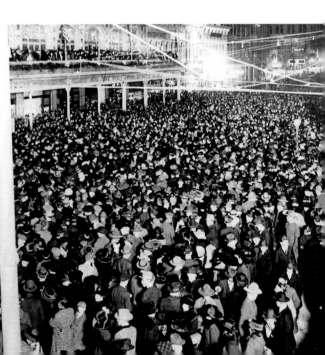

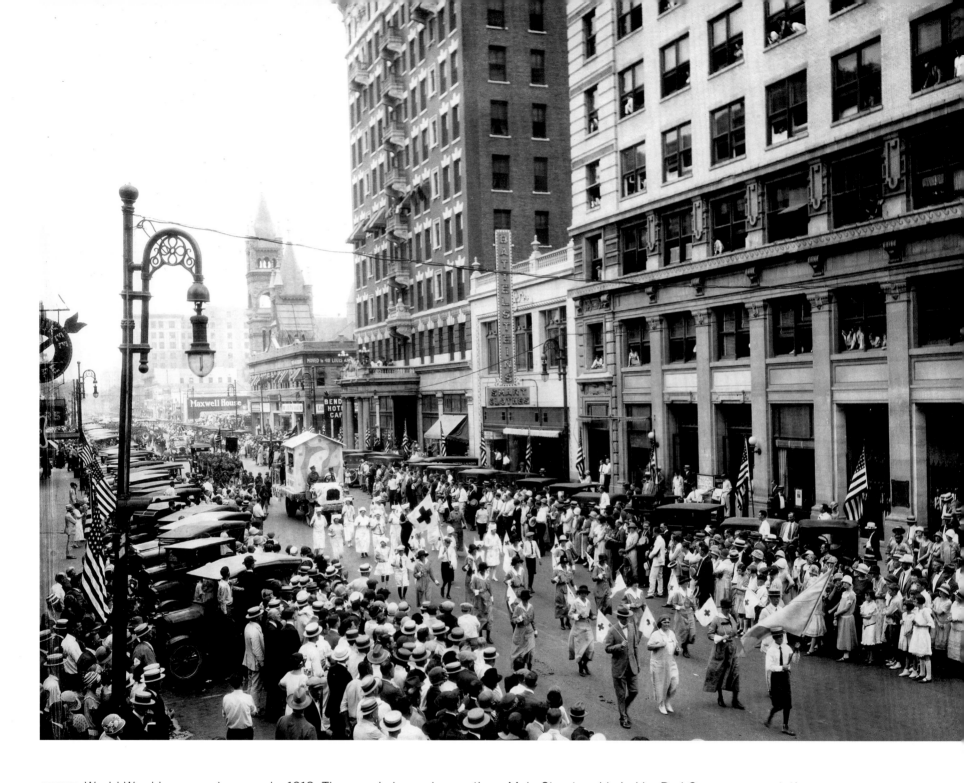

ABOVE: World War I homecoming parade, 1918. The parade is moving north on Main Street and is led by Red Cross representatives.
COURTESY UNIVERSITY OF HOUSTON

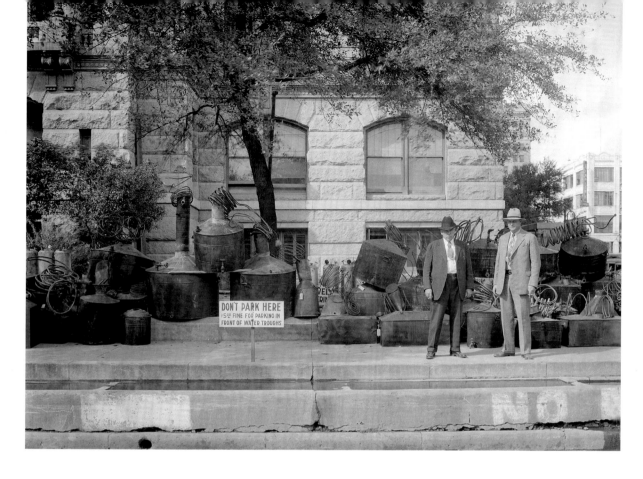

LEFT: Whiskey stills are piled up at the Harris County Courthouse during Prohibition, 1928.

COURTESY THE SLOANE COLLECTION

BOTTOM LEFT: Jesse H. Jones, publisher of the Houston Chronicle, builder and philanthropist, goes over blueprints for Sam Houston Hall with architect A.C. Finn, 1928.

COURTESY HOUSTON CHRONICLE ARCHIVES

BELOW: The 1928 Democratic National Convention was held at the Sam Houston Hall, later the site of the Sam Houston Coliseum and the Hobby Center for the Performing Arts.

COURTESY THE SLOANE COLLECTION

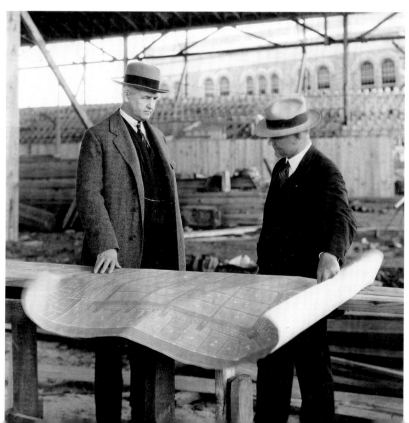

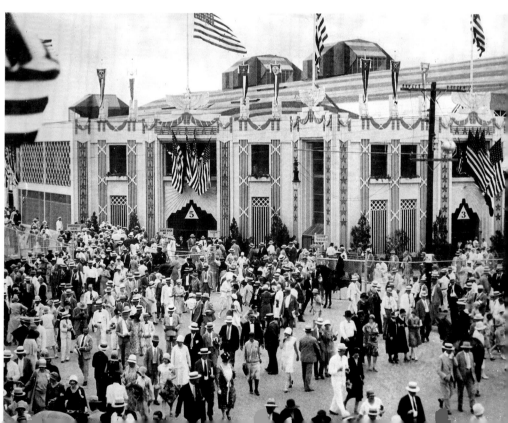

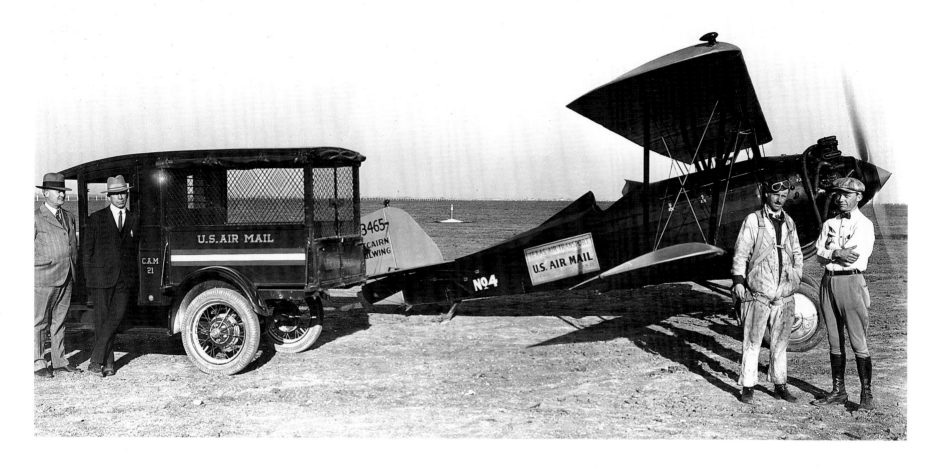

ABOVE: Air mail service got under way in Houston on Feb. 6, 1928.

COURTESY HOUSTON PUBLIC LIBRARY, HOUSTON METROPOLITAN RESEARCH CENTER

RIGHT: The two millionth 8-cylinder Ford sits in front of old City Hall on Travis Street, mid-1930s.

COURTESY THE SLOANE COLLECTION

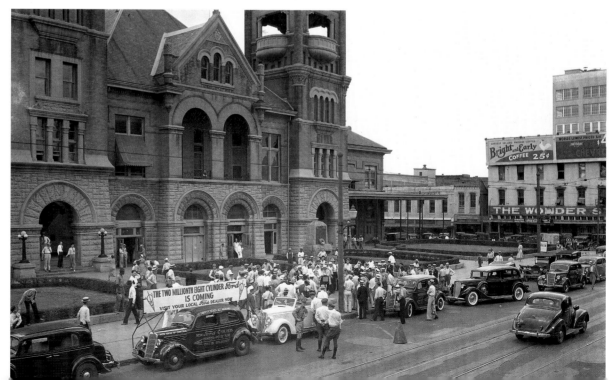

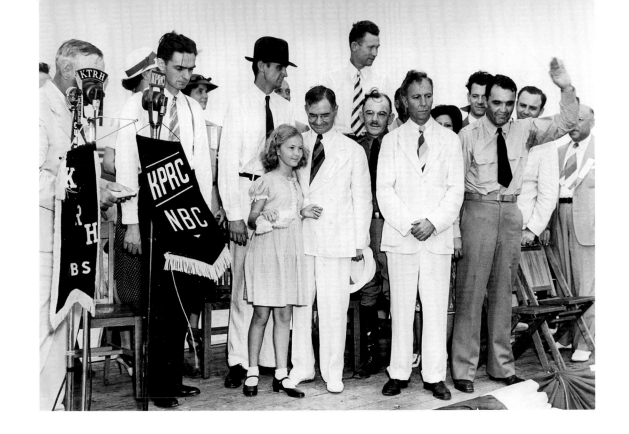

LEFT: Clarita Fonville, daughter of Mayor R.H. Fonville, breaks a bottle of champagne and rechristens Houston's Municipal Airport as the Howard Hughes Airport on July 30, 1938, as part of Howard Hughes Jr.'s homecoming after his record-setting around-the-world flight. Hughes, with hat, is standing behind Clarita and Mayor Fonville. COURTESY HOUSTON CHRONICLE ARCHIVES

BELOW: Houstonians gather at Union Station to welcome President Franklin Roosevelt in 1936. This view is looking northeast from Texas Avenue near Jackson. COURTESY MARY BAVOUSET

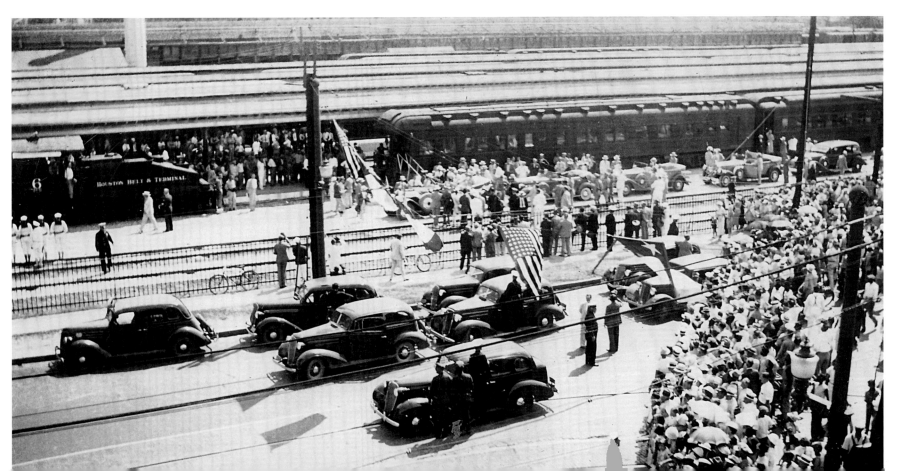

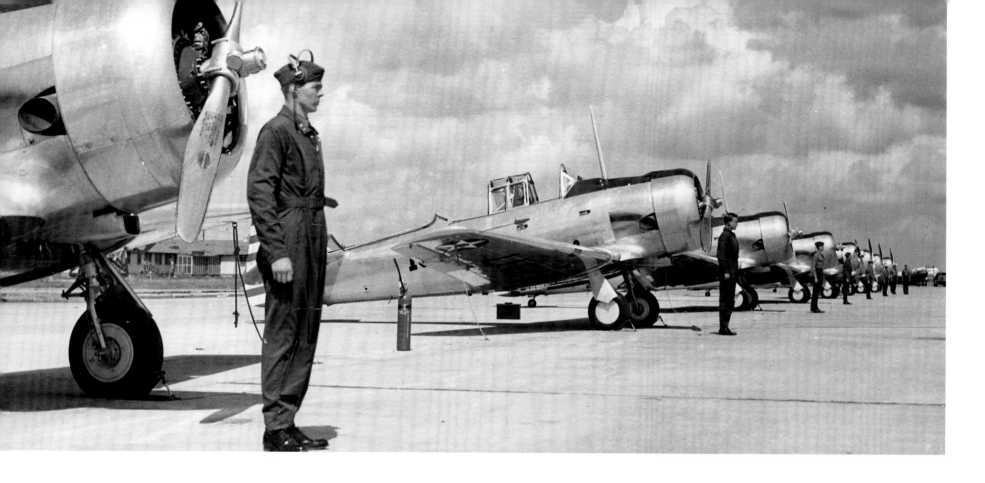

ABOVE: Ellington Field has served many purposes since it was established in 1917. By the time this photo was taken in late 1941, the base had been reopened to serve as a training ground for thousands of pilots.
COURTESY HOUSTON CHRONICLE ARCHIVES

RIGHT: Volunteers parade through the streets of downtown Houston on Memorial Day 1942. The men were sworn into the Navy to replace those lost when the USS Houston sank during a battle in the Sunda Strait.
COURTESY HOUSTON CHRONICLE ARCHIVES

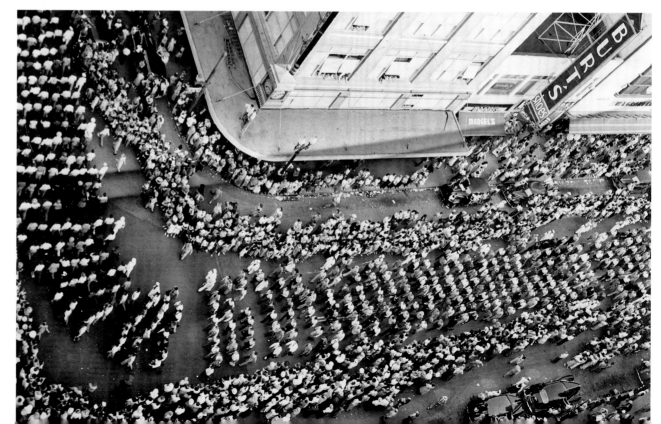

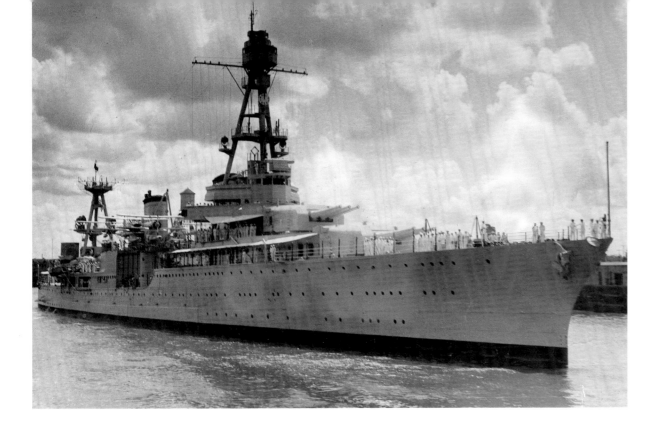

LEFT: The USS Houston makes its way up the Houston Ship Channel during a stop in September 1934, its second time visiting the city. The ship, which often hosted President Franklin Roosevelt, would be sunk by Japanese forces in 1942.
COURTESY HOUSTON CHRONICLE ARCHIVES

BELOW: The USS Houston, built out of funds raised after the sinking of the previous USS Houston, visits the city for Navy Day celebrations, Oct. 26, 1945. After seeing heavy action late in World War II, the ship was eventually scrapped in 1959.
COURTESY HOUSTON CHRONICLE ARCHIVES

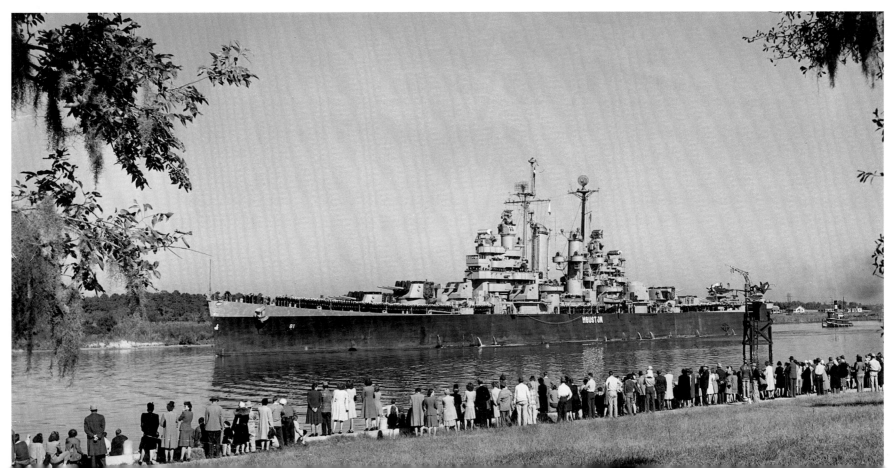

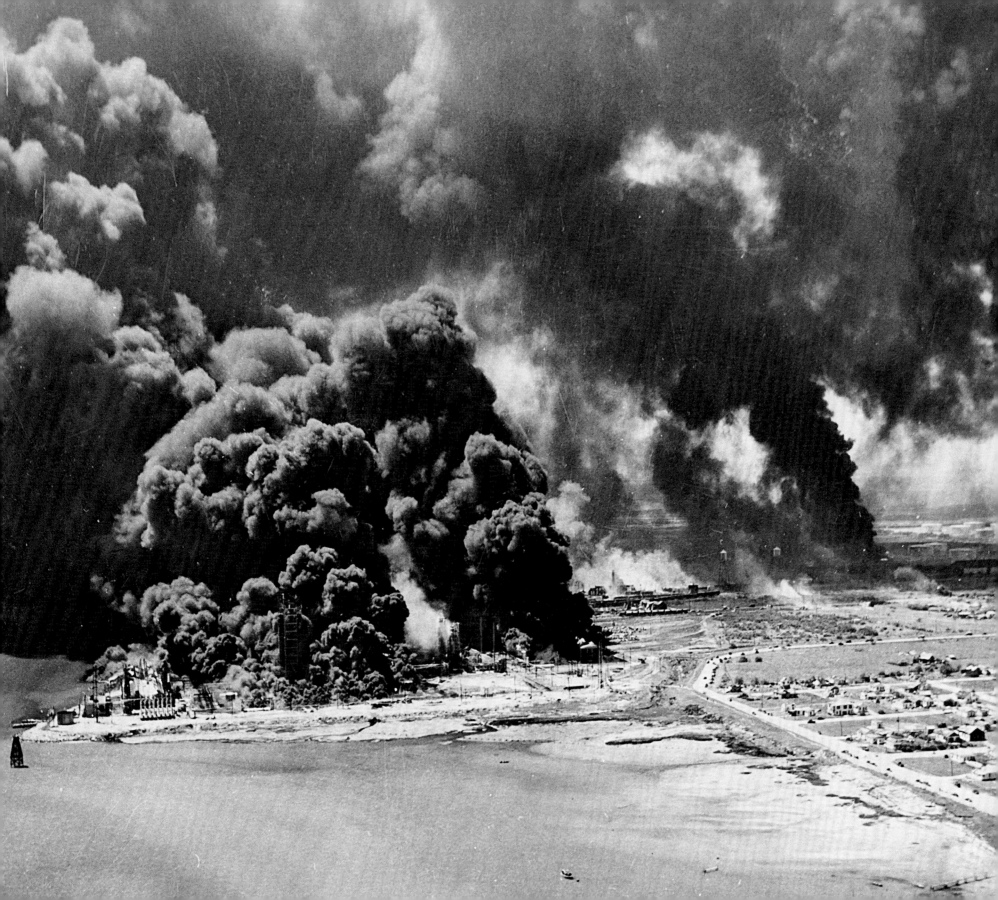

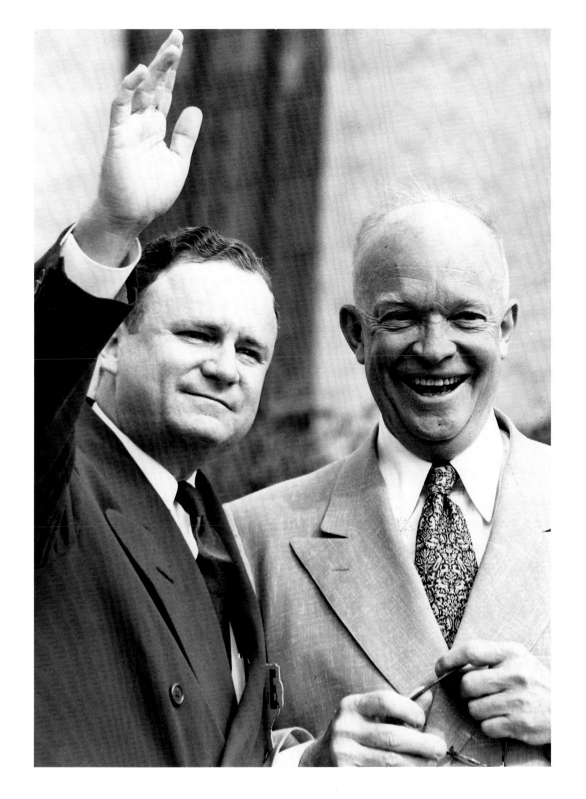

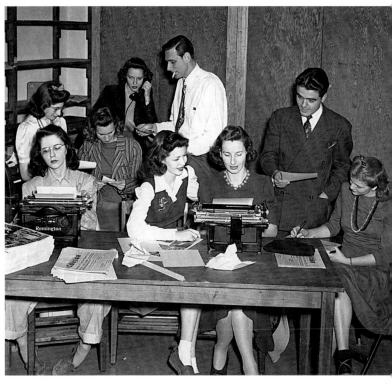

ABOVE: Before he became an aide to President Lyndon Johnson and longtime president of the Motion Picture Association of America, Jack Valenti, second from right, was news editor at the Daily Cougar at the University of Houston in the 1940s.
COURTESY UNIVERSITY OF HOUSTON

LEFT: Texas Attorney General Price Daniel, left, the unopposed Democratic nominee for the United States Senate, gave his unqualified endorsement to Gen. Dwight D. Eisenhower's candidacy when he introduced the general before a crowd outside the Sam Houston Coliseum and Music Hall, Oct. 14, 1952. COURTESY HOUSTON CHRONICLE ARCHIVES

OPPOSITE: The Monsanto chemical plant burns following the explosion of the SS Grandcamp in Texas City, April 16, 1947. More than 500 were killed in the disaster and thousands were injured in what came to be known as the worst industrial accident in U.S. history. COURTESY HOUSTON CHRONICLE ARCHIVES

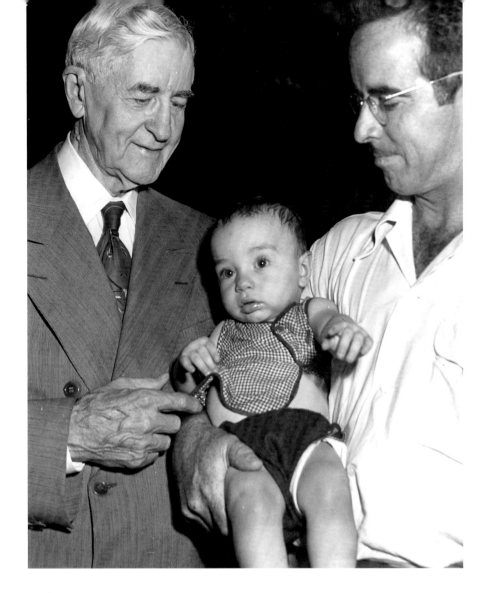

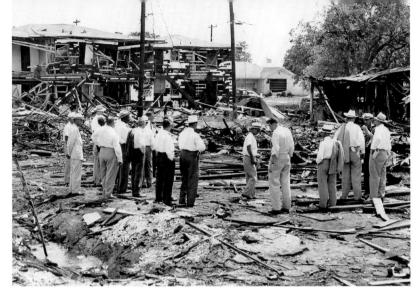

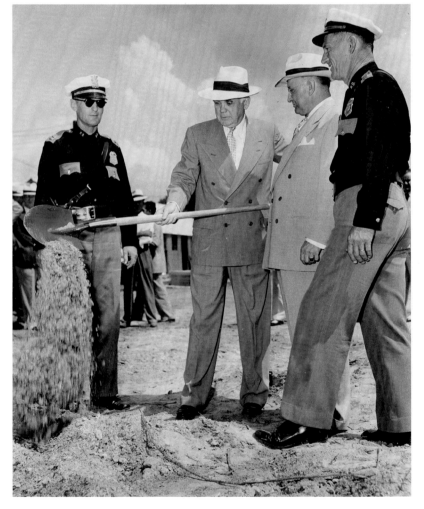

ABOVE: Jesse H. Jones, left, greets Houston's honorary millionth resident, Barney C. McCasland Jr., and his 9-month-old son, Bruce, during the 1954 celebration of the milestone event.

COURTESY HOUSTON CHRONICLE ARCHIVES

RIGHT TOP: Four people were killed in the Alco Fireworks and Specialty explosion, on Rosine between West Dallas and West Clay, June 5, 1953.

COURTESY HOUSTON CHRONICLE ARCHIVES

RIGHT BOTTOM: Houston Mayor Oscar Holcombe breaks ground on the new headquarters for the Houston Police Department at 61 Riesner St., 1950. With Holcombe is Lt. Sam Clauder, far right.

COURTESY ELAINE (CLAUDER) VAN HORN

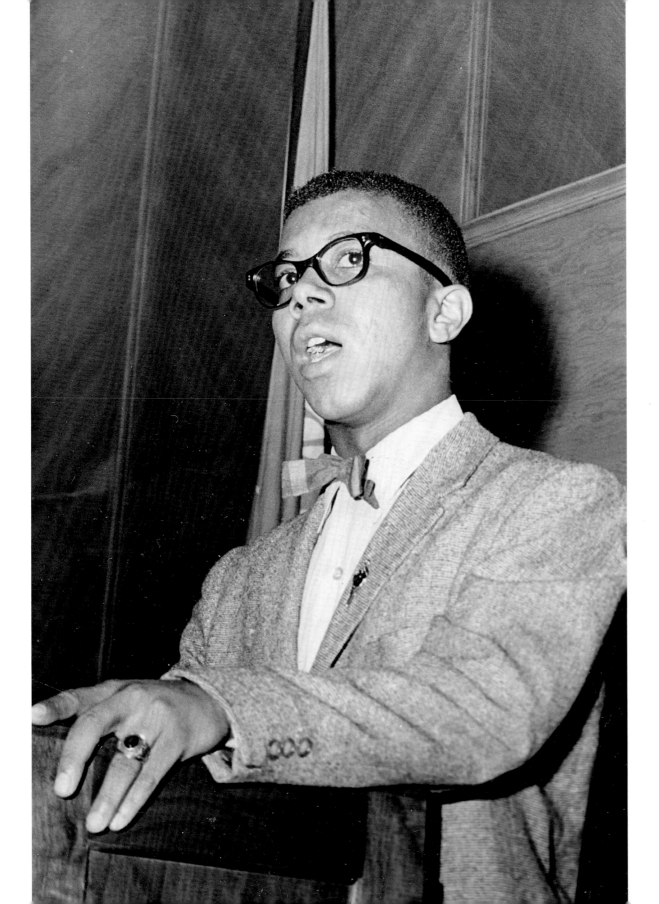

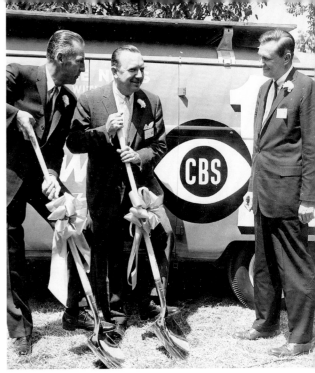

ABOVE: Walter Cronkite, center, J.C. Richdale, left, and C.W. Peters-meyer take part in groundbreaking ceremonies for KHOU's studio and office building, May 1959. COURTESY HOUSTON CHRONICLE ARCHIVES

LEFT: Beginning in 1960, Texas Southern University law student Eldrewey J. Stearns led a peaceful series of sit-ins designed to end segregation in Houston. COURTESY HOUSTON CHRONICLE ARCHIVES

RIGHT Crowds line the Gulf Freeway as President John F. Kennedy's motorcade heads north near the Scott Street exit, Nov. 21, 1963. COURTESY HOUSTON CHRONICLE ARCHIVES

BOTTOM LEFT: The Kennedy motorcade moves through downtown Houston on Nov. 21, 1963, en route to the Rice Hotel. The president and first lady are being welcomed by members of Phi Kappa Theta near the Houston Chronicle building. COURTESY JIM KADLECEK

BOTTOM RIGHT: From left, first lady Jacqueline Kennedy, President John F. Kennedy, Lady Bird Johnson and Vice President Lyndon Johnson attend a LULAC function at the Rice Hotel, Nov. 21, 1963. COURTESY HOUSTON CHRONICLE ARCHIVES

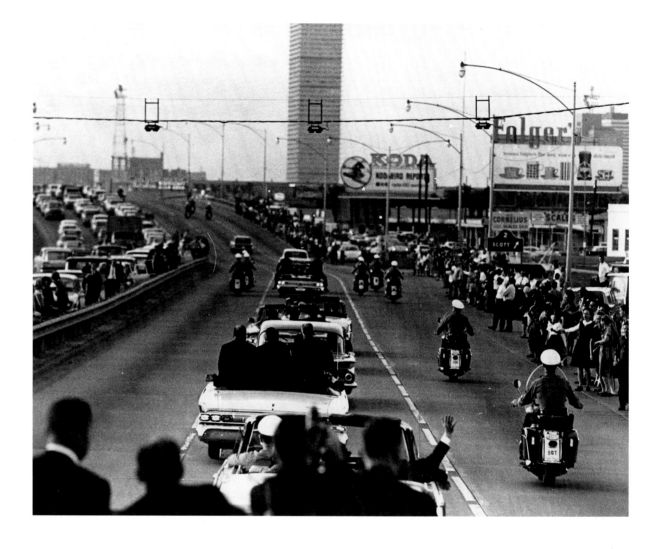

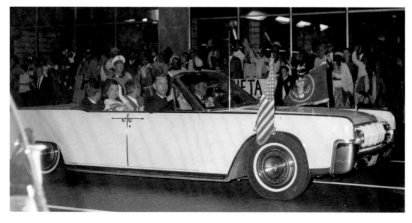

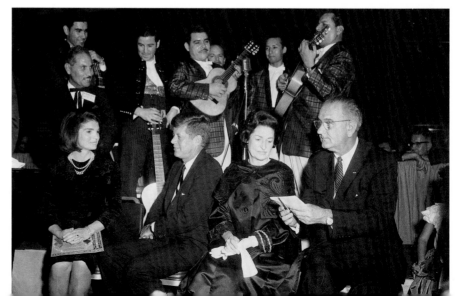

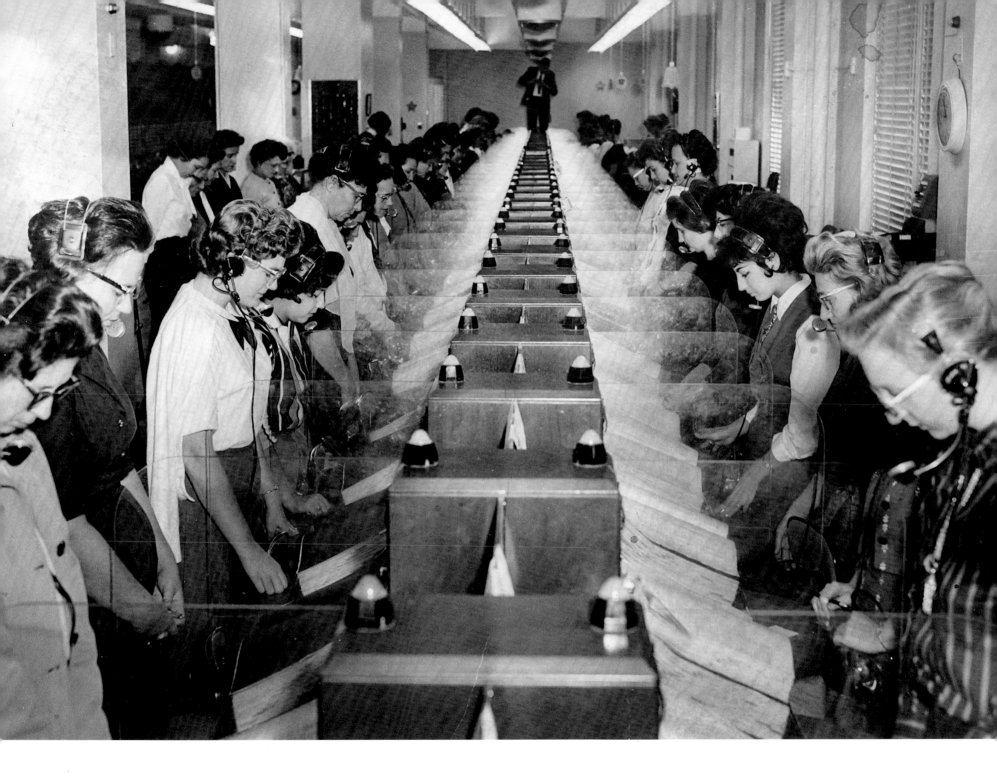

ABOVE: Southwestern Bell Telephone Co. switchboard operators rise for a silent prayer at 11 a.m. Nov. 25, 1963, as President John F. Kennedy's funeral procession gets under way. COURTESY HOUSTON CHRONICLE ARCHIVES

RIGHT: Houston Press editors show off the extra editions the newspaper published following the Kennedy assassination. COURTESY HOUSTON PUBLIC LIBRARY, HOUSTON METROPOLITAN RESEARCH CENTER

BOTTOM LEFT: George H.W. Bush and supporters cheer a major victory in 1964 as the Republican senatorial nominee looks toward the general election. COURTESY HOUSTON CHRONICLE ARCHIVES

BOTTOM RIGHT: George and Alice Brown, circa 1964. George, with brother Herman, teamed with brother-in-law Dan Root to form Brown & Root Engineering Co. in 1919. Both George and Alice formed the Brown Foundation with Herman and his wife, Margaret, to support education and the arts throughout Texas. COURTESY HOUSTON CHRONICLE ARCHIVES

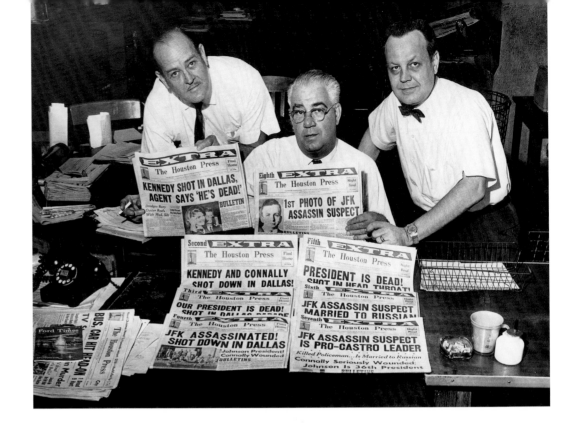

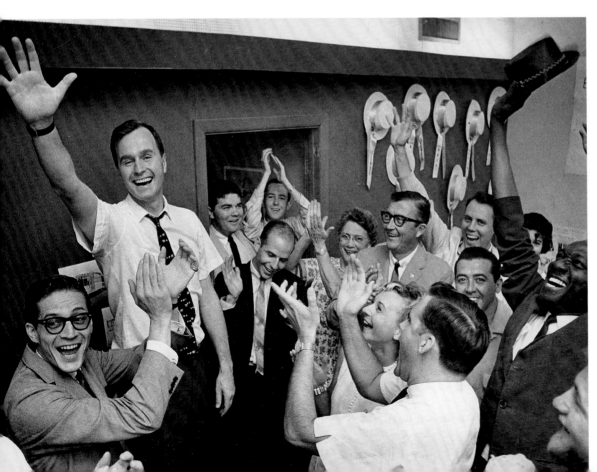

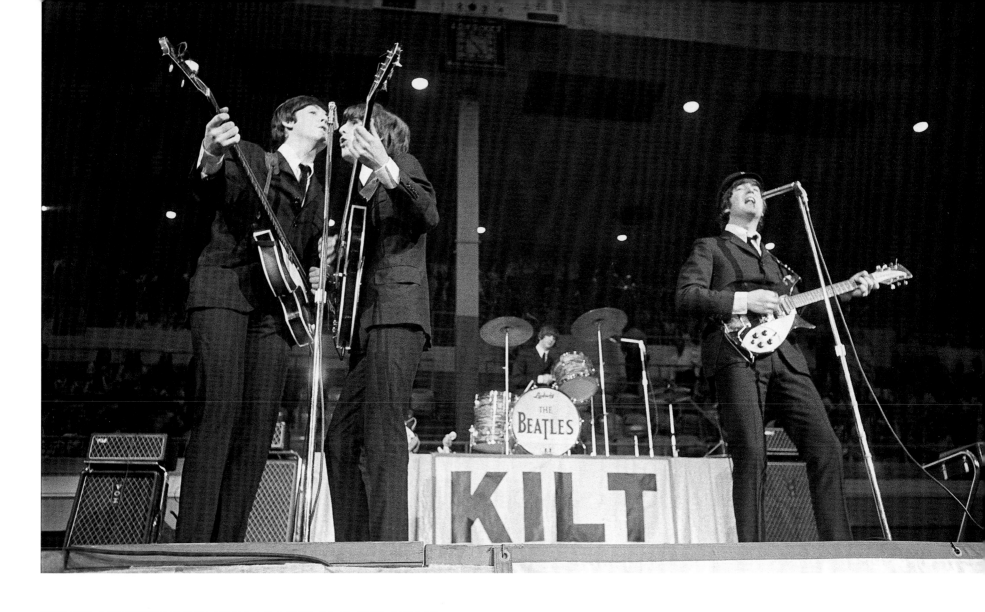

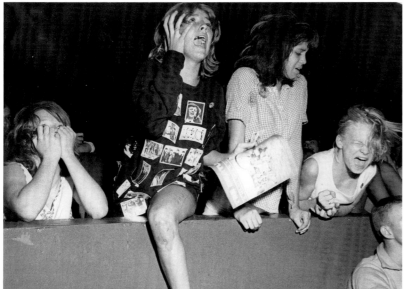

ABOVE: Performing before a deafening crowd of admirers, the Beatles performed two concerts on Aug. 19, 1965, at the Sam Houston Coliseum. COURTESY HOUSTON PUBLIC LIBRARY, HOUSTON METROPOLITAN RESEARCH CENTER

LEFT: Screaming teenagers drown out the Beatles during one of the band's concerts. COURTESY HOUSTON CHRONICLE ARCHIVES

RIGHT: The Rev. Martin Luther King Jr. at the Sam Houston Coliseum, Oct. 17, 1967. King's visit was part of a concert headlined by Harry Belafonte and Aretha Franklin to raise money for the Southern Christian Leadership Conference.
COURTESY HOUSTON CHRONICLE ARCHIVES

OPPOSITE: Evangelist Billy Graham draws tens of thousands to the Astrodome, late 1965, the same year the stadium opened.
COURTESY HOUSTON CHRONICLE ARCHIVES

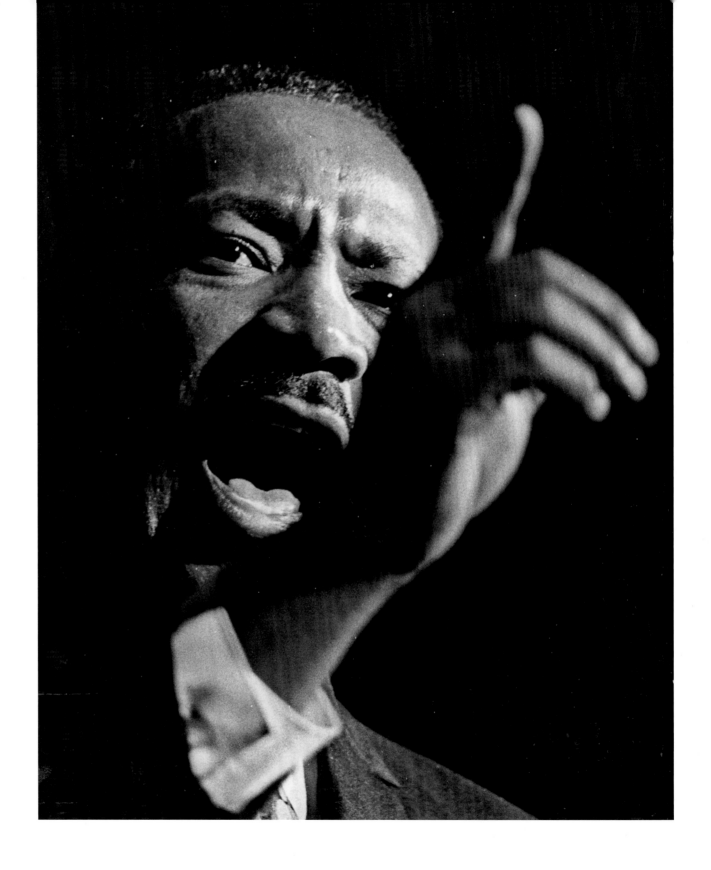

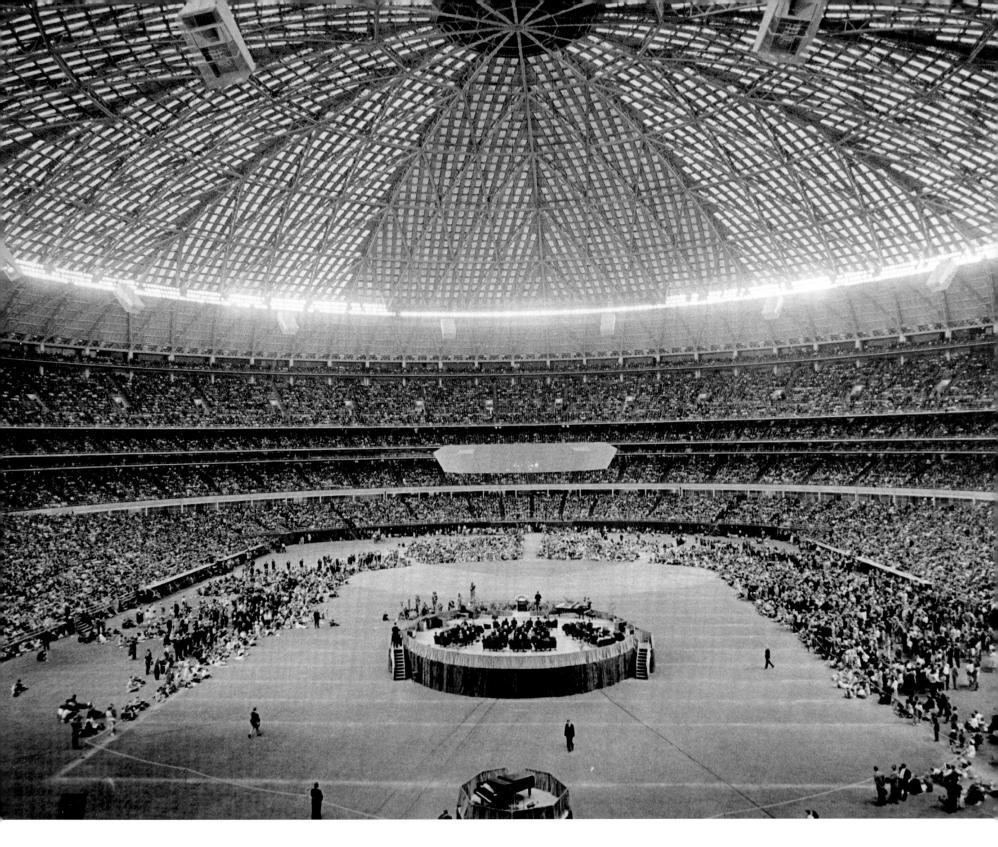

RIGHT: About 1,200 people march in memory of the Rev. Martin Luther King Jr. on April 14, 1968, just days after the civil rights leader was assassinated in Memphis.
COURTESY HOUSTON CHRONICLE ARCHIVES

BOTTOM LEFT: Desi Arnaz, campaigning in Houston for GOP presidential nominee Richard "Ricardo" Nixon, strummed the guitar and sang a song for Nixon at Good Latin-American Democrats for Nixon headquarters, Oct. 31, 1968.
COURTESY HOUSTON CHRONICLE ARCHIVES

BOTTOM RIGHT: Police line suspects against a wall after a shoot-out between the Houston Police Department and People's Party II members, July 26, 1970. Following the gunbattle, more than 50 people were arrested on minor charges in a 10-block area surrounding Dowling and Tuam streets. Carl Hampton, People's Party II leader, was killed in the shootout.
COURTESY HOUSTON CHRONICLE ARCHIVES

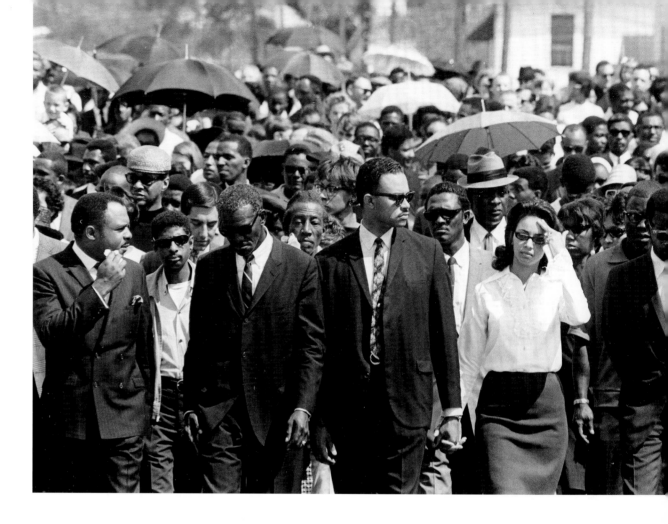

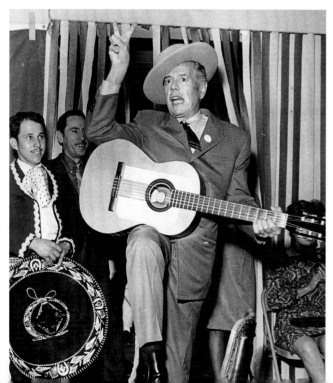

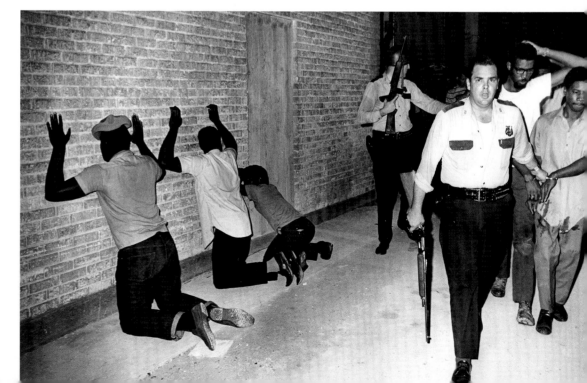

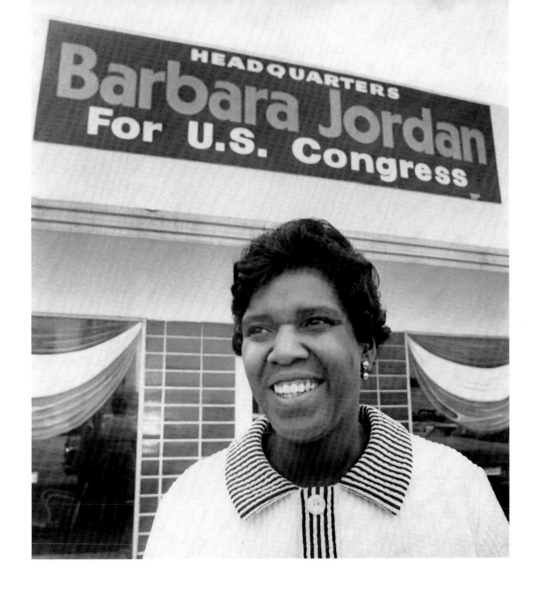

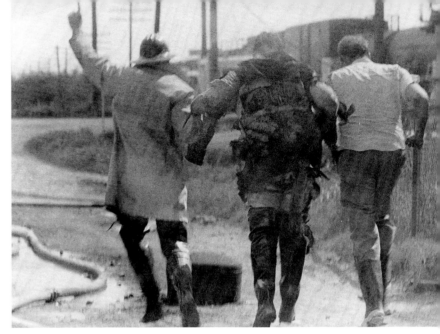

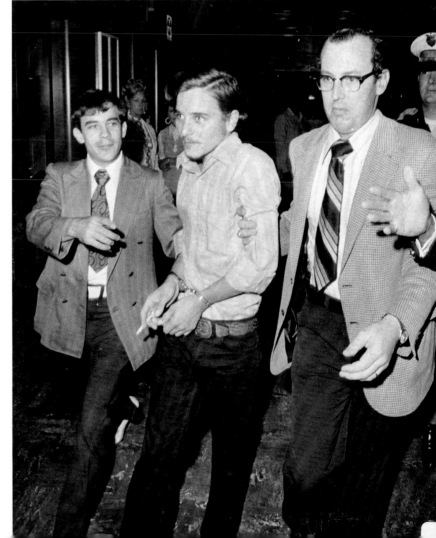

ABOVE: State Sen. Barbara Jordan outside her campaign headquarters near downtown Houston, 1972. COURTESY HOUSTON CHRONICLE ARCHIVES

RIGHT TOP: Two firefighters help a fellow firefighter to safety after part of his clothes burned off during a railroad tank car explosion, October 1971. One man was killed and 37 others were injured. While taking this photo, Houston Chronicle photographer Othell O. Owensby Jr. was severely injured with second- and third-degree burns. COURTESY HOUSTON CHRONICLE ARCHIVES

RIGHT BOTTOM: A handcuffed Elmer Wayne Henley is escorted by police officers into a courtroom in August 1973 to face murder charges following the death of Dean Arnold Corll. Henley was given a life sentence for his role as Corll's accomplice in the slayings of at least 29 youths.

COURTESY HOUSTON CHRONICLE ARCHIVES

RIGHT: After serving as a congressman years earlier, Lloyd Bentsen, seen here in November 1970, would re-enter the political arena that year with a successful campaign for U.S. Senate, defeating Republican George H.W. Bush. Bentsen's return to politics would kick off a long career in Washington, which included a position as secretary of the Treasury under President Bill Clinton and candidacies for the presidency in 1976 and vice presidency in 1988. COURTESY HOUSTON CHRONICLE ARCHIVES

BELOW: City Controller Leonel Castillo, the first Mexican-American elected to citywide office, is shown with the electric car he used for short trips around town, July 1975. The car, powered by six 6-volt batteries that had to be recharged every night, was said to be cheaper to operate than conventional cars. COURTESY HOUSTON CHRONICLE ARCHIVES

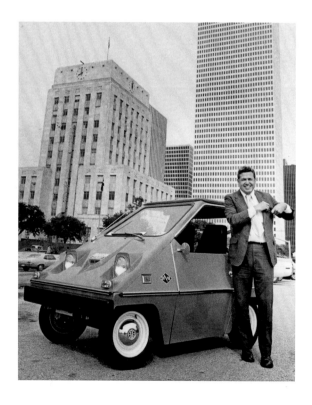

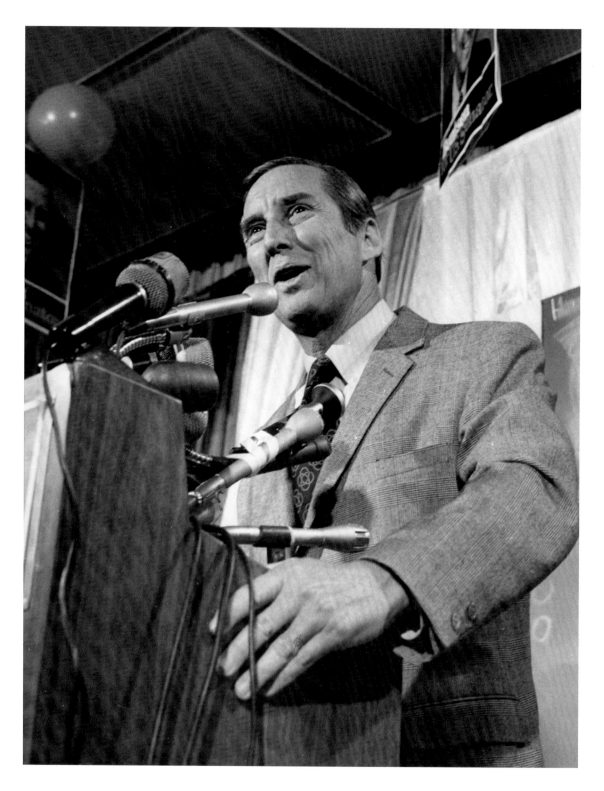

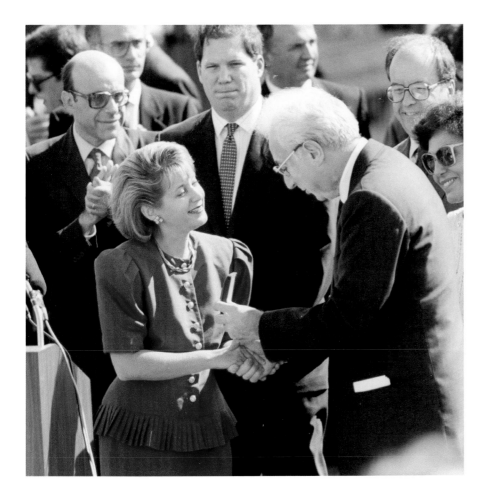

LEFT: Mayor Kathy Whitmire, the first woman elected mayor of Houston, presents a key to the city to Italian President Francesco Cossiga at Ellington Field, October 1989.
COURTESY HOUSTON CHRONICLE ARCHIVES

BELOW: Mayor Kathy Whitmire and fellow Texans Sandy Duncan and Tommy Tune at City Council chambers for "My One and Only Day" honors, June 1985. COURTESY HOUSTON CHRONICLE ARCHIVES

LEFT: On May 11, 1976, a truck carrying 7,500 gallons of anhydrous ammonia overturned at Loop 610 and the Southwest Freeway, sending a toxic cloud of fumes through the interchange. Seven people died in the accident.
COURTESY HOUSTON CHRONICLE ARCHIVES

FAR LEFT: Councilman Judson Robinson Jr., left, and Hattie Mae White, Houston's first black council member and school trustee, respectively, were honored at a banquet for their political achievements in 1987. With them is Congressman Mickey Leland, D-Houston. COURTESY HOUSTON CHRONICLE ARCHIVES

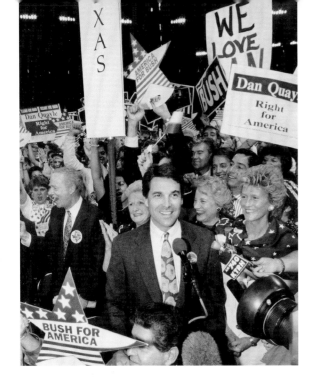

ABOVE: Texas Agriculture Commissioner Rick Perry stands with the Texas delegation as he casts his state's votes for President George H.W. Bush in August 1992. The votes from Texas helped clinch the GOP presidential nomination for Bush at the Republican National Convention in Houston.
COURTESY HOUSTON CHRONICLE ARCHIVES

ABOVE RIGHT: President George H.W. Bush and Barbara Bush during the Republican National Convention at the Astrodome, Aug. 20, 1992.
COURTESY HOUSTON CHRONICLE ARCHIVES

RIGHT: Downtown Houston becomes a concert backdrop during Jean-Michel Jarre's *Rendez-Vous Houston: A City in Concert*, April 5, 1986. *Rendez-Vous Houston* was planned in celebration of the 150th birthdays of Texas and Houston and the 25th anniversary of NASA.
COURTESY HOUSTON CHRONICLE ARCHIVES

ABOVE: The Houston Livestock Show and Rodeo called the Astrodome home from 1966 to 2002. COURTESY HOUSTON CHRONICLE ARCHIVES

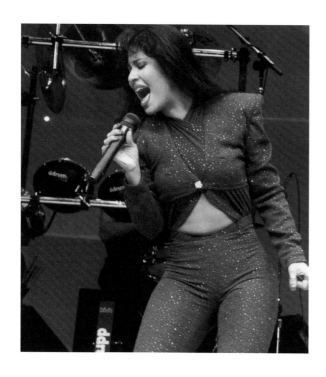

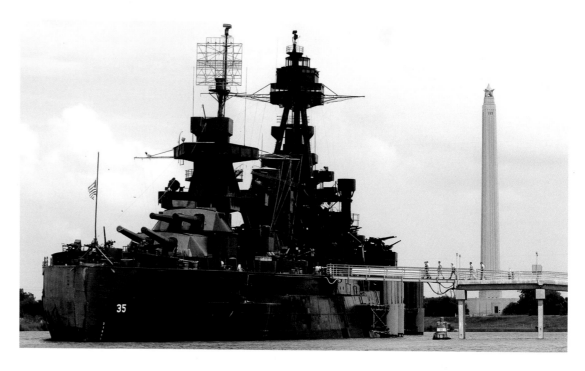

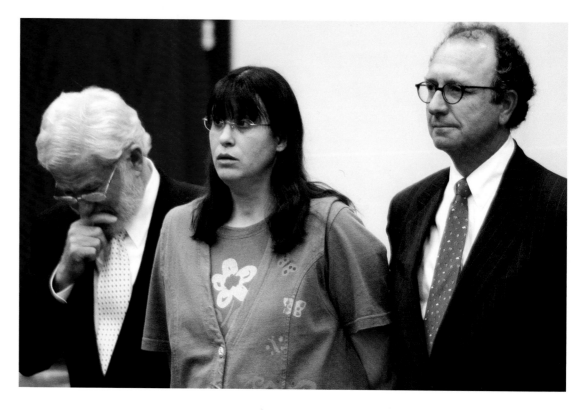

ABOVE: Tejano superstar Selena performs before a packed rodeo crowd on Feb. 26, 1995. At the time, Selena Quintanilla-Perez, just 23, was on the brink of crossing over to the mainstream U.S. pop market. Sadly, more than a month later, the Lake Jackson native would be gunned down in a Corpus Christi motel by her fan club manager. COURTESY HOUSTON CHRONICLE ARCHIVES

ABOVE RIGHT: The Battleship Texas and the San Jacinto Monument, 2004.
COURTESY HOUSTON CHRONICLE ARCHIVES

RIGHT: Andrea Yates, flanked by her lawyers, George Parnham, left, and Wendell Odom, stands as the verdict in her murder retrial is read on July 26, 2006. Yates was found not guilty by reason of insanity for the 2001 drowning deaths of her children. An earlier jury had found her guilty of murder, but the verdict was overturned on appeal.
COURTESY HOUSTON CHRONICLE ARCHIVES

RIGHT: Houston mayoral candidate Annise Parker celebrates her runoff election victory at the George R. Brown Convention Center, Dec. 12, 2009. Parker would take office as Houston's first openly gay mayor, which was also a first for any major American city.
COURTESY HOUSTON CHRONICLE ARCHIVES

BOTTOM RIGHT: With her belongings removed from her office, Meredith Stewart waits for a ride on Dec. 3, 2001, after being laid off from her job at Enron Corp. Thousands would be laid off following the company's December 2 bankruptcy filing.
COURTESY HOUSTON CHRONICLE ARCHIVES

BELOW: Former Enron top executive Ken Lay tries to separate himself from the swarm of media as he and his wife, Linda, enter the Bank of America Building, May 25, 2006. COURTESY HOUSTON CHRONICLE ARCHIVES

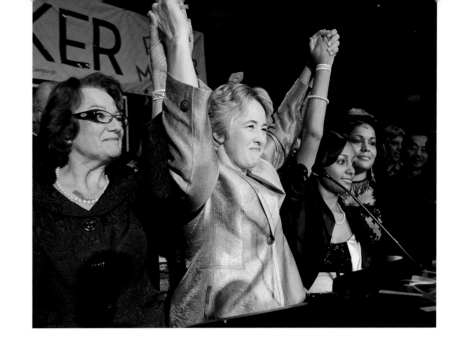

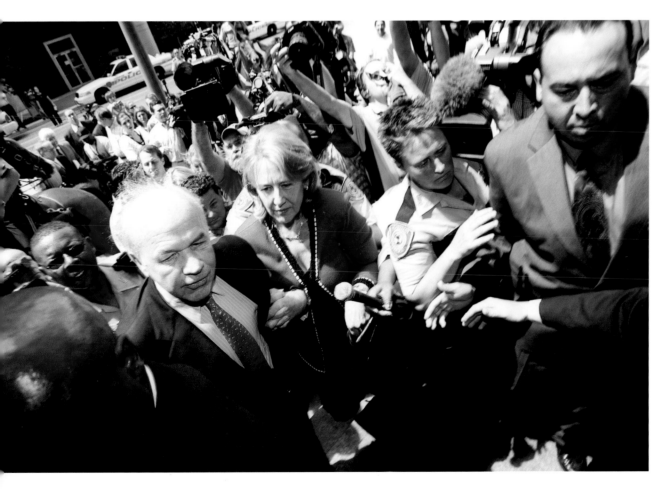

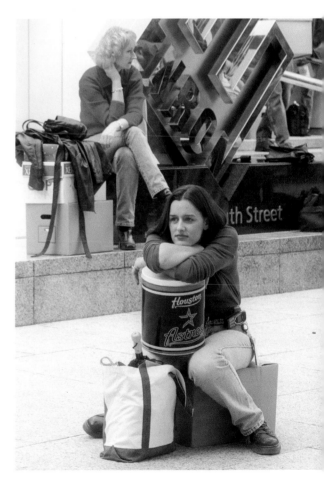

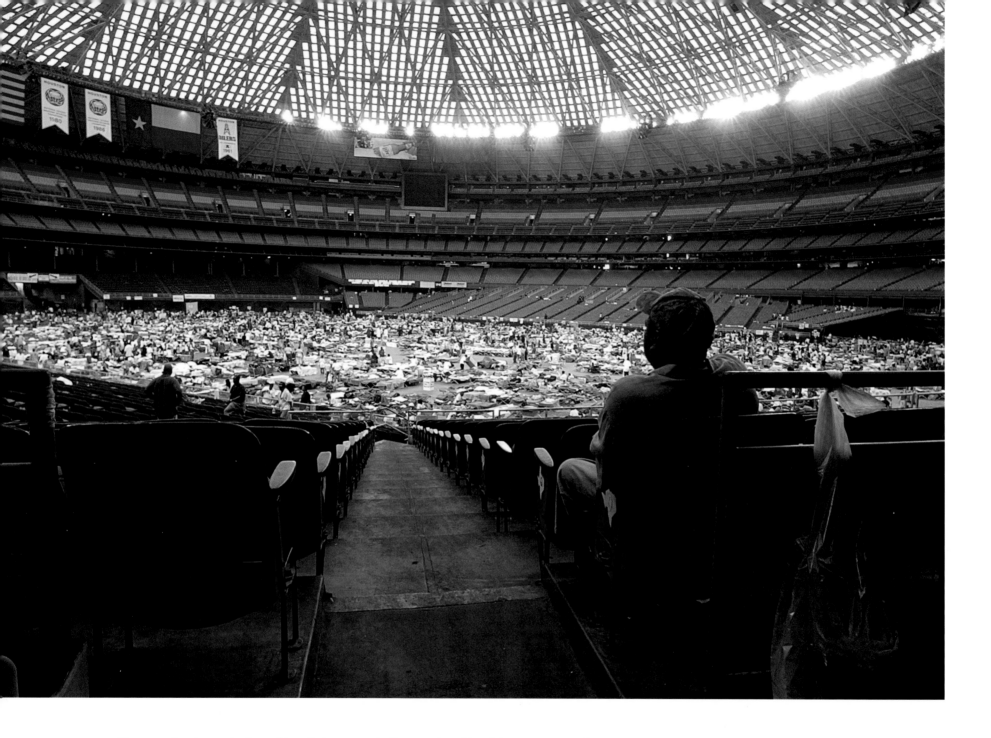

ABOVE: Thousands of people from New Orleans and other parts of Louisiana temporarily called the Astrodome home in September 2005 following the devastation caused by Hurricane Katrina. In all, about 24,000 people took shelter in Reliant Park in the days after the hurricane struck the central Gulf Coast. COURTESY HOUSTON CHRONICLE ARCHIVES

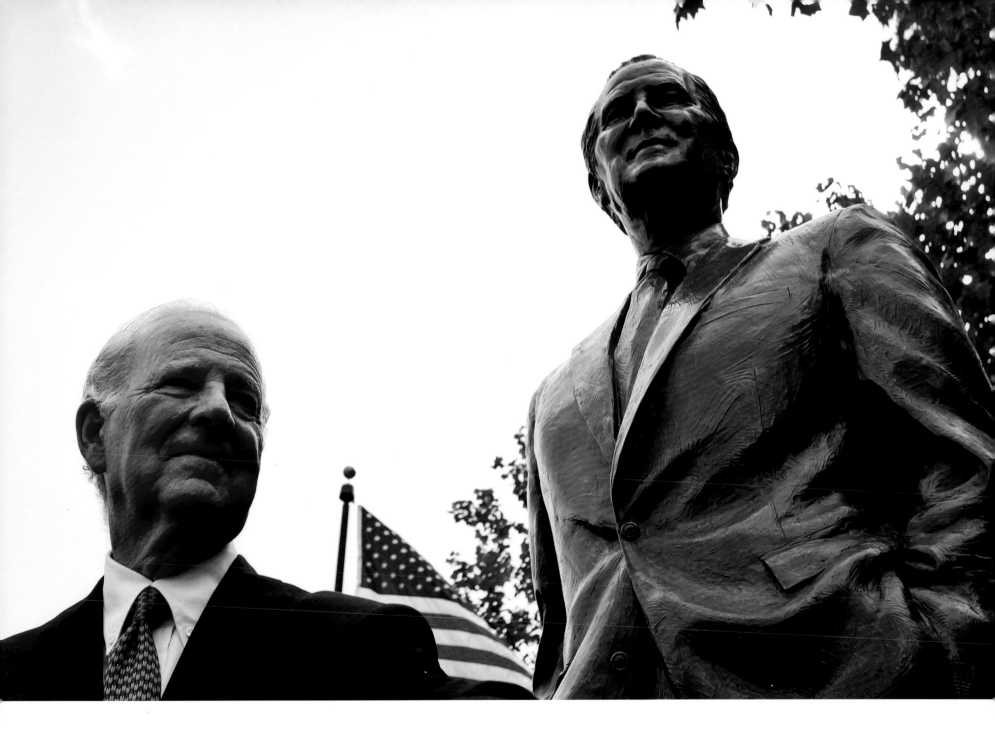

ABOVE: James A. Baker III, standing in front of the statue that bears his name in 2011, has served in the top levels of government under three presidents, including secretary of state during the administration of President George H.W. Bush. Baker is a partner in the Baker Botts law firm, which was founded by his great-grandfather. COURTESY HOUSTON CHRONICLE ARCHIVES

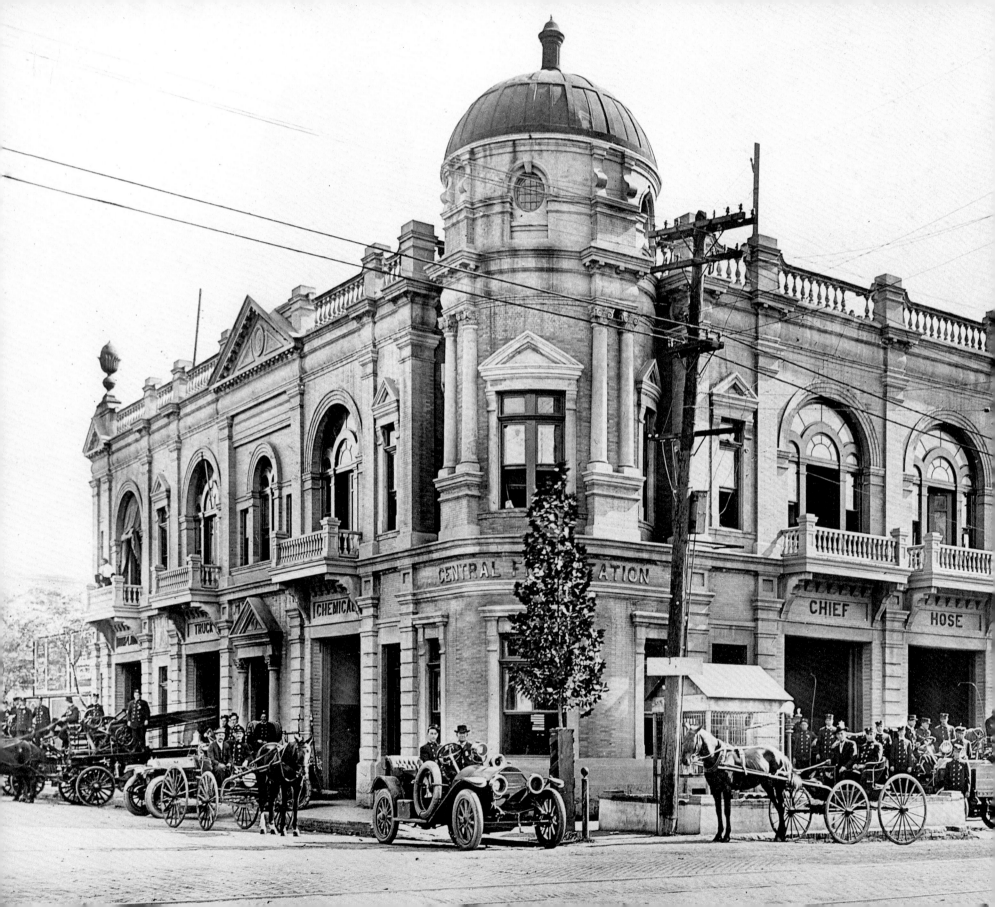

ARCHITECTURE & LANDMARKS

In the late 19th and early 20th centuries, Houston went through a construction boom that filled its streets with fine architecture. Being a young city, however, and one with an eye ever on the future, civic leaders neglected to pass laws to preserve many of those buildings. Why be concerned about old when you can have new? Many of those classic buildings fell in the face of the next economic surge.

With Houston moving toward its bicentennial, attitudes have begun to change, and efforts are under way to preserve what does remain. That growing concern may explain the reluctance to demolish the unused Astrodome, where generations of residents saw their first professional ball games.

The emphasis on new, on big and bold, did have an upside. As Houston boomed through the 1970s and 1980s, skyscrapers from the renowned architects Cesar Pelli, I.M. Pei and Philip Johnson erupted on the city's skyline. Johnson's Pennzoil Place, uncharacteristically dark with sharp, oblique angles, is the city's most decorated building. But the massive Chase Tower, one of the 15 tallest in America, cannot be missed, and Johnson's Bank of America Center, with its Dutch Gothic overtones, would be admired in any cityscape.

In the Uptown District that is home to the Galleria, the Williams Tower rises 901 feet and is one of the tallest buildings in the world outside of a central business district. Visitors can't help but be struck by its rotating beacon on top, or the luscious Water Wall at its base. Texas Monthly magazine in 1999 named the Williams Tower its "skyscraper of the century."

On a more human scale, Houston has only a handful of architecturally significant neighborhoods. Most notable is Houston Heights, a Victorian holdover that has done its best to maintain its style with restrictive building covenants. Isolated jewels can be found around the city, from the privately owned Frank Lloyd Wright home on the west side to the Beer Can House decorated with tops, bottoms and flattened sides of the common beverage container to The Orange Show, a folk-artistic creation in south Houston that turned a private residence into a mix of whimsy, aphorisms, mosaics and simple oddball, orange-flavored fun. And few can forget the "Hole House," another artistic oddity that suggests an old house being sucked into the wormhole that ran smack through the middle of it. No one can say Houston doesn't have a sense of humor.

LEFT: Central Fire Station at the corner of Texas and San Jacinto, circa 1915.
COURTESY UNIVERSITY OF HOUSTON

BELOW: Henry S. Fox mansion, 1206 Main at Dallas, 1904. The house, built for the president of Houston National Bank, was demolished in 1927.
COURTESY UNIVERSITY OF HOUSTON

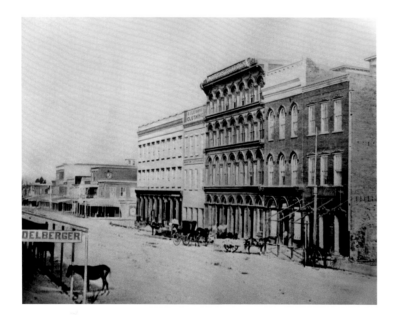

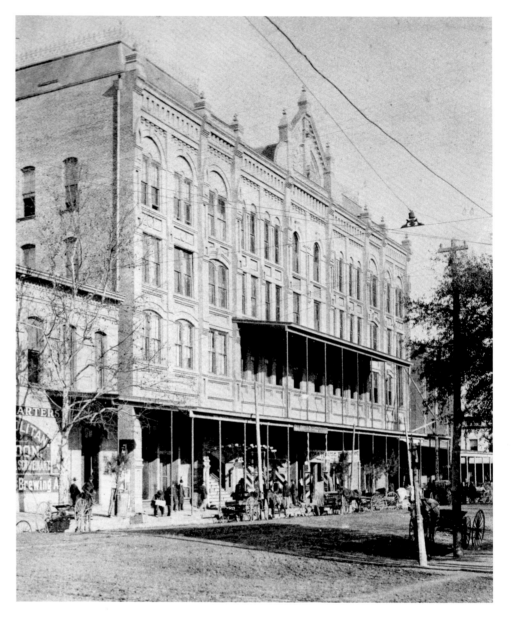

ABOVE: Sweeney & Coombs Opera House opened in 1890 and was located on Fannin Street, opposite the Harris County Courthouse.
COURTESY UNIVERSITY OF HOUSTON

LEFT: Main Street near Preston Avenue, 1866. J.R. Morris built the city's first four-story building, pictured at center, which was also the first iron-front building in Houston. COURTESY UNIVERSITY OF HOUSTON

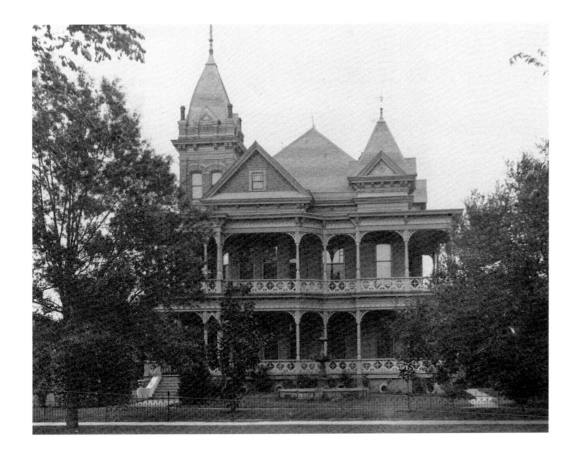

LEFT: Reconstruction-era Mayor T.H. Scanlan's home was located at 1917 Main at Pierce. Scanlan lived in the Eugene Heiner-designed home with his seven daughters. Built in 1891, the house was demolished in 1937. COURTESY UNIVERSITY OF HOUSTON

BOTTOM LEFT: Carnegie Library, 1904. The building, located at the corner of McKinney and Travis, was later replaced by the Julia Ideson Building a few blocks away. COURTESY UNIVERSITY OF HOUSTON

BOTTOM RIGHT: The Binz Building, located at the corner of Texas and Main, 1904. This building was constructed in the mid-1890s and is considered to be Houston's first skyscraper. It's said that visitors came from miles around to ride the elevator and view the city from the top floor. COURTESY UNIVERSITY OF HOUSTON

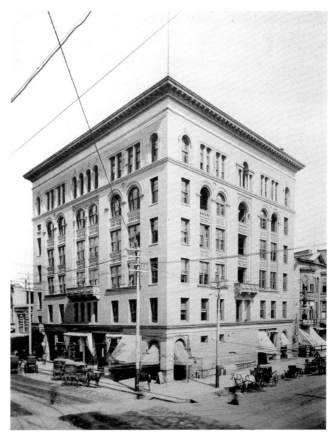

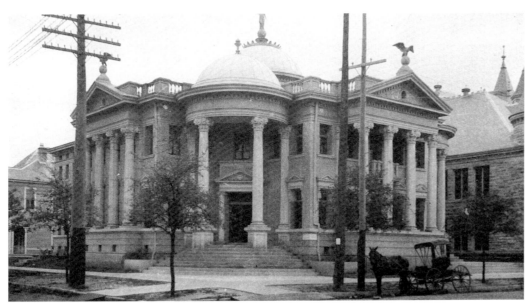

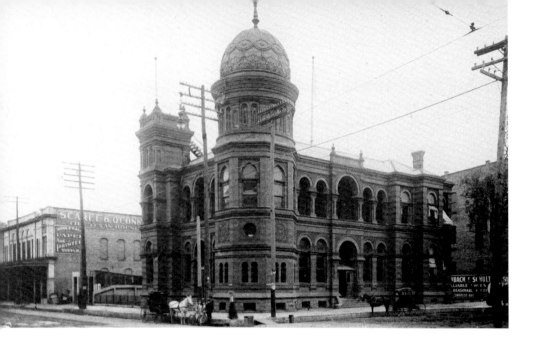

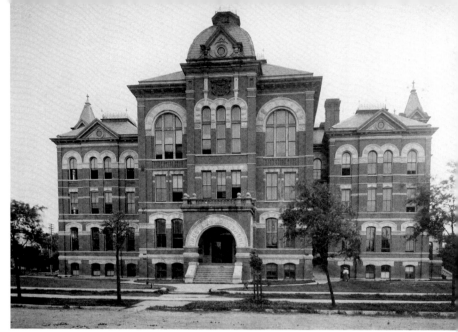

ABOVE: The U.S. Post Office building at the southeast corner of Franklin and Fannin, 1904.
COURTESY UNIVERSITY OF HOUSTON

ABOVE RIGHT: Houston High School (Central High School), 1904. In 1894, ground was broken on the $80,000 building located on the square block bordered by Austin, Rusk, Caroline and Capitol. Described as one of the finest high schools in this part of the country, it burned down in March 1919.
COURTESY UNIVERSITY OF HOUSTON

RIGHT: The Cotton Exchange building at 202 Travis, 1904. Before Houston was an oil town, it was a cotton town. This structure, designed by Eugene T. Heiner, was home to Houston's cotton market for 40 years. The building was restored and renovated into offices in 1971.
COURTESY UNIVERSITY OF HOUSTON

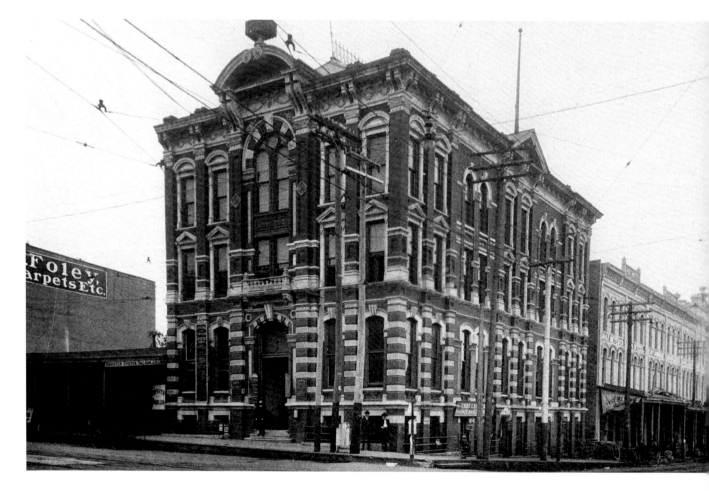

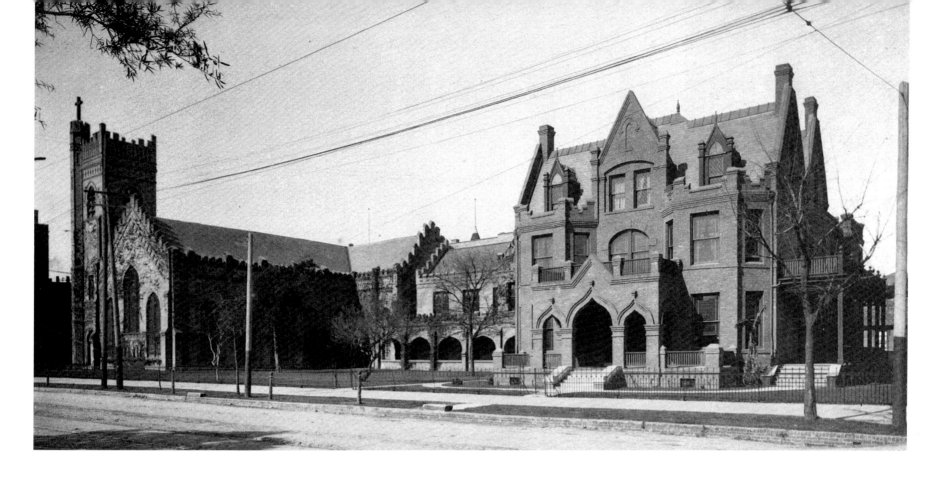

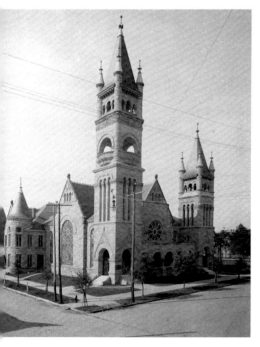

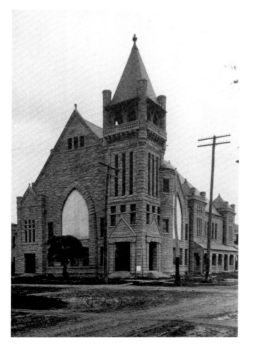

ABOVE: Christ Church Cathedral, 1904. Founded on March 16, 1839, Christ Church Cathedral is one of Houston's earliest religious congregations and is the only one still worshiping on its original site from the days when Houston was the capital of the Republic of Texas. Services have been held in the present church since the 1890s. COURTESY UNIVERSITY OF HOUSTON

LEFT: First Baptist Church, 1904. This church, once located at Fannin and Walker, was designed by architect George E. Dickey and built in 1884. Dickey was responsible for numerous buildings in Houston, nearly all of which have been demolished. His major works in Houston include the Capitol Hotel, the Grand Central Depot, the 1891 Houston Light Guard Armory, Elysian Street School and the 1904 Houston City Hall and Market House. COURTESY UNIVERSITY OF HOUSTON

FAR LEFT: First Presbyterian Church, 1904. This church, which used to be located at the corner of Main and McKinney, also was designed by architect George E. Dickey and built in 1894. COURTESY UNIVERSITY OF HOUSTON

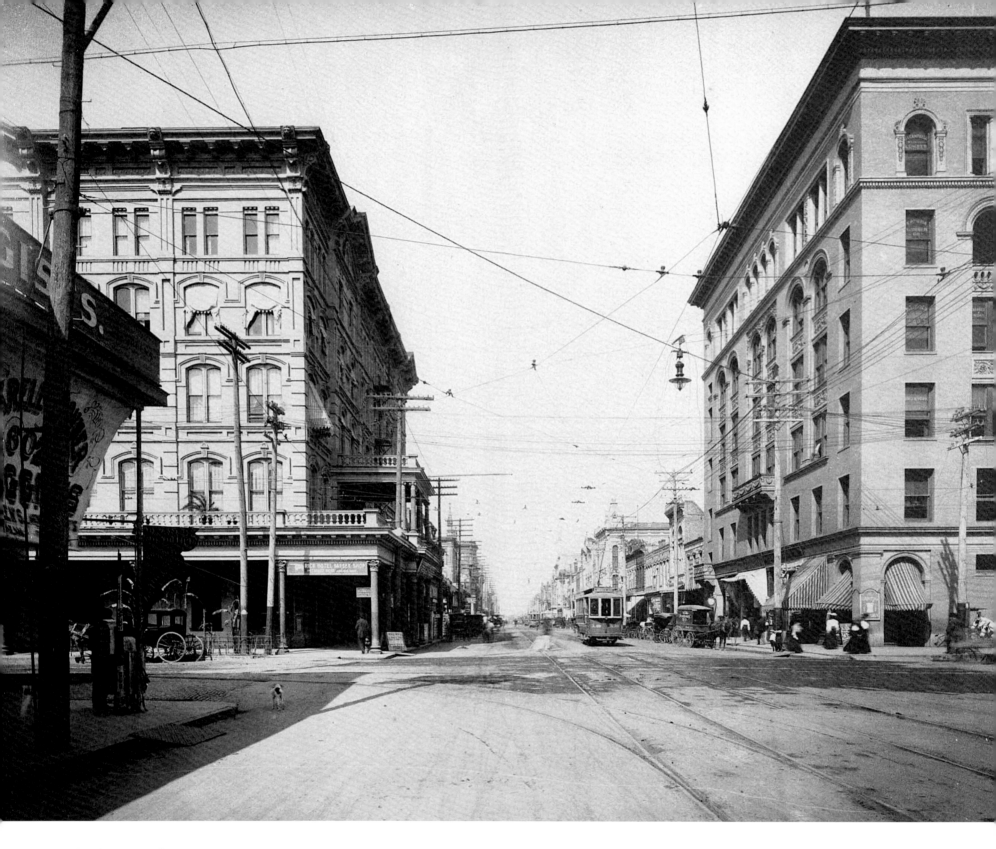

BELOW: Construction continues on the Commercial National Bank Building, Main and Franklin, in early 1904. This six-story building was one of the largest neoclassical commercial buildings remaining in what was the center of Houston's financial district. The building was designed by the firm of Green and Svarz. COURTESY UNIVERSITY OF HOUSTON

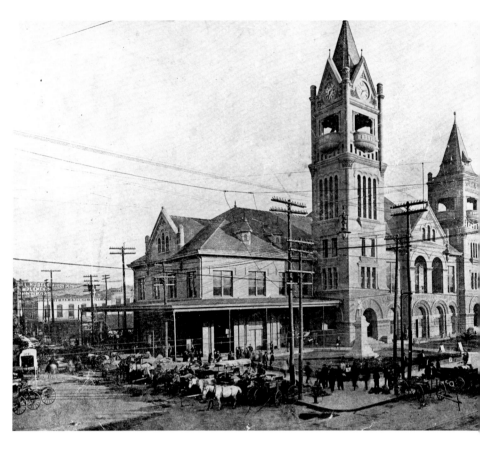

ABOVE: Until the late 1930s, the center of Houston city government was located at Market Square. The City Hall seen here was built in 1904 and torn down in the 1960s.
COURTESY UNIVERSITY OF HOUSTON

LEFT: A view of Allen's Landing, 1904.
COURTESY UNIVERSITY OF HOUSTON

OPPOSITE: A view of Main Street, looking north from Texas Avenue, 1904.
COURTESY UNIVERSITY OF HOUSTON

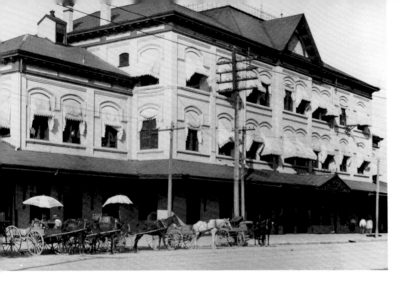

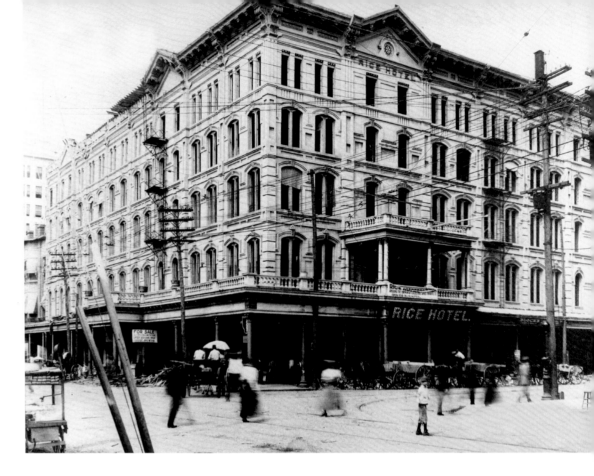

ABOVE: Horse-drawn wagons line Washington Avenue in front of Grand Central Depot, circa 1912.
COURTESY UNIVERSITY OF HOUSTON

RIGHT: The Rice Hotel, named after Rice University benefactor William Marsh Rice, Oct. 14, 1911. By the time this photo was taken, the building was set to be dismantled to make room for a much larger Rice Hotel. COURTESY HOUSTON CHRONICLE ARCHIVES

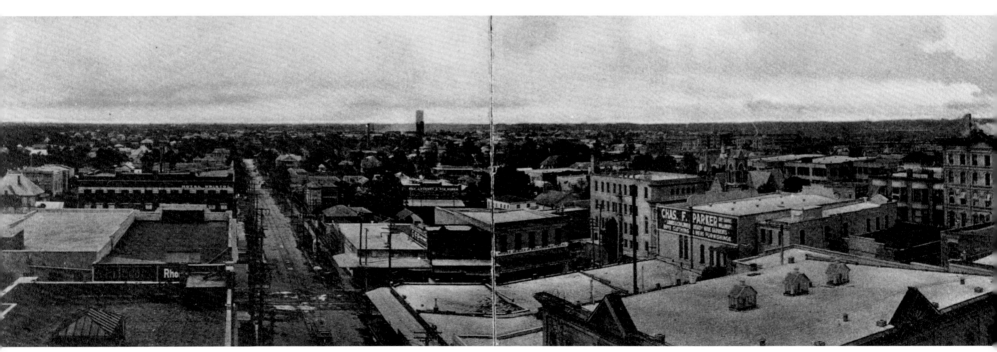

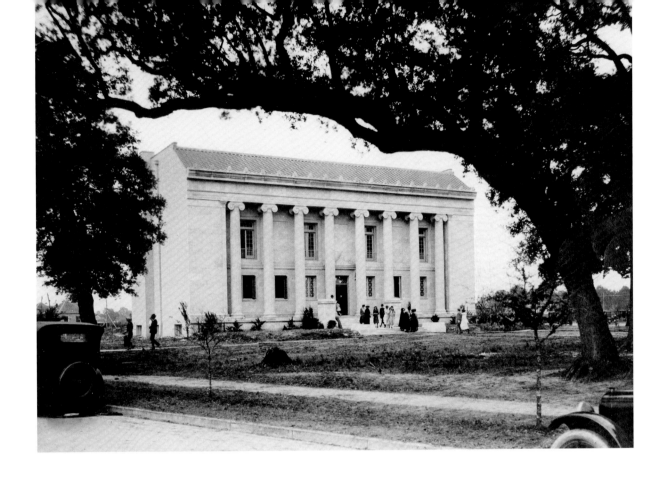

LEFT: Grand opening of Houston architect William Ward Watkin's Museum of Fine Arts, Houston building, April 12, 1924. Established in 1900, the museum has grown over the decades to become one of the 10 largest art museums in the United States.

COURTESY HOUSTON CHRONICLE ARCHIVES

BELOW: A panoramic view of downtown Houston, circa 1910. The photograph appears to have been taken from an elevated position at Capitol Avenue, looking north up Main Street.

COURTESY UNIVERSITY OF HOUSTON

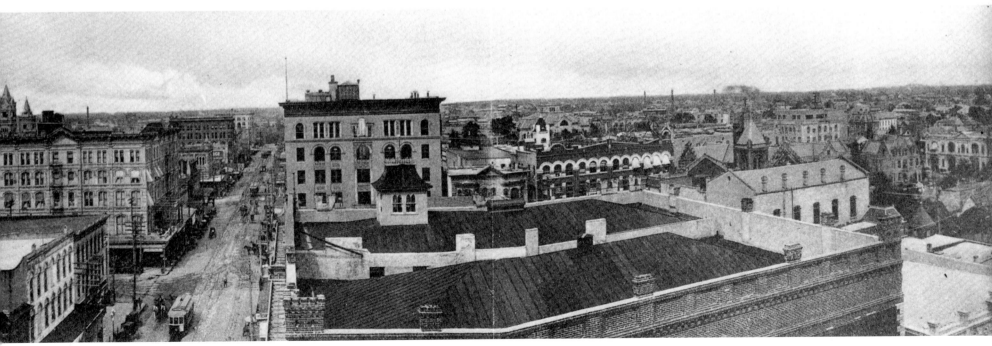

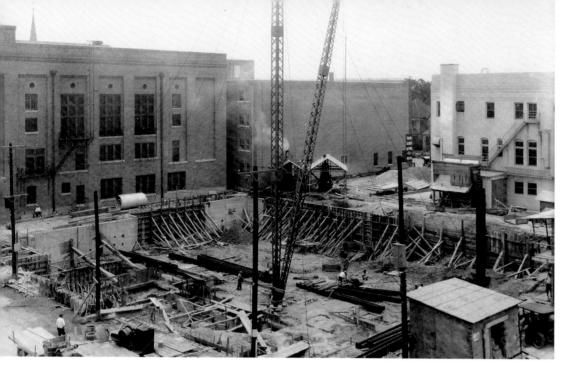

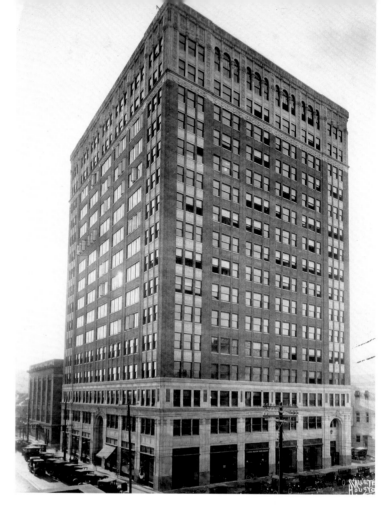

ABOVE: Construction work begins on the new Cotton Exchange Building at 1300 Prairie, June 2, 1923. COURTESY DENISE SMESNY

RIGHT: Another view of the Cotton Exchange Building at 1300 Prairie, 1924. This building, built by Don Hall Construction, later became known as the Anderson Clayton Building and is now owned by Harris County. COURTESY DENISE SMESNY

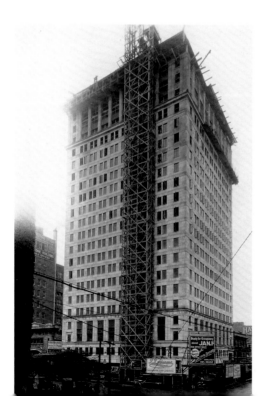

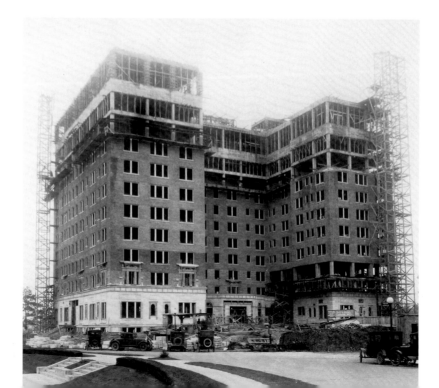

LEFT: Construction is almost complete on the Warwick Apartments, Oct. 31, 1925. For decades, the apartment-hotel located in what's now the Museum District has served as one of Houston's more exclusive places to stay. COURTESY DENISE SMESNY

FAR LEFT: Houston Post-Dispatch Building (now Magnolia Hotel) at 609 Fannin nears completion, Nov. 2, 1925. COURTESY DENISE SMESNY

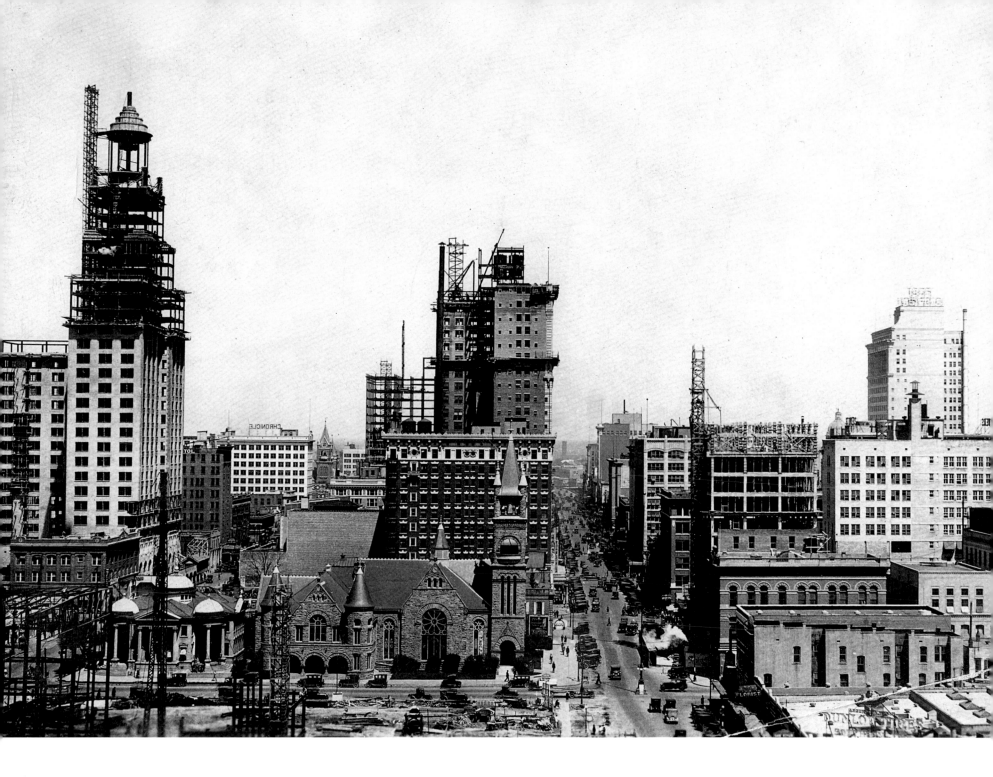

ABOVE: The 32-story Esperson building, left, highlighted a building boom in 1927 and would stand as Houston's tallest building for a short time. It was built as a memorial to famed real estate and oil tycoon Niels Esperson by his widow, Mellie. COURTESY UNIVERSITY OF HOUSTON

RIGHT TOP: For more than 100 years, the Houston Chronicle has had a presence at the corner of Texas and Travis. During that time, the Chronicle Building has undergone a series of face-lifts and expansions. Even the entrance has moved, which prompted a change of address, from 512 Travis to 801 Texas. Before the Chronicle occupied the site, the land belonged to the Charles Shearn Memorial Church, known today as First Methodist Houston.

COURTESY HOUSTON CHRONICLE ARCHIVES

RIGHT BOTTOM: Looking west toward the Niels Esperson building and Sam Houston Hall, right, 1930s.

COURTESY THE SLOANE COLLECTION

BELOW: 1910 Harris County Courthouse, 1928.

COURTESY THE SLOANE COLLECTION

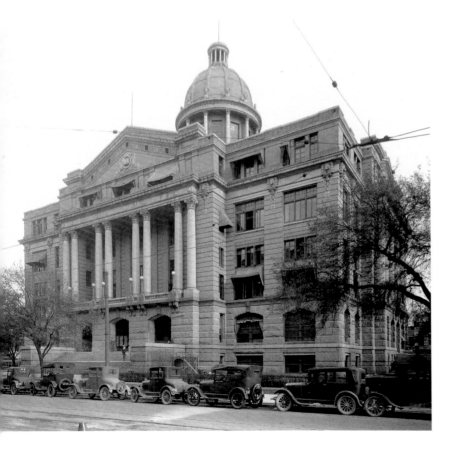

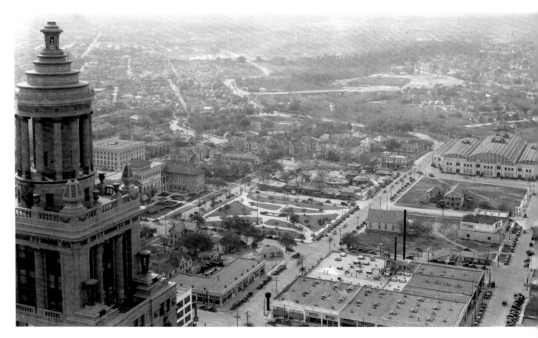

BELOW: The Abe M. Levy house, located at 2016 Main at Gray, was built in 1906 and shared by the Houston merchant and his two siblings. The house only existed for 32 years and was demolished a year after the last sibling passed away. COURTESY HOUSTON PUBLIC LIBRARY, HOUSTON METROPOLITAN RESEARCH CENTER

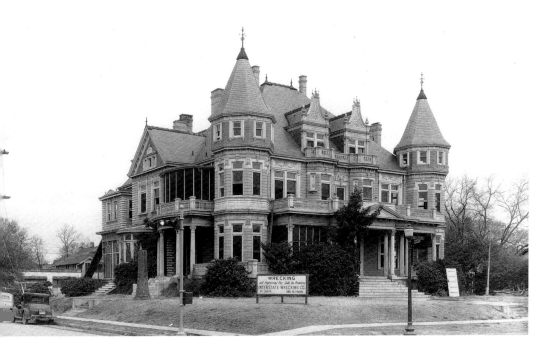

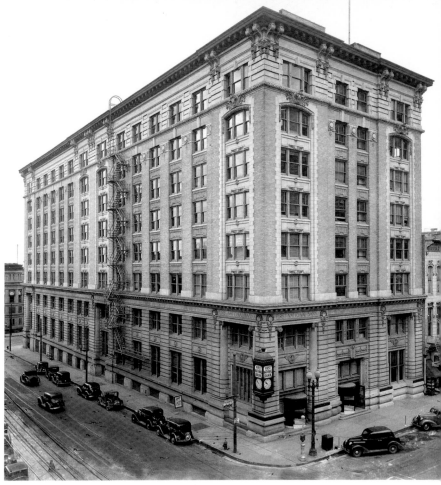

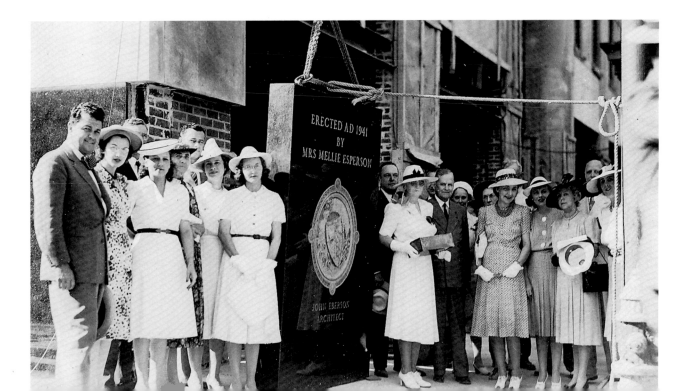

ABOVE: Located at the corner of Main and Franklin, the First National Bank building, pictured here in 1932, was the first steel-framed structure in the city. Designed by noted skyscraper architects Sanguinet & Staats, it is now home to the Franklin Lofts. COURTESY THE SLOANE COLLECTION

LEFT: A ceremony to place the cornerstone of the Mellie Esperson Building, the first skyscraper in Houston to be built with central air-conditioning, was held in 1941. COURTESY JAMES FISHER

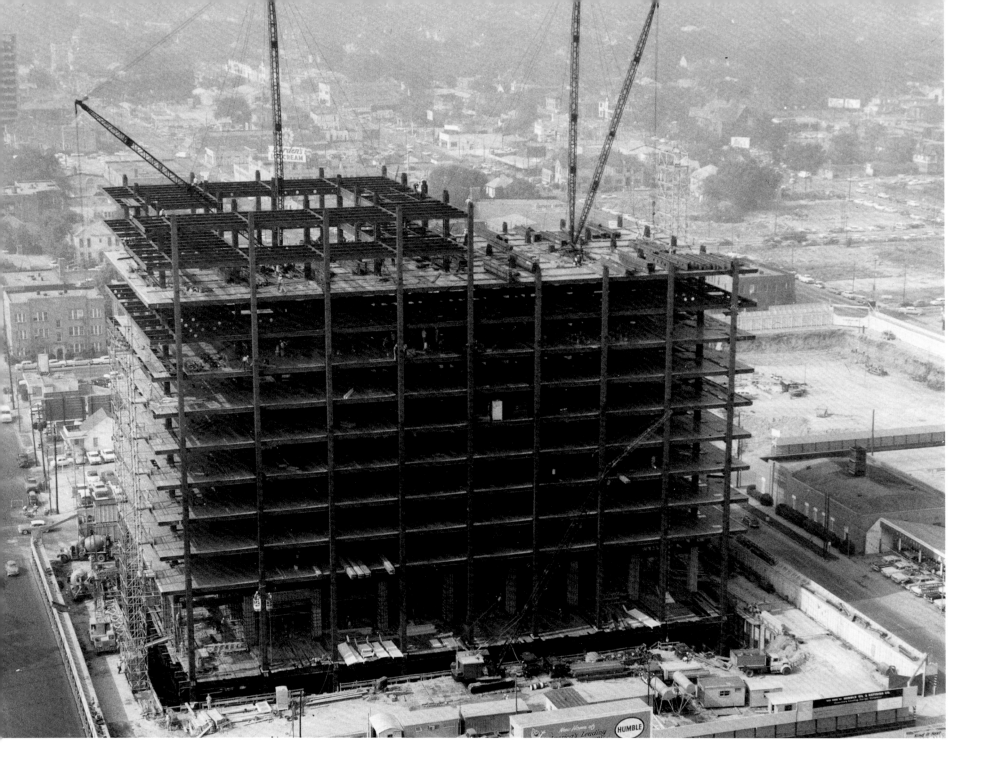

ABOVE: Workers put up steel on the 12th and 13th floors of the tallest building west of the Mississippi River, September 1960, as construction work continues on the 44-story $32 million Humble Oil Building. COURTESY HOUSTON CHRONICLE ARCHIVES

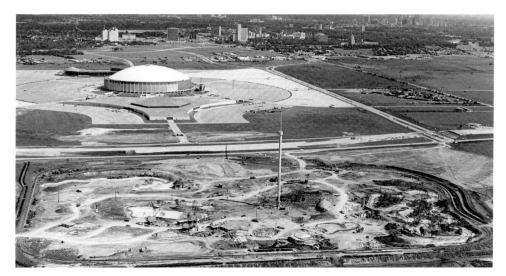

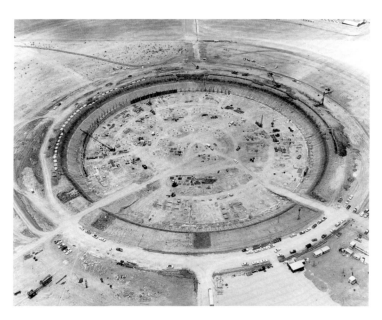

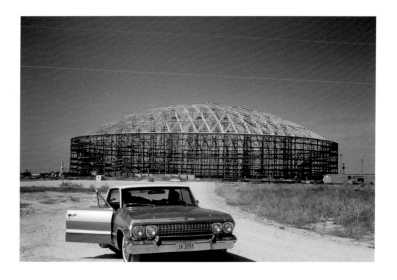

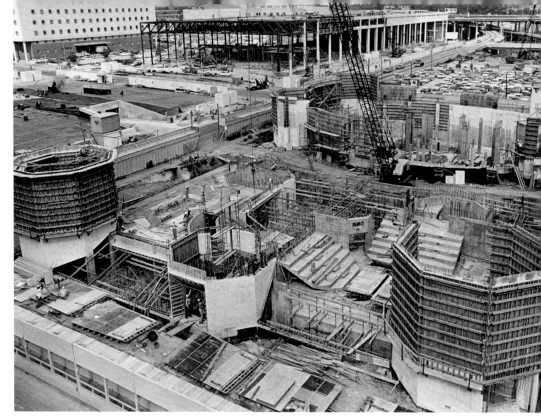

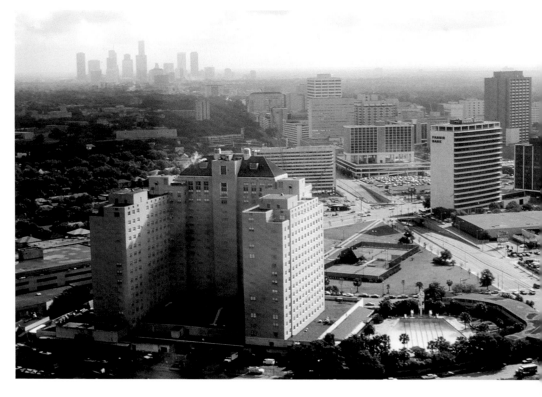

ABOVE: Annunciation Catholic Church, 1975.
COURTESY HOUSTON CHRONICLE ARCHIVES

RIGHT TOP: The Alley Theatre's new home is under construction in this 1967 photo. In the background, work is also progressing on the Albert Thomas Convention Center.
COURTESY HOUSTON CHRONICLE ARCHIVES

RIGHT BOTTOM: The Shamrock Hilton occupies a view of the Texas Medical Center with the Houston skyline in the distance, June 1981. COURTESY FERRELL MOORE

LEFT: As RepublicBank Center, seen in this 1982 photo, unfolds to its 56 stories, it will eventually block this view from the federal courthouse. The $180 million building was a project of Gerald D. Hines Interests, which was also responsible for the Texas Commerce Tower, left, and Pennzoil Place. COURTESY HOUSTON CHRONICLE ARCHIVES

BELOW: Antioch Missionary Baptist Church, 500 Clay, is dwarfed by the steel skeleton of Four Allen Center just prior to its 1983 completion. COURTESY HOUSTON CHRONICLE ARCHIVES

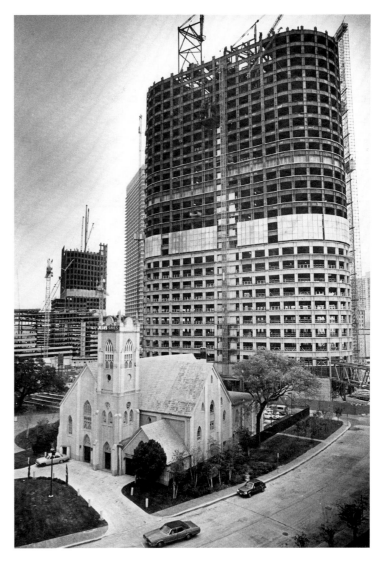

RIGHT: The 64-story Transco Tower (now Williams Tower), seen here prior to its 1983 completion, is one of Houston's most recognizable buildings.
COURTESY HOUSTON CHRONICLE ARCHIVES

FAR RIGHT: The 56-story Bank of America Center (formerly RepublicBank Center) at 700 Louisiana was completed in October 1983. Designed by the architectural team of Philip Johnson and John Burgee, the building contains 1.25 million square feet of office and retail space.
COURTESY HOUSTON CHRONICLE ARCHIVES

BELOW: Spectators line Allen Parkway in 1999 as Jefferson Davis Hospital is imploded to make room for development. COURTESY HOUSTON CHRONICLE ARCHIVES

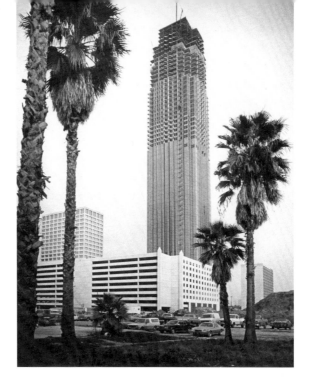
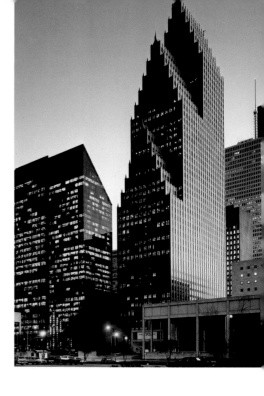
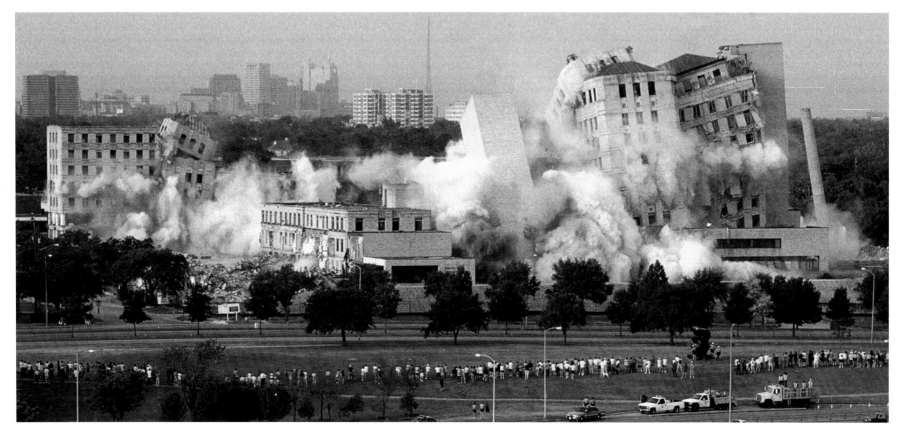

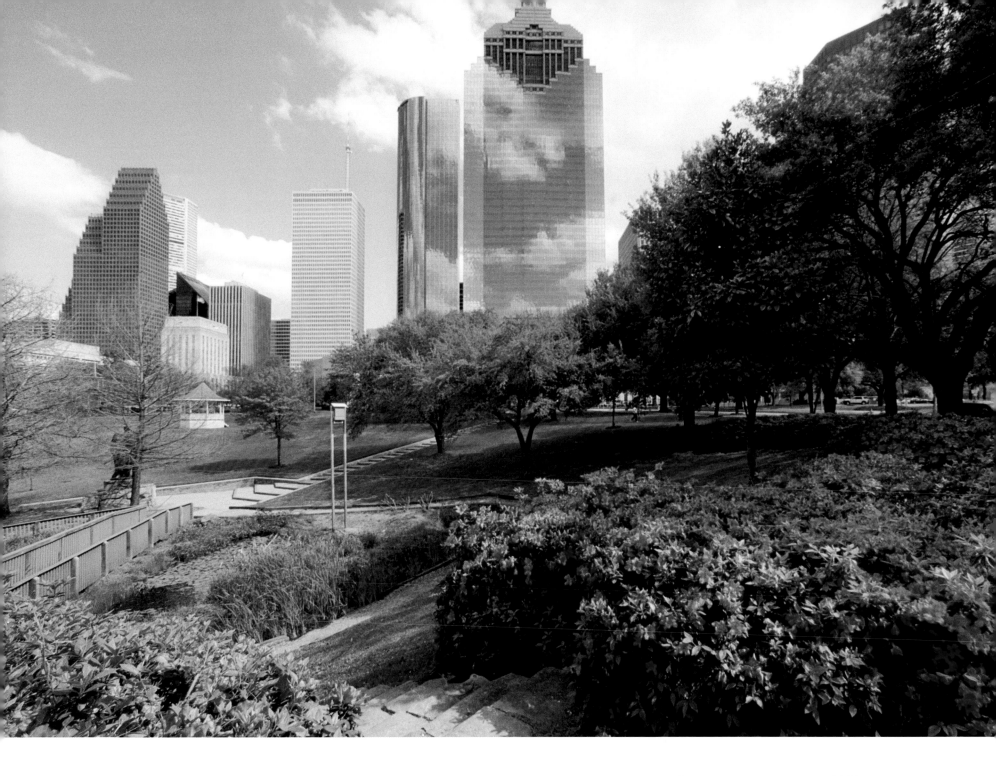

ABOVE: From left, the Bank of America Center, City Hall, One Shell Plaza, Wells Fargo Plaza and Heritage Plaza can be seen in this 2003 view of the Houston skyline, looking east from Sam Houston Park. COURTESY HOUSTON CHRONICLE ARCHIVES

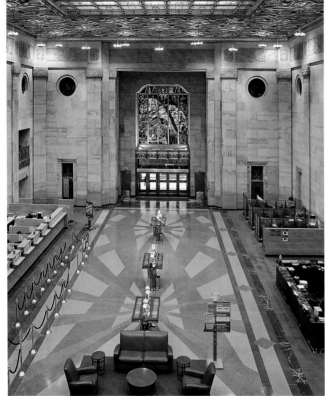

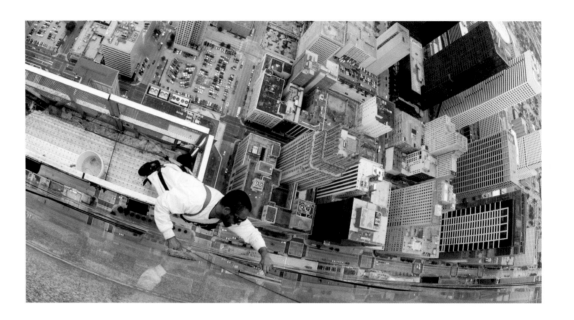

BELOW: Jose-Luis Riquelme keeps the 75-story JPMorgan Chase Tower clean in this 2008 photo. For a time, the tower, earlier known as the Texas Commerce Tower, was the tallest building west of the Mississippi River. COURTESY HOUSTON CHRONICLE ARCHIVES

ABOVE: This 2007 photo shows the lobby inside the JPMorgan Chase Building, formerly the Gulf Building. Widely considered Houston's most impressive Art Deco space, the building was designed by architects Alfred C. Finn, Kenneth Franzheim and J.E.R. Carpenter and completed in 1929. This room, with its terrazzo floors and walls of polished travertine, was built to serve Jesse H. Jones' National Bank of Commerce, now a part of JPMorgan Chase. COURTESY HOUSTON CHRONICLE ARCHIVES

RIGHT: The 33-story Calpine Center at 717 Texas enters the final stages of construction in this July 22, 2003, photo. COURTESY HOUSTON CHRONICLE ARCHIVES

FAR RIGHT: The 40-story 1500 Louisiana building, seen here in 2009, was designed by internationally renowned architect Cesar Pelli and completed in early 2002. Originally, Enron Corp. was to occupy the building, but in the wake of the company's financial scandal, it never materialized. Chevron USA would later purchase the building in 2004. COURTESY HOUSTON CHRONICLE ARCHIVES

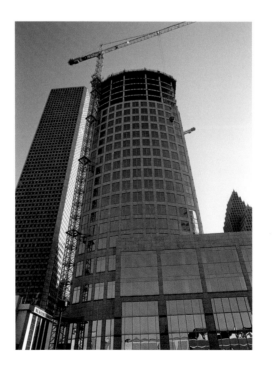

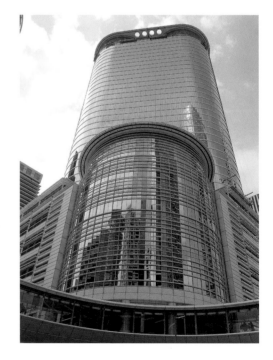

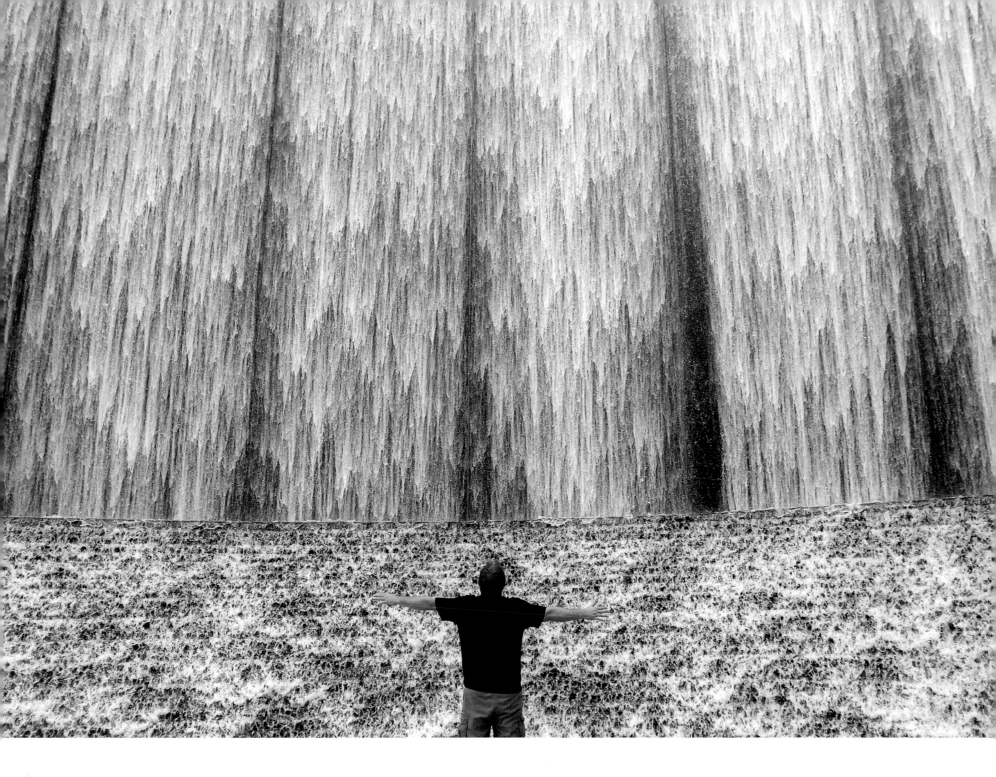

ABOVE: A visitor enjoys the mist while standing in front of the Williams Water Wall, located adjacent to the Williams Tower, 2011.
COURTESY HOUSTON CHRONICLE ARCHIVES

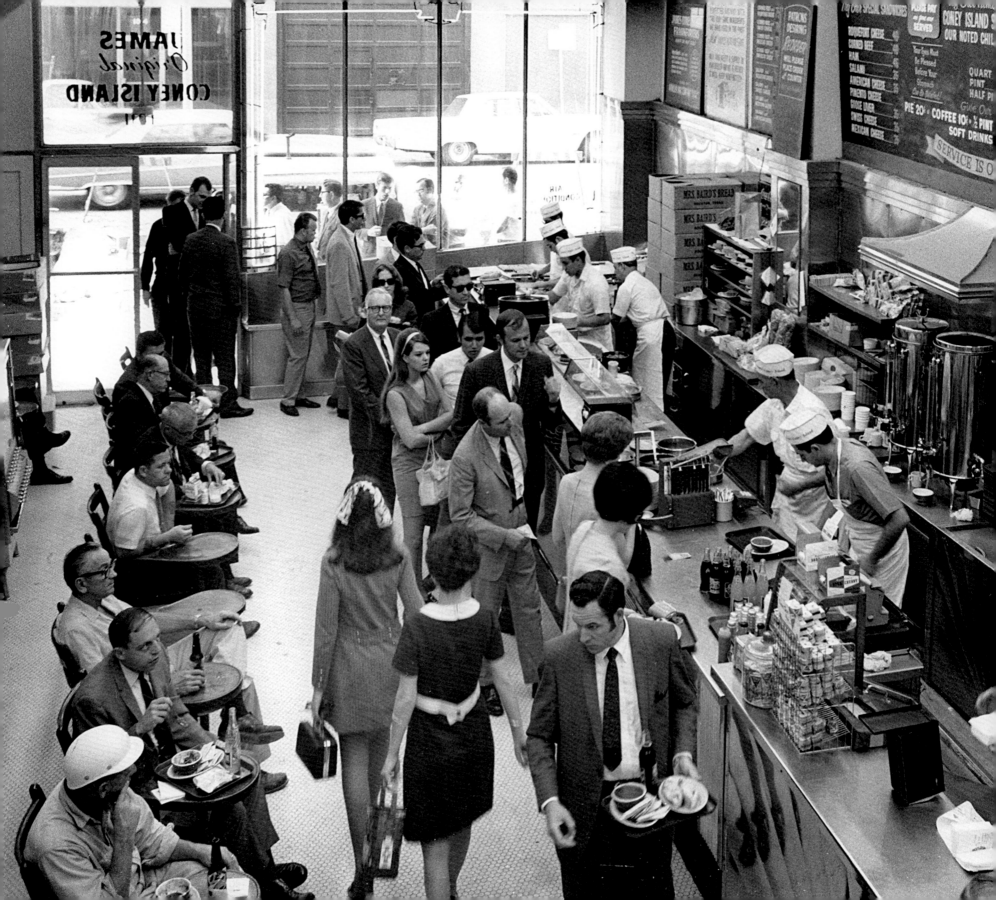

Chapter three

COMMERCE & GROWTH

Houston — once a malarial hamlet nestled in swampy Southeast Texas – grew to become America's fourth-largest city. Today it is home to the world's largest medical center and one of the busiest U.S. ports. Twenty-three of the country's Fortune 500 companies have their corporate headquarters here, and many others have major operations in the city, including multinational corporations.

After the energy bust of the 1980s, concern over Houston's reliance on energy prices led to a broad civic effort to diversify the city's economy. The campaign paid big dividends two decades later as Houston weathered a national economic downturn far better than many American cities.

For all its skyscrapers and corporate giants, Houston also is well known for business with a small "b." A lack of zoning and lightly regulated commercial environment provide fertile soil for any entrepreneur willing to work hard, from the owner of a roving taco truck to the operator of a string of dry-cleaning shops to geophysicists striking out on their own to sell specialized software.

With Houston's growth has come increasing diversity, fed in part by immigration. By 2000, no ethnic or racial group held a majority. The rapidly growing Latino population claimed more than a third of city's population. Houston is home to the third-largest group of Vietnamese-Americans in the country. And with new arrivals from South Asia and Africa, Houston now speaks more than 90 different languages. By the 2010 census, Houston had grown to a population of 2.1 million with the greater metropolitan area reaching just over 6 million — numbers beyond the imagination of even the wildest dreamer a century earlier.

LEFT: From 1923 to 1993, this James Coney Island location at 1011 Walker Ave. kept Houstonians rich and poor well-fed. Wooden school desks, a familiar sight at the restaurant, were brought in to handle the overflow of traffic. COURTESY HOUSTON PUBLIC LIBRARY, HOUSTON METROPOLITAN RESEARCH CENTER

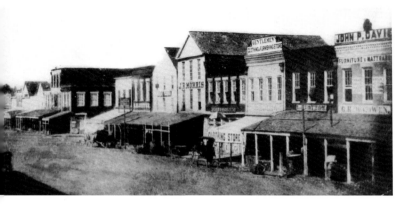

BELOW: Capitol Hotel, 1868. Originally, this structure was the home of the original capitol building of the Texas republic. By the early 1840s, it was converted into the Capitol Hotel before eventually being replaced by the Rice Hotel. COURTESY FRED BURI

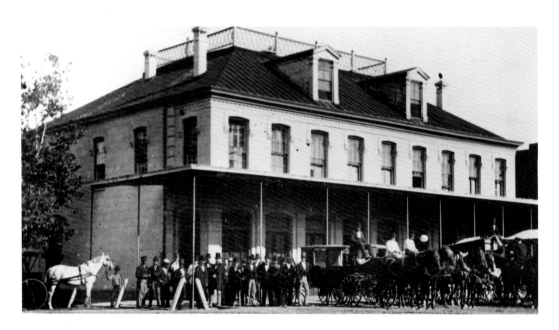

ABOVE: This 1858 photo of the 300 block of Main Street is one of the earliest known photos of Houston. COURTESY HOUSTON PUBLIC LIBRARY, HOUSTON METROPOLITAN RESEARCH CENTER

BELOW: The St. Clair out of Galveston is loaded with cotton during a visit to Allen's Landing, circa 1870. COURTESY HOUSTON PUBLIC LIBRARY, HOUSTON METROPOLITAN RESEARCH CENTER

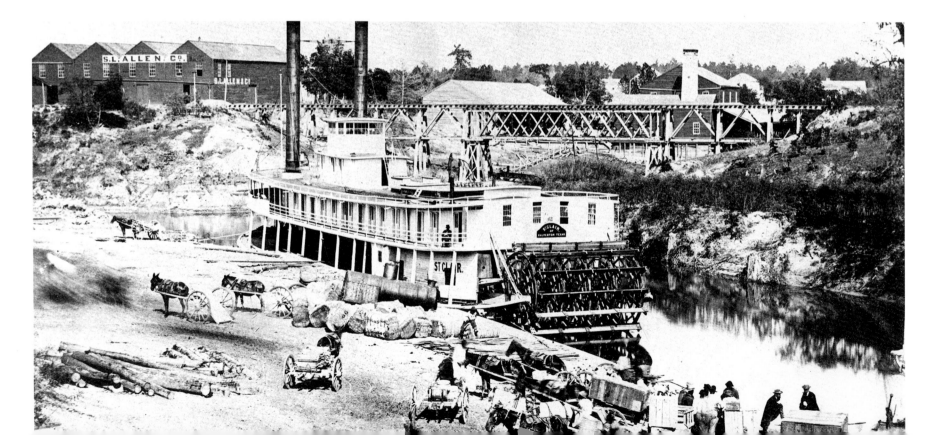

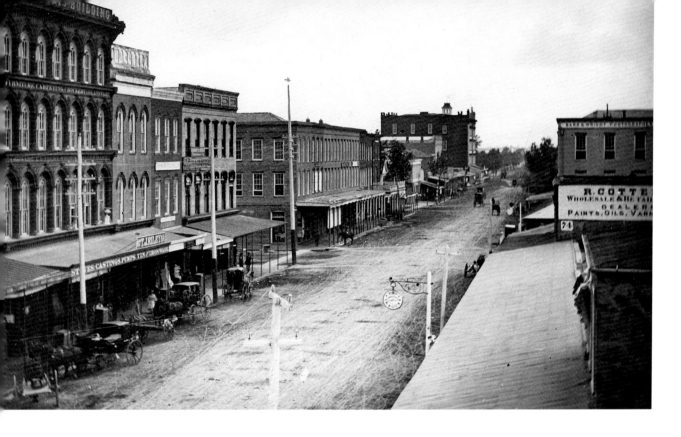

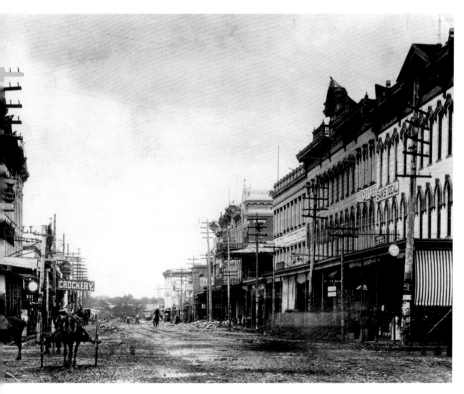

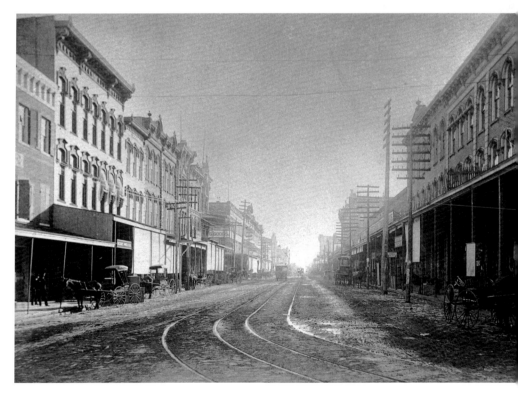

LEFT: View of businesses along Main Street, 1876.
COURTESY HOUSTON CHRONICLE ARCHIVES

BOTTOM LEFT: View of Main Street and Preston Avenue in 1880.
COURTESY HOUSTON CHRONICLE ARCHIVES

BELOW: This late 1880s scene along Main Street shows the city when public transportation featured mulecars. Commerce may have moved at a slower pace, but business thrived in the city in the late 1800s.
COURTESY HOUSTON PUBLIC LIBRARY, HOUSTON METROPOLITAN RESEARCH CENTER

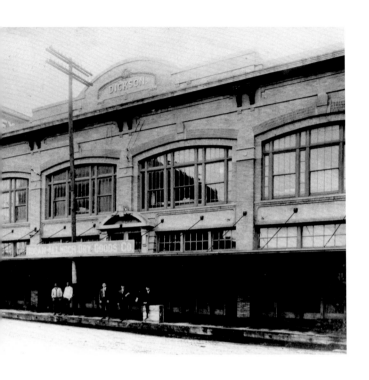

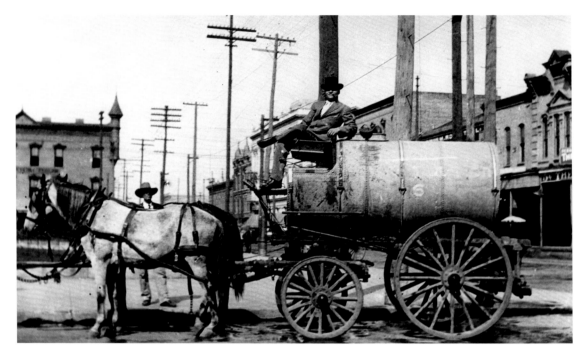

ABOVE: The Dickson Building, part of Houston's Produce Row along Buffalo-Bayou, 800 Commerce, circa 1910. The building served as the original Hogan-Allnoch Dry Goods store and warehouse. In the early 1970s this building was renovated to become the law offices of what is now Abraham, Watkins, Nichols, Sorrels, Agosto & Friend.
COURTESY ABRAHAM, WATKINS, NICHOLS, SORRELS, AGOSTO & FRIEND

ABOVE RIGHT: Water wagons were used to keep the dust at a minimum before the streets were paved, 1890s.
COURTESY UNIVERSITY OF HOUSTON

RIGHT: Stray dogs share the road with horse-drawn carts, buggies and streetcars on Main Street, circa 1890.
COURTESY HOUSTON PUBLIC LIBRARY, HOUSTON METROPOLITAN RESEARCH CENTER

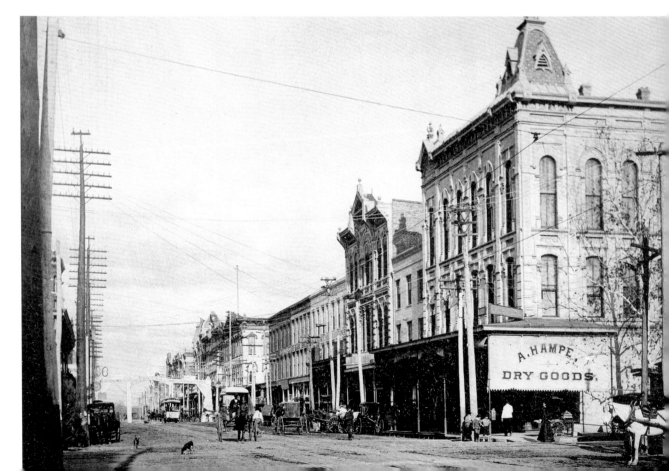

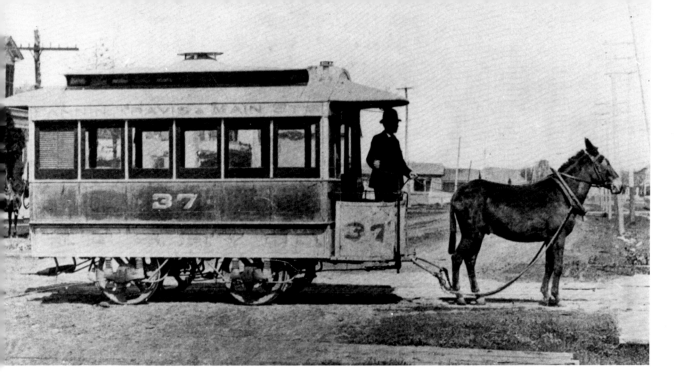

LEFT: Old mule car at the corner of Preston and Dowling, looking west, circa 1890. Mule-drawn streetcars served Houston until 1891 when they were replaced with electric streetcars.
COURTESY HOUSTON CHRONICLE ARCHIVES

BELOW: Rail and cotton made up much of Houston's commerce in the 19th century. Here, rail cars loaded with cotton are parked at Grand Central Depot, circa 1900.
COURTESY UNIVERSITY OF HOUSTON

ABOVE: The Theo Dreyling Grocery store was located at the corner of Austin and Pease, circa 1890.
COURTESY UNIVERSITY OF HOUSTON

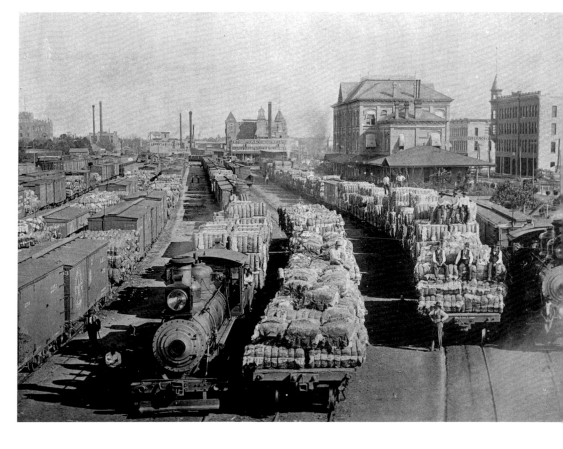

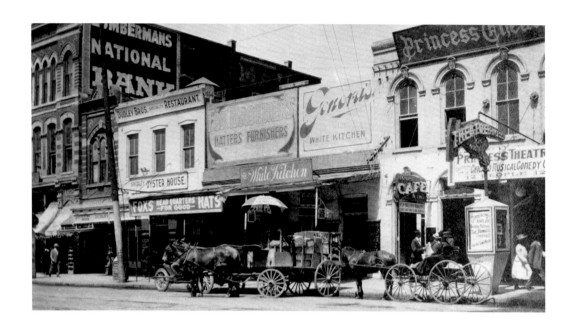

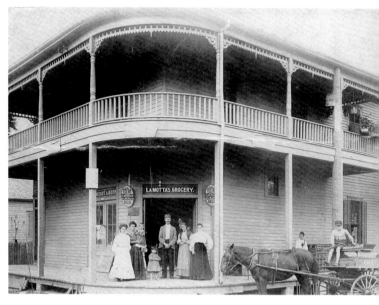

ABOVE: Storefronts on the 400 block of Main between Preston and Prairie, circa 1900. Note theater at right.

COURTESY UNIVERSITY OF HOUSTON

ABOVE RIGHT: La Motta Grocery Store, 2202 Hardy, between Quitman and Loraine, circa 1905.

COURTESY ANNETTE LESTER

RIGHT: Horse-drawn delivery wagon belonging to Maida & Cuccia Shoe Makers, later Houston Shoe Hospital, at 910 Congress, circa 1906. The company was founded by John L. Maida, pictured on the left.

COURTESY JOHN L. MAIDA

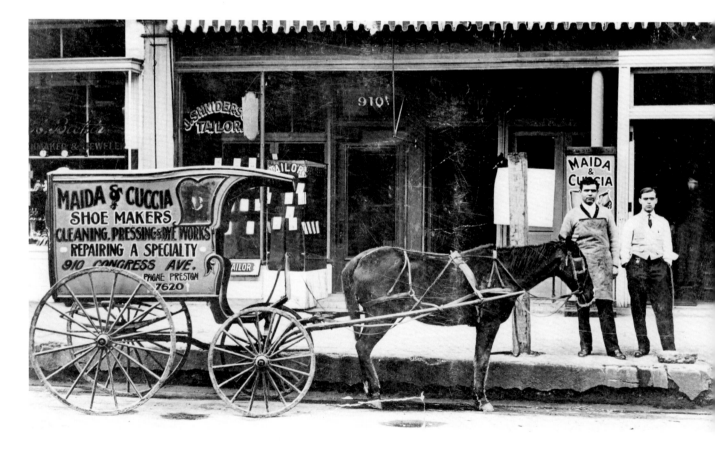

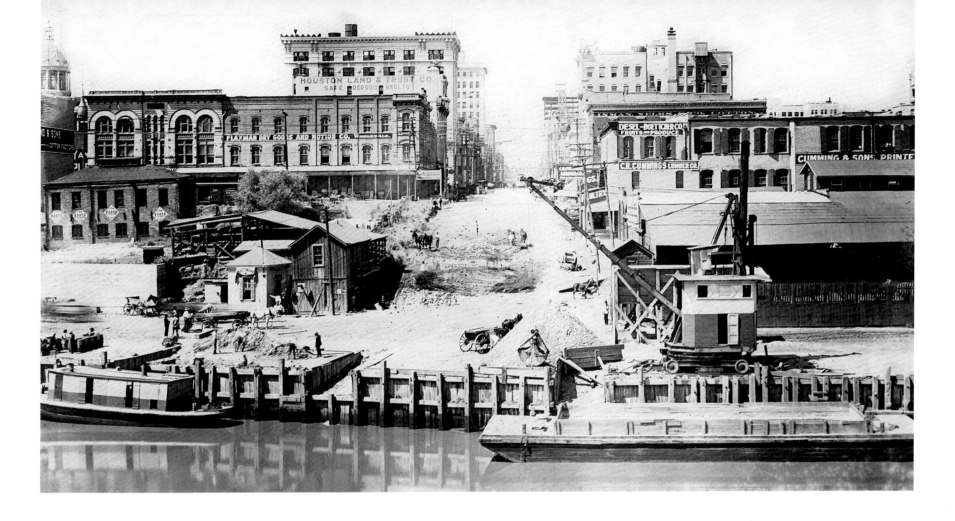

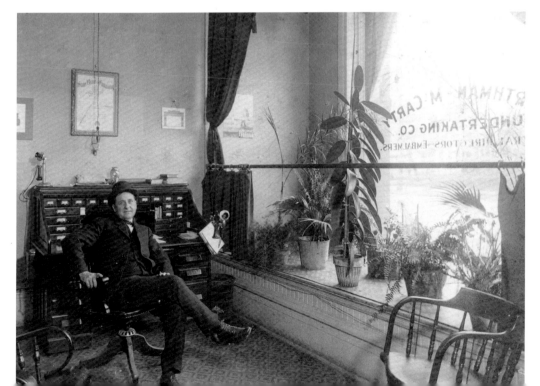

ABOVE Allen's Landing at the foot of Main Street remained a source of commerce for the city as this circa 1910 photo shows. COURTESY HOUSTON PUBLIC LIBRARY, HOUSTON METROPOLITAN RESEARCH CENTER

LEFT: James Bradshaw Earthman, a congenial blacksmith and proprietor of a livery stable in Central Texas, came to Houston with railroad surveyor J.C. McCarty in 1904 and opened Earthman & McCarty Undertaking Co. at 715 Main. Twenty years later, the company moved to 2420 Fannin. After Earthman's death in 1931, James B. Earthman Jr. managed the company. James B. Earthman Jr.'s wife, Blanche Bastien Earthman, worked with him in the daily operation of the business and was one of the first women in Texas to become a licensed funeral director. COURTESY HOUSTON CHRONICLE ARCHIVES

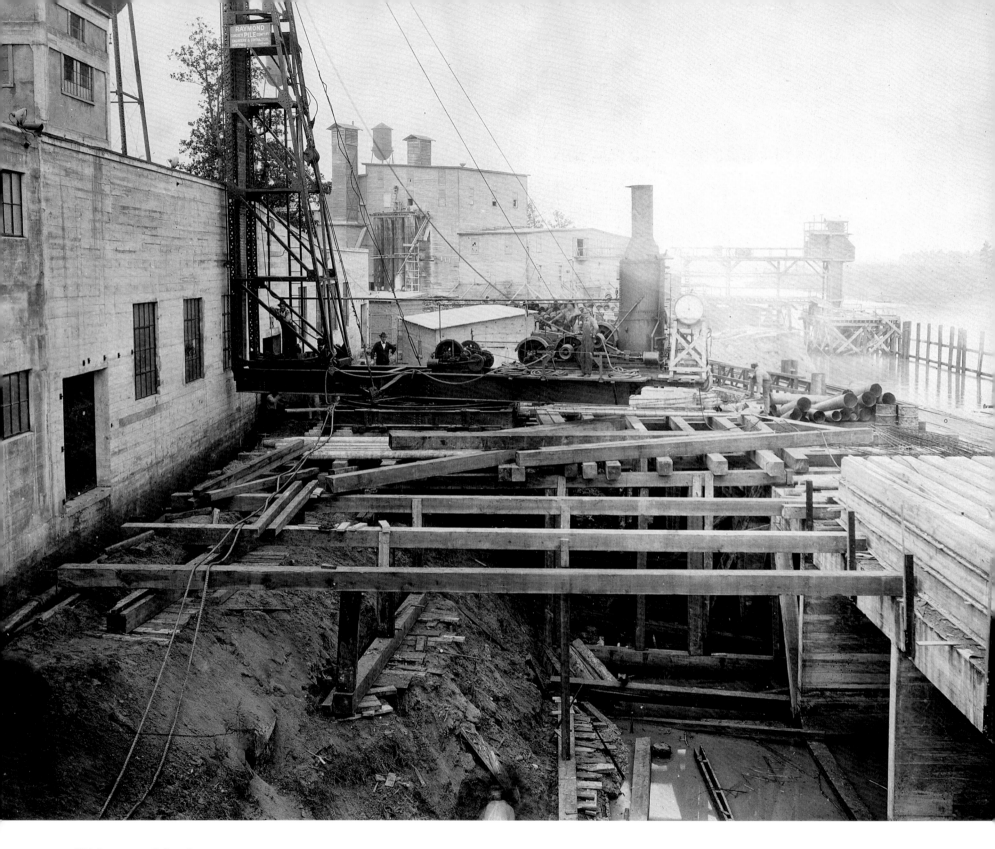

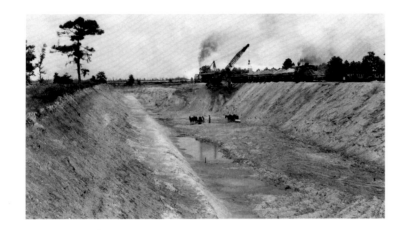

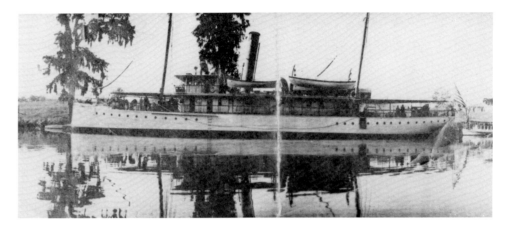

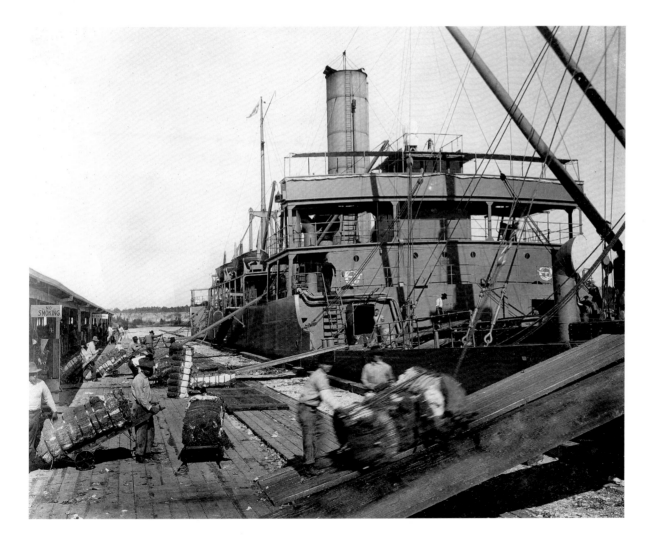

ABOVE: The 171-foot, 670-ton U.S. Revenue Cutter Windom is tied to a dock at the Port of Houston, circa 1915.
COURTESY UNIVERSITY OF HOUSTON

ABOVE LEFT: A mule skinner drives two teams of mules below a giant dragline during construction of the Houston Ship Channel, circa 1914. This area later became the Ship Channel's turning basin.
COURTESY HOUSTON CHRONICLE ARCHIVES

LEFT: A 20,300-bale shipment of cotton is loaded on the SS Merrymount on its way to Liverpool, England, from Houston, November 1919.
COURTESY HOUSTON PUBLIC LIBRARY,
HOUSTON METROPOLITAN RESEARCH CENTER

OPPOSITE Construction of a wharf along the Houston Ship Channel, circa 1914.
COURTESY HOUSTON CHRONICLE ARCHIVES

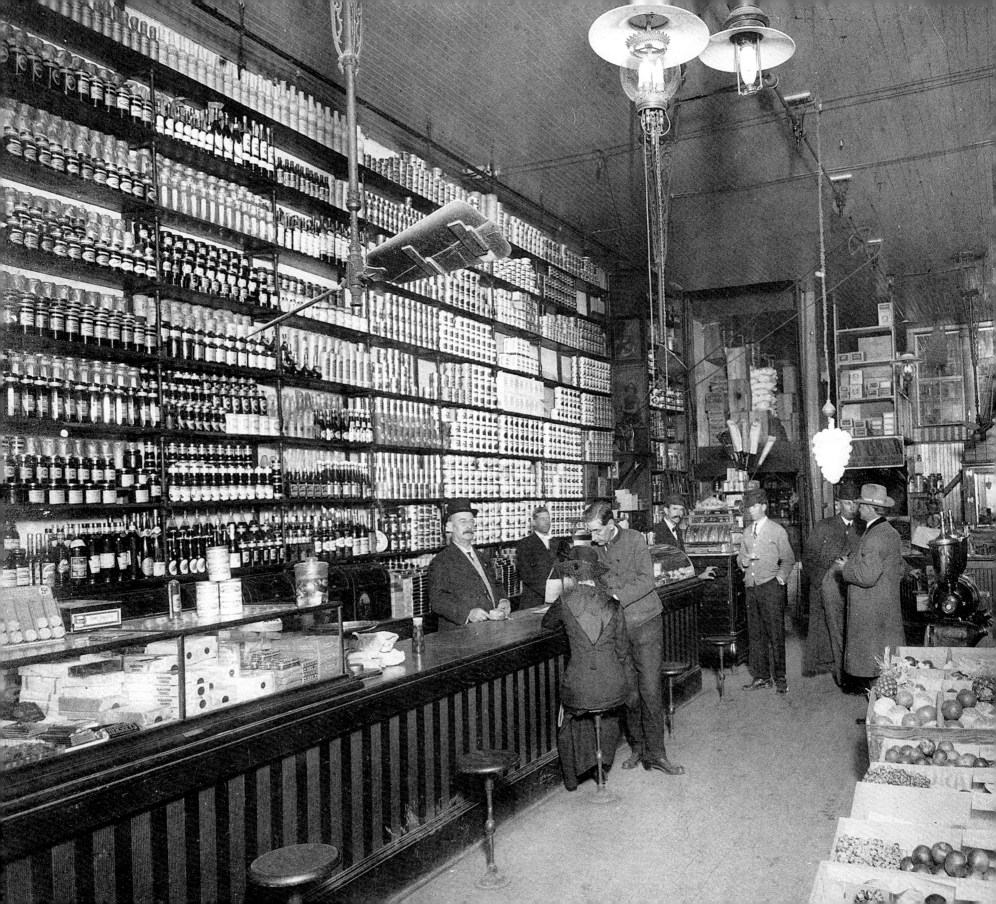

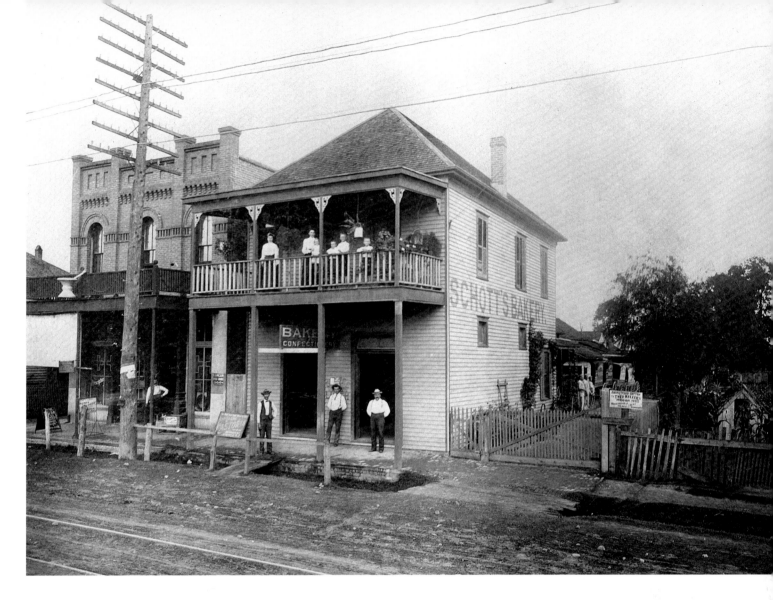

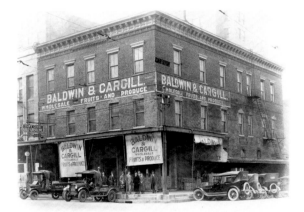

ABOVE: Over the years Schott's Bakery has long held a presence on Washington Avenue.
COURTESY HOUSTON PUBLIC LIBRARY,
HOUSTON METROPOLITAN RESEARCH CENTER

LEFT: Baldwin and Cargill wholesale fruits and produce, 102 Main, circa early 1920s. COURTESY HOUSTON PUBLIC LIBRARY,
HOUSTON METROPOLITAN RESEARCH CENTER

FAR LEFT: Downtown was home to a number of grocers, such as this one in the early 20th century.
COURTESY HOUSTON PUBLIC LIBRARY,
HOUSTON METROPOLITAN RESEARCH CENTER

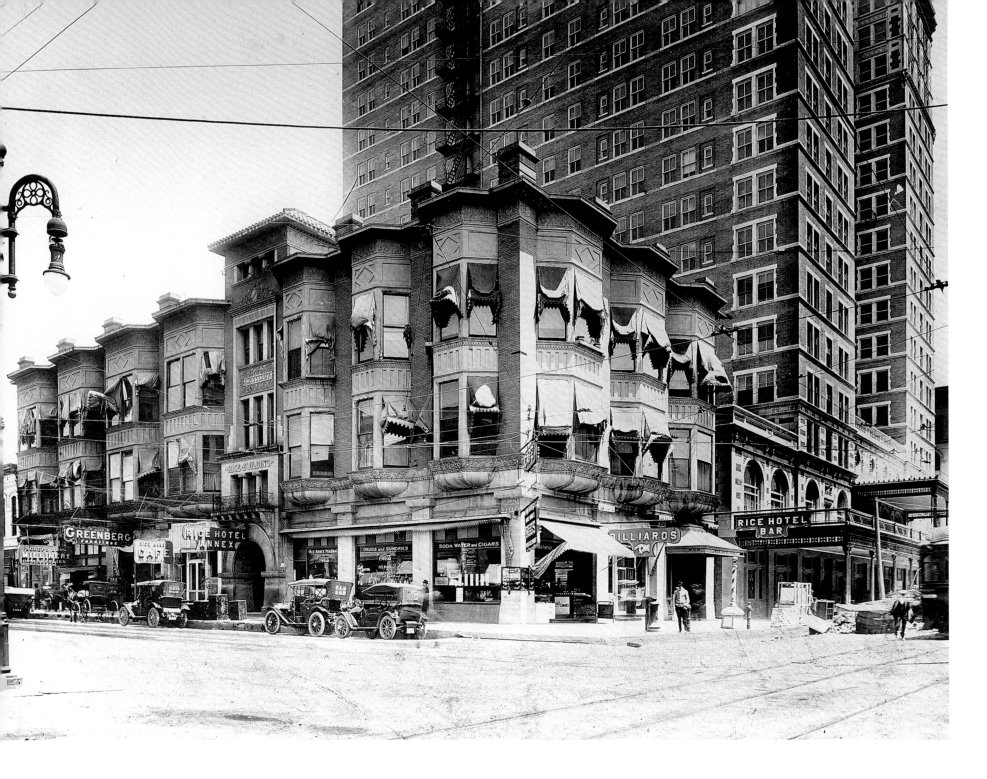

ABOVE: Before another wing was added to the Rice Hotel in the mid-1920s, the hotel's annex at the corner of Texas and Travis provided a number of services for hotel guests. COURTESY HOUSTON PUBLIC LIBRARY, HOUSTON METROPOLITAN RESEARCH CENTER

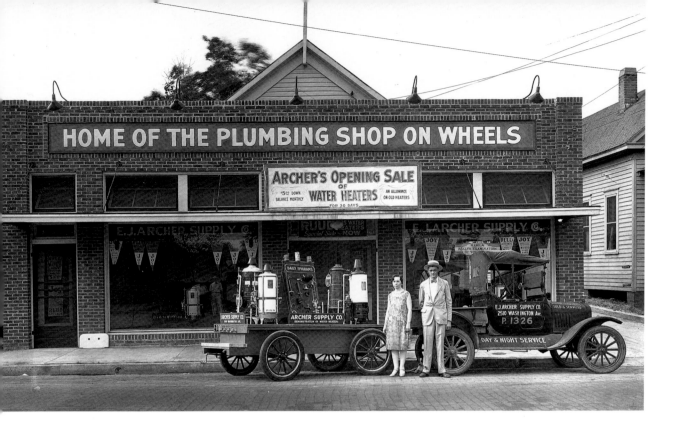

LEFT: E.J. Archer Supply Co. officials show off their stock of water heaters in front of their Washington Avenue shop.
COURTESY HOUSTON PUBLIC LIBRARY, HOUSTON METROPOLITAN RESEARCH CENTER

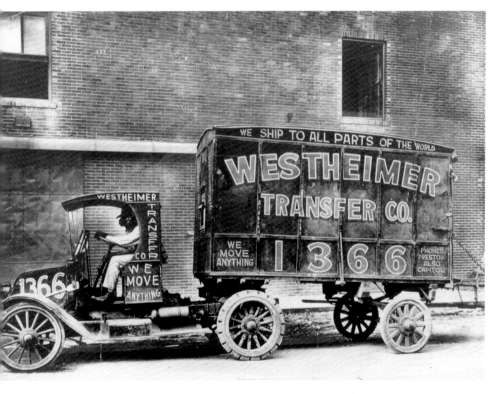

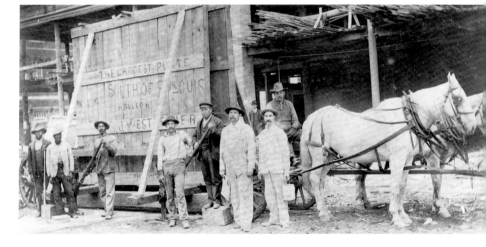

ABOVE: Westheimer Transfer & Storage moving crew, circa 1920. Man in suit, standing on the block, is S.J. Westheimer.
COURTESY WESTHEIMER TRANSFER AND STORAGE

LEFT: Westheimer Transfer & Storage moving truck in the 1920s.
COURTESY WESTHEIMER TRANSFER AND STORAGE

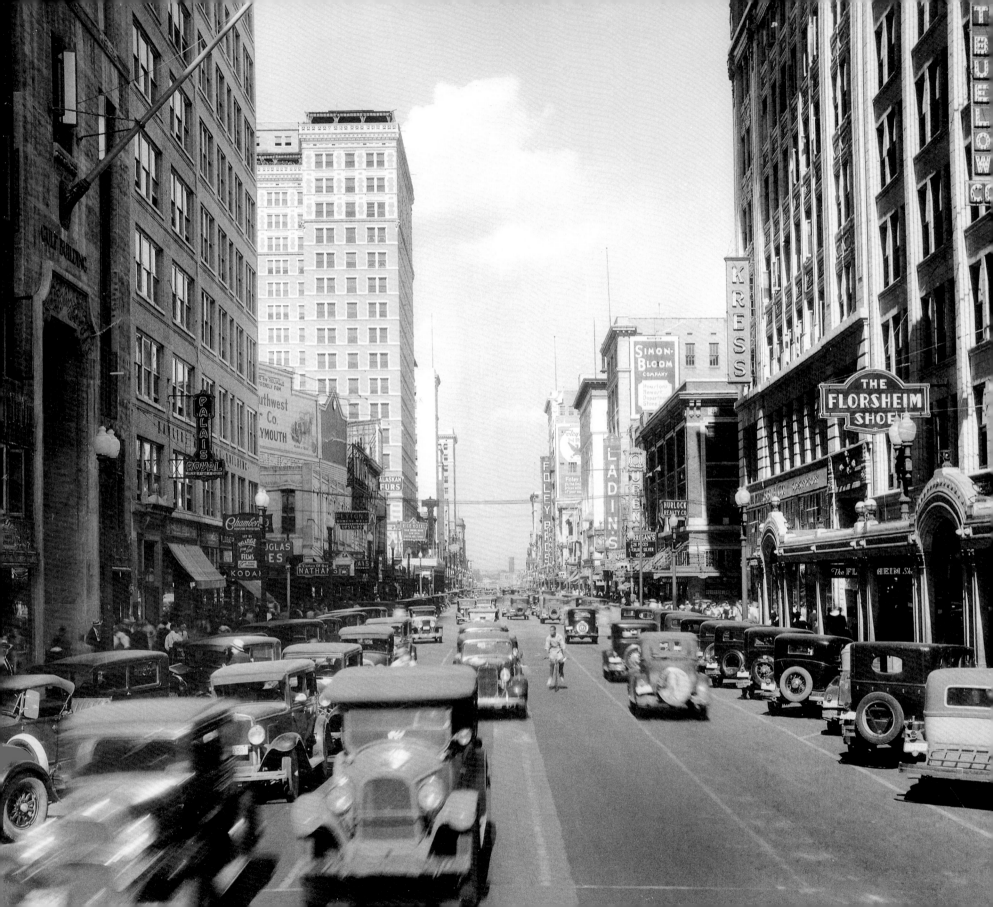

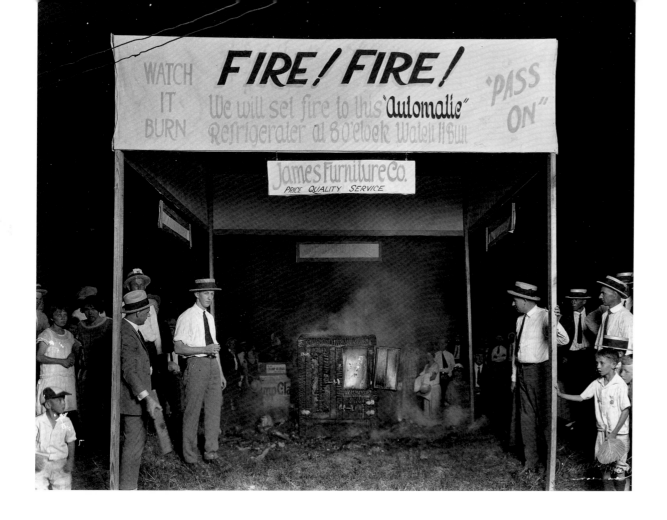

LEFT: Representatives from James Furniture Company set out to show that an "automatic" ice box set on fire can keep the ice inside frozen, circa early 1920s. COURTESY DON JAMES

OPPOSITE: Main Street, looking north from Rusk Avenue, mid-1930s. COURTESY LEE LADIN

BOTTOM LEFT: Crowds gather outside James Furniture Company's 14th Anniversary Sale. COURTESY DON JAMES

BOTTOM RIGHT: Employees of Model Cleaners, 1920s. COURTESY THE SLOANE COLLECTION

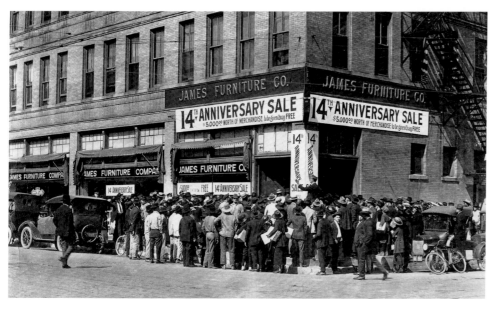

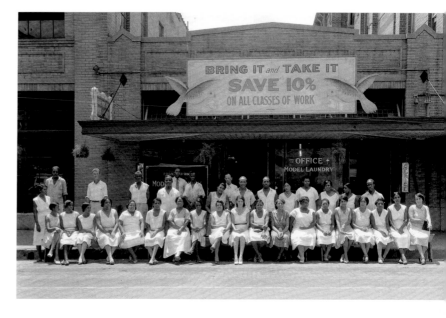

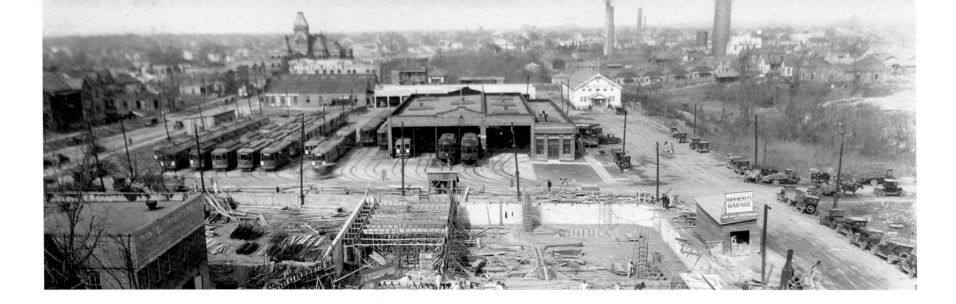

ABOVE: Looking west over Smith Street and the Galveston-Houston Electric Railway shed, circa 1925. On the right is Texas Avenue and Capitol Avenue is to the left. In the foreground, construction is under way on Sterling Garage, site of Jones Plaza today.
COURTESY DENISE SMESNY

RIGHT: Dock workers and the crew of a cargo ship in the Houston Ship Channel gather around a bale of cotton with a sign indicating it is the first bale of the new crop for 1924-25. The bale was purchased by J.M. Edel and Co. for $1,405 to benefit needy children in Germany. COURTESY HOUSTON PUBLIC LIBRARY, HOUSTON METROPOLITAN RESEARCH CENTER

BELOW: Looking east over downtown Houston, 1924.
COURTESY FRANK CHAVEZ COLLECTION,
COURTESY JEANETTE CHAVEZ BARTA

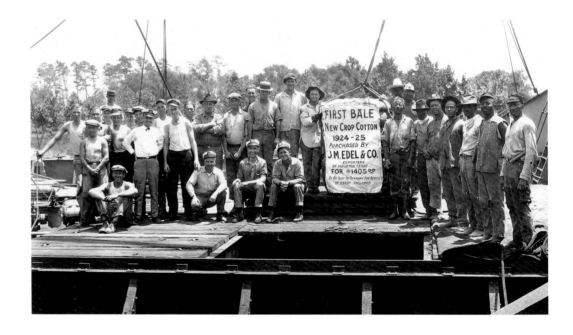

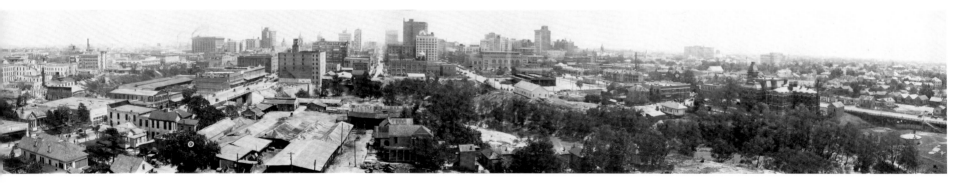

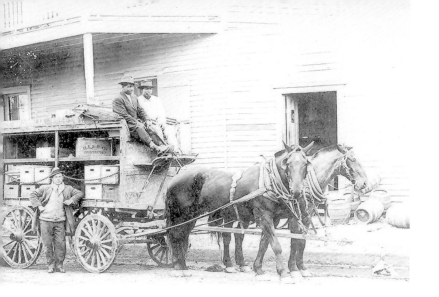

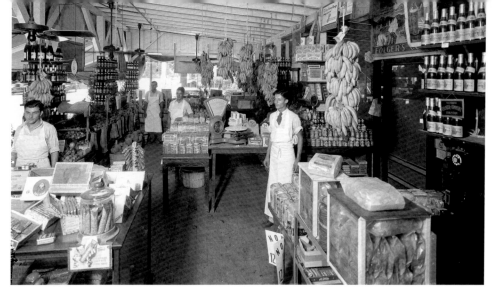

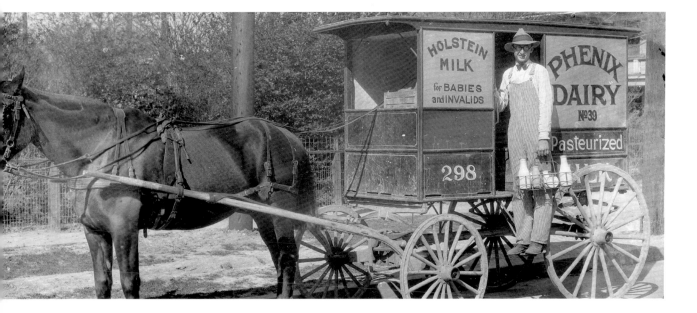

ABOVE: Interior of Orange Grove Market on Milam in the early 1930s. COURTESY THE SLOANE COLLECTION

ABOVE LEFT: Charles B. Vogel, leaning on the wagon, leads a crew for beer delivery for Southern Brewery in the 1920s. COURTESY PEGGY JENNINGS

LEFT: Phenix Dairy Milk Wagon, 1927. COURTESY THE SLOANE COLLECTION

BELOW: Ford trucks equipped with Ruckstell axles parked along McKinney, Jan. 14, 1925. COURTESY FRANK CHAVEZ COLLECTION, COURTESY JEANETTE CHAVEZ BARTA

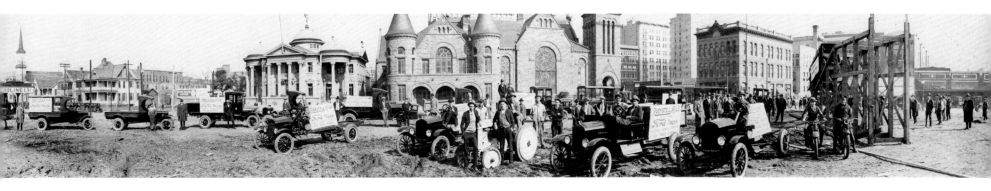

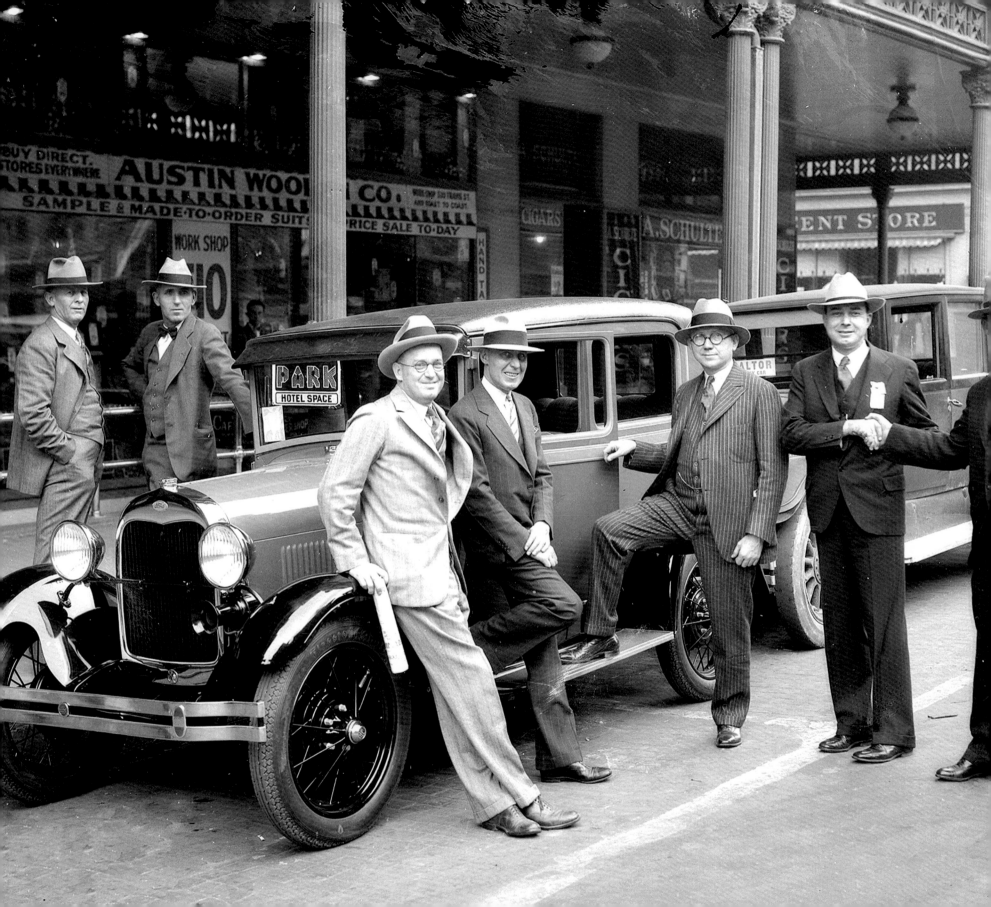

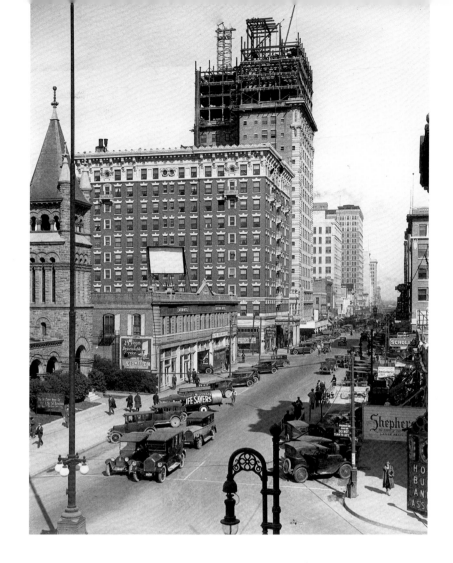

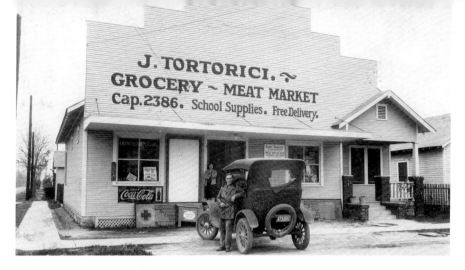

ABOVE: Joe and Josephine Tortorici immigrated to the United States from Italy and established this neighborhood grocery store at 2424 Chapman, seen here on Oct. 1, 1927, at the end of a streetcar line in Houston. The store ran "tabs" for customers who could not pay their groceries during difficult times. COURTESY CHARLEEN BAUGH

LEFT: Looking north on Main from McKinney, 1920s. Note the Life Savers truck parked at left. COURTESY HOUSTON CHRONICLE ARCHIVES

OPPOSITE: First Ford Model A delivered in Houston by Bonner Motor Company, Jan. 26, 1928. COURTESY THE SLOANE COLLECTION

BELOW: Houston Kelloggs Cornflakes salesmen parked at Root Memorial Square, 1928. COURTESY THE SLOANE COLLECTION

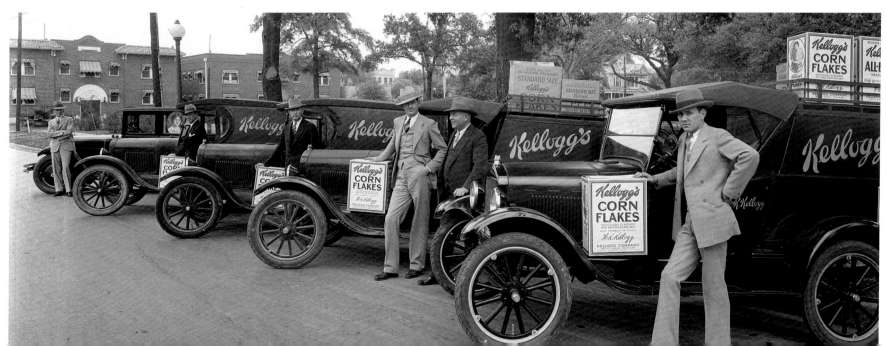

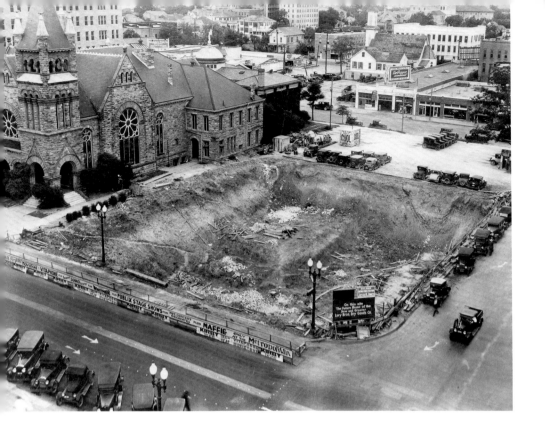

ABOVE: Construction site of the "new and greater" Levy Bros. Dry Goods Co. at the corner of Main and Walker, 1928. First Presbyterian Church can be seen at left. COURTESY UNIVERSITY OF HOUSTON

ABOVE RIGHT: Workers at the Maxwell House Coffee loading docks, 1929. COURTESY THE SLOANE COLLECTION

RIGHT: Barry's Shoe Shop, 1120 Capitol, July 1929. COURTESY HOUSTON PUBLIC LIBRARY, HOUSTON METROPOLITAN RESEARCH CENTER

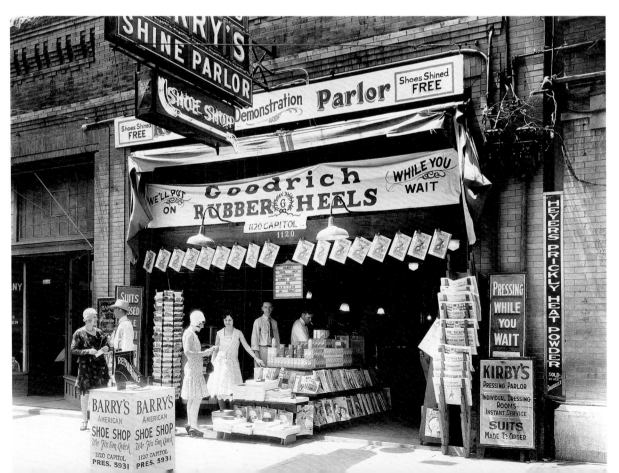

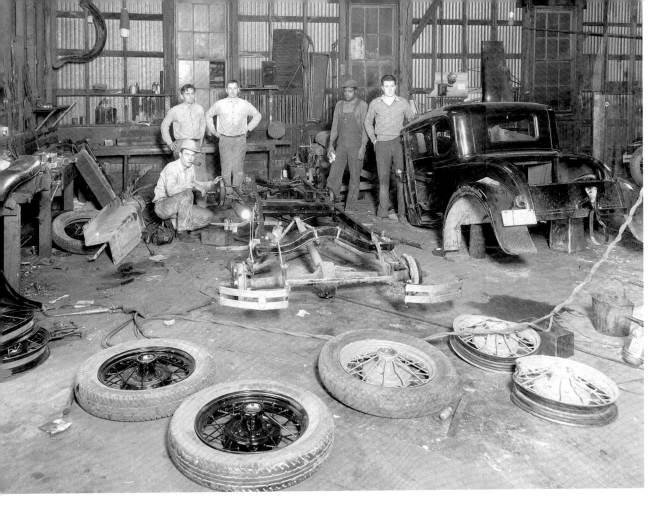

LEFT: Mechanics take a break from their work to pose at a Houston auto garage in the 1930s.
COURTESY THE SLOANE COLLECTION

BOTTOM LEFT: Woolworth store at Capitol and Main, circa 1930.
COURTESY HOUSTON PUBLIC LIBRARY, HOUSTON METROPOLITAN RESEARCH CENTER

BOTTOM RIGHT: Looking north on Fannin from Congress, circa 1930. Zindler's clothing store is at left.
COURTESY HOUSTON PUBLIC LIBRARY, HOUSTON METROPOLITAN RESEARCH CENTER

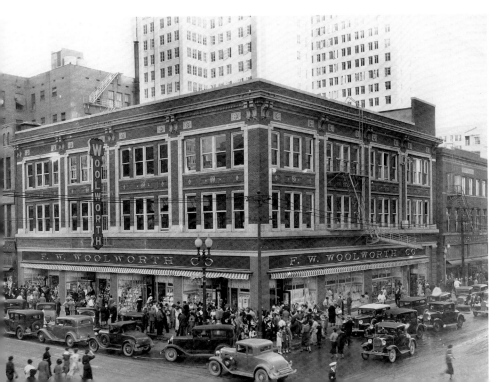

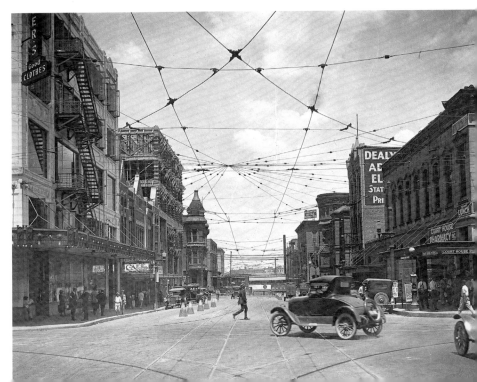

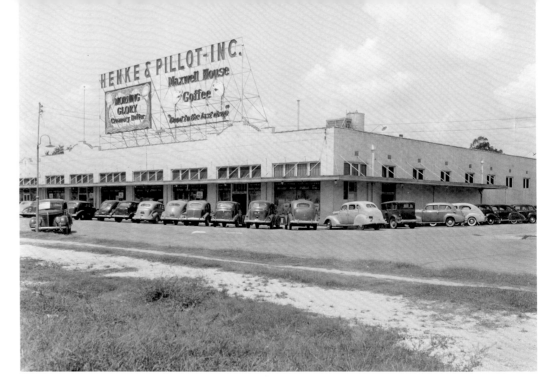

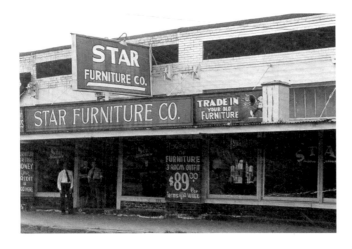

ABOVE: Late 1930s storefront for Star Furniture Co. Note sign advertising three rooms of furniture for $89. COURTESY STAR FURNITURE

TOP: Houston Ship Channel, 1935.
COURTESY HOUSTON CHRONICLE ARCHIVES

RIGHT TOP: For nearly 100 years, grocery shoppers frequented Houston's own Henke & Pillot, including this store at 2800 Travis. The chain expanded as Houston did in the early 20th century, but, after being purchased by a competitor in the 1950s, the name was phased out. COURTESY HOUSTON CHRONICLE ARCHIVES

RIGHT BOTTOM: Automobiles and streetcars share the road in this 1936 view down Main Street.
COURTESY HOUSTON CHRONICLE ARCHIVES

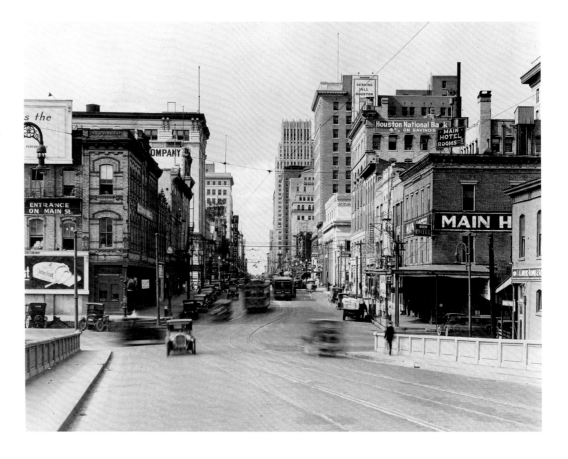

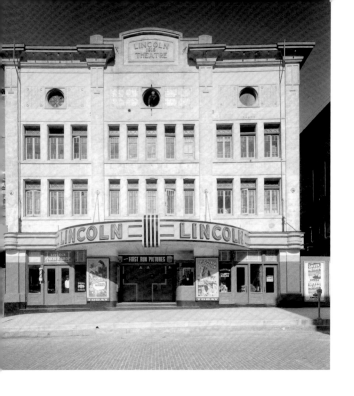

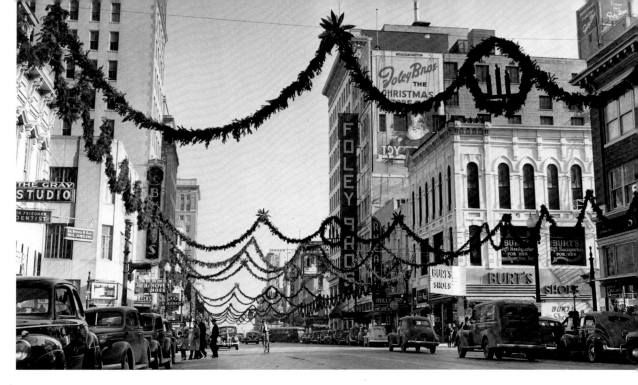

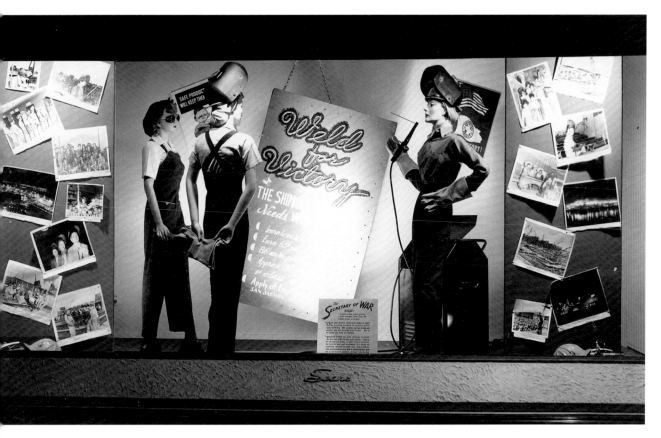

ABOVE: Main Street, looking north from Prairie, is all decked out for the 1941 holiday season.
COURTESY HOUSTON CHRONICLE ARCHIVES

ABOVE LEFT: Lincoln Theatre, Houston's first black-owned and –operated theater, located at 711 Prairie.
COURTESY THE SLOANE COLLECTION

LEFT: Charles W. Pittenger designed this window display at the Sears store on South Main in 1942. This Sears location opened in November 1939.
COURTESY DOLORES TOUCHTON

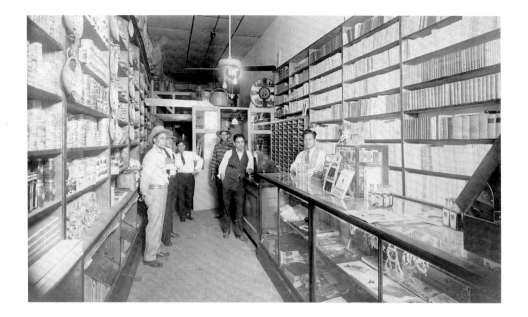

ABOVE: Jose Socorro Sarabia owned this Hispanic bookstore located at 1800 Congress, seen here around 1946. Libreria Hispano-Americana was one of several businesses Sarabia owned over the years, including a grocery store, a night club, cleaners and a bookstore.
COURTESY EMILIO SARABIA

RIGHT: Owner George Malavis, center, with the staff of Ship-Ahoy restaurant in 1948. The restaurant was located at 6634 South Main near the Shamrock Hotel. COURTESY ELLIE MALAVIS

OPPOSITE: Interior of a Hispanic variety store at 1803 Congress, circa 1946. In the photo are Mary Lopez, saleswoman, Frances Sarabia, Emilio Sarabia and Linda Ramirez, foreground.
COURTESY EMILIO SARABIA

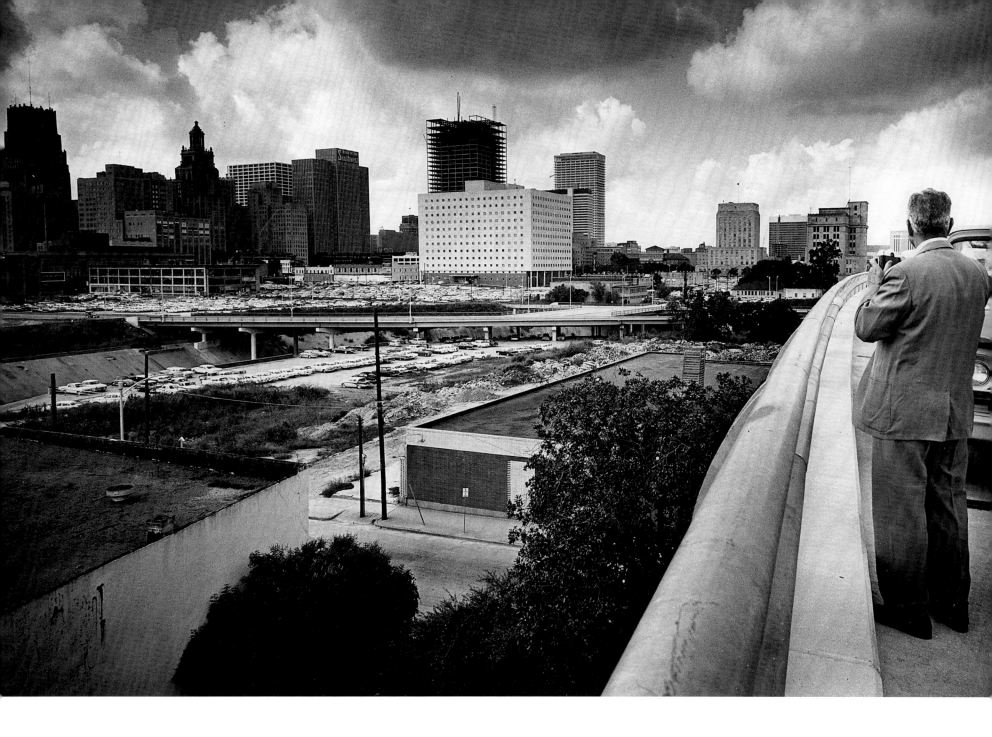

ABOVE: Houston Mayor Lewis Cutrer snaps a picture of the growing Houston skyline during ceremonies to open a section of the North Freeway in July 1962. At center, construction work continues on what's now the El Paso Energy building. COURTESY HOUSTON CHRONICLE ARCHIVES

RIGHT: Rancher, businessman and philanthropist Gus S. Wortham, seen here in 1966, was born in Mexia in 1891 and moved to Houston with his father in 1915. There, the two started John L. Wortham and Son, an insurance agency. More than a decade later, Wortham co-founded American General Insurance Company. He would serve as American General's chairman of the board and CEO for almost five decades. His philanthropic work benefited the Houston Symphony Orchestra and other organizations. Wortham's estate also helped lead to the creation of the Wortham Theater Center in 1987.
COURTESY HOUSTON
CHRONICLE ARCHIVES

BOTTOM RIGHT: Employees of the Phil Rich Fan Mfg. Co. at 2900 Caroline at Tuam, 1963. The company was one of the largest family-owned electric-fan manufacturers, employing over 200 employees. It was sold to Sunbeam Inc. in 1980 and operations moved to Mississippi.
COURTESY MARVIN A. RICH

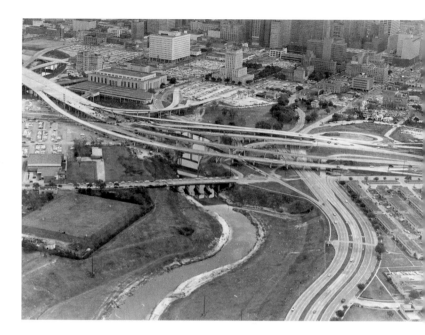

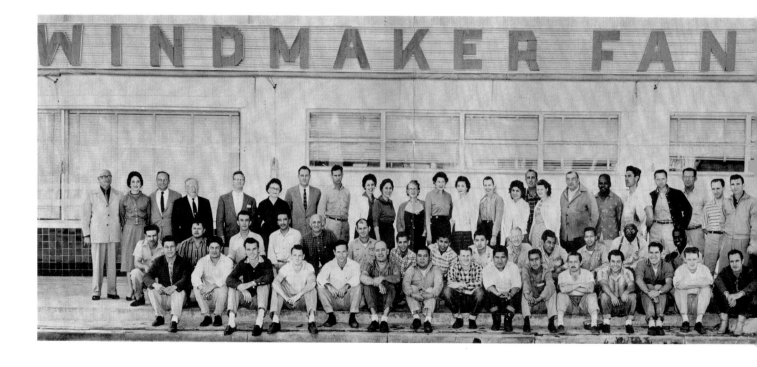

BELOW: Aerial view of I-45 under construction, early 1962.
COURTESY HOUSTON CHRONICLE ARCHIVES

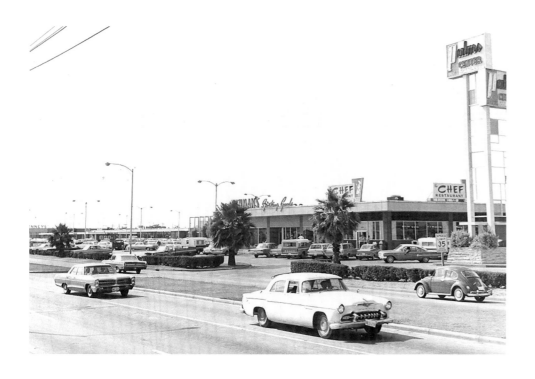

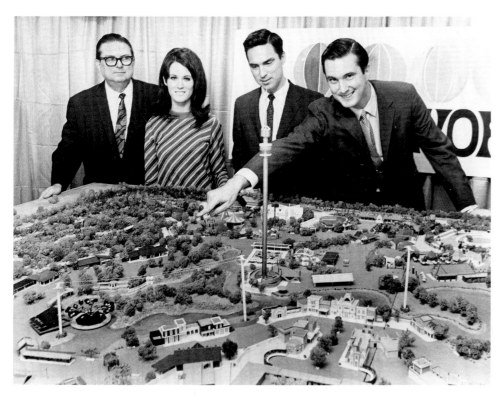

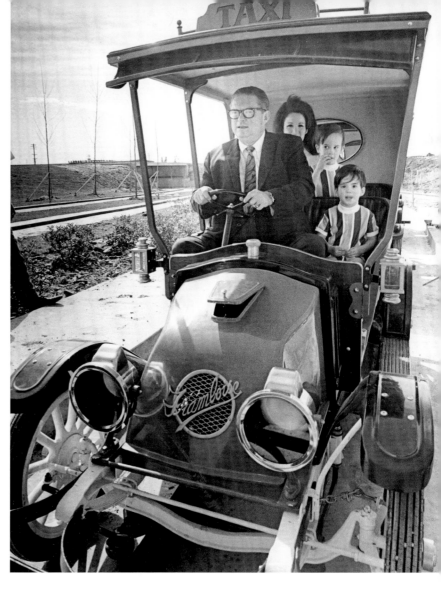

ABOVE: AstroWorld builder Roy Hofheinz gives his daughter and grandchildren the first ride aboard this replica 1918 taxicab, one of a fleet of 35 being installed at the amusement park, 1968. COURTESY HOUSTON CHRONICLE ARCHIVES

LEFT TOP: Palms Center shopping center, 1967. Opened in 1955, this was the first major shopping center outside the city's core. COURTESY HOUSTON CHRONICLE ARCHIVES

LEFT BOTTOM: Roy Hofheinz, left, looks over a model of AstroWorld in 1967 with daughter Dene Hofheinz and sons Roy Hofheinz Jr., and Fred Hofheinz. COURTESY HOUSTON CHRONICLE ARCHIVES

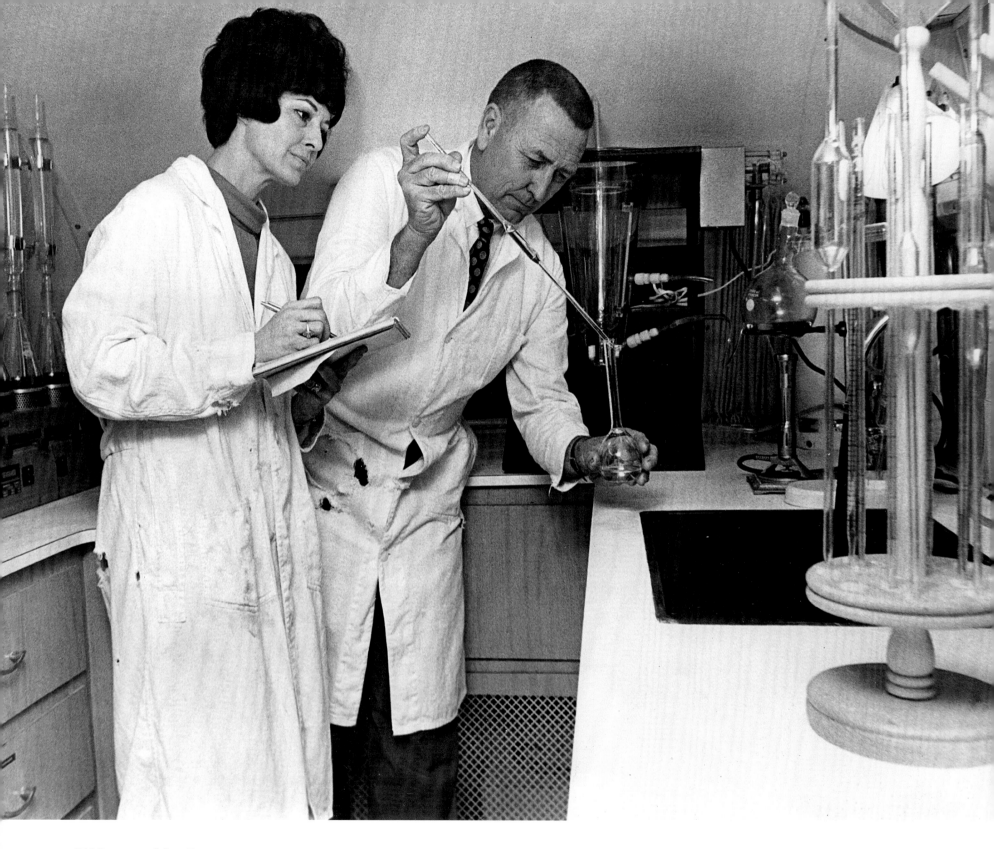

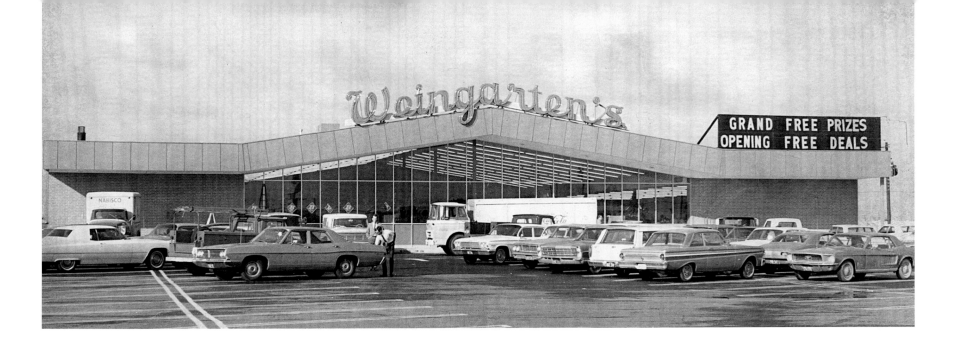

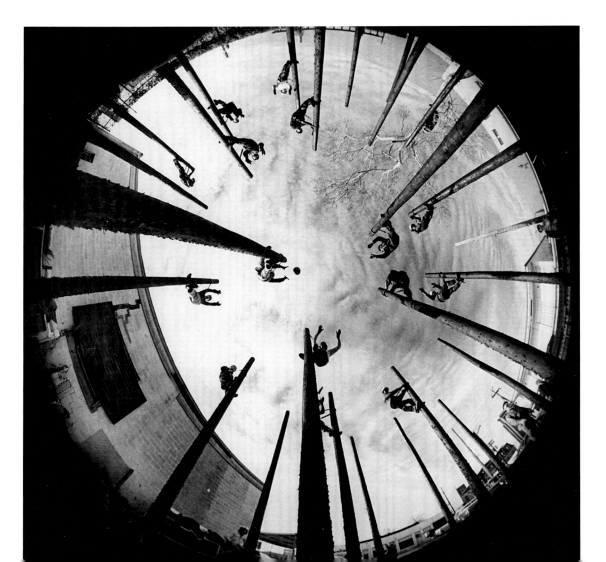

ABOVE: Weingarten's Cullen Plaza Store, 9420 Cullen, 1968. The supermarket chain started when Harris Weingarten and his son, Joseph, opened a dry goods store in downtown Houston in 1901. The chain grew to several southern states and was eventually acquired by Grand Union in the early 1980s. COURTESY HOUSTON CHRONICLE ARCHIVES

LEFT: One of the city's most exclusive schools, the pole-climbing school operated by Southwestern Bell at the corner of Smith and Elgin, has just graduated its latest class, February 1973. This "fish-eye" photo shows the group tossing a basketball around while atop the 25-foot poles. The basketball is used to make the pupils learn to shift their bodies instead of their feet. COURTESY HOUSTON CHRONICLE ARCHIVES

OPPOSITE: Roxanne Law and M.A. Mathews conduct a field analysis on water in a traveling laboratory belonging to Brown & Root Inc., April 1968. This mobile laboratory was one of the many exhibits showing off pollution control equipment at the National Pollution Control Exposition and Conference at the Astrohall. COURTESY HOUSTON CHRONICLE ARCHIVES

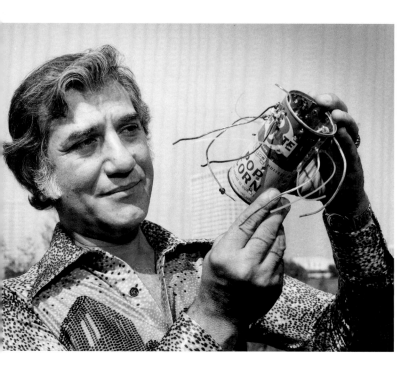

ABOVE: Houstonian George Ballas shows off his original Weed Eater prototype in this 1975 photo.
COURTESY HOUSTON CHRONICLE ARCHIVES

ABOVE RIGHT: Looking east along Allen Parkway toward downtown Houston, 1975. COURTESY JOSEPH ASNA

RIGHT: Looking east toward construction of I-10 East at Main Street, May 11, 1971.
COURTESY HOUSTON CHRONICLE ARCHIVES

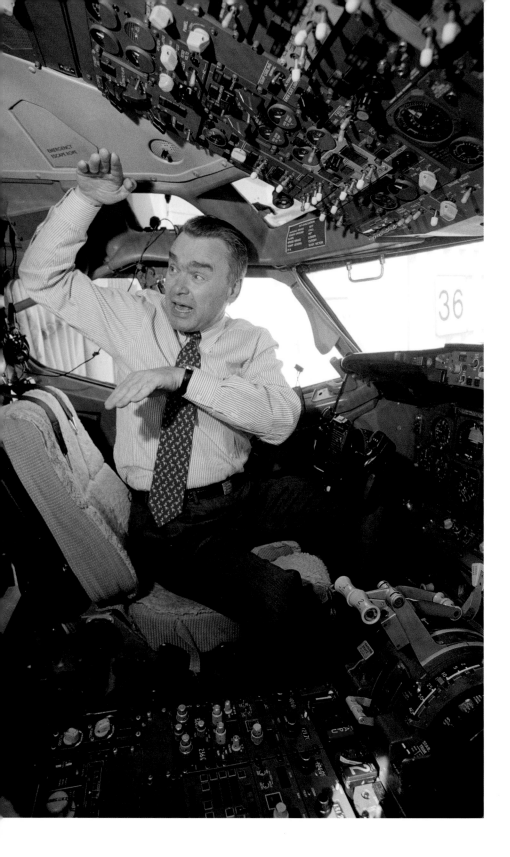

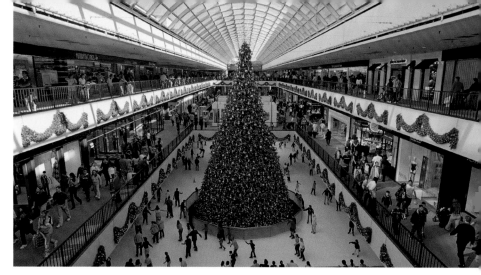

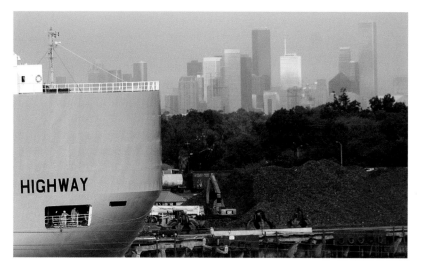

ABOVE: The Athens Highway cruises into the Houston Ship Channel on Sept. 29, 2009. Since its official opening in 1914, the Ship Channel has become home to one of the world's busiest ports.
COURTESY HOUSTON CHRONICLE ARCHIVES

TOP: Holiday shoppers and ice skaters pack the Galleria in 2001. The upscale mall opened on Nov. 16, 1970.
COURTESY HOUSTON CHRONICLE ARCHIVES

LEFT: Gordon Bethune, then-Continental Airlines CEO, checks out the cockpit of a jet before a 1995 flight to New York. During his 10 years overseeing the company, Bethune was instrumental in turning around the Houston-based airline.
COURTESY HOUSTON CHRONICLE ARCHIVES

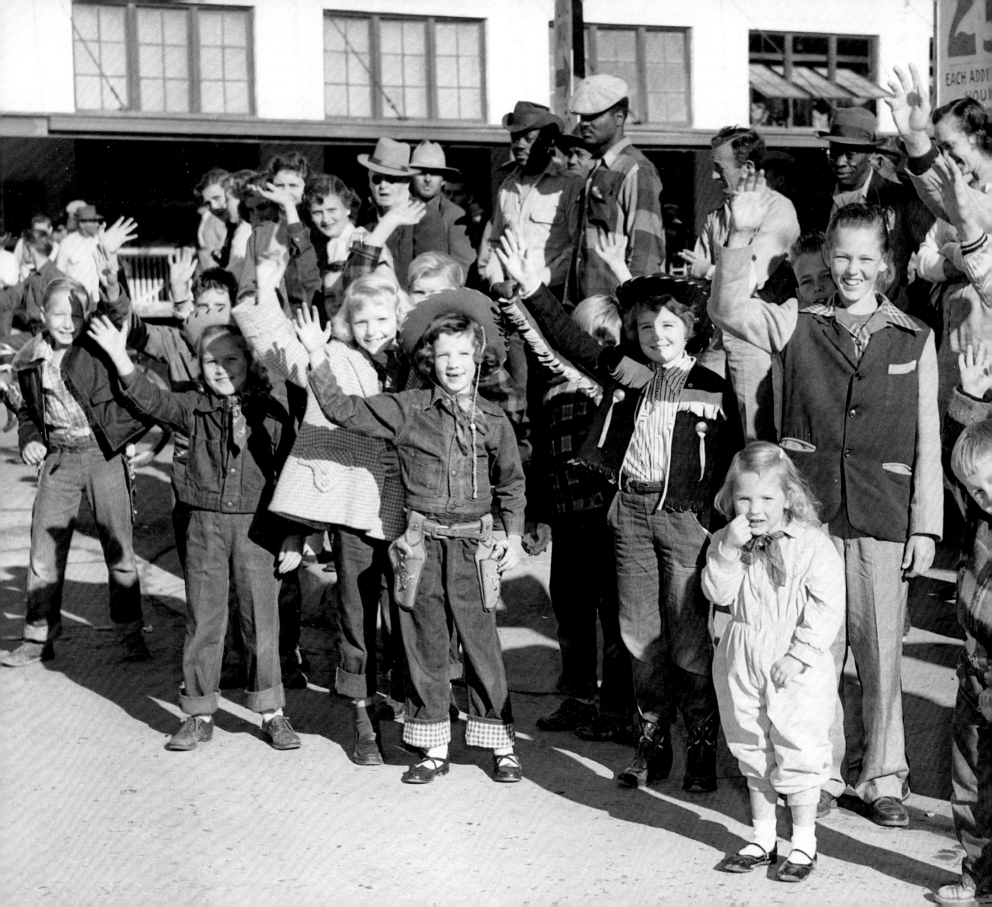

LIFE & CULTURE

For all of its fame as one of the nation's leading commercial centers, Houston has never hesitated to enjoy itself. Its cultural life is second-to-none in Texas, boasting a nationally renowned opera company, a decorated regional theater, a major ballet troupe and a smorgasbord of museums. Those who live on the East Coast and don't venture into Texas may not realize it, but Houston defines the modern cosmopolitan city, with almost any cultural or recreational amenity one could want save for a ski lift nearby. For all its good points, topography is not one of them.

Houston is big. By far the largest city in Texas, it sprawls over 656 square miles. It hates its big mosquitoes and cockroaches, copes with big storms, but loves big buildings and big highways and big everything else. When the state decided to build a giant obelisk to commemorate the Battle of San Jacinto that helped cement independence from Mexico, it had to be 15 feet taller than the Washington Monument, which it resembles.

Houstonians are big on food, too. The city has one of the nation's most impressive collection of restaurants, featuring cuisine from every part of the world, a reflection of the diversity that can be found within its boundaries. Some have called eating one of the city's favorite forms of recreation, understandable when a long, hot summer puts a premium on indoor entertainment.

Houston also has what it claims is the biggest live entertainment show this side of the Olympics in the annual rodeo and livestock show, which attracts more than 2 million people, an impressive lineup of musical talent and the world's best rodeo cowboys. The city may be as Southern as it is Western, but you wouldn't know that when the rodeo comes to town and all the big belt buckles and fancy cowboy boots emerge for Go Texan Day.

LEFT: Youngsters enjoy the Houston Fat Stock Show and parade in 1954.
COURTESY HOUSTON CHRONICLE ARCHIVES

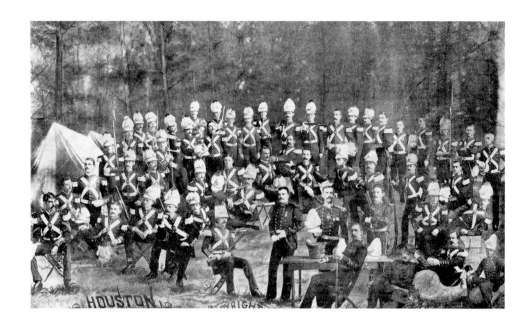

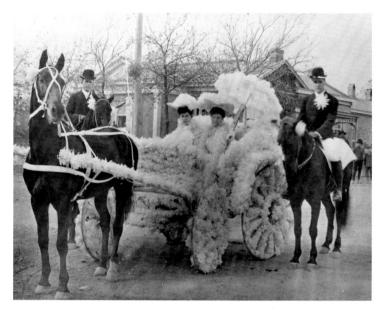

ABOVE: The Houston Light Guards is one of the oldest national guard companies in Texas. In the 1880s, the unit, aside from military service, had a renowned reputation in drill competitions. COURTESY HOUSTON PUBLIC LIBRARY, HOUSTON METROPOLITAN RESEARCH CENTER

ABOVE RIGHT: Ima Hogg and an unidentified woman sit in a horse-drawn carriage decorated with flowers for the Tekram parade, part of Houston's No-Tsu-Oh Festival, late 1890s. COURTESY UNIVERSITY OF HOUSTON

RIGHT: Thomas Ravell, left, was named fire chief of the newly paid fire department in 1896. Pinky Bradly, right, was his chauffeur. COURTESY UNIVERSITY OF HOUSTON

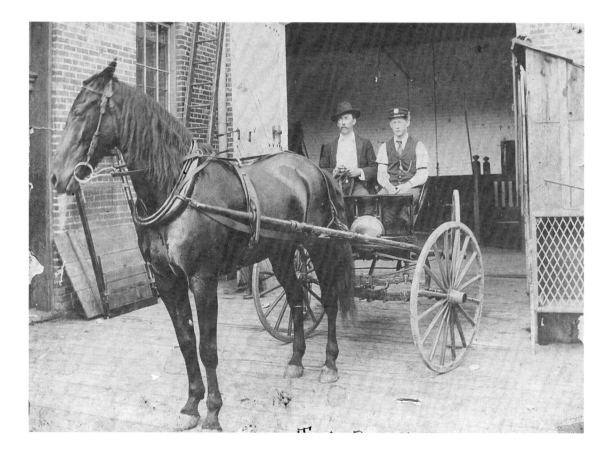

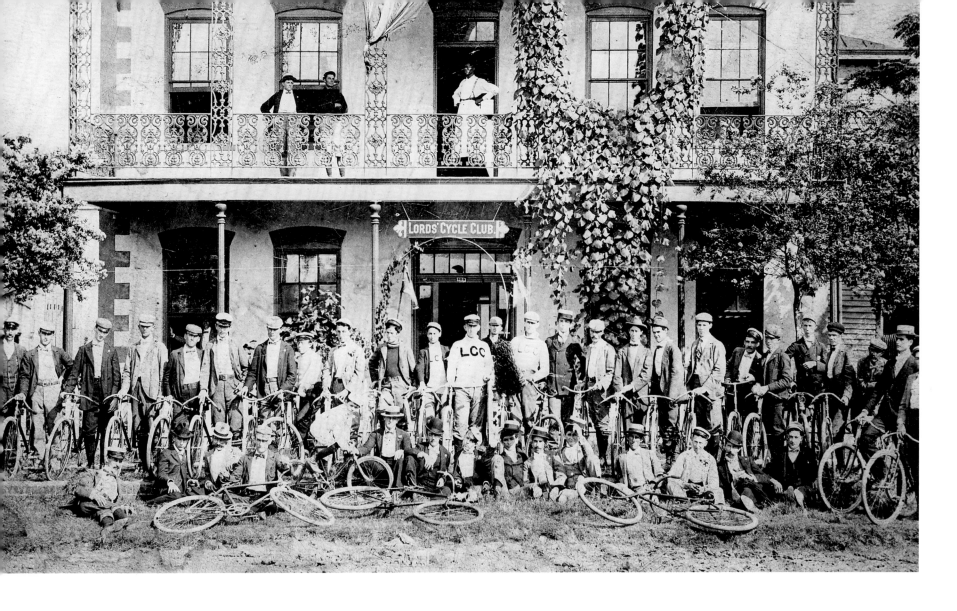

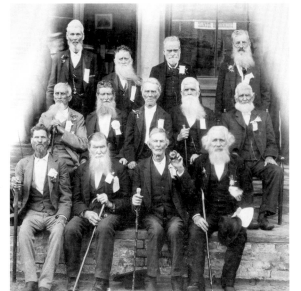

ABOVE: Cycle club members gather in front of Lord's Cycle Club at 109 Chenevert, 1897.
COURTESY UNIVERSITY OF HOUSTON

LEFT: A gathering of veterans from the Battle of San Jacinto, early 1900s.
COURTESY THE SLOANE COLLECTION

RIGHT: Spectators shield themselves from the sun as a baptism takes place in Buffalo Bayou, circa 1900.
COURTESY UNIVERSITY OF HOUSTON

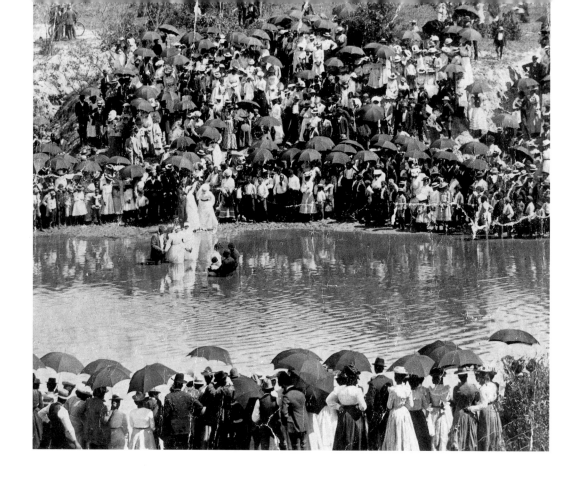

BOTTOM LEFT: Miss Ima Hogg, early 1900s. Born in Mineola in 1882, she was the second of four children from Sarah Ann and James Stephen "Big Jim" Hogg. Her father left Hogg and her siblings land that was rich in oil. Over the years, Hogg used that wealth to help found the Houston Symphony and promote historic preservation and public education. An avid art collector, Hogg donated the River Oaks mansion she and her brothers built in 1927 to the Museum of Fine Arts, Houston. Today, the Bayou Bend Collection draws thousands of visitors each year. Hogg also founded the Houston Child Guidance Center, which later merged with DePelchin Children's Center. She also helped create the Austin-based Hogg Foundation for Mental Health. COURTESY HOUSTON CHRONICLE ARCHIVES

BOTTOM RIGHT: Looking north on Main Street toward Congress Avenue, circa 1900.
COURTESY UNIVERSITY OF HOUSTON

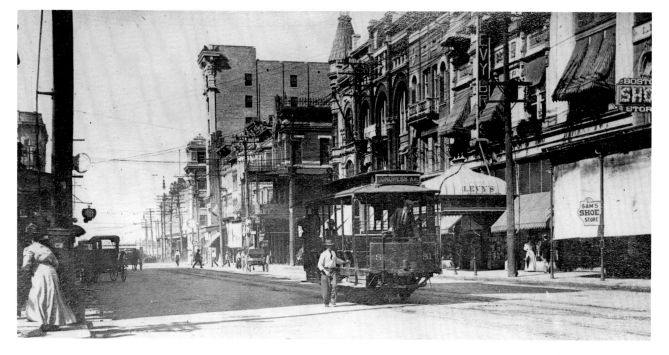

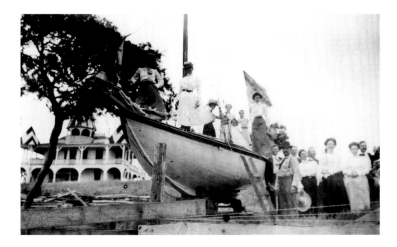

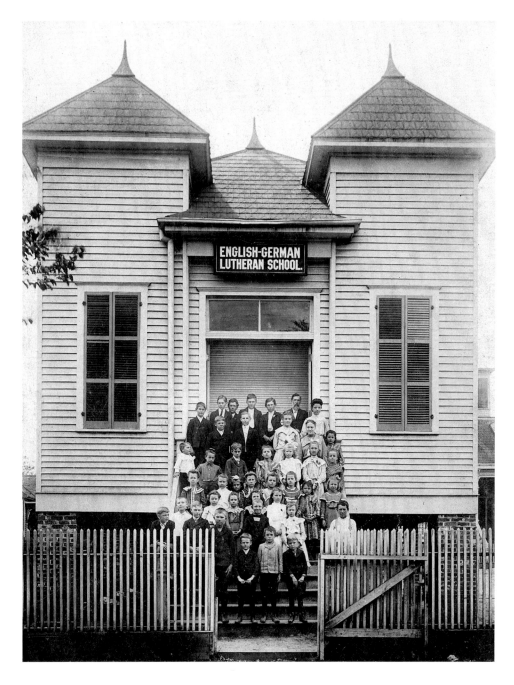

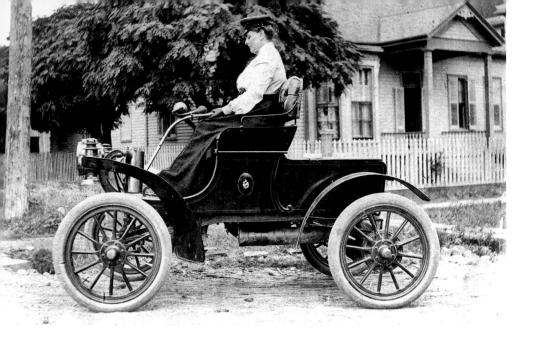

ABOVE: A 1900s motorist shows off an early model, curved dash Oldsmobile. Houstonians got their first look at a "horseless carriage" in 1897. COURTESY HOUSTON PUBLIC LIBRARY, HOUSTON METROPOLITAN RESEARCH CENTER

TOP RIGHT: The daughters of the Rev. Jack Yates are shown in 1908 during celebrations marking Juneteenth. COURTESY HOUSTON PUBLIC LIBRARY, HOUSTON METROPOLITAN RESEARCH CENTER

RIGHT: Pictured are two Civil War veterans, who, according to the photo, "fought with their masters." COURTESY HOUSTON PUBLIC LIBRARY, HOUSTON METROPOLITAN RESEARCH CENTER

BELOW: Joseph Seymour, left, John Frisbie, "Flying fool" Rene Simon, Edmund Audemars, Rene Barrier, Roland Garros, Peter Young and Charles Hamilton take part in an air show during the early days of aviation south of Houston, January 1911. COURTESY THE SLOANE COLLECTION

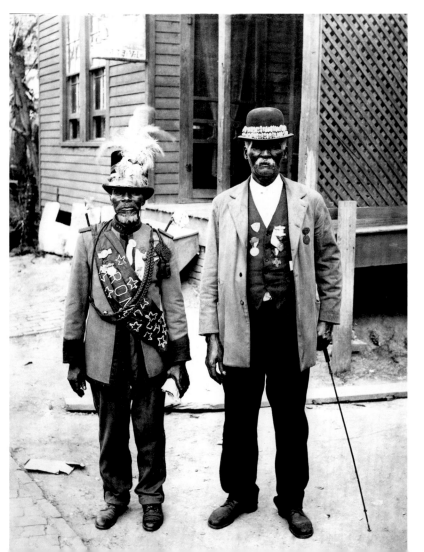

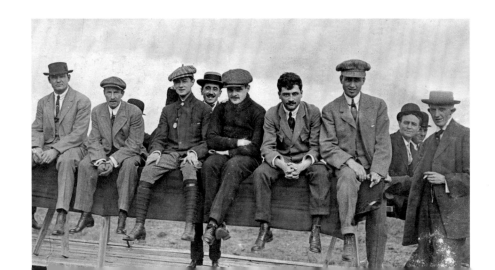

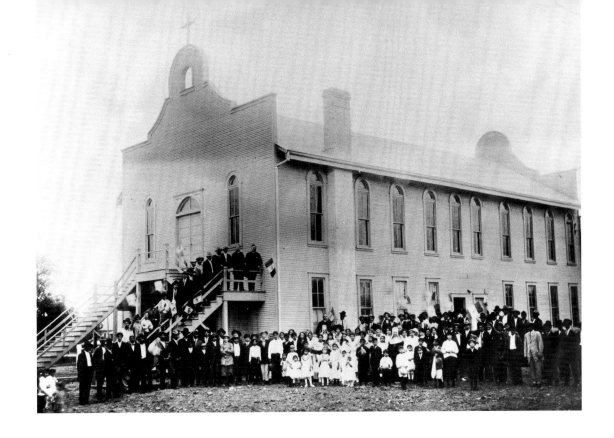

LEFT: Our Lady of Guadalupe Church, circa 1913. Houston's first Mexican-American church, Our Lady of Guadalupe, 2405 Navigation, has long been a nucleus of life in El Segundo Barrio east of downtown, one of the city's first Hispanic neighborhoods. The original structure pictured here was replaced with a brick building in 1923. COURTESY HOUSTON CHRONICLE ARCHIVES

BOTTOM LEFT: Motorists show off their vehicles in front of Southern Tire & Repair Co. at 812 Fannin, circa 1913. COURTESY UNIVERSITY OF HOUSTON

BOTTOM RIGHT: Dr. Ralph C. Cooley shows off his prize-winning roadster in front of his parents' home at 1892 Heights Blvd. in 1914. The Floral Parade was part of the Deep Water Jubilee in conjunction with the opening of the Houston Ship Channel. COURTESY MR. TALBOT COOLEY

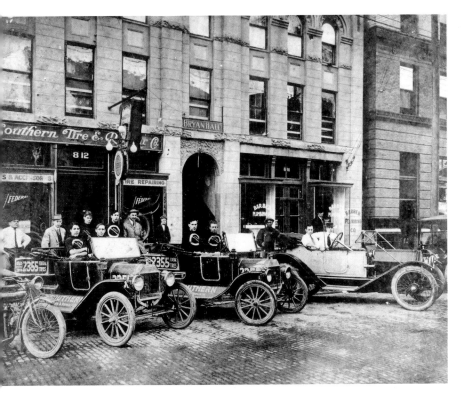

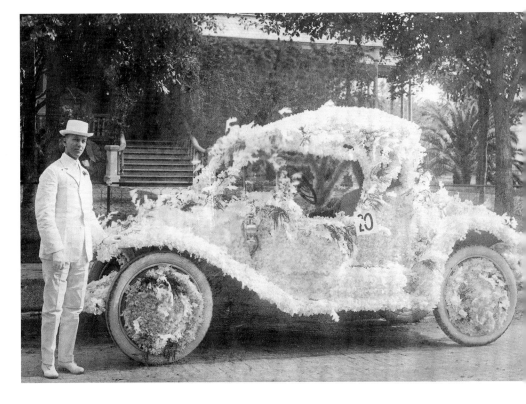

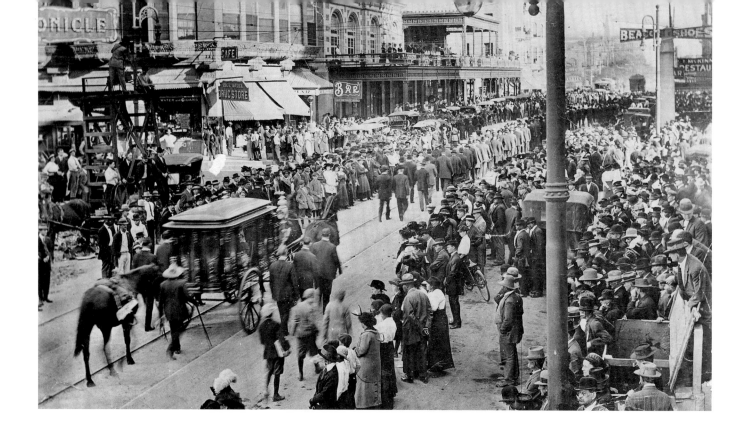

RIGHT: Thousands turn out for a funeral procession for Houston benefactor George H. Hermann, Oct. 27, 1914. This view is looking east on Texas Avenue with Rice Hotel in center background.
COURTESY HOUSTON CHRONICLE ARCHIVES

OPPOSITE: A picnic on the banks of Buffalo Bayou, 1920s. COURTESY THE SLOANE COLLECTION

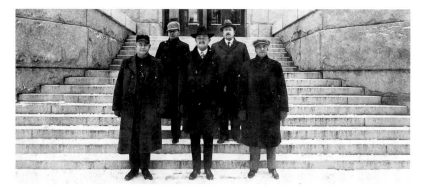

ABOVE: Harris County Sheriff Marion F. Hammond and deputies J.W. Milam, James Fitzgerald, O. Patterson and T. Margiotta on the steps of the Harris County Courthouse, Jan. 11, 1918.
COURTESY CAROLYN FITZGERALD MATLOCK

RIGHT: Houston's Victory Flag Staff was erected at the intersection of Main and McKinney in 1919 to honor World War I veterans. It was eventually relocated to the Sam Houston Coliseum.
COURTESY HOUSTON PUBLIC LIBRARY,
HOUSTON METROPOLITAN RESEARCH CENTER

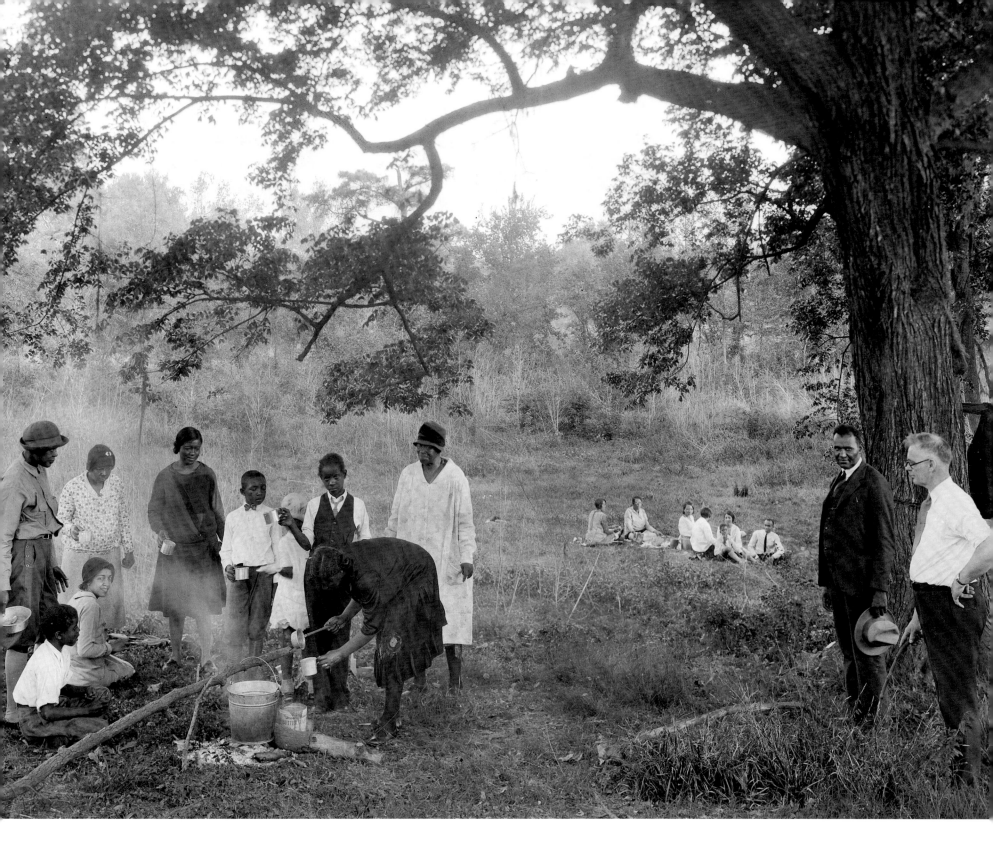

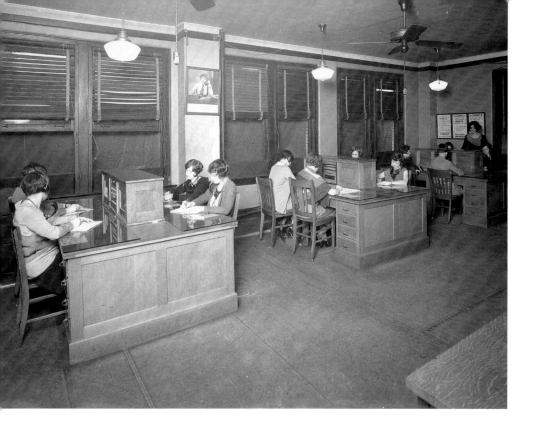

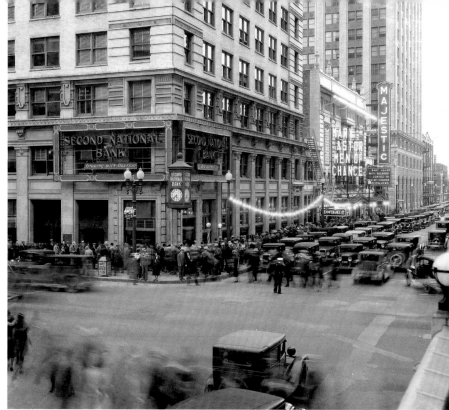

ABOVE: Houston Chronicle's "Miss Classified" girls at work in the 1920s. For a time, professional models were used to personify the classified advertising department. Trained to understand classified advertising, they often spoke at clubs and civic groups on a variety of topics. Changing times led the newspaper to phase out Miss Classified in 1994. COURTESY THE SLOANE COLLECTION

ABOVE RIGHT: Looking west along Rusk Avenue from Main, early 1930s. COURTESY THE SLOANE COLLECTION

RIGHT: Since 1888, Harris County has operated the Lynchburg Ferry, which shuttles traffic across the Houston Ship Channel. Ferry service in that part of the county has been around since 1822 and even played a vital role in the Texas Revolution. COURTESY HOUSTON PUBLIC LIBRARY, HOUSTON METROPOLITAN RESEARCH CENTER

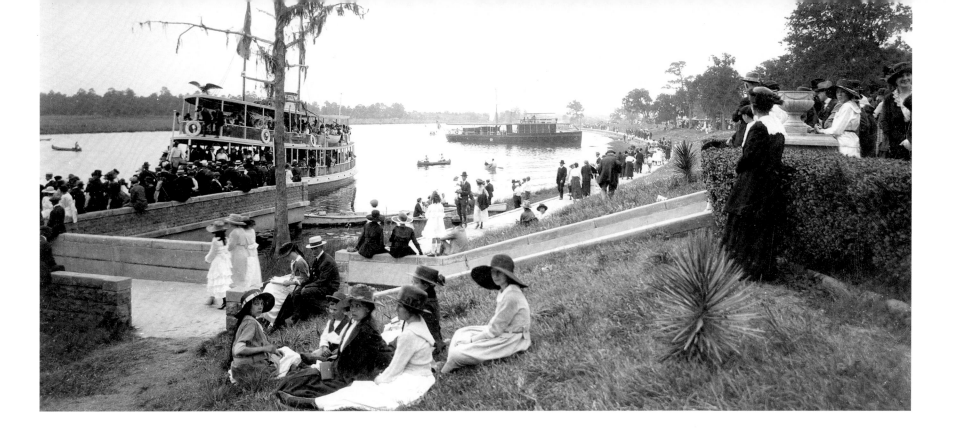

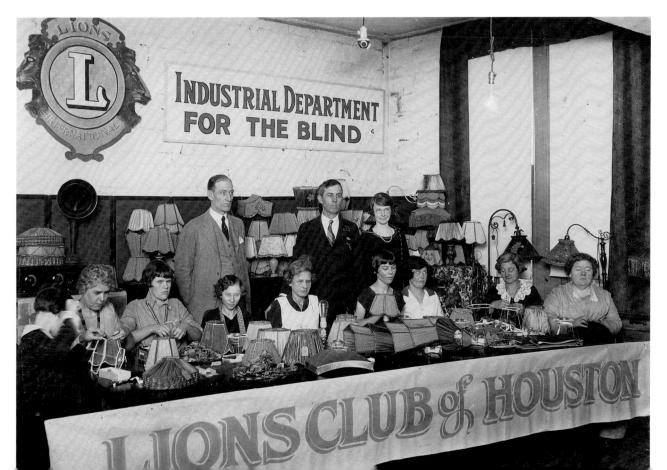

RIGHT: Firefighters from Station No. 7 in front of their steam truck, 1920. Firefighters from left are, Mike Lathrop, "Poop" and Magerson Smith.

COURTESY UNIVERSITY OF HOUSTON

BOTTOM LEFT: A funeral procession heads west along Preston Avenue in the early 1920s.

COURTESY HOUSTON PUBLIC LIBRARY, HOUSTON METROPOLITAN RESEARCH CENTER

BOTTOM RIGHT: Firefighters outside Station No. 4. Second from left are Mike Lathrop, George Bishop (who died in the line of duty in 1926), Pat Sullivan and John Ruby, 1922. The firefighter at left is unidentified.

COURTESY UNIVERSITY OF HOUSTON

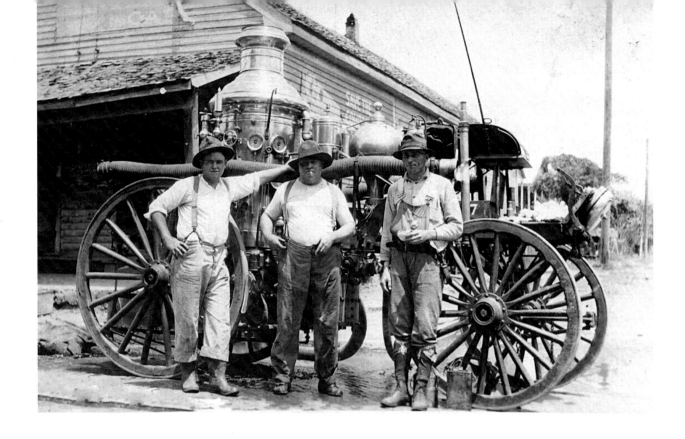

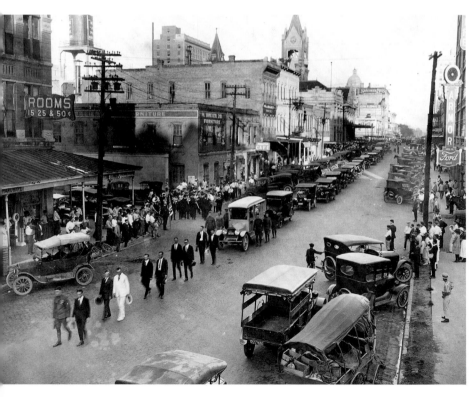

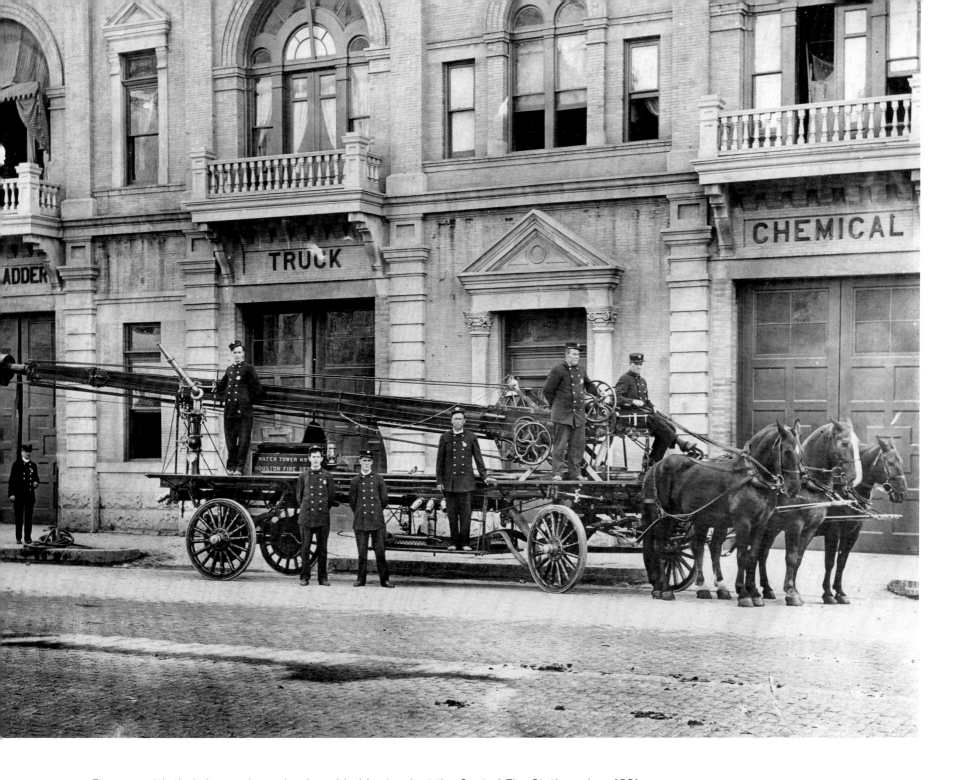

ABOVE: Firemen with their horse-drawn hook and ladder truck at the Central Fire Station, circa 1921. COURTESY UNIVERSITY OF HOUSTON

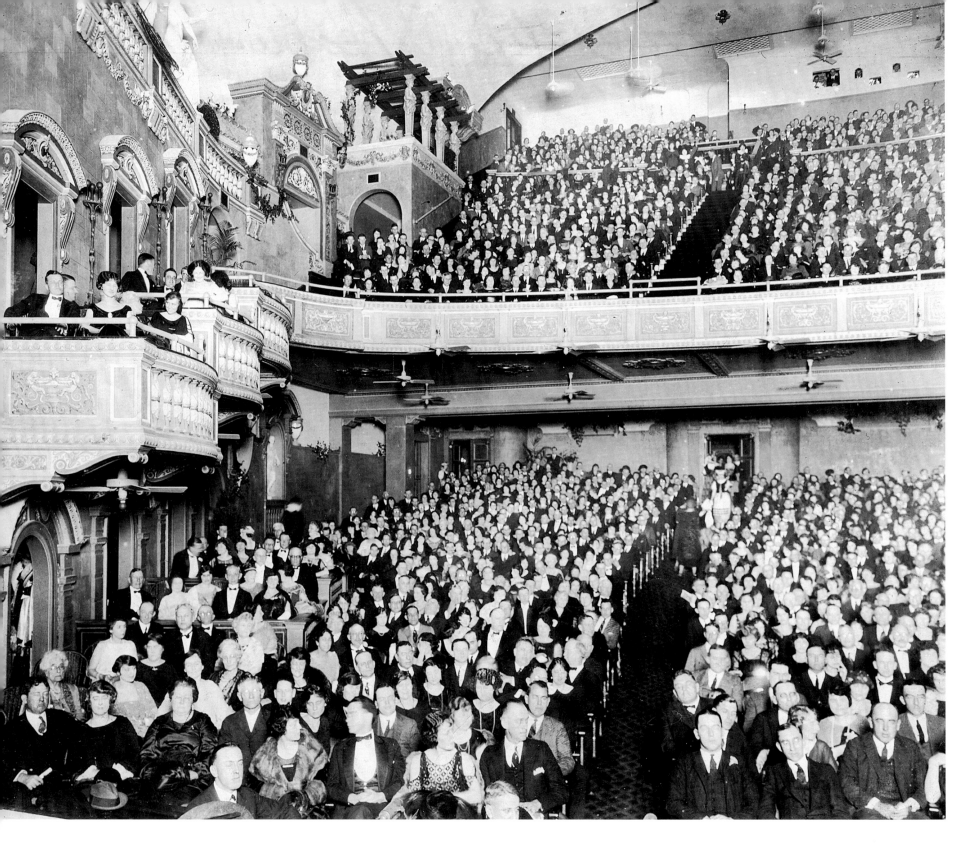

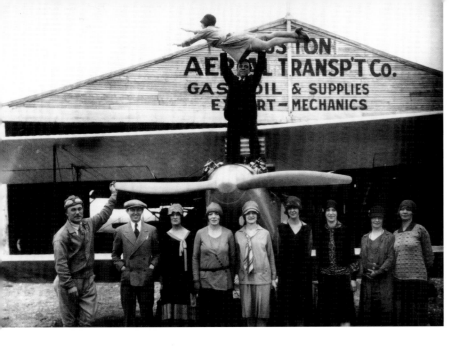

ABOVE: Hispanic Society gathering at the Brazos Hotel on Washington Avenue in the 1920s. COURTESY EMILIO SARABIA

ABOVE LEFT: Flying circuses and wing walkers, similar to those seen here in Houston, were all the rage in the 1920s. COURTESY HOUSTON PUBLIC LIBRARY, HOUSTON METROPOLITAN RESEARCH CENTER

LEFT: Luna Park, located near what's today the southeast corner of Houston Avenue and Interstate 10, opened in 1924. COURTESY HOUSTON PUBLIC LIBRARY, HOUSTON METROPOLITAN RESEARCH CENTER

OPPOSITE: The Majestic Theatre on opening night, January 1923. Considered a jewel among Houston's movie palaces, the theater was eventually demolished in February 1972. COURTESY HOUSTON CHRONICLE ARCHIVES

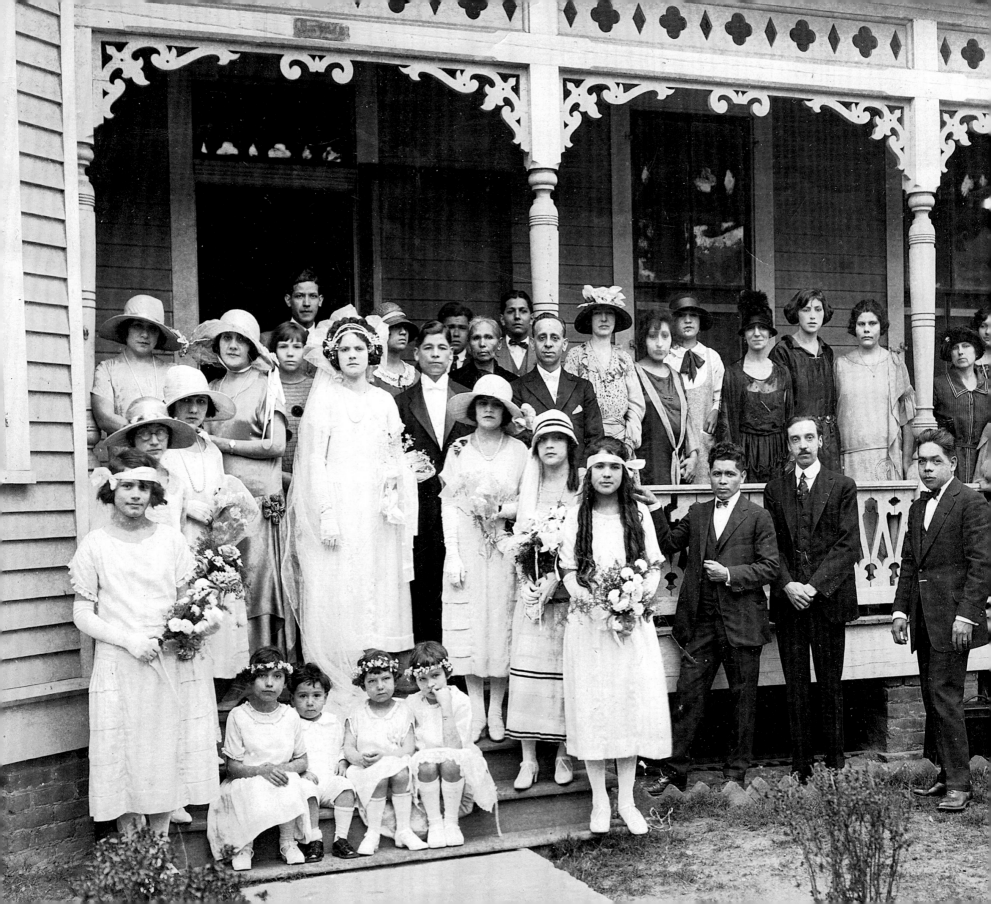

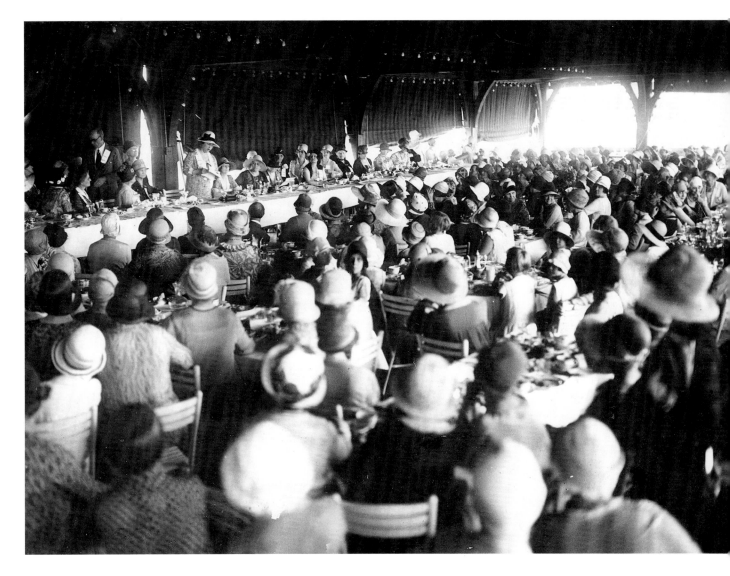

ABOVE: A "dry" meeting held by the National Women's Committee for Law Enforcement, a federation of Protestant women's organizations, circa 1920s. This group held their meeting on the roof of the Rice Hotel. COURTESY HOUSTON CHRONICLE ARCHIVES

LEFT: Felipe and Berta Benne Vendo Sarabia's wedding reception at a home at 1520 Center St. in 1925. The wedding was held at Our Lady of Guadalupe Church. COURTESY EMILIO SARABIA

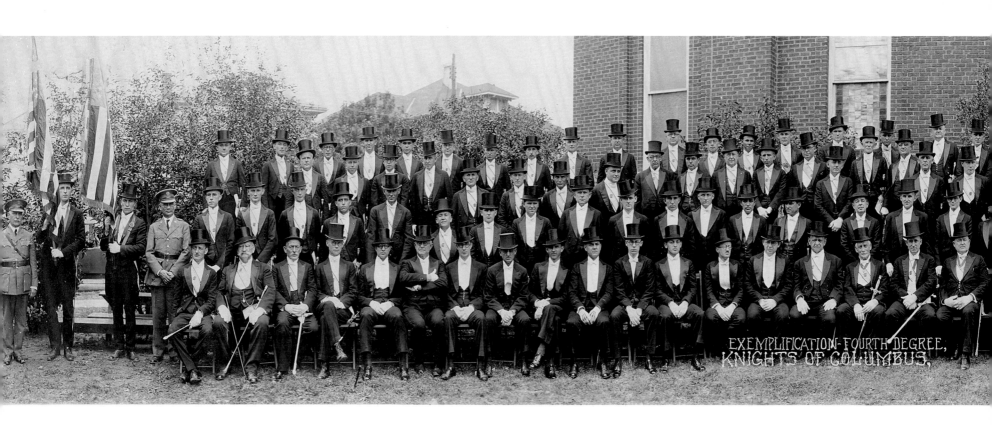

RIGHT: Opening night crowd at the Azteca Theatre, 1809½ Congress Ave., 1927.

COURTESY EMILIO SARABIA

BELOW: Knights of Columbus, Southern District of Texas, gather for the Fourth Degree Exemplification in Houston, April 18, 1926.

COURTESY JUDY KOCH

EXEMPLIFICATION-FOURTH DEGREE, KNIGHTS OF COLUMBUS,

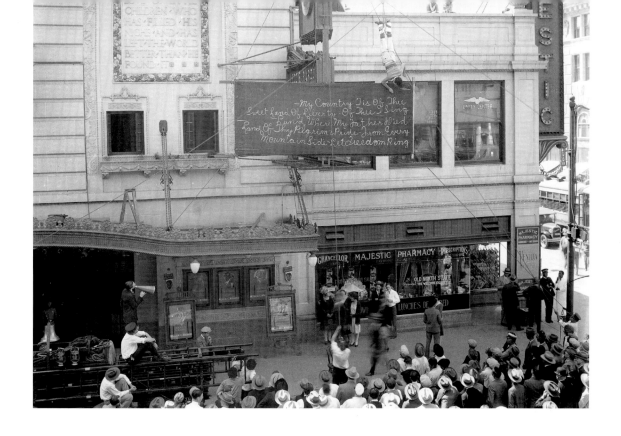

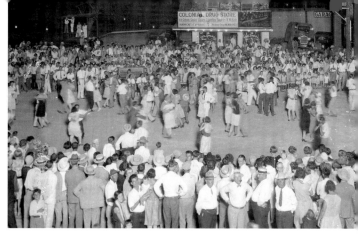

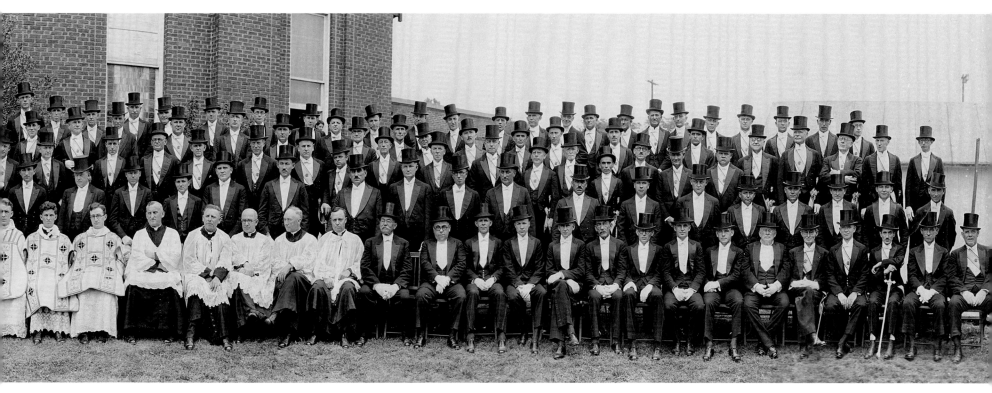

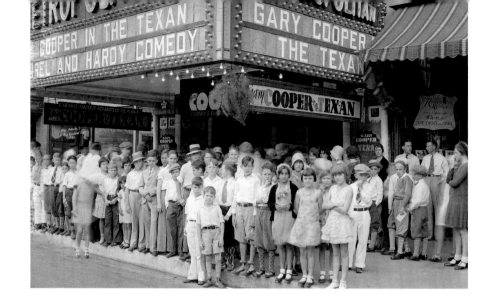

RIGHT: In 1930, the Metropolitan Theatre marquee advertised Gary Cooper's *The Texan* and the latest comedy from Laurel and Hardy.
COURTESY THE SLOANE COLLECTION

BELOW: Linder Lake, located at 517 Melbourne between Irvington and Fulton, circa 1933.
COURTESY FRANK CHAVEZ COLLECTION, COURTESY JEANETTE CHAVEZ BARTA

BOTTOM: Venice Park, formerly known as Luna Park, circa 1927.
COURTESY FRANK CHAVEZ COLLECTION, COURTESY JEANETTE CHAVEZ BARTA

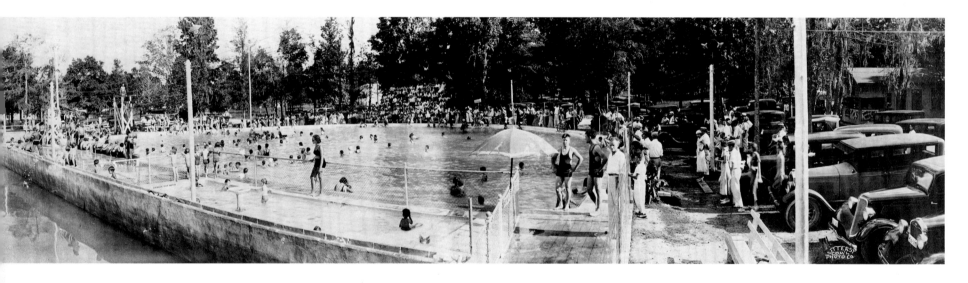

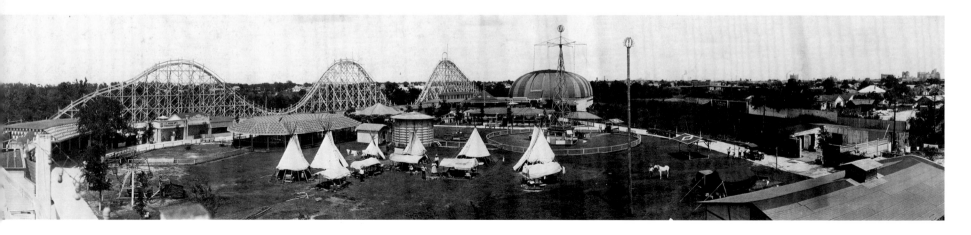

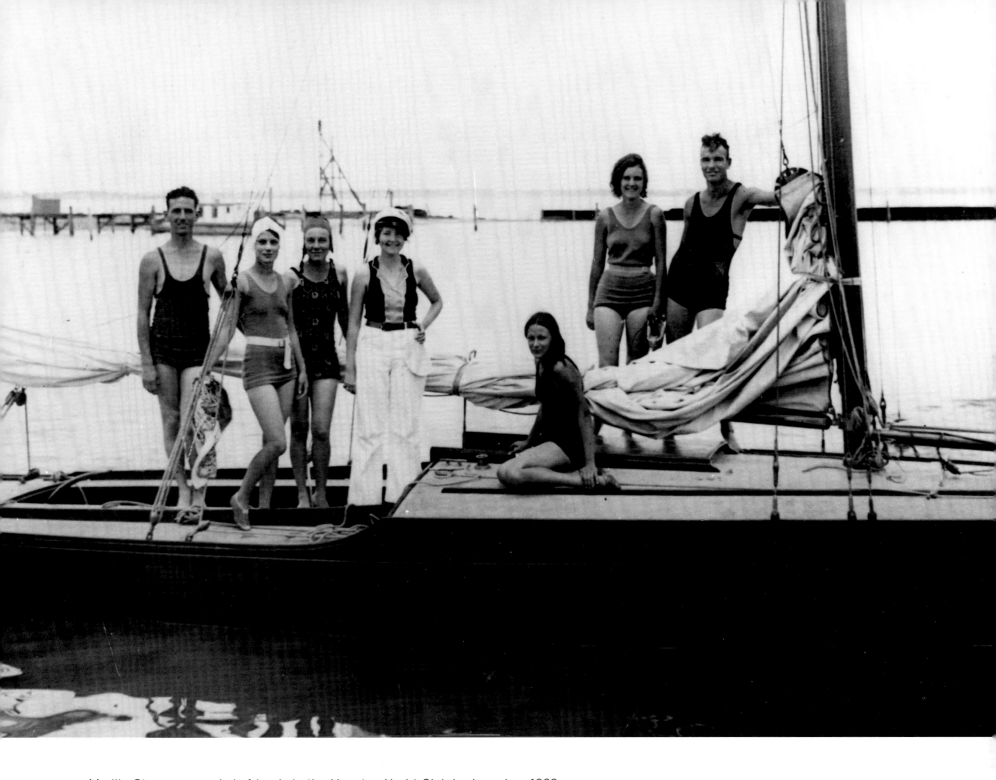

ABOVE: Madlin Stevenson and six friends in the Houston Yacht Club harbor, circa 1929. COURTESY HOUSTON YACHT CLUB

RIGHT: The Cynthia Grey Milk Fund Group gathers at the Rice Hotel to raise funds to provide fresh milk to indigent children. COURTESY THE SLOANE COLLECTION

BOTTOM LEFT: Chamber of Commerce clothing drive for the needy, 900 block of Main, late summer 1933. COURTESY HOUSTON PUBLIC LIBRARY, HOUSTON METROPOLITAN RESEARCH CENTER

BOTTOM RIGHT: Dave's Black Spasm Incomparable One Man Band from Tulsa, Okla., performs in Houston at Weber's Pleasure and Beer Garden in October 1933. COURTESY THE SLOANE COLLECTION

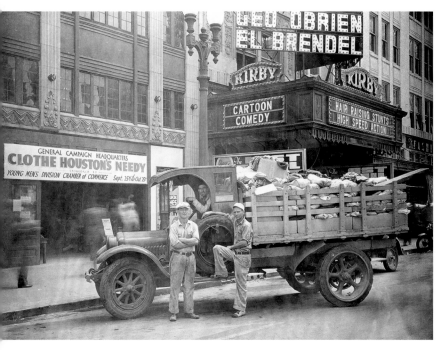

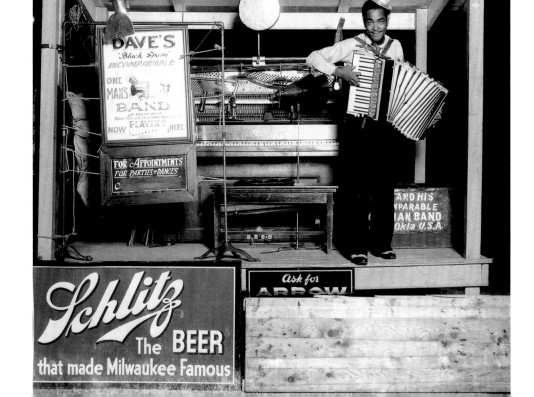

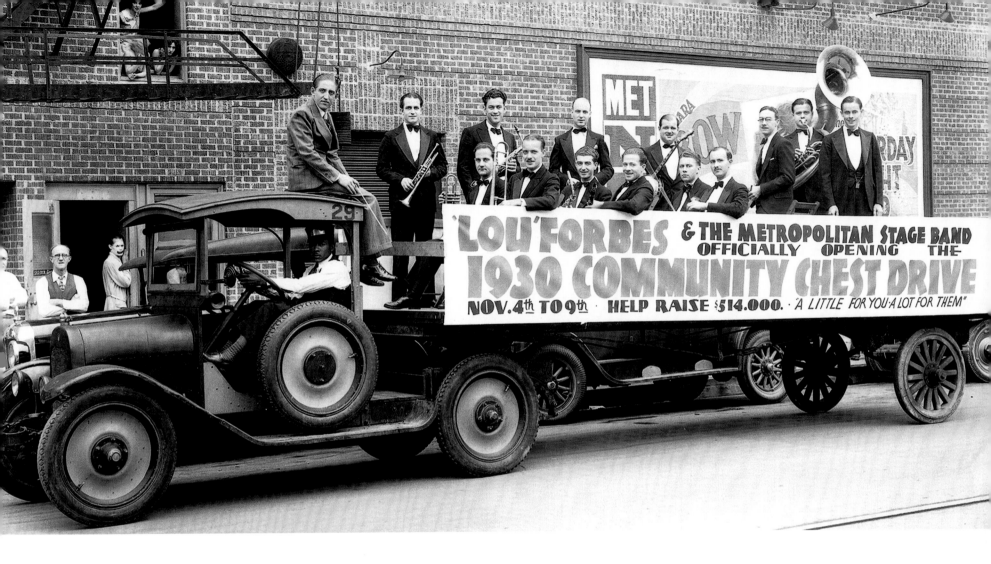

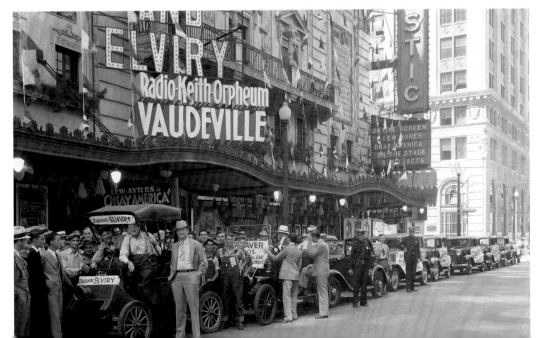

ABOVE: Lou Forbes and the 1930 Community Chest Drive at the Metropolitan. The Community Chest Drive would eventually evolve into the United Way of Greater Houston. COURTESY THE SLOANE COLLECTION

LEFT: Popular comedy team the Weaver Brothers and Elviry drops by the Majestic Theatre for a vaudeville show in the early 1930s.
COURTESY THE SLOANE COLLECTION

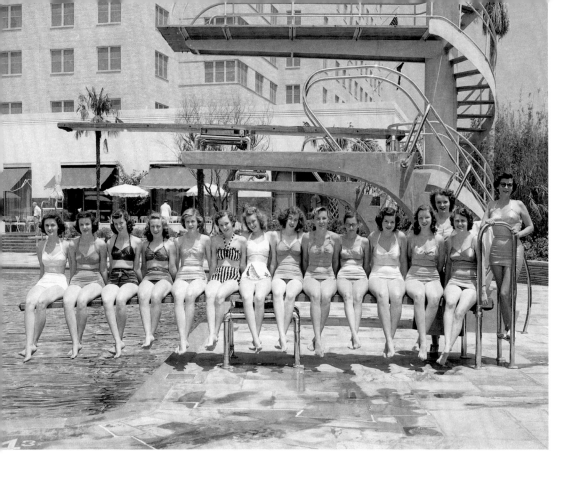

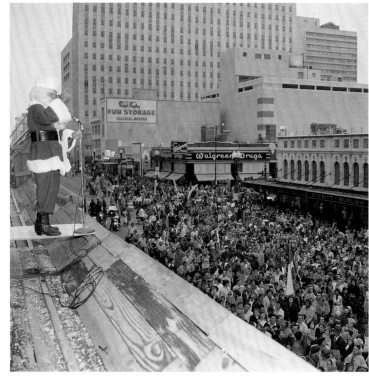

ABOVE: The Shamrock "Corkettes" gather at the Shamrock Hotel pool, circa 1950. The team was named after the hotel's famous Cork Club. COURTESY THE SLOANE COLLECTION

ABOVE RIGHT: Santa Claus helps usher in the holiday season along Main Street, circa 1940. COURTESY HOUSTON PUBLIC LIBRARY, HOUSTON METROPOLITAN RESEARCH CENTER

RIGHT: Temple Beth Israel, at the corner of Austin and Holman, February 1938. The Beth Israel congregation moved into this, their third building, in 1925. Houston architect Joseph Finger, a member of the congregation, designed the large Greek classical building with its massive columns. COURTESY HOUSTON CHRONICLE ARCHIVES

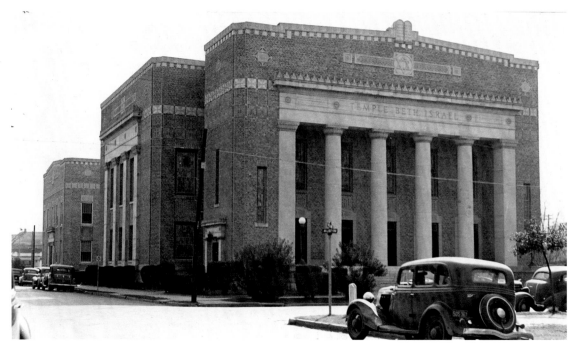

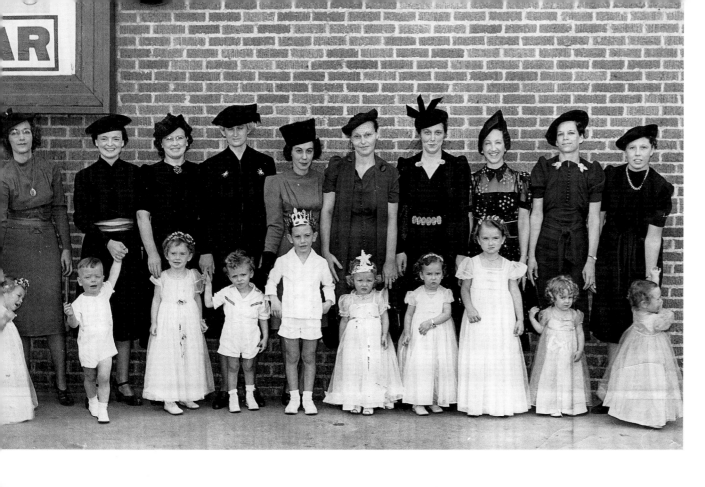

LEFT: A king and queen gather with eight runner-ups during the Houston Post's Baby Show and Tournament, Sept. 18, 1938. Wendell M. Smith was named king and Margaret Elaine Clauder was named queen. They, along with the runner-ups, won a trip to Hollywood, Calif., and visited the MGM Studios during the filming of *The Wizard of Oz*.
COURTESY ELAINE (CLAUDER) VAN HORN

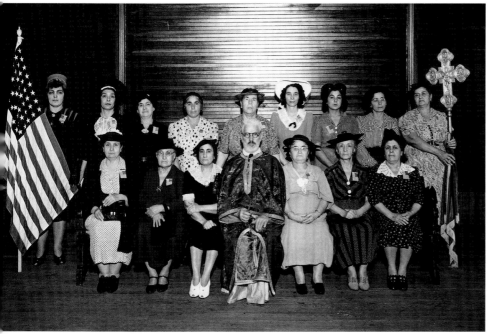

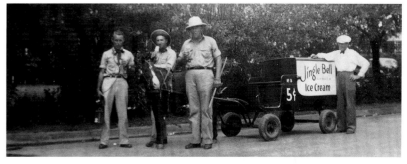

ABOVE: A City of Houston surveying team in 1939. The three are cooling down with a treat from a horse-drawn ice cream cart.
COURTESY VICKIE GILBREATH

LEFT: These War Mothers of soldiers taking part in World War II attended St. George Syrian Orthodox Church. The first War Mothers group in Houston was established in May 1918.
COURTESY HOUSTON PUBLIC LIBRARY,
HOUSTON METROPOLITAN RESEARCH CENTER

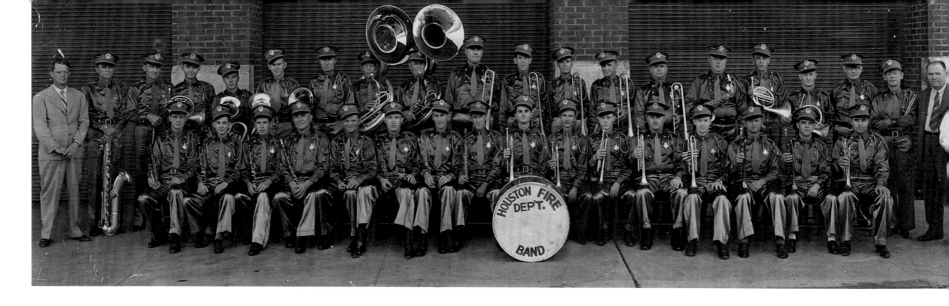

ABOVE: Houston Fire Department Band, Oct. 22, 1939. Fire Commissioner Frank E. Mann is on the left and Fire Chief Homer F. Lyles and director Walter Cross are on the right. COURTESY UNIVERSITY OF HOUSTON

RIGHT: Trinity Lutheran Church at 12 Riesner St., 1940s. This was the church's second sanctuary from 1905-54. COURTESY TRINITY LUTHERAN CHURCH, RUTH STOERKEL, ARCHIVIST

BELOW: For years, the Pan American Ballroom, 1705 N. Main, was one of the more popular nightclubs for Houston's Hispanic community. COURTESY HOUSTON PUBLIC LIBRARY, HOUSTON METROPOLITAN RESEARCH CENTER

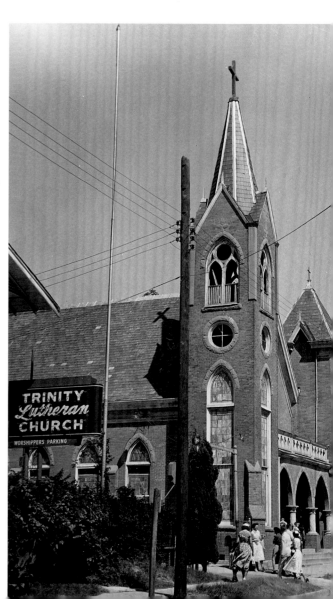

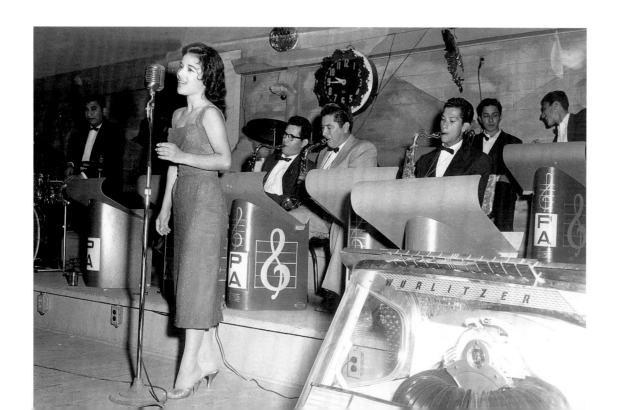

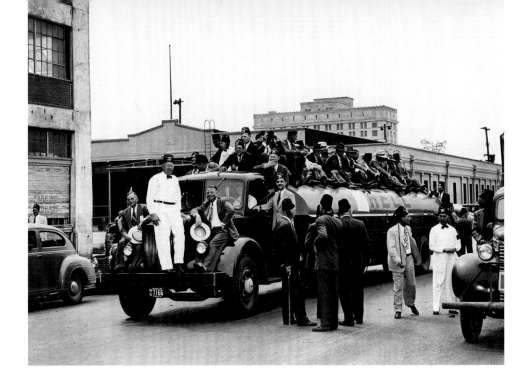

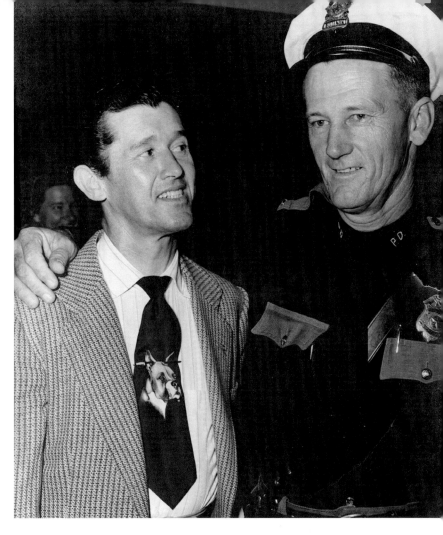

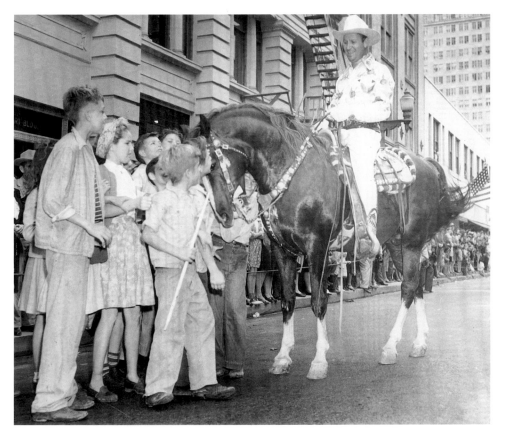

ABOVE: Country music singer and fiddler Roy Acuff hangs out with Houston police Lt. Sam Clauder at the Houston Fat Stock Show in the Sam Houston Coliseum, 1950. COURTESY ELAINE (CLAUDER) VAN HORN

LEFT TOP: The Arabia Temple Group makes good use of a Shell Oil distributor's truck for the Armistice Day Parade in downtown Houston, Nov. 11, 1946. Notice the "S" on Shell has been blocked out for their ride down Main Street. The owner of the truck, Richard "Dutch" Clauder, is wearing the white uniform on the front bumper. COURTESY ELAINE (CLAUDER) VAN HORN

LEFT BOTTOM: Movie star Gene Autry and his horse entertain children in downtown Houston in 1947 during a rodeo parade. COURTESY HOUSTON CHRONICLE ARCHIVES

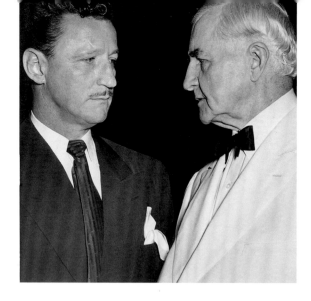

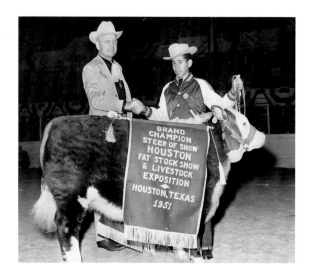

ABOVE: Louis Reyes, 15, with his 825-pound grand champion steer, gets a handshake from Houston Fat Stock Show President W. Albert Lee. COURTESY HOUSTON CHRONICLE ARCHIVES

TOP: Texas oilman Glenn McCarthy, left, the man behind the creation of the Shamrock Hotel, with Jesse H. Jones, 1950s.
COURTESY HOUSTON CHRONICLE ARCHIVES

RIGHT: Houston Fat Stock Show parade marches down Main, circa 1950.
COURTESY THE SLOANE COLLECTION

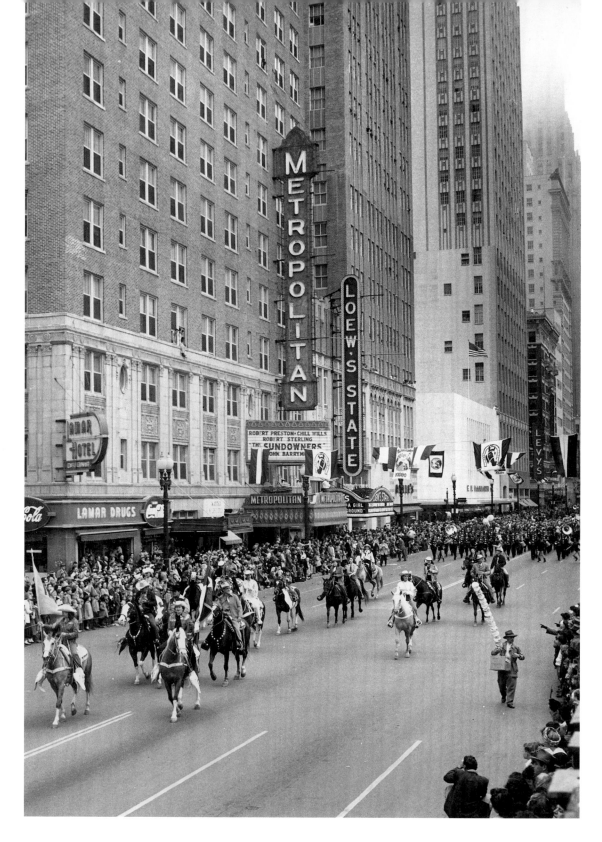

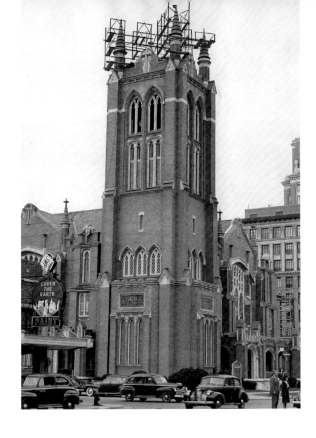

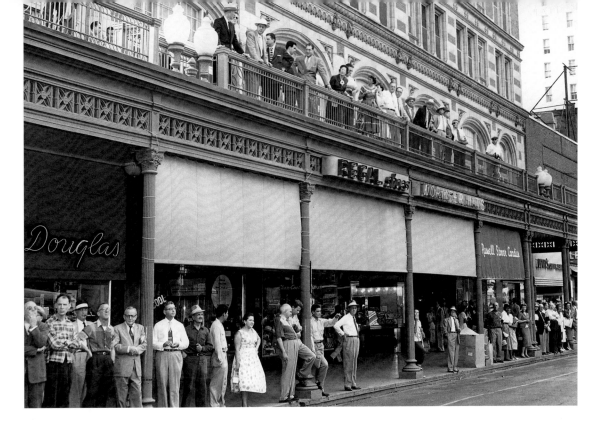

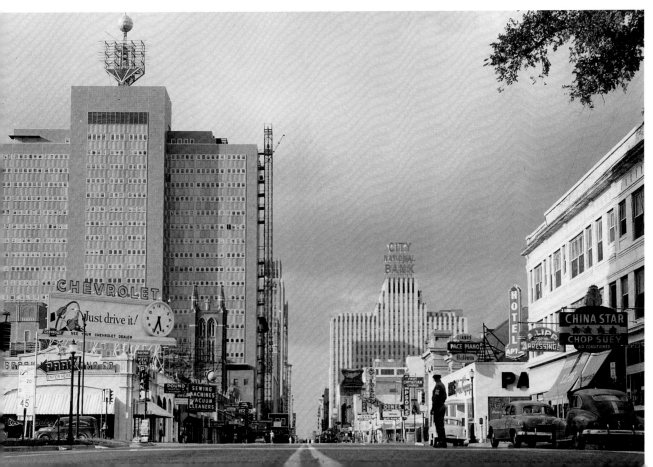

ABOVE: People on the street and on the balcony of the Main Street side of the Rice Hotel watch a civil defense evacuation practice on June 15, 1955.
COURTESY HOUSTON CHRONICLE ARCHIVES

ABOVE LEFT: Though the neighborhood has changed, First Methodist Houston has called the corner of Main and Clay home for more than 100 years. The church traces its roots to the Republic of Texas.
COURTESY HOUSTON CHRONICLE ARCHIVES

LEFT: A view of Main Street at Pease looking north, June 15, 1955. The street is deserted as part of a civil defense evacuation drill.
COURTESY HOUSTON CHRONICLE ARCHIVES

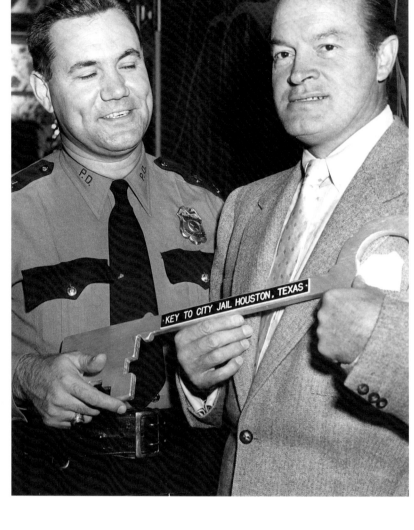

ABOVE: Jerry Lewis is greeted by Glynnene LePhiew, assistant director of the Houston Spinnerettes, and Yvonne McCutcheon, creator and director, at Houston International Airport when Lewis came to emcee the Miss Houston Pageant in 1957. He was the first of many celebrities who were greeted by the Spinnerettes from 1957-70 upon arriving in Houston.
COURTESY GLYNNENE SNYDER

RIGHT: Houston Police Chief Jack Heard presents Bob Hope a key to the city jail during the comedian's Houston visit in 1955.
COURTESY HOUSTON CHRONICLE ARCHIVES

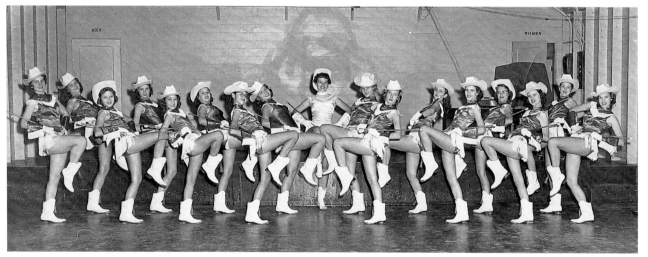

LEFT: The Houston Spinnerettes Twirling Team, which was made up of girls from all over Houston, existed from 1956 to 1970. Founder and director Yvonne McCutcheon formed the group from her twirling students from Houston's Parks and Recreation Department. The group was named Houston's official hostesses by the city and designated Texas ambassadors by the state.
COURTESY GLYNNENE SNYDER

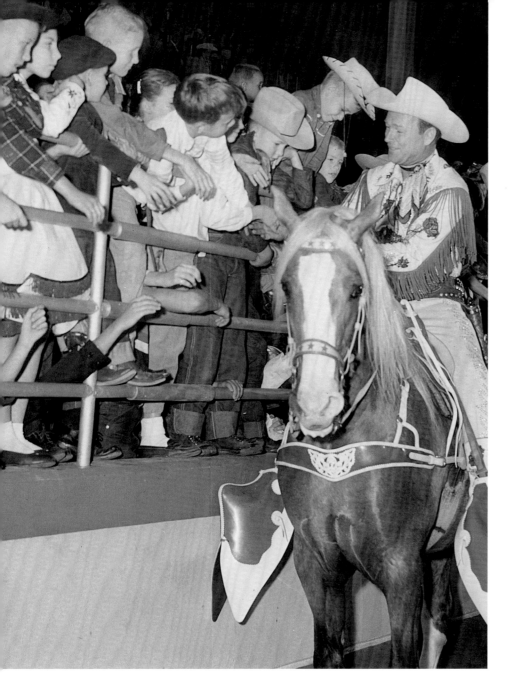

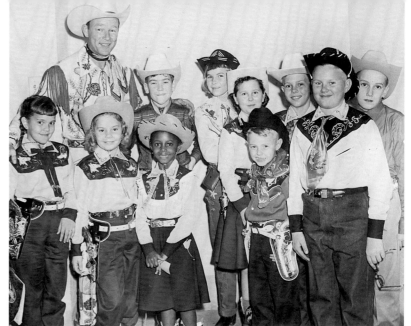

ABOVE: The 1957 winners of the Houston Chronicle's Roy Rogers Coloring Contest gather with their cowboy hero in the outfits they won. They not only got to meet Rogers, but they also met his wife, Dale Evans, and were guests of the famous couple at their performance at the Houston Fat Stock Show. First-place winners were, front row from left to right, Kathy Carroll, Webster; Sandra Honea, Houston; Jamie Jones, Houston; Bobby Furra, Cushing; and Ronald Krischke, Schulenburg. Back row, from left to right, are Rogers; Nickie Davenport, Houston; Helen Childeck, Yoakum; Nancy Sherrill, Genoa; James Hale, Raywood; and Jimmy Payne. COURTESY HOUSTON CHRONICLE ARCHIVES

ABOVE: Young fans got to see Roy Rogers up close on his equally famous horse, Trigger, at the 1957 Houston Fat Stock Show at the Sam Houston Coliseum. COURTESY HOUSTON CHRONICLE ARCHIVES

RIGHT: Pin Oak Charity Horse Show, June 1957. Since 1945, Pin Oak has become one of the pre-eminent horse shows in the nation, raising millions of dollars for local charities. COURTESY HOUSTON CHRONICLE ARCHIVES

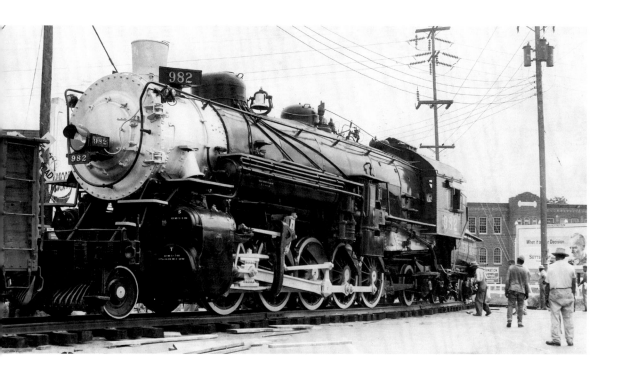

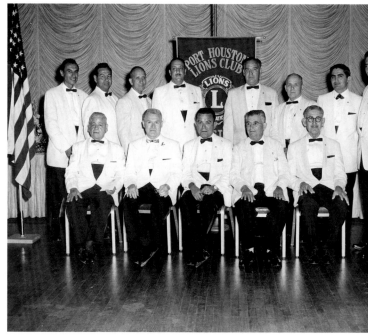

ABOVE: Southern Pacific engine No. 982 at the time of its retirement in 1957. The locomotive, built by Baldwin Locomotive in 1919, was moved from downtown to Hermann Park. For four days workers leapfrogged sections of track down Fannin as others pushed the 188-ton engine being pulled by tractors. In 2005, engine No. 982 was once again moved, this time across from Minute Maid Park. COURTESY HOUSTON CHRONICLE ARCHIVES

ABOVE RIGHT: Members of the Port Houston Lions Club, circa 1958. COURTESY EMILIO SARABIA

RIGHT: Houston Prison Farm inmates are used by the city to tidy up the central business area, September 1959. Here, they are busy on Fannin at Lamar working on the area between the curb and sidewalk. Mayor Lewis Cutrer encouraged the plan because he said it was good to get the inmates outside while at the same time clean up the city. COURTESY HOUSTON CHRONICLE ARCHIVES

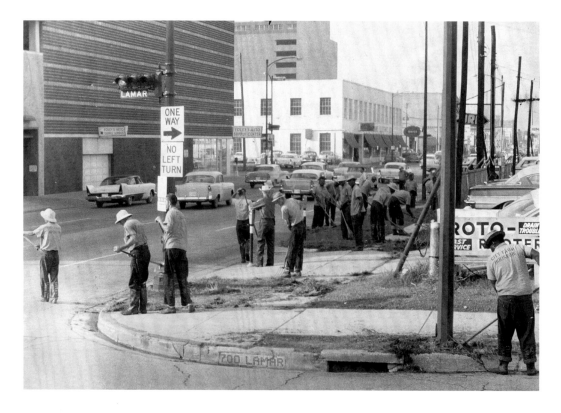

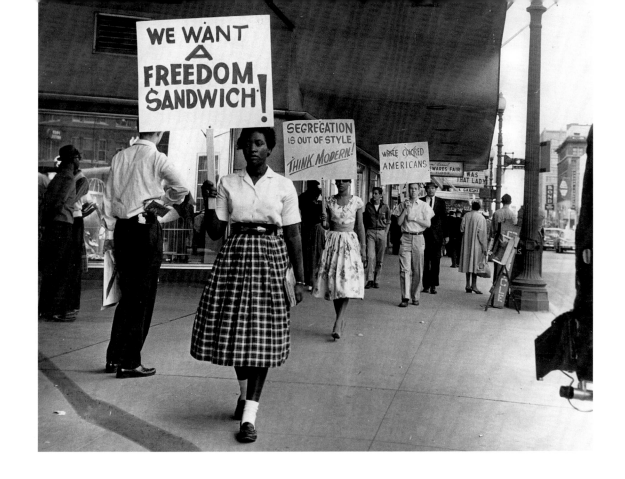

LEFT: Protesters demand equal rights at lunch counters as they picket in front of Foley's in downtown Houston, March 23, 1960.
COURTESY HOUSTON CHRONICLE ARCHIVES

BOTTOM LEFT: Leopold Stokowski, seen here in this 1960 photo, was conductor of the Houston Symphony from 1955-61.
COURTESY HOUSTON CHRONICLE ARCHIVES

BOTTOM RIGHT: Black students are denied service at the Houston Police Department cafeteria, January 1961.
COURTESY HOUSTON CHRONICLE ARCHIVES

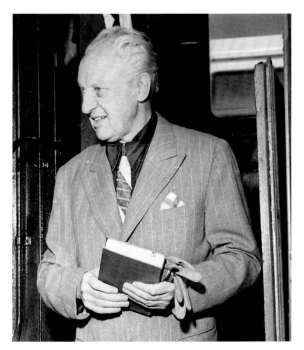

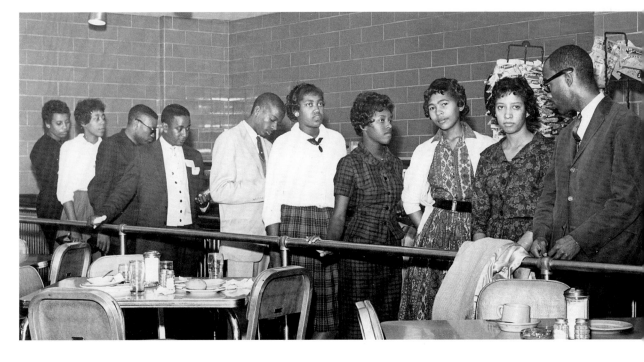

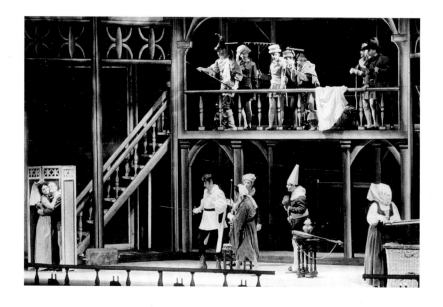

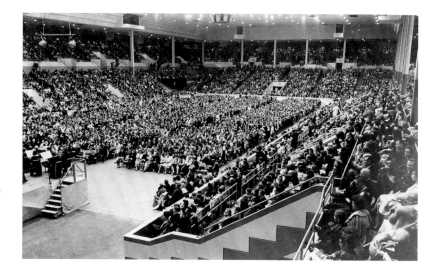

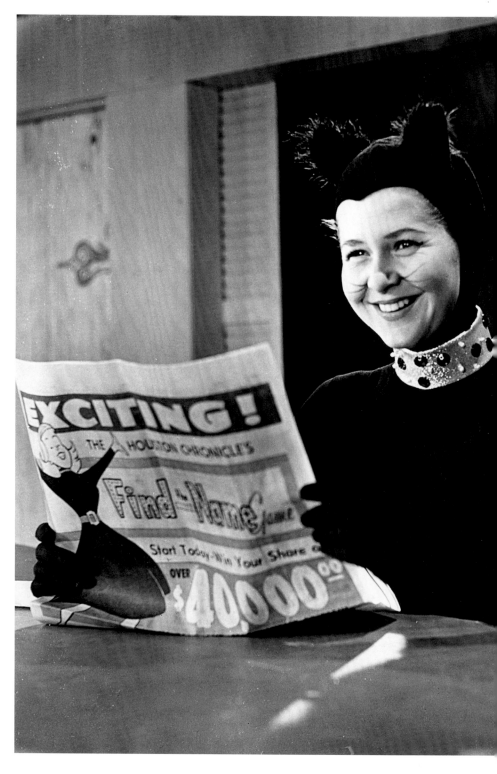

ABOVE: Concertgoers pack the Sam Houston Coliseum for the Houston Symphony Orchestra's Dollar Concert, 1962.
COURTESY HOUSTON CHRONICLE ARCHIVES

TOP: A scene from Houston Grand Opera's *Falstaff*, 1961.
COURTESY HOUSTON CHRONICLE ARCHIVES

RIGHT: KTRK's Kitirik (Bunny Orsak) was a fixture on Houston television for nearly 20 years. COURTESY HOUSTON CHRONICLE ARCHIVES

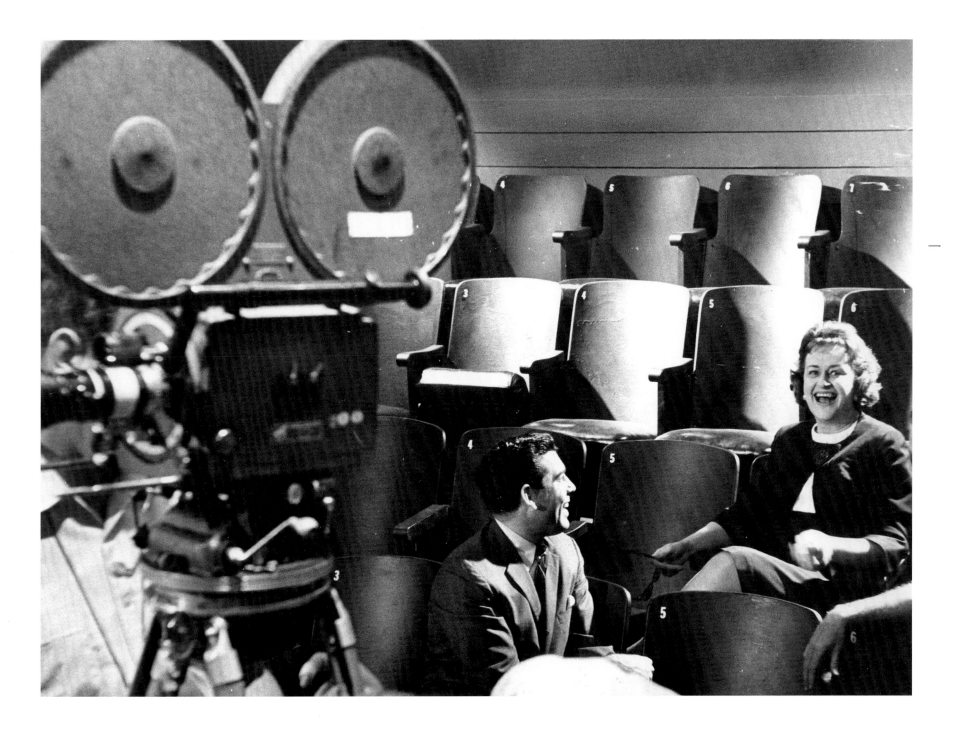

ABOVE: Wharton native Dan Rather interviews Alley Theatre founder Nina Vance as part of a CBS report, October 1960.

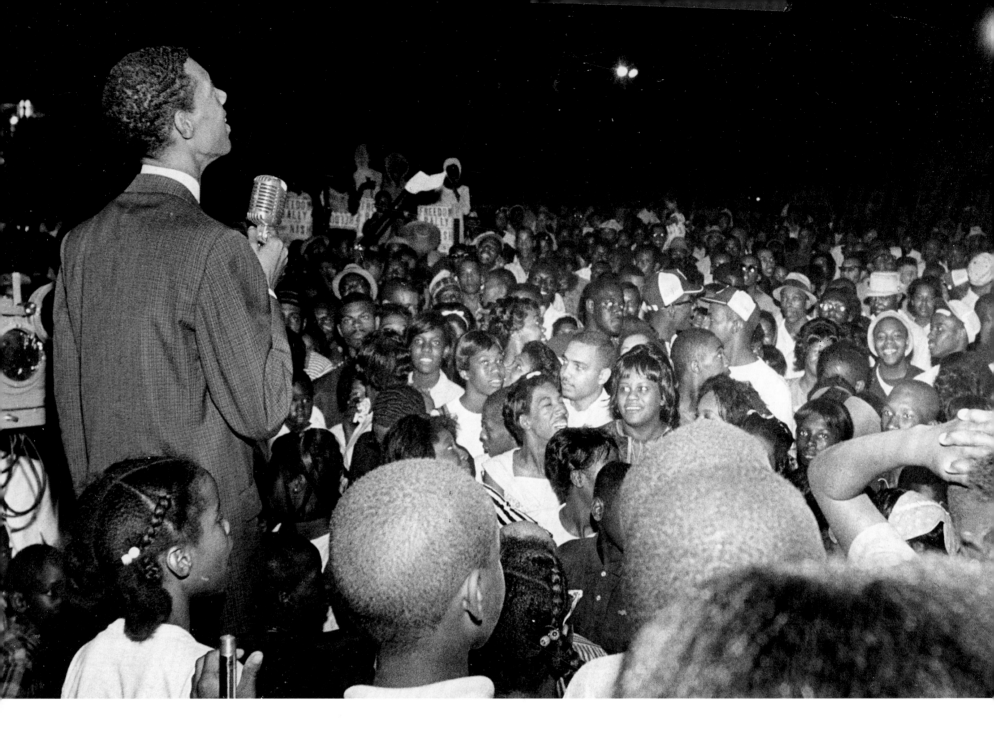

ABOVE: The Rev. William Lawson, pastor of Wheeler Avenue Baptist Church, tells demonstrators in June 1965 that they have waited long enough for school desegregation. COURTESY HOUSTON CHRONICLE ARCHIVES

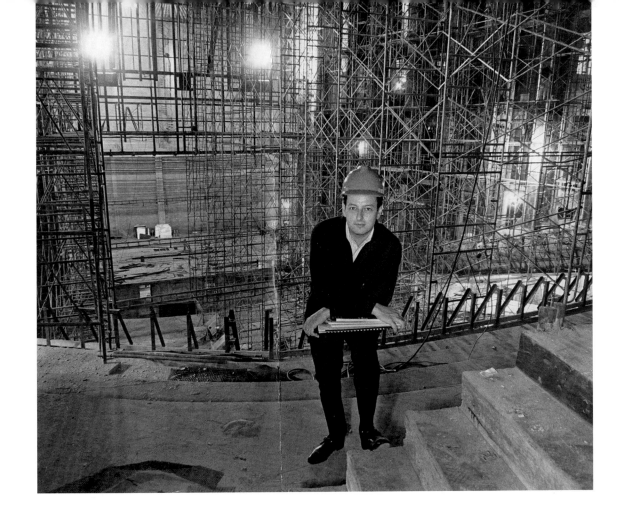

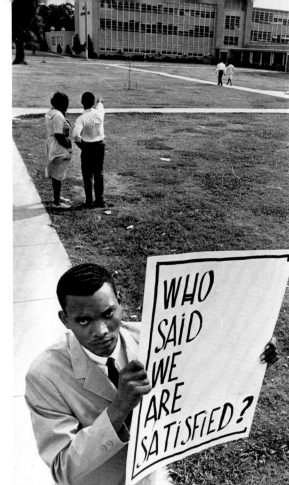

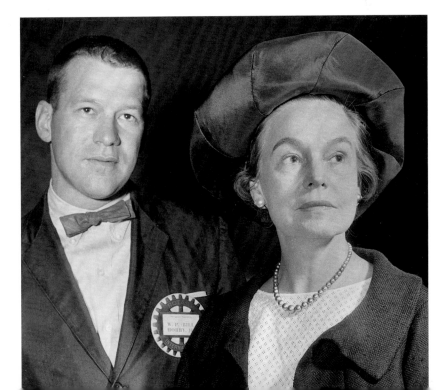

ABOVE: Guest conductor André Previn pauses for a photograph during a tour of Jones Hall following a rehearsal, December 1965. To Previn's right, the orchestra pit and stage of the new hall are partially visible through a break in the scaffolding. Previn was music director for the Houston Symphony from 1967-69. COURTESY HOUSTON CHRONICLE ARCHIVES

ABOVE RIGHT: Black high school students staged a boycott at Houston's five black high schools — including Yates High School in this photo — to protest the slow pace of integration, May 10, 1965. COURTESY HOUSTON CHRONICLE ARCHIVES

RIGHT: Over the years, Oveta Culp Hobby held many titles, including first secretary of the Department of Health, Education and Welfare; first commanding officer of the Women's Army Corps, and president and editor of the Houston Post. With her in this 1962 photo is her son, William P. Hobby Jr., who would serve 18 years as lieutenant governor. COURTESY HOUSTON CHRONICLE ARCHIVES

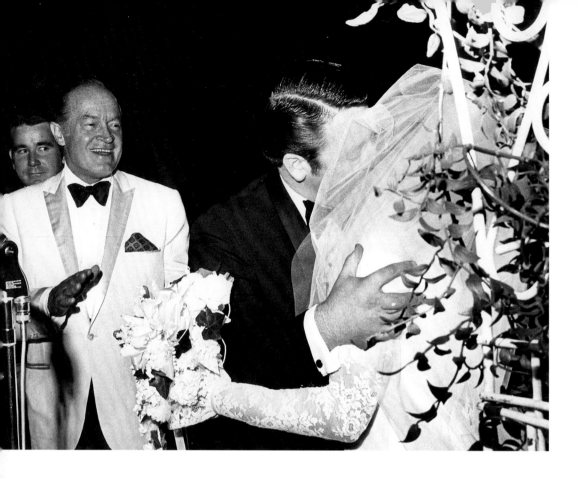

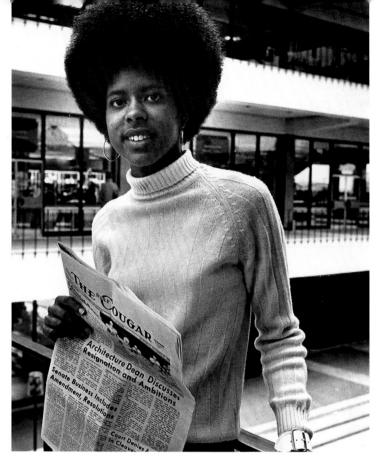

ABOVE: Comedian Bob Hope applauds as Bobby Bailey kisses his new bride, Grace Davila. The couple was wed on the stage of the Majestic Theatre on May 30, 1969, with Hope acting as Bailey's best man. Bailey and his bride were the winners of an Interstate Theatres contest designed to plug Hope's new film *How to Commit Marriage.* COURTESY HOUSTON CHRONICLE ARCHIVES

ABOVE RIGHT: Lynn Eusan became the first African-American homecoming queen at the University of Houston, and the first black homecoming queen at a predominantly white university in the South in 1968. COURTESY HOUSTON CHRONICLE ARCHIVES

RIGHT: Paradegoers welcome the Ringling Bros. and Barnum & Bailey Circus into Houston, 1969. COURTESY HOUSTON CHRONICLE ARCHIVES

OPPOSITE: Stephanie Bell, 10, center, and Deidre Jones, 11, get caught up in the fun during a Ringling Bros. and Barnum & Bailey Circus show in 1969. The girls, from Highland Heights Elementary School, were participating in the school's Focus on Achievement summer program. COURTESY HOUSTON CHRONICLE ARCHIVES

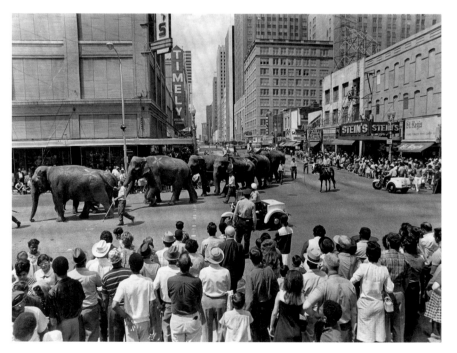

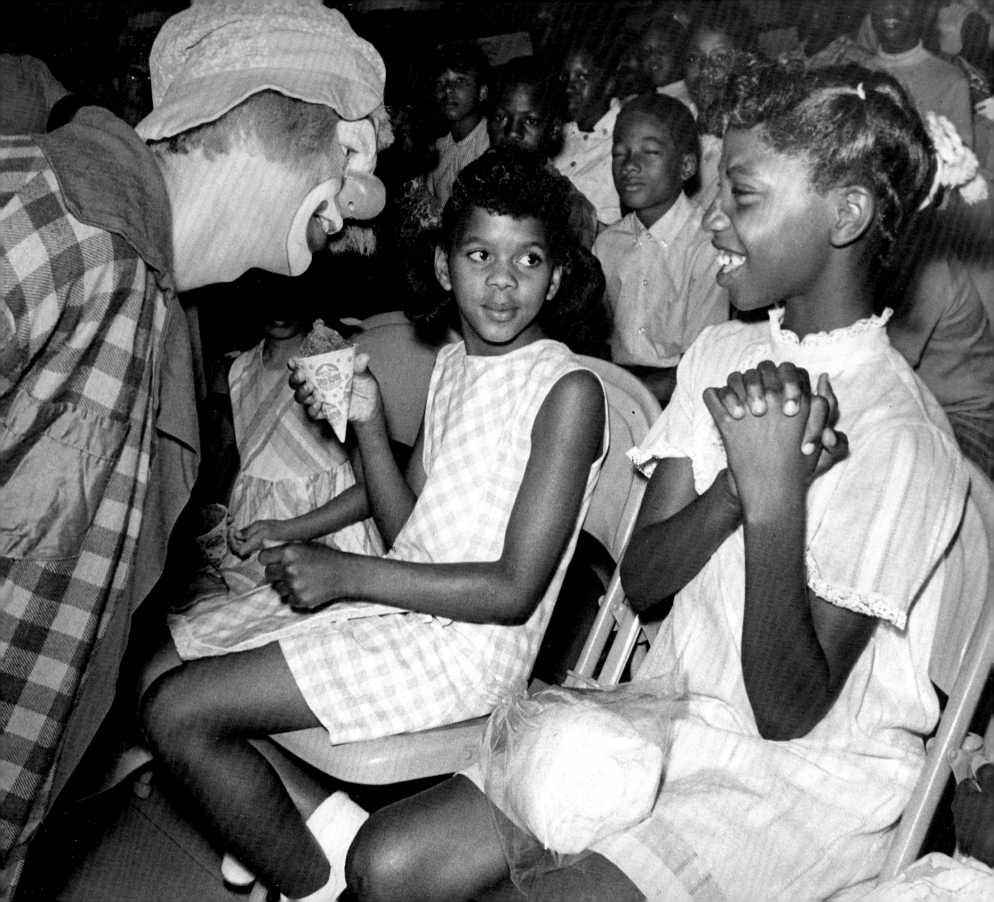

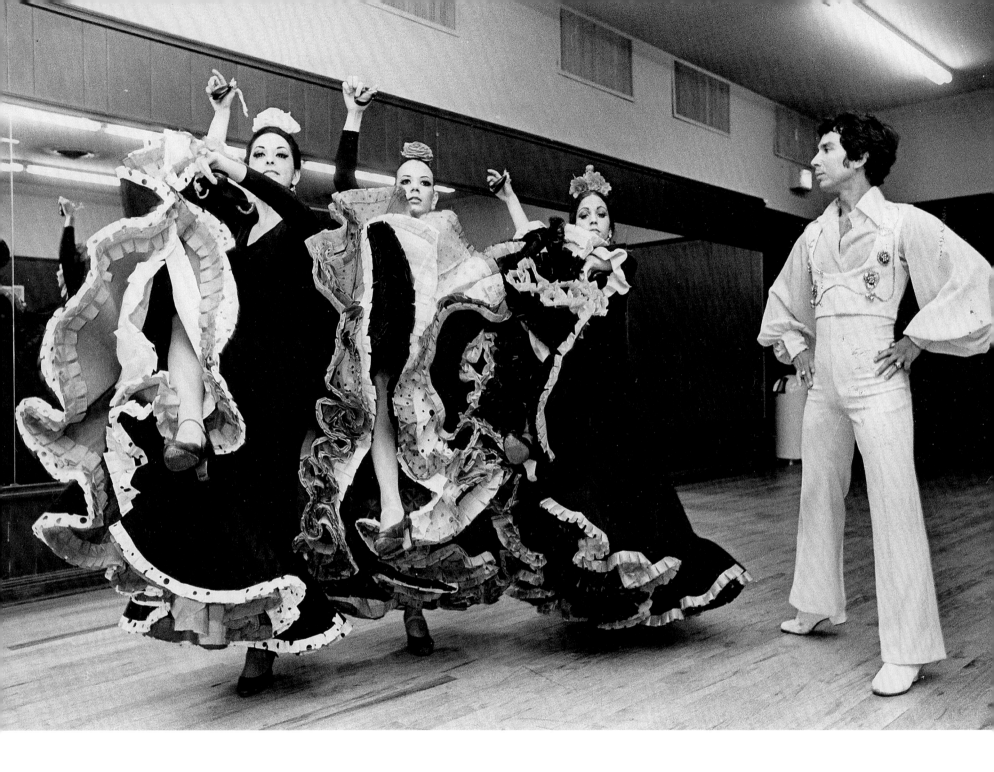

ABOVE: Flamenco dancers practice for a performance in Houston Grand Opera's Carmen to be held in Hermann Park, February 1974. With instructor-dancer Rogelio Rodriquez are, from left, assistant teachers Magda Ruiz, Sylvia Garcia and student Jo De Romano of the High School for the Performing and Visual Arts. COURTESY HOUSTON CHRONICLE ARCHIVES

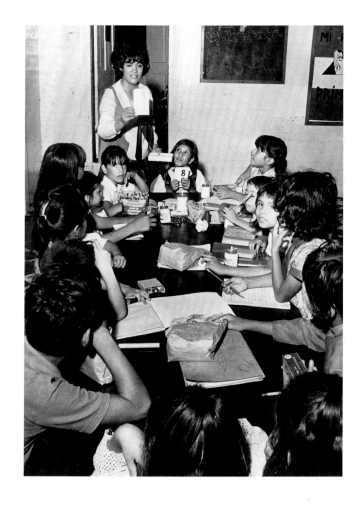

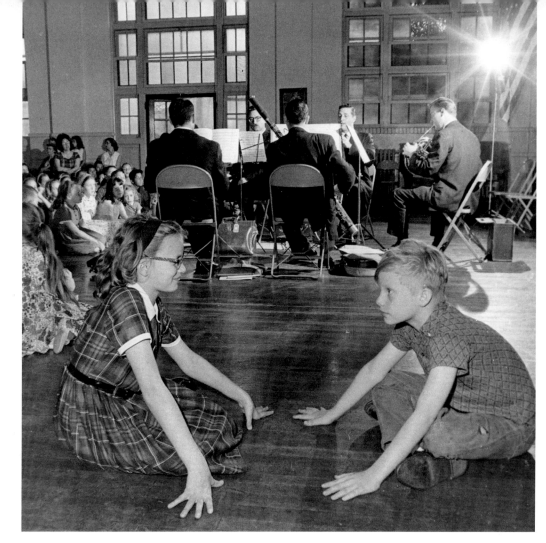

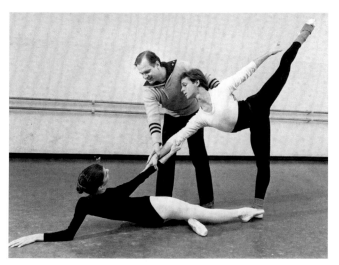

ABOVE: Mary Sue Halliburton and Eddie Manley, two deaf children, "listen" to an ensemble of the Houston Symphony Orchestra by placing their hands on the floor to pick up the musical vibrations, April 1964. The two children and their classmates, who were able to hear, were from Montrose Elementary School. COURTESY HOUSTON CHRONICLE ARCHIVES

LEFT TOP: Teacher Yolanda Flores leads a class of Hispanic students in their makeshift *huelga* classroom, September 1970. More than 3,500 students boycotted Houston schools to protest integration plans that many Mexican-Americans felt adversely affected their community. COURTESY HOUSTON CHRONICLE ARCHIVES

LEFT BOTTOM: Houston Ballet Artistic Director Ben Stevenson, center, works with dancers Katie King and Paul Le Gros in preparation for an upcoming performance of *Four Last Songs*, January 1980. COURTESY HOUSTON CHRONICLE ARCHIVES

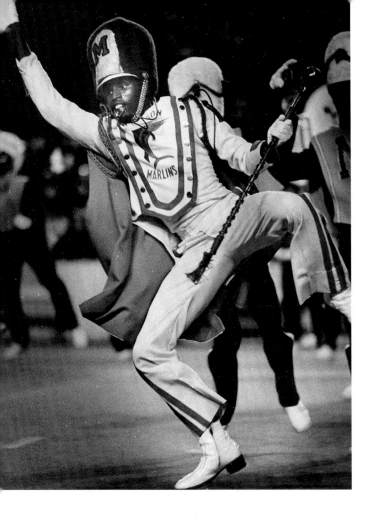

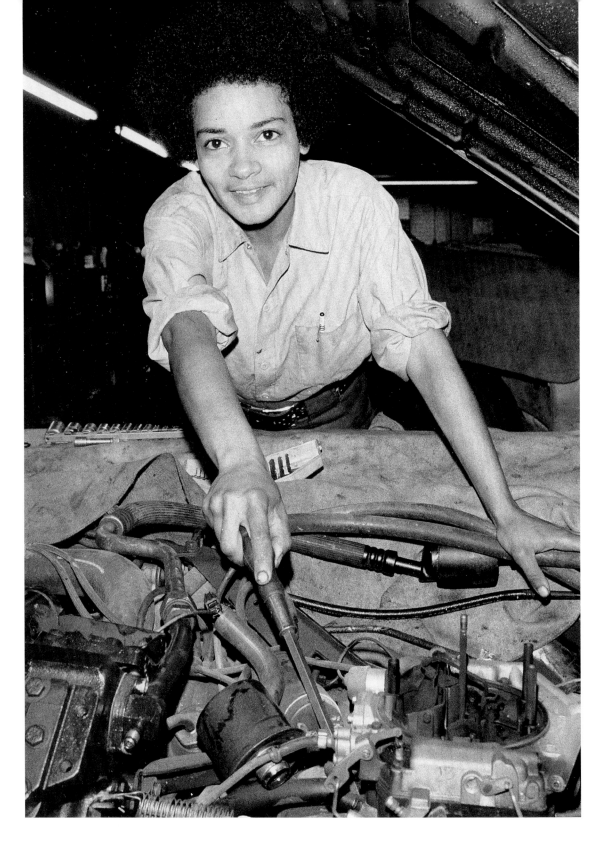

ABOVE: Ronald Elgin, head drum major at Madison High School, October 1980. Madison High was one of 17 schools taking part in a battle of the bands contest at Rice Stadium.
COURTESY HOUSTON CHRONICLE ARCHIVES

RIGHT: Janet Tarver, the first female mechanic to be employed at the Houston Police Department garage, March 1977. This was her first day on the job.
COURTESY HOUSTON CHRONICLE ARCHIVES

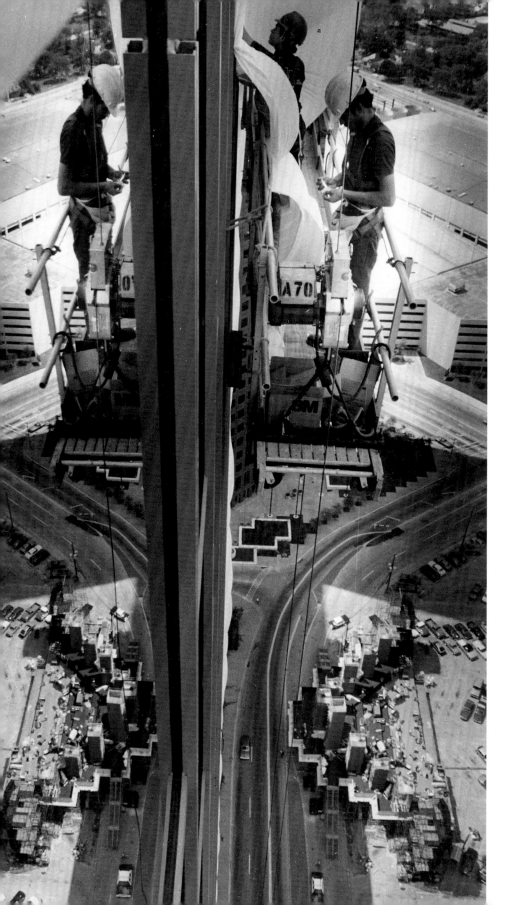

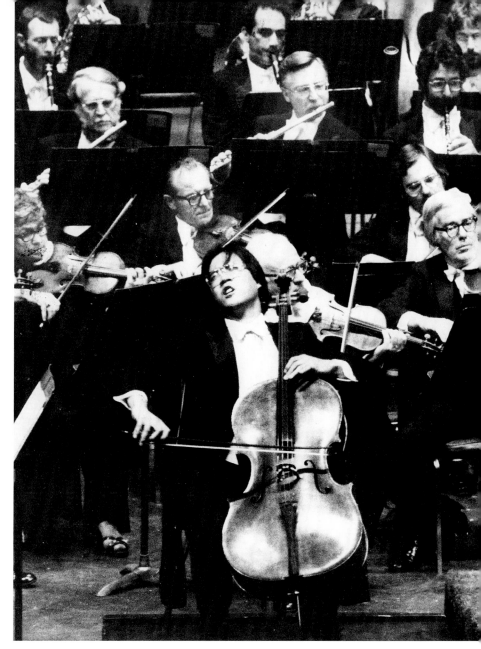

ABOVE: Famed cellist Yo-Yo Ma makes his debut with the Houston Symphony Orchestra, 1979. COURTESY HOUSTON CHRONICLE ARCHIVES

LEFT: Workers stretch a huge piece of sailcloth over the exterior of the Heritage Plaza building under construction, April 2, 1986. The sailcloth serves as a screen for Jean-Michel Jarre's *Rendez-Vous Houston: A City in Concert* on April 5, 1986. COURTESY HOUSTON CHRONICLE ARCHIVES

Life & Culture | 141

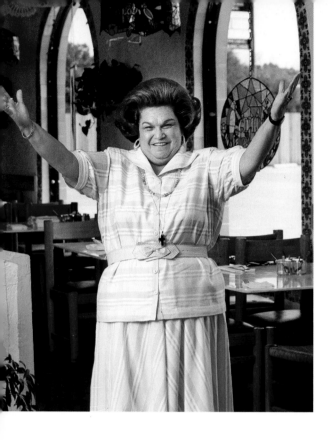

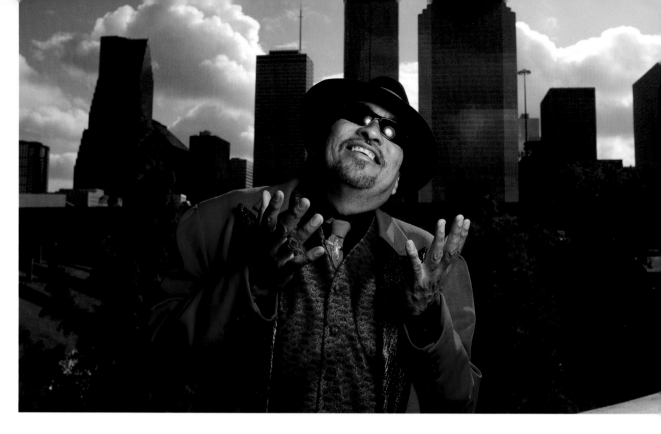

ABOVE: Ninfa Laurenzo, matriarch of the Laurenzo restaurant family and head of Ninfa's Inc., 1990. She was affectionately known as "Mama Ninfa" to those who ate her tacos al carbon, chili con queso and enchiladas.
COURTESY HOUSTON CHRONICLE ARCHIVES

ABOVE RIGHT: For years Richard Reyes, aka Pancho Claus, has brought Christmas cheer to Houston's at-risk youths.
COURTESY HOUSTON CHRONICLE ARCHIVES

RIGHT: Ronesha Burch holds her son Jeremiah while KTRK reporter Marvin Zindler prepares a report from Dr. Joseph Agris' office in February 2006. Zindler's pioneering brand of consumer reporting and work to help the poor both in Houston and abroad, made him one of the city's most well-known media personalities.
COURTESY HOUSTON CHRONICLE ARCHIVES

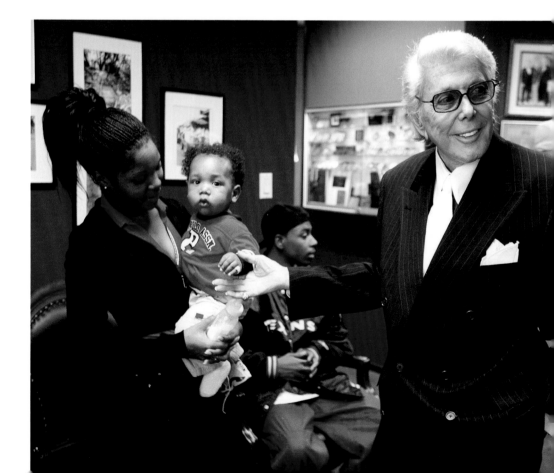

RIGHT: The Art Guys — Jack Massing, left, and Michael Galbreth — cut up in front of an Absolut Vodka billboard along Loop 610 that they and their crew painted 1,000 times.
COURTESY HOUSTON CHRONICLE ARCHIVES

BOTTOM LEFT: Houston-area Muslims take part in a 2010 Eid al-Fitr prayer service marking the end of the holy month of Ramadan at the George R. Brown Convention Center.
COURTESY HOUSTON CHRONICLE ARCHIVES

BOTTOM RIGHT: Postman Jeff McKissack turned an affection for the orange into a piece of folk art known as The Orange Show, seen here in 2004. Open to the public since 1979, the East End attraction falls under the care of the Orange Show Center for Visionary Art, which also oversees the Art Car Parade and the Beer Can House. COURTESY HOUSTON CHRONICLE ARCHIVES

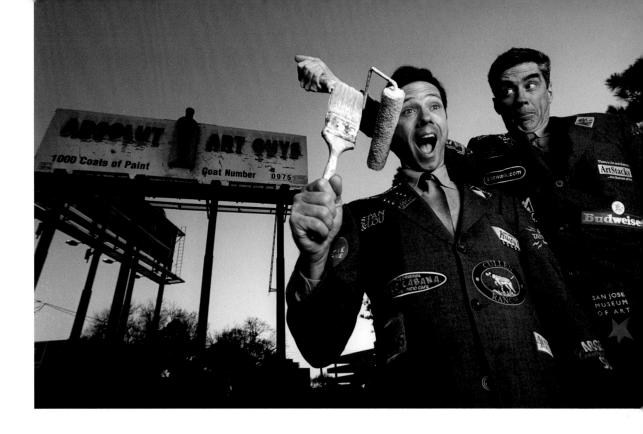

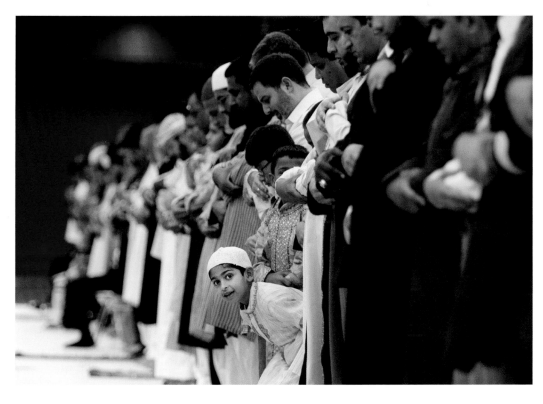

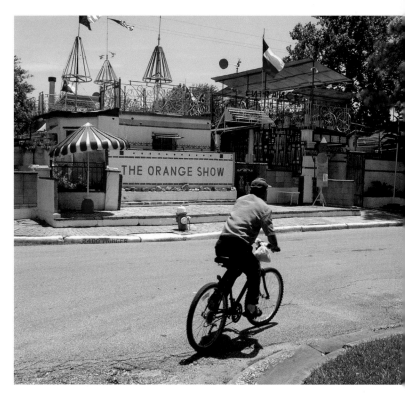

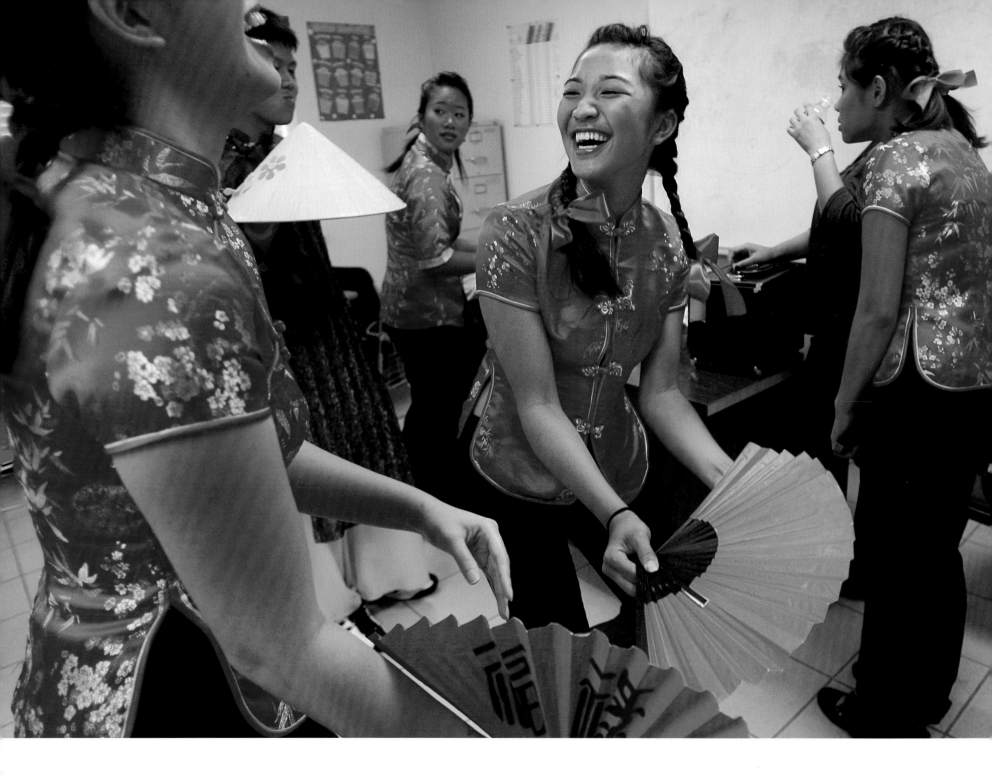

ABOVE: Amanda Nguyen, left, and Cindy Tran share a light moment before performing a Chinese traditional dance in celebration of the Moon Festival in 2007 at the Vietnamese Martyr Church. COURTESY HOUSTON CHRONICLE ARCHIVES

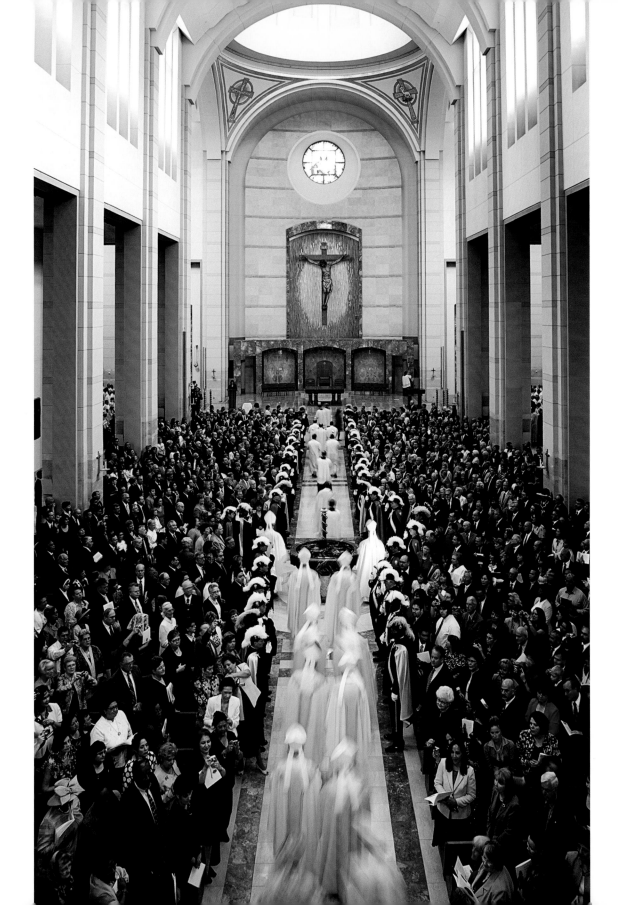

ABOVE: Joel Osteen, pastor of Lakewood Church, prays during the swearing-in of Mayor Annise Parker and City Council, Jan. 4, 2010, at the Wortham Theater. Osteen took over Lakewood Church in 1999 after the death of his father, John Osteen, who founded Lakewood in 1959. Osteen moved the congregation from its northeast Houston campus to the building formerly known as the Compaq Center (and before that, the Summit), home of the Rockets. COURTESY HOUSTON CHRONICLE ARCHIVES

LEFT: A procession of clergy enters the Sacred Heart Co-Cathedral during dedication ceremonies, April 2, 2008. The downtown co-cathedral cost $49 million and seats more than 1,800.
COURTESY HOUSTON CHRONICLE ARCHIVES

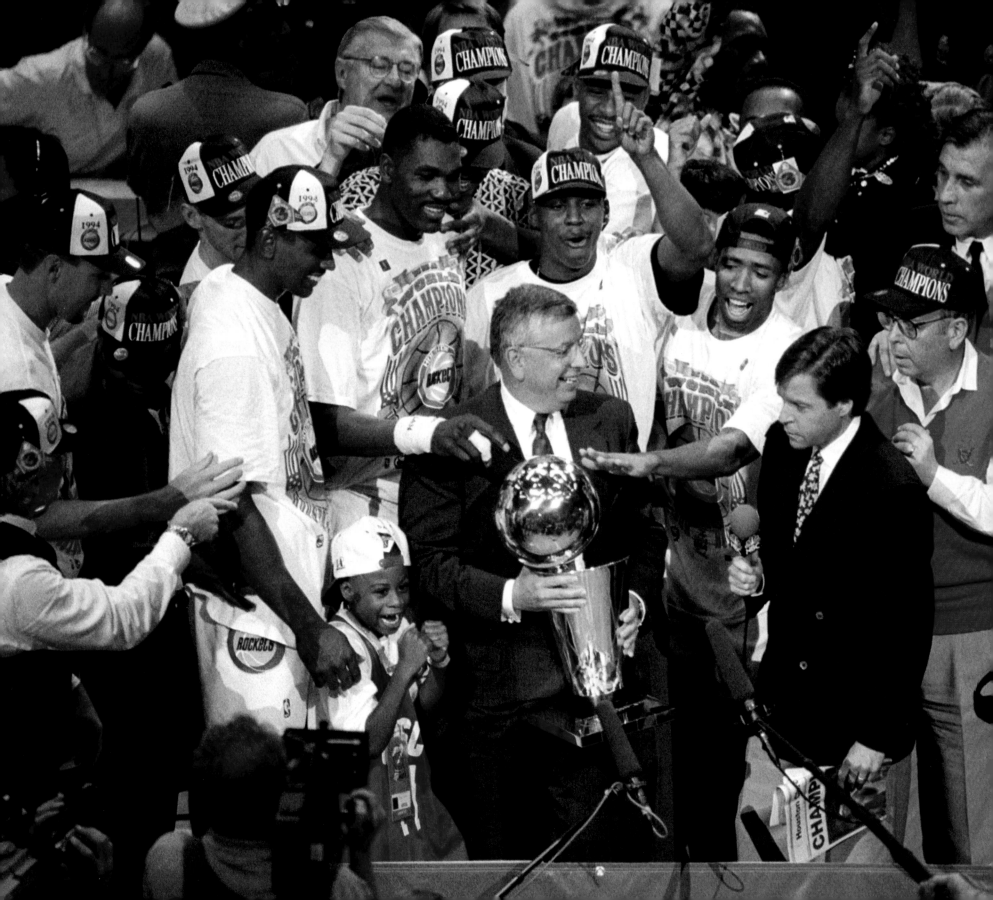

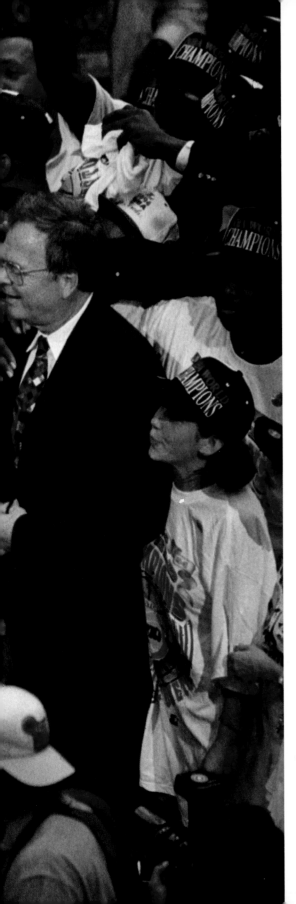

SPORTS

For many decades, Houston was a minor-league town in just about every sense of the word, and nowhere was that more obvious than in the world of professional sports.

That changed, sort of, when Bud Adams brought the Oilers to town in 1960 as a charter member of the fledgling American Football League. Though many pooh-poohed the upstart league, the Oilers won the first two AFL titles. The team eventually left us for Tennessee, but the Texans soon would satisfy the need for professional football here.

The Houston Buffs, a longtime member of the Texas League, was the city's professional baseball team until 1962, when the awkwardly named Colt .45s began play as a Major League Baseball expansion team. The Colt .45s played in a sweaty makeshift stadium while their eventual home — a revolutionary marvel that would allow the game to be played indoors in air-conditioned comfort — was being built nearby.

Consistent with Houston becoming NASA's headquarters for manned spaceflight, the team was renamed the Astros when it moved into the Astrodome in 1965. The first large domed stadium in the world was such an attraction in itself that people came from all over the country just to tour it, even during the offseason. The Astrodome served as the site for major concerts and special sporting events, including the "Game of the Century" basketball contest between UCLA and

the University of Houston in 1968 and the bizarre "Battle of the Sexes" tennis match between Bobby Riggs and Billie Jean King. The Astros played there until a new, smaller, baseball-specific downtown stadium opened in 2000.

The city gained an NBA team in 1971 when the Rockets moved from San Diego, then set about building them a permanent home. The Summit opened in 1975 and served not only the Rockets but also the Aeros hockey team. The Rockets struggled early but enjoyed several successful periods later on. Their high point came when Hakeem Olajuwon led them to back-to-back NBA titles in 1994 and 1995. Not to be outdone, the WNBA's Comets proved they were a team worthy of being called champions, too. Four times over, in fact.

Rice University brought Houston its first real taste of sports glory when it won the Southwest Conference football title four times from 1946 to 1957. Changing times made it harder for the small school to remain competitive as college sports boomed, but Rice did win the NCAA baseball title in 2003. The University of Houston joined the SWC in 1971 and enjoyed success in football, baseball and especially basketball. The Cougars under coach Guy Lewis reached the Final Four on five occasions. The famous "Phi Slama Jama" squad of the early 1980s, also led by Olajuwon, played in the 1983 and 1984 championship games.

LEFT: NBA commissioner David Stern presents the NBA championship trophy to the Rockets after they defeated the New York Knicks in Game 7 of the NBA Finals on June 22, 1994.
COURTESY HOUSTON CHRONICLE ARCHIVES

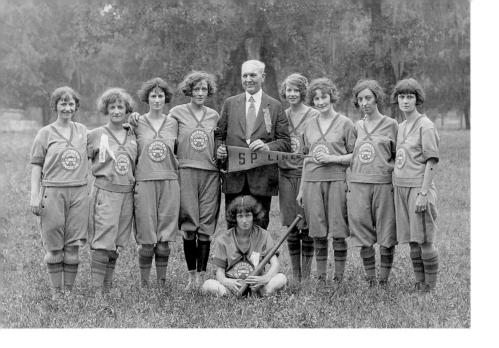

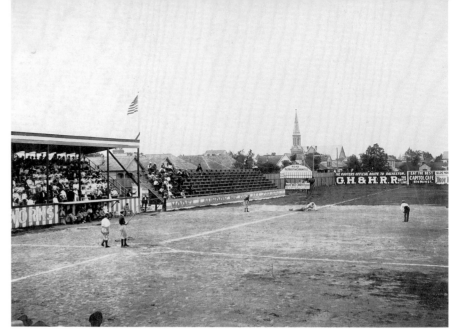

ABOVE: These Southern Pacific employees took part in track competitions during the company's annual track and field meet, which involved employees from across the state and Louisiana. COURTESY HOUSTON PUBLIC LIBRARY, HOUSTON METROPOLITAN RESEARCH CENTER

ABOVE RIGHT: West End Park, located on Andrews Street in what is now the southwest corner of downtown, was home to the Houston Buffaloes from the mid-1800s to 1928, when Buff Stadium opened. COURTESY HOUSTON PUBLIC LIBRARY, HOUSTON METROPOLITAN RESEARCH CENTER

RIGHT: The 1920 Heights High School football team played Cleburne to a 0-0 tie in the state championship, resulting in both teams sharing the title. Front row, from left, R. McCraty, V. Shown, K. Nairn, W. Doc Bruder, Ed Prather, L. Jensen and H. Woodward. Middle row, H. Beutell, W. Peacock, G. Parmalee, W. Kendricks, F. Stamp, J. Axeline and B. Zown. Back row, Robert Countryman, assistant coach; Jack Glenn, D. King, M. Barrett, L. Green, E. Hunter, T. Boswell, F. Hines, R. Waltrip and Coach W. B. Welling. COURTESY HOUSTON PUBLIC LIBRARY, HOUSTON METROPOLITAN RESEARCH CENTER

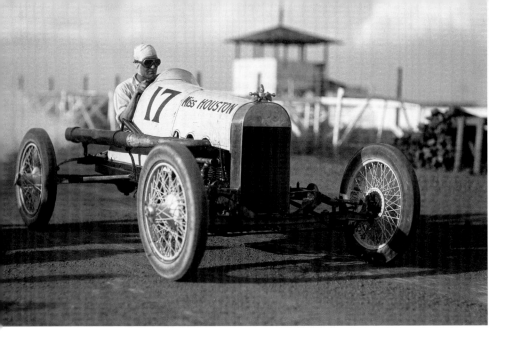

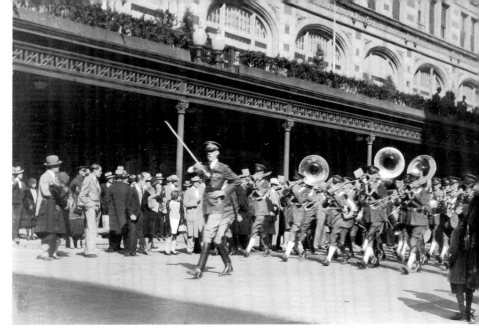

ABOVE: The Fightin' Texas Aggie Band leads the Texas A&M Corps of Cadets through downtown Houston in front of the Rice Hotel, likely for a football game against Rice Institute, circa 1928. COURTESY JAMES HUDSON

ABOVE LEFT: The racer Miss Houston at the Houston Speedway in the 1920s. The track was located just west of Main Street and south of Bellaire Boulevard. In later years, it also was known as Bellaire Speedway. COURTESY THE SLOANE COLLECTION

LEFT: Golf legend Walter Hagen tees off at River Oaks Country Club Estates in the 1920s. COURTESY THE SLOANE COLLECTION

RIGHT: Babe Ruth addresses the Kiwanis Club's "Knot Hole Gang" at the Houston City Auditorium, March 29, 1930. This group was made up of boys who could not afford to go to baseball games. Behind Ruth are members of the Houston Buffaloes.

COURTESY THE SLOANE COLLECTION

BELOW: Seventh annual Southern Pacific track and field meet, May 23, 1930.

COURTESY THE SLOANE COLLECTION

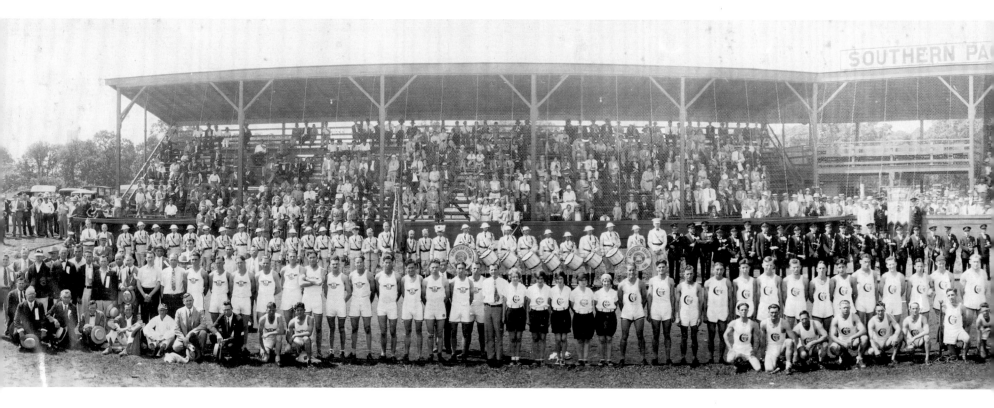

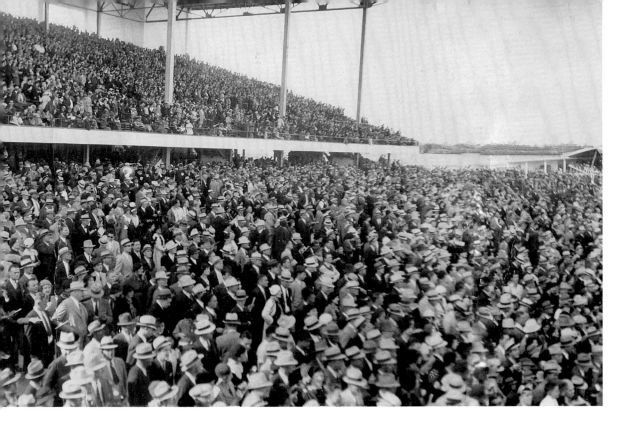

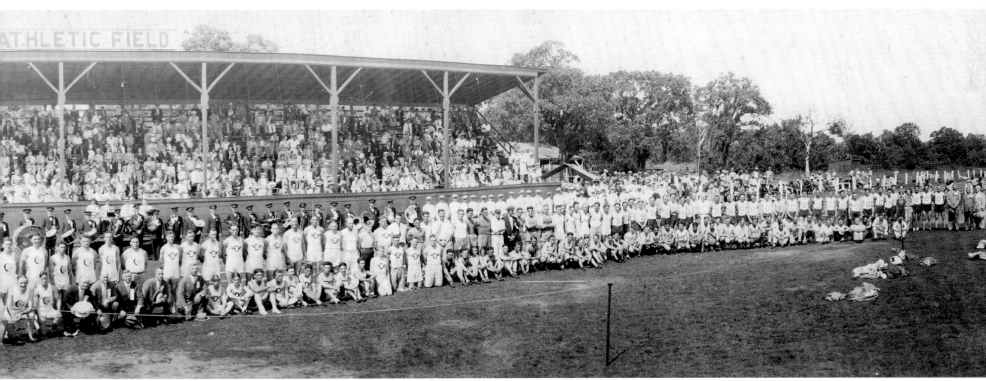

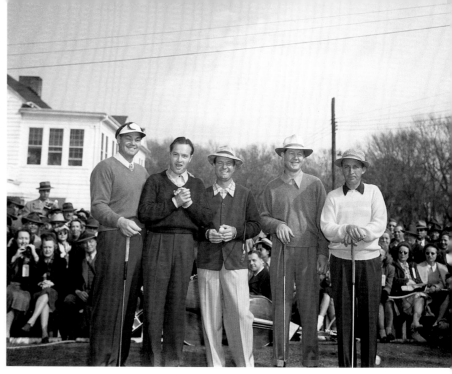

ABOVE: Mexican Inn was a Main Street restaurant operated by future community leader Felix Tijerina, left. The restaurant would close shortly after this 1934 photo showing off his amateur baseball team was taken, but he wouldn't stay out of the restaurant business for long. COURTESY HOUSTON PUBLIC LIBRARY, HOUSTON METROPOLITAN RESEARCH CENTER

TOP RIGHT: Johnny Weismuller, left, Bob Hope, Jimmy Demaret, Byron Nelson and Bing Crosby get a golf game in at BraeBurn Country Club as part of a 1942 visit to raise money for the war effort. COURTESY HOUSTON PUBLIC LIBRARY, HOUSTON METROPOLITAN RESEARCH CENTER

RIGHT: The Houston Public School Board led the creation of two junior colleges for whites and blacks. Teams with Houston Colored Junior College, later Houston College for Negroes, competed with other all-black schools on the collegiate and high school level. COURTESY HOUSTON PUBLIC LIBRARY, HOUSTON METROPOLITAN RESEARCH CENTER

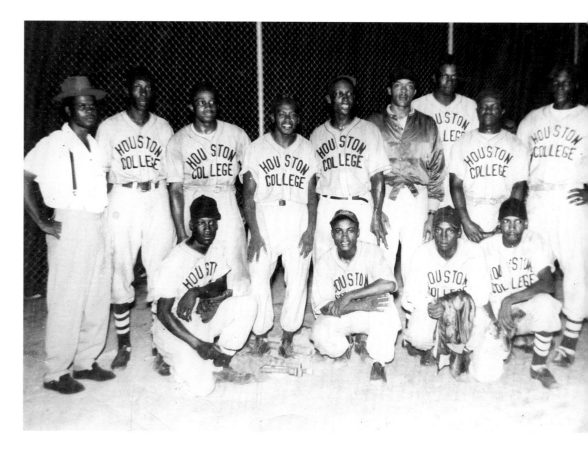

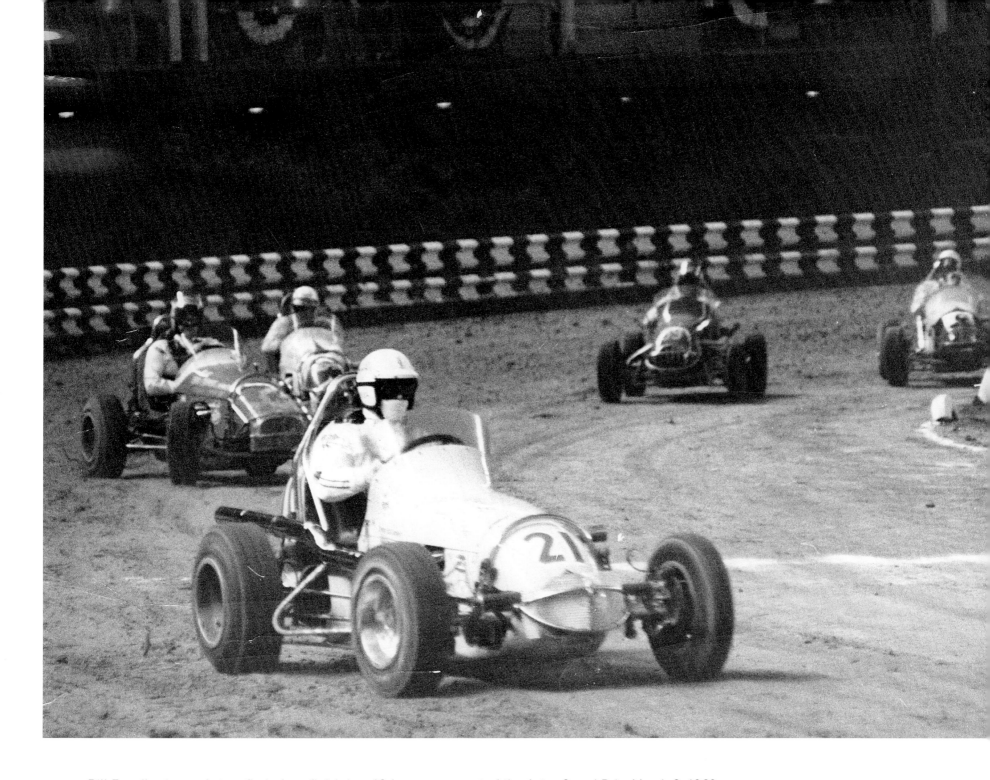

ABOVE: Bill Engelhart speeds to a first place finish in a 10-lap race as part of the Astro Grand Prix, March 8, 1969.

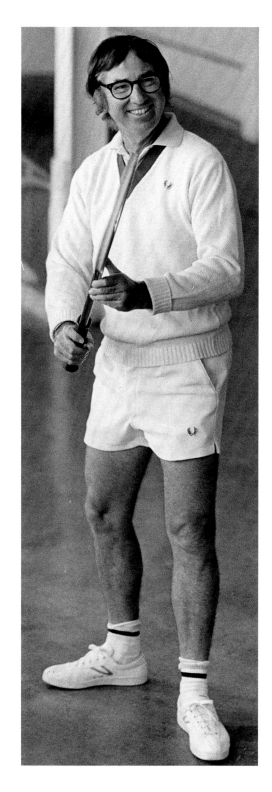

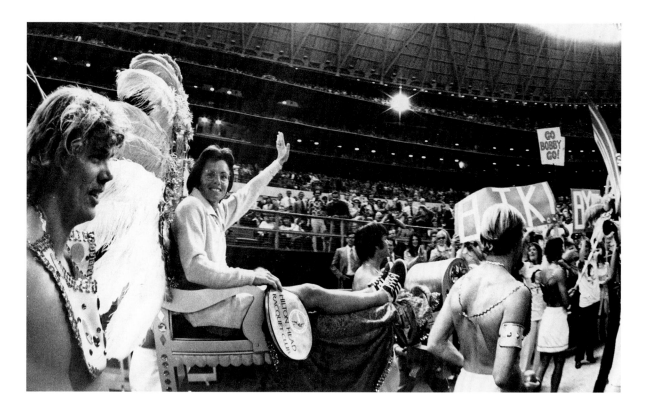

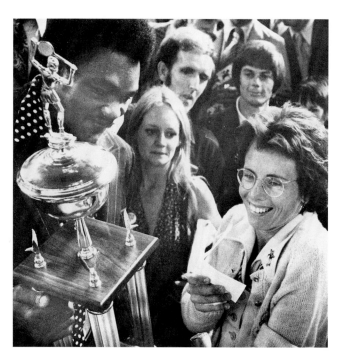

ABOVE: A circuslike atmosphere reigned in the Astrodome on Sept. 20, 1973, during the second "Battle of the Sexes" with Bobby Riggs facing off against Billie Jean King.
COURTESY HOUSTON CHRONICLE ARCHIVES

LEFT: Billie Jean King receives her trophy from heavyweight champion George Foreman, left, after she defeated Bobby Riggs in 1973.
COURTESY HOUSTON CHRONICLE ARCHIVES

FAR LEFT: Bobby Riggs, September 1973.
COURTESY HOUSTON CHRONICLE ARCHIVES

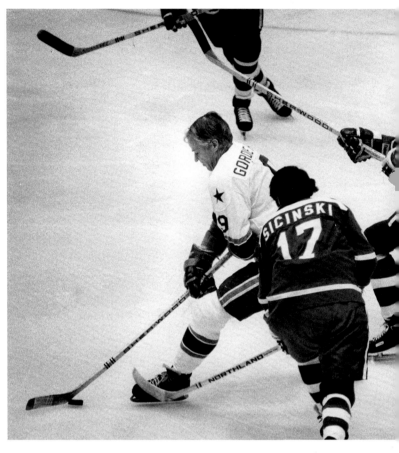

ABOVE: Hockey legend Gordie Howe played for the Houston Aeros of the World Hockey Association in the mid-1970s. He helped lead the team to two championship titles before the franchise folded in 1978. COURTESY HOUSTON CHRONICLE ARCHIVES

ABOVE LEFT: Astros pitching coach Roger Craig, left, with pitchers Don Wilson, Dave Roberts, Larry Dierker and Claude Osteen in 1974.
COURTESY HOUSTON CHRONICLE ARCHIVES

LEFT: Houstonian A.J. Foyt and his father make last-minute adjustments on his car ahead of the 1976 Astro Grand Prix in the Astrodome. The new look on the car is a roll cage, which protects the driver in case of a crash. COURTESY HOUSTON CHRONICLE ARCHIVES

RIGHT: Future NBA Hall of Famer Moses Malone tries to get a shot away over Jack Sikma of the Seattle Supersonics in the first half of the season-opening game at The Summit in 1980. Malone played for the Rockets from 1976-82.
COURTESY HOUSTON CHRONICLE ARCHIVES

FAR RIGHT: Tyler native and Heisman Trophy winner Earl Campbell (34), seen here during the 1978 AFC divisional playoff game against the New England Patriots, played a crucial role in shaping the Oilers' Luv Ya Blue era. In his eight-season career with the Oilers and New Orleans Saints, Campbell rushed 2,187 times for 9,407 yards and 74 touchdowns.
COURTESY HOUSTON CHRONICLE ARCHIVES

BOTTOM LEFT: University of Houston track star Carl Lewis, 1980. COURTESY HOUSTON CHRONICLE ARCHIVES

BOTTOM RIGHT: Philadelphia Phillies first baseman Pete Rose slides into Astros catcher Luis Pujols during Game 3 of the 1980 National League Championship Series at the Astrodome, Oct. 10, 1980. Though the Astros won the game, the Phillies would end up winning the series.
COURTESY HOUSTON CHRONICLE ARCHIVES

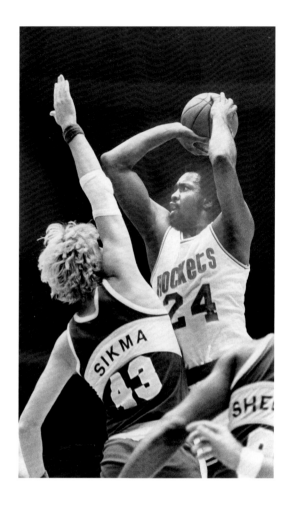

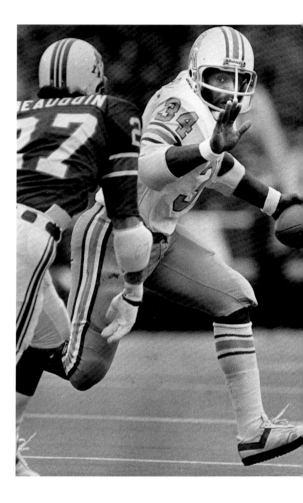

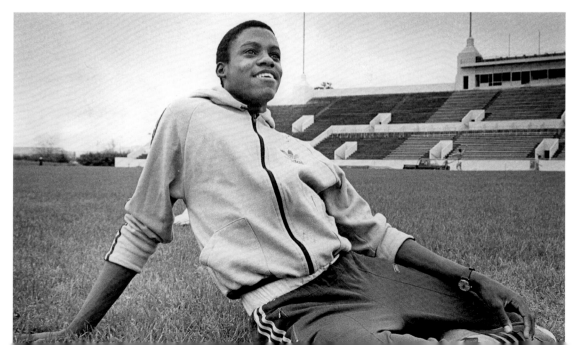

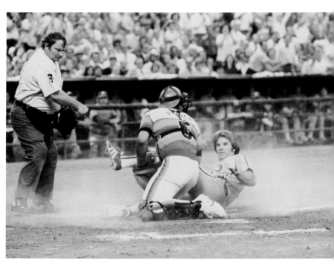

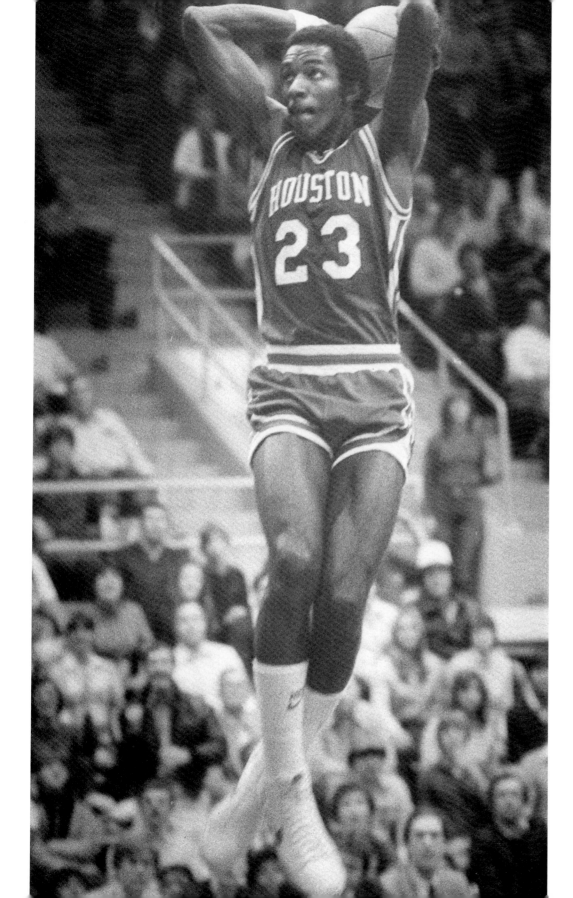

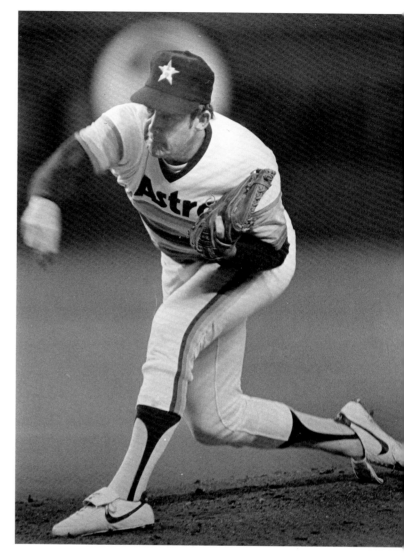

ABOVE: Astros pitcher Nolan Ryan brings the heat in 1983, the same year he passed Walter Johnson's all-time strikeout record.
COURTESY HOUSTON CHRONICLE ARCHIVES

LEFT: Clyde Drexler was part of the University of Houston's Phi Slama Jama, the most entertaining high-wire act in college basketball in the early-1980s. COURTESY HOUSTON CHRONICLE ARCHIVES

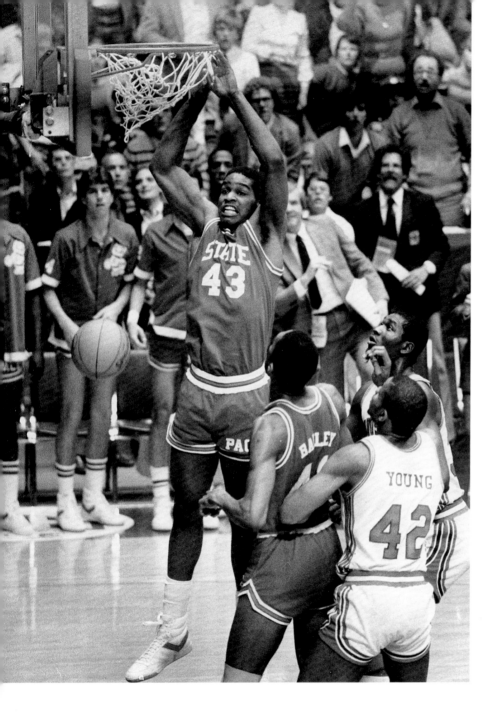

ABOVE: Robert Reid looks frustrated as the Rockets fall 20 points behind with less than a minute left in Game 3 of the 1980 Eastern Conference semifinals against the Boston Celtics. The Rockets would eventually be swept by the Celtics. Behind Reid, teammates, from left, Rick Barry, Billy Paultz, Calvin Murphy and Rudy Tomjanovich listen to coach Del Harris.
COURTESY HOUSTON CHRONICLE ARCHIVES

BELOW: Hakeem Olajuwon lies on the court, overcome with emotion, after a last-second dunk by North Carolina State's Lorenzo Charles ended Phi Slama Jama's plans for an NCAA title in 1983.
COURTESY HOUSTON CHRONICLE ARCHIVES

ABOVE: The 1982-83 Houston Cougars were the top team in SWC history, but they also were victims of the one of the NCAA's most memorable plays: Lorenzo Charles' dunk of a Dereck Whittenburg last-second air ball, before a stunned Hakeem Olajuwon and Michael Young, to give North Carolina State the NCAA title.
COURTESY HOUSTON CHRONICLE ARCHIVES

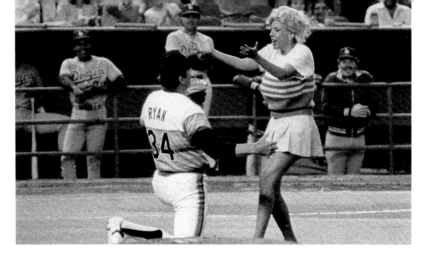

ABOVE: Astros pitcher Nolan Ryan goes to one knee to receive a kiss from Morganna Roberts, an exotic dancer known as baseball's kissing bandit, April 1985. Roberts was arrested for trespassing after her appearance and was released on $800 bond.
COURTESY HOUSTON CHRONICLE ARCHIVES

LEFT TOP: Hakeem Olajuwon helped lead the Rockets past the Los Angeles Lakers in Game 4 of the 1986 Western Conference finals. The Rockets would go on to win the series before losing to the Boston Celtics in the NBA Finals.
COURTESY HOUSTON CHRONICLE ARCHIVES

LEFT BOTTOM: Ralph Sampson's improbable, buzzer-beating shot that finished off the Lakers and sent the Rockets to the 1986 NBA Finals put him at the center of a frenzied celebration.
COURTESY HOUSTON CHRONICLE ARCHIVES

BELOW: Houston police surround a line of fans who had lined up early on the morning of May 25, 1986, to buy Rockets-Celtics playoff tickets. COURTESY HOUSTON CHRONICLE ARCHIVES

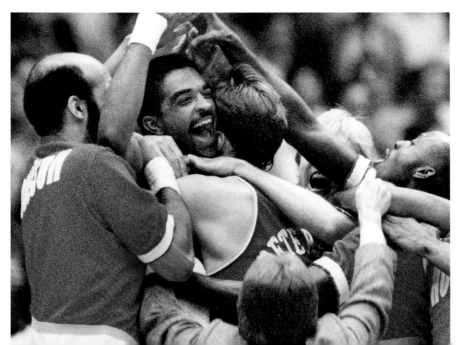

RIGHT: Pitcher Mike Scott can't contain his excitement as he puts away San Francisco Giants first baseman Will Clark to clinch the National League West title for the Astros, Sept. 25, 1986. Adding to the excitement that day was that Scott pitched a no-hitter to put the Astros in the playoffs. Though the team would eventually lose to the New York Mets in the NLCS, the game is widely considered one of the most memorable moments in Astrodome history.
COURTESY HOUSTON CHRONICLE ARCHIVES

BOTTOM LEFT: Steve Elkington helped lead the University of Houston's golf team to two NCAA championships in the 1980s. COURTESY HOUSTON CHRONICLE ARCHIVES

BOTTOM MIDDLE: Oilers receiver Ken Burrough (00) out-jumps Cleveland's Ron Bolton for quarterback Dan Pastorini's 44-yard bomb on Oct. 1, 1978.
COURTESY HOUSTON CHRONICLE ARCHIVES

BOTTOM RIGHT: University of Houston quarterback Andre Ware gets ready to fire his SWC-record seventh touchdown pass, Sept. 30, 1989, in the Cougars' 65-7 victory over Temple.
COURTESY HOUSTON CHRONICLE ARCHIVES

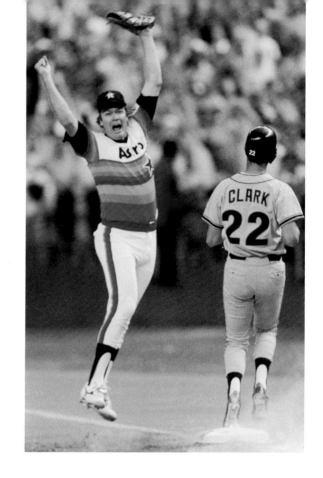

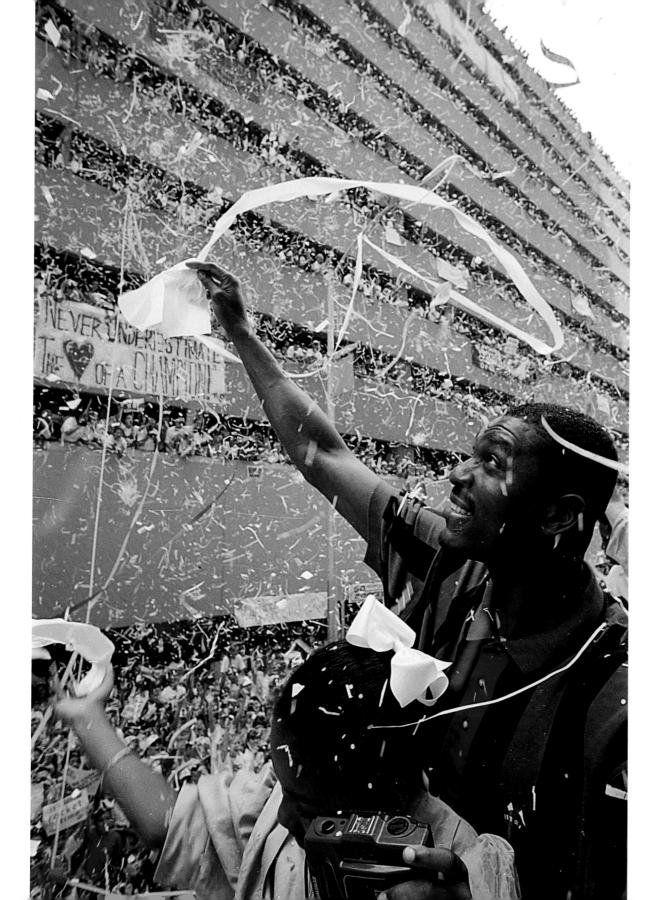

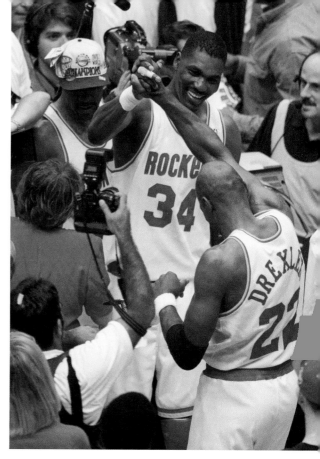

ABOVE: What better way to follow up the Rockets' first title than to repeat with a little help from your friend. On June 14, 1995, Hakeem Olajuwon did just that, celebrating the second of back-to-back NBA titles, this time with University of Houston pal Clyde Drexler. The Rockets had just completed a sweep of the Orlando Magic.
COURTESY HOUSTON CHRONICLE ARCHIVES

LEFT: Riding atop a fire truck, Hakeem Olajuwon and his daughter, Abisola, celebrate during a championship parade down Jefferson Street on June, 16, 1995, after the Rockets won their second-straight NBA title.
COURTESY HOUSTON CHRONICLE ARCHIVES

ABOVE: The Astrodome scoreboard lights up following an Astros win over the St. Louis Cardinals, 1988. The massive scoreboard originally included 1,200 miles of wire. COURTESY HOUSTON CHRONICLE ARCHIVES

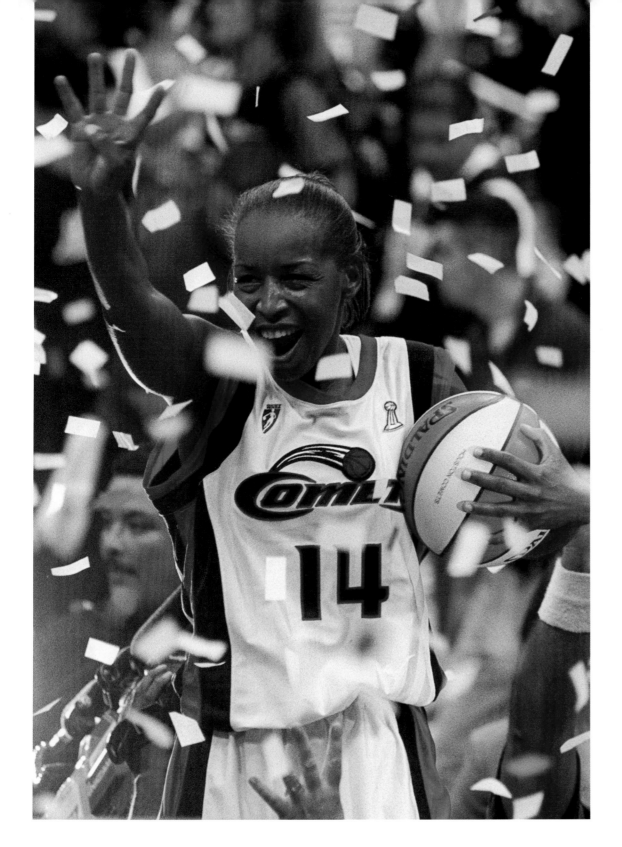

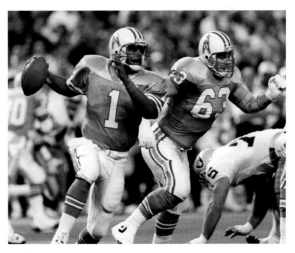

ABOVE: NFL Hall of Fame quarterback Warren Moon played for the Oilers from 1984 to 1993.
COURTESY HOUSTON CHRONICLE ARCHIVES

TOP: Before winning a national championship with the Texas Longhorns and joining the Tennessee Titans, quarterback Vince Young showed his talent on the football field while attending Madison High School.
COURTESY HOUSTON CHRONICLE ARCHIVES

LEFT : Cynthia Cooper celebrates the Comets' fourth consecutive WNBA championship after she and her teammates defeated the New York Liberty 79-73, Aug. 26, 2000. Cooper was named the championship's Most Valuable Player all four seasons.
COURTESY HOUSTON CHRONICLE ARCHIVES

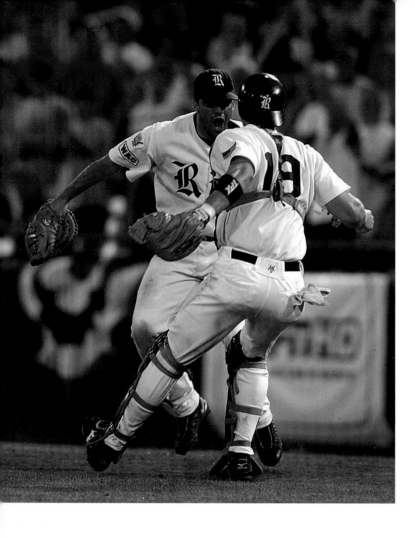

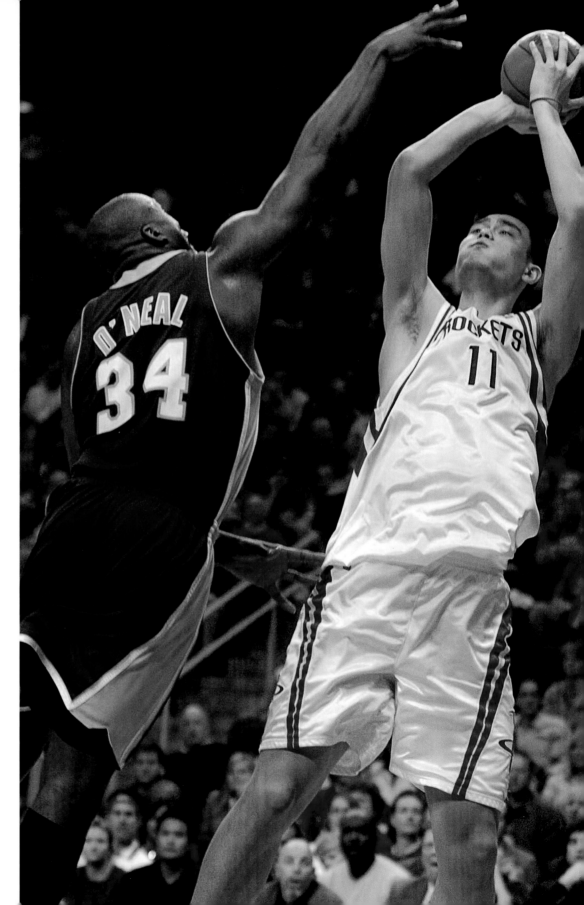

ABOVE: Rice University's Vincent Sinisi celebrates with Justin Ruchti after making the final out to win the 2003 College World Series. The Owls defeated Stanford 14-2 to win the title on June 23, 2003.
COURTESY HOUSTON CHRONICLE ARCHIVES

RIGHT: Rockets center Yao Ming, seen here in 2004, helped to expand the NBA's reach into Asia. Before retiring in 2011, Yao spent his entire NBA career with the Rockets. COURTESY HOUSTON CHRONICLE ARCHIVES

OPPOSITE: The Houston Astros celebrate at Busch Stadium after reaching the World Series for the first time in franchise history with a 5-1 win over the St. Louis Cardinals in Game 6 of the 2005 NLCS.
COURTESY HOUSTON CHRONICLE ARCHIVES

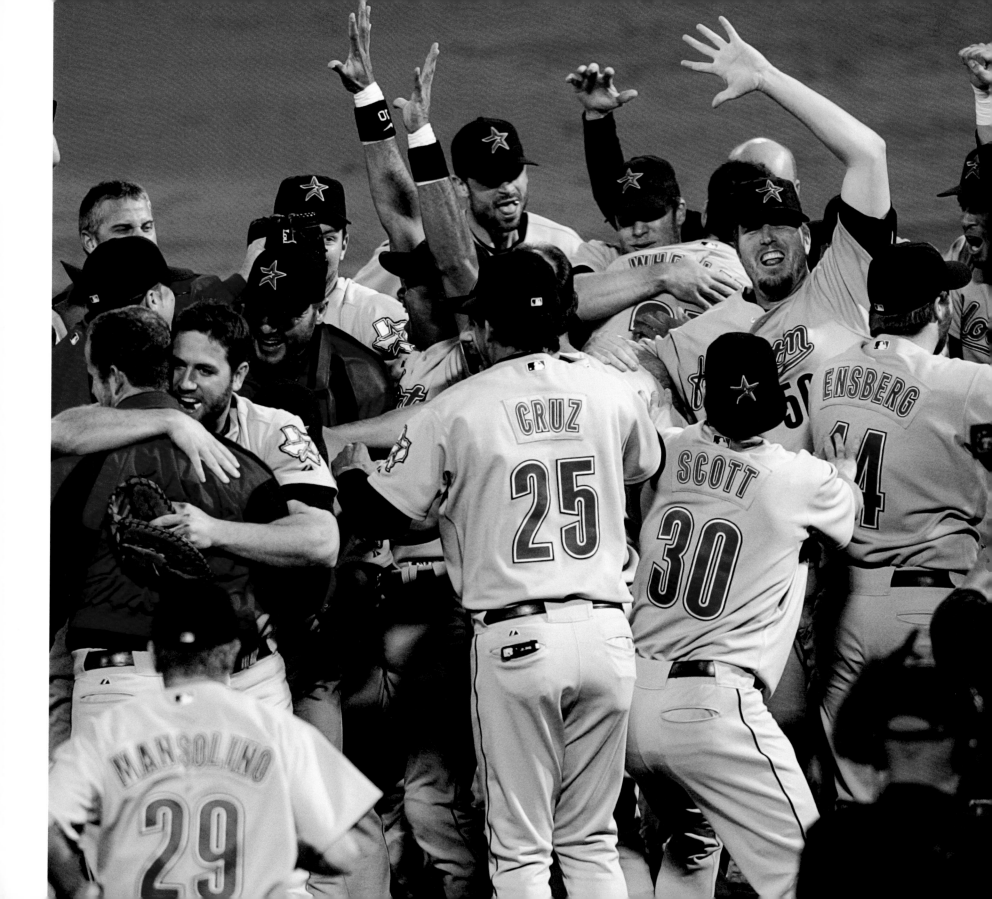

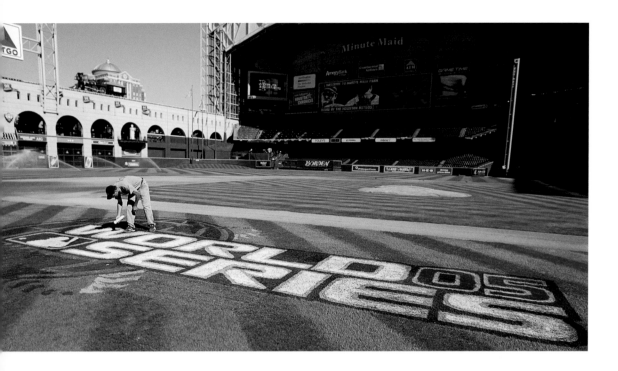

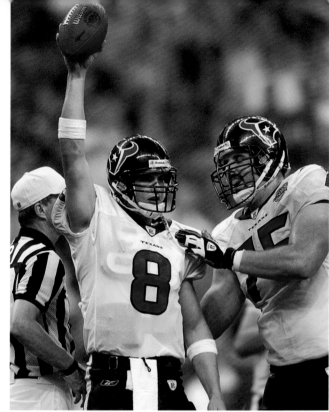

ABOVE: Groundskeepers put the finishing touches to the field at Minute Maid Park ahead of Game 3 of the 2005 World Series.
COURTESY HOUSTON CHRONICLE ARCHIVES

ABOVE RIGHT: David Carr, left, and Jimmy Herndon celebrate the Texans' 19-10 victory in their NFL regular-season debut against the Dallas Cowboys at Reliant Stadium, Sept. 8, 2002.
COURTESY HOUSTON CHRONICLE ARCHIVES

RIGHT: Craig Biggio celebrates his 3,000th career hit with former teammate Jeff Bagwell during the seventh inning as the Astros hosted the Colorado Rockies at Minute Maid Park, June 28, 2007.
COURTESY HOUSTON CHRONICLE ARCHIVES

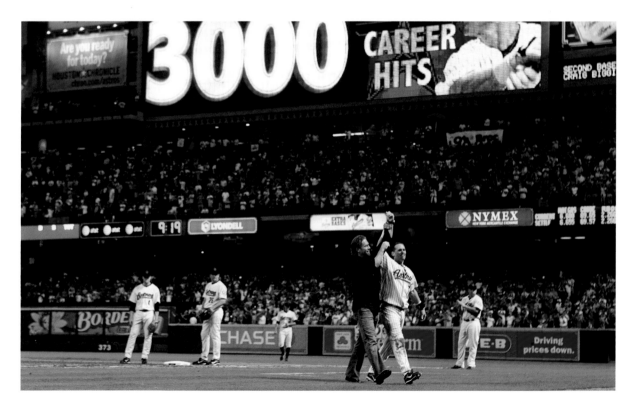

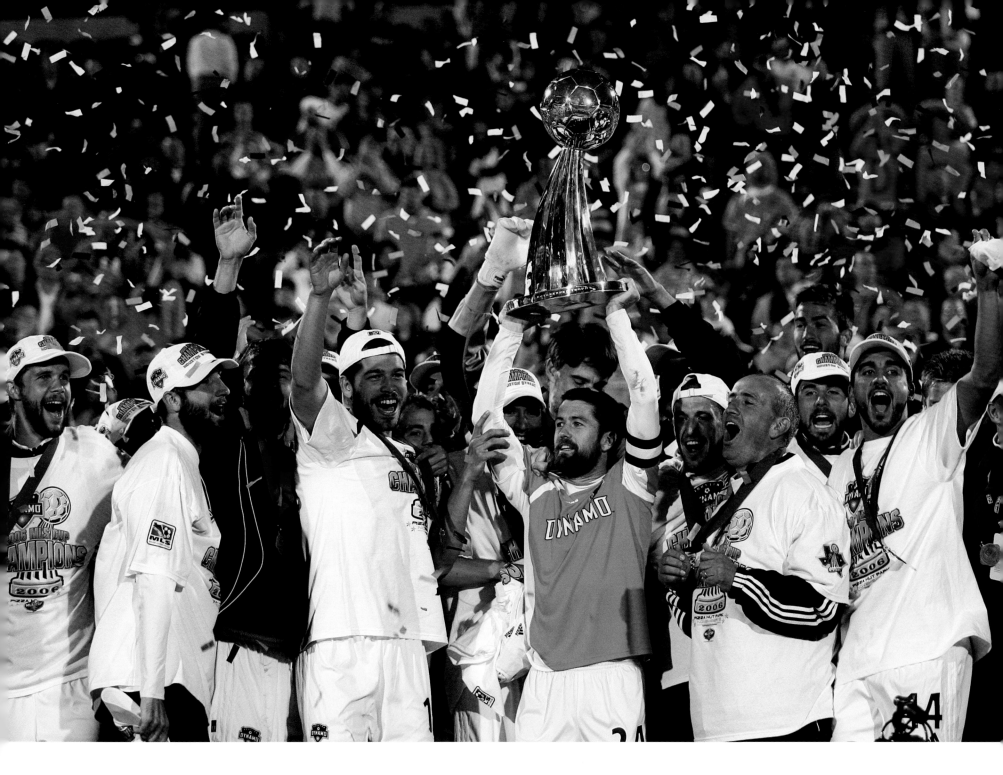

ABOVE: Dynamo captain Wade Barrett holds up the MLS Cup after the Dynamo defeated the New England Revolution for the MLS Cup in Frisco, on Nov. 12, 2006. Brian Ching scored the tying goal late in the second half of regulation to send the game into overtime. The Dynamo won 1-1 and 4-3 in penalty kicks. COURTESY HOUSTON CHRONICLE ARCHIVES

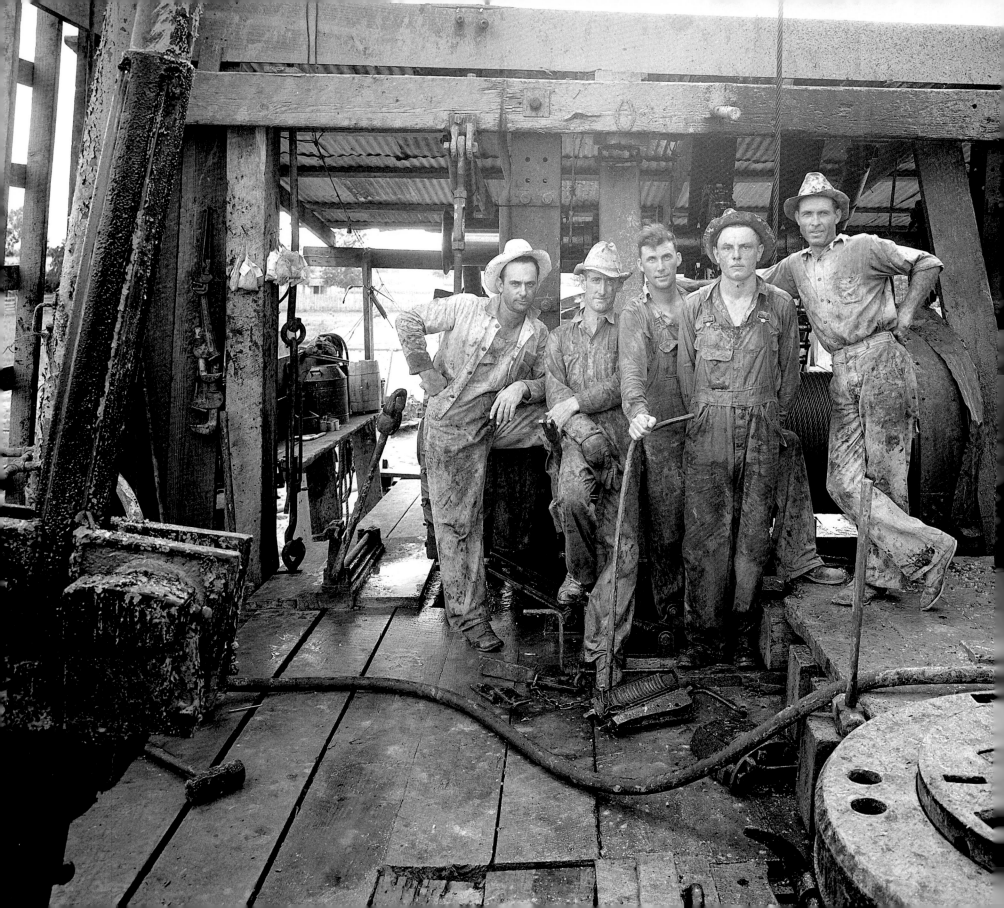

ENGERY

Chapter six

ENERGY

The gleaming towers and sprawling campuses of Houston's signature businesses have their origins in the dirt, mud and muck of thousands of oil wells that began to spread across the state in the first decades of the 20th century.

The famous 1901 gusher at Spindletop Hill, a salt dome near Beaumont, produced so many barrels per day that news of the discovery spread across the country. As industrialization took hold and highways filled up with cars, the demand for "black gold" intensified. Wildcatters and emerging oil companies turned Texas into the center of U.S. oil exploration, and the Houston area's access to Galveston Bay and the huge East Texas fields made it a natural place to build refineries. Fortunes were made, lost and made again, and the image of the self-made Texas oilman became a stock character among American stereotypes.

Many of the companies they founded would disappear, but a few would become industry giants, with their names living still on the sides of buildings and through their philanthropic foundations.

The industry transformed Texas from a rural place with plenty of cattle, cotton and small towns into something much more modern. Houston virtually exploded. The city claimed a population of 44,000 in 1900, just a bit more than Galveston. As oil grew in importance, Houston mushroomed to 292,000 residents by 1930. No longer was rice, lumber and cotton the lifeblood of city commerce. Oil was king. Every driller, large or small, needed equipment to do it. That translated into a new manufacturing industry. And they needed someplace to send the sticky black crude if they were lucky enough to find it. That meant the growth of refineries, pipelines and ultimately storage and loading facilities for transfer to ever-larger tanker ships.

Variations in the price of oil have long brought cycles of boom and bust to Houston, memorably in the 1980s when a price collapse torpedoed the economy and led to record bankruptcies and foreclosures. But as a new century dawned, the demand for hydrocarbons from developing countries meant that the days of cheap oil may be gone forever, and that suggests continued prominence for a city whose name is synonymous with energy.

LEFT: Roughnecks of Pierce Junction, the closest oil field to Houston, 1928.
COURTESY THE SLOANE COLLECTION

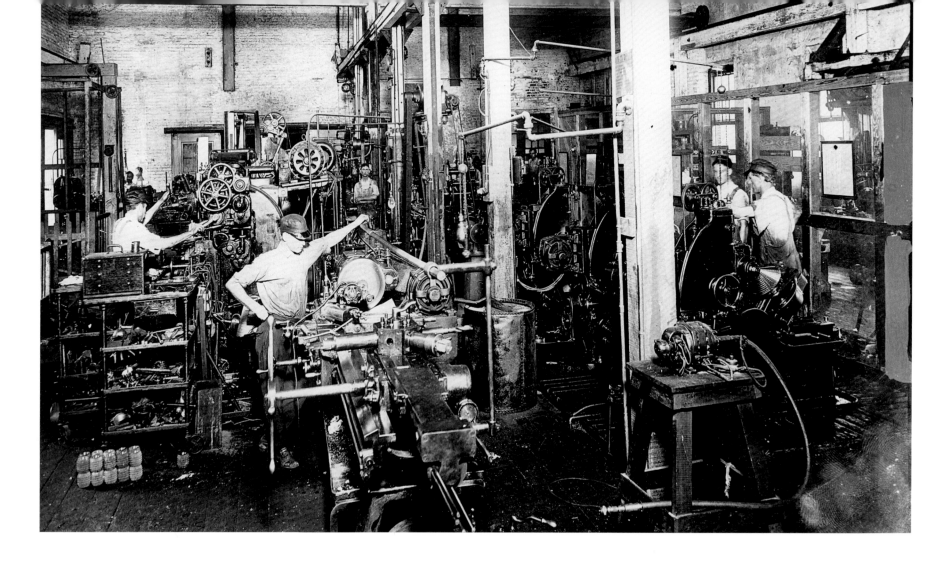

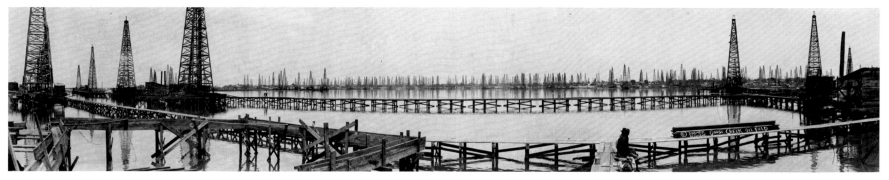

ABOVE: Goose Creek oil field, circa 1918. COURTESY FRANK CHAVEZ COLLECTION, COURTESY JEANETTE CHAVEZ BARTA

TOP: Hughes Tool Co. machine shop, circa 1909. COURTESY HOUSTON CHRONICLE ARCHIVES

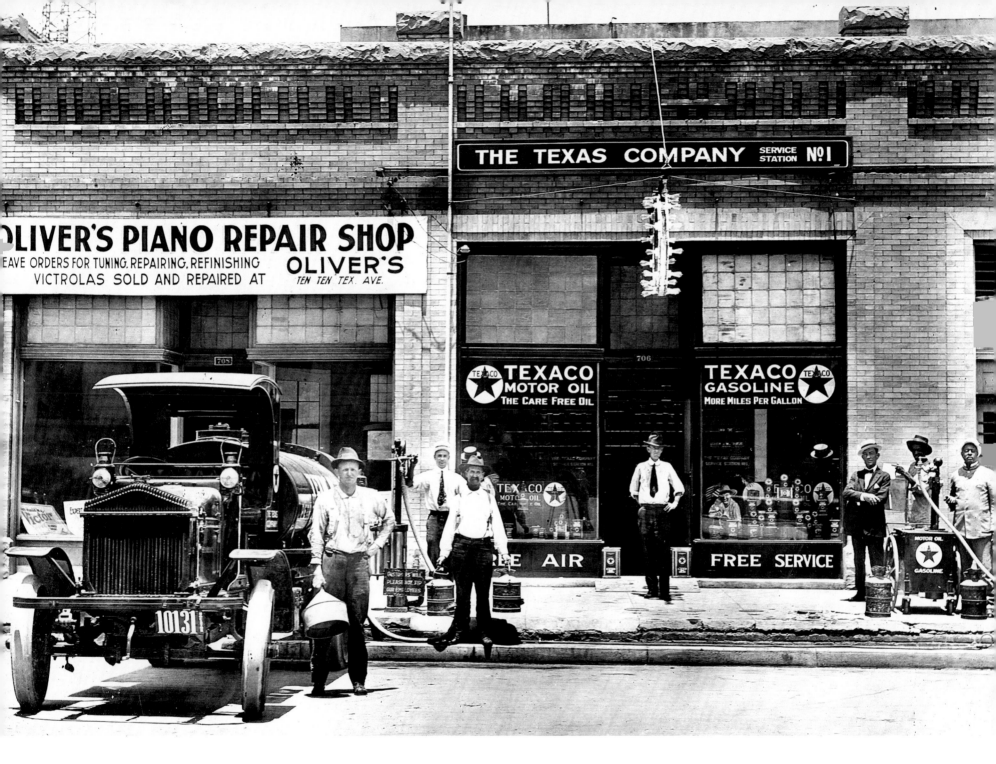

ABOVE: An early Texaco service station with pumps on the sidewalk. COURTESY HOUSTON PUBLIC LIBRARY, HOUSTON METROPOLITAN RESEARCH CENTER

ABOVE: With its refinery located along the Houston Ship Channel, Sinclair Oil Company helped usher in Houston's rise as a powerhouse in the petroleum industry. Here, steamships are docked at the company's refinery along the Port of Houston unloading crude oil from Mexico.

COURTESY HOUSTON PUBLIC LIBRARY,
HOUSTON METROPOLITAN RESEARCH CENTER

RIGHT: Hughes Tool Company, circa 1913. In 1909, Howard Hughes Sr. forever changed the drilling industry by improving the rotary drilling process. He soon teamed with Walter B. Sharp to form the Sharp-Hughes Tool Company. After Sharp and Hughes died, Howard Hughes Jr. assumed control of the company. Eventually, it merged with Baker International to form Baker Hughes.

COURTESY HOUSTON CHRONICLE ARCHIVES

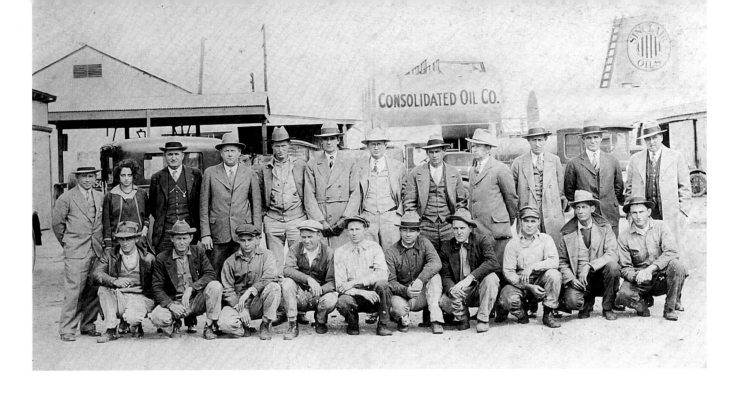

LEFT: Employees of Consolidated Oil Co., 1929.
COURTESY DIANA CLAUDER

BELOW: Eastman Oil Well Survey fleet, 1930s.
COURTESY THE
SLOANE COLLECTION

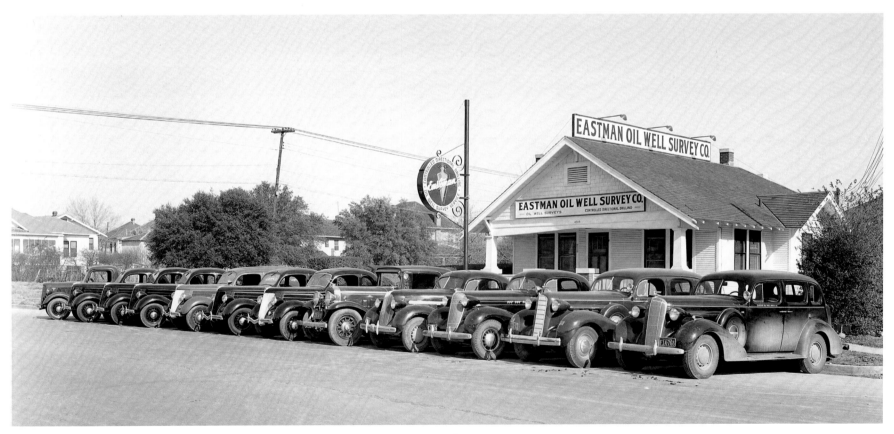

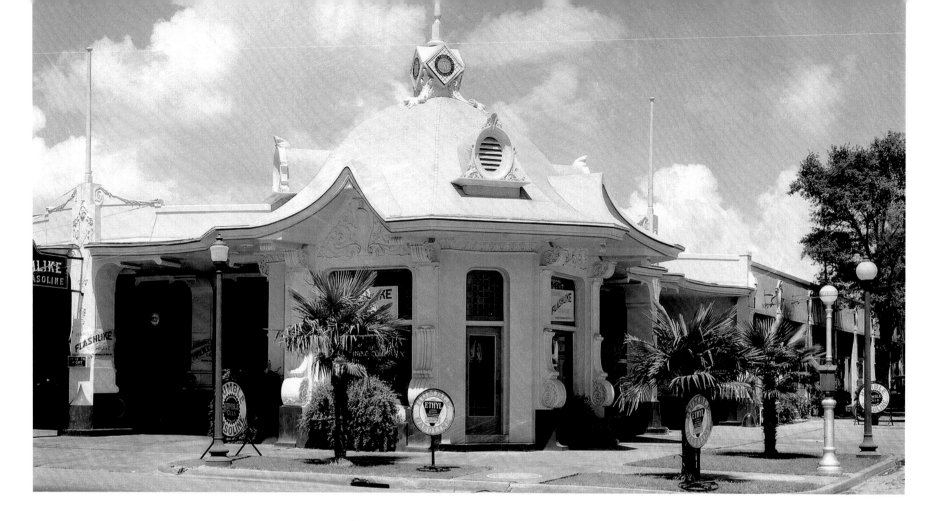

ABOVE: First Humble Oil service station, Main at Jefferson.

COURTESY THE SLOANE COLLECTION

RIGHT: Oilman and philanthropist Hugh Roy Cullen and his wife, Lillie Cranz Cullen, in the living room of their River Oaks home, March 1947. Known as the "king of the wildcatters," Cullen became a Texas legend not only from his oil, but his generosity toward higher education and medicine.

COURTESY HOUSTON CHRONICLE ARCHIVES

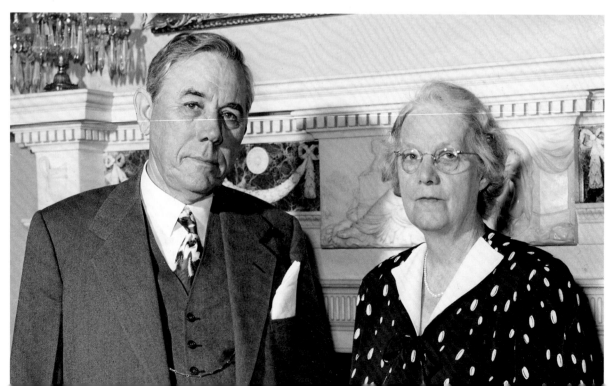

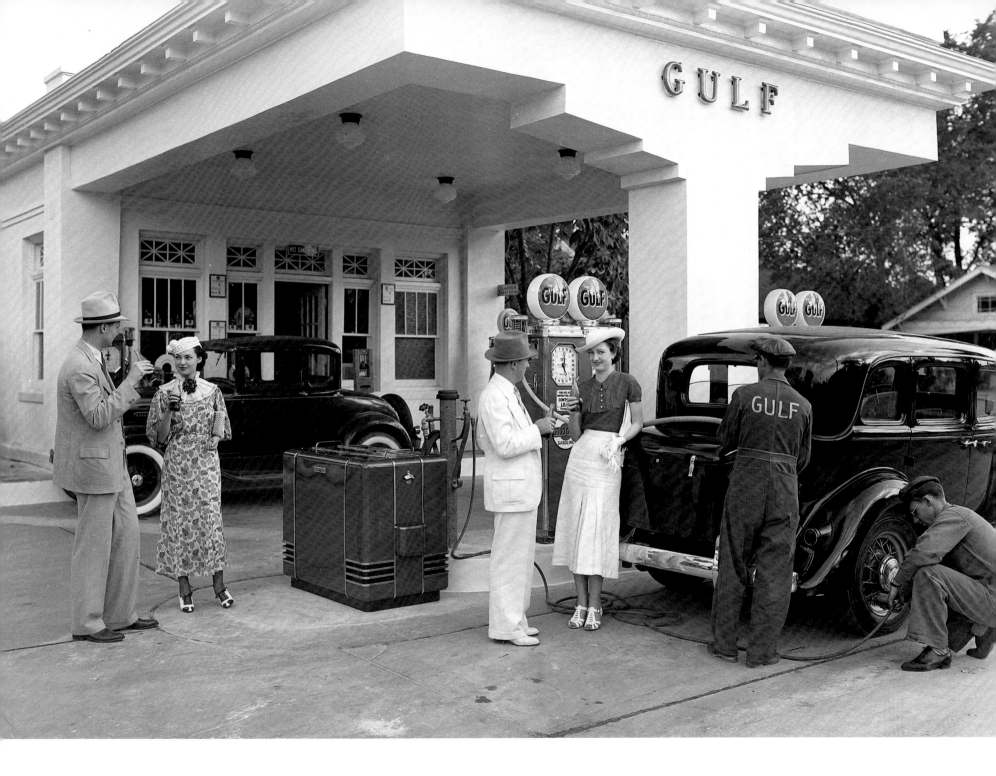

ABOVE: Gulf Station employees provide quality service as customers stretch their legs and enjoy a cold drink. COURTESY THE SLOANE COLLECTION

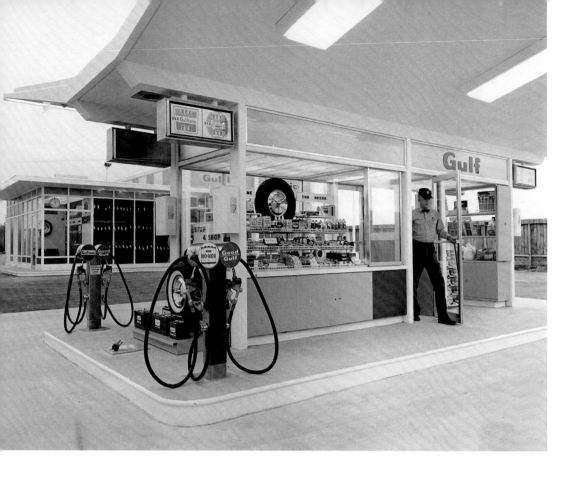

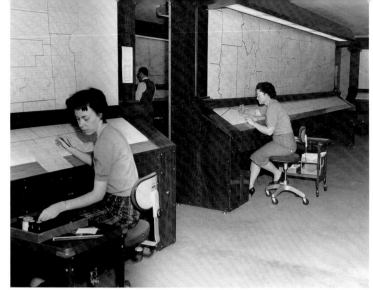

ABOVE: Gulf Oil Corp. unveils its new style of service station at Stella Link and Woodvalley in southwest Houston, March 1962.
COURTESY HOUSTON CHRONICLE ARCHIVES

RIGHT TOP: The production division of Gulf Oil Corp. map room, seen here in March 1960, is operated electronically to roll up or down so the operators can get to any section to find leasing and drilling information. The maps cover an area of nearly 1,500,000 square miles and drilling data is posted on about 52,000 wells. COURTESY HOUSTON CHRONICLE ARCHIVES

RIGHT BOTTOM: A drilling crew with T-L Drilling Company make a connection to add more drill pipe on a rig in the Mykawa field area of southeast Houston, October 1961. COURTESY HOUSTON CHRONICLE ARCHIVES

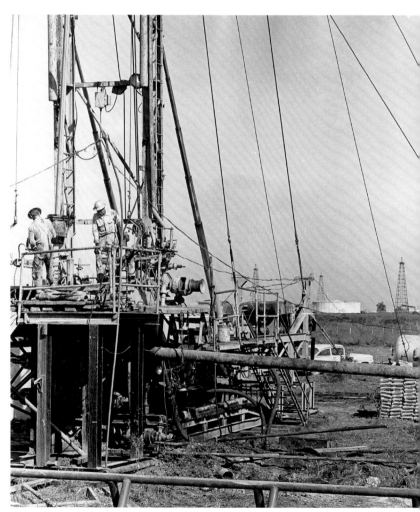

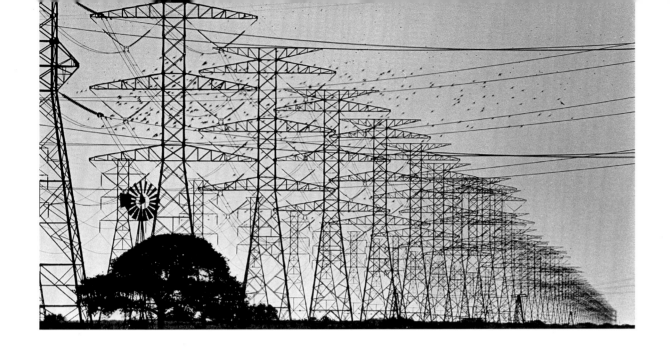

LEFT: Columns of power lines reach seemingly to infinity in their march across northwest Harris County, October 1974.
COURTESY HOUSTON CHRONICLE ARCHIVES

BELOW: Construction work is well under way on the cylindrical access ramp of the Exxon Chemical USA headquarters between Memorial Drive and Interstate 10, near Eldridge Road, September 1980.
COURTESY HOUSTON CHRONICLE ARCHIVES

LEFT: A group of officials from Texas Commerce Bank-Houston and Pennzoil monitor the electronic transfer of $3 billion from Texaco to Pennzoil, April 1988. The officials are Texas Commerce Bank-Houston President Merriman Morton, left; Pennzoil Director of Treasury Operations Linda Condit; Pennzoil Assistant Treasurer Dave Alderson; TCB-Houston Vice Presidents Bill Hurt and Lucy Waller; and TCB-Houston Operations Officer Marge Summers, seated. COURTESY HOUSTON CHRONICLE ARCHIVES

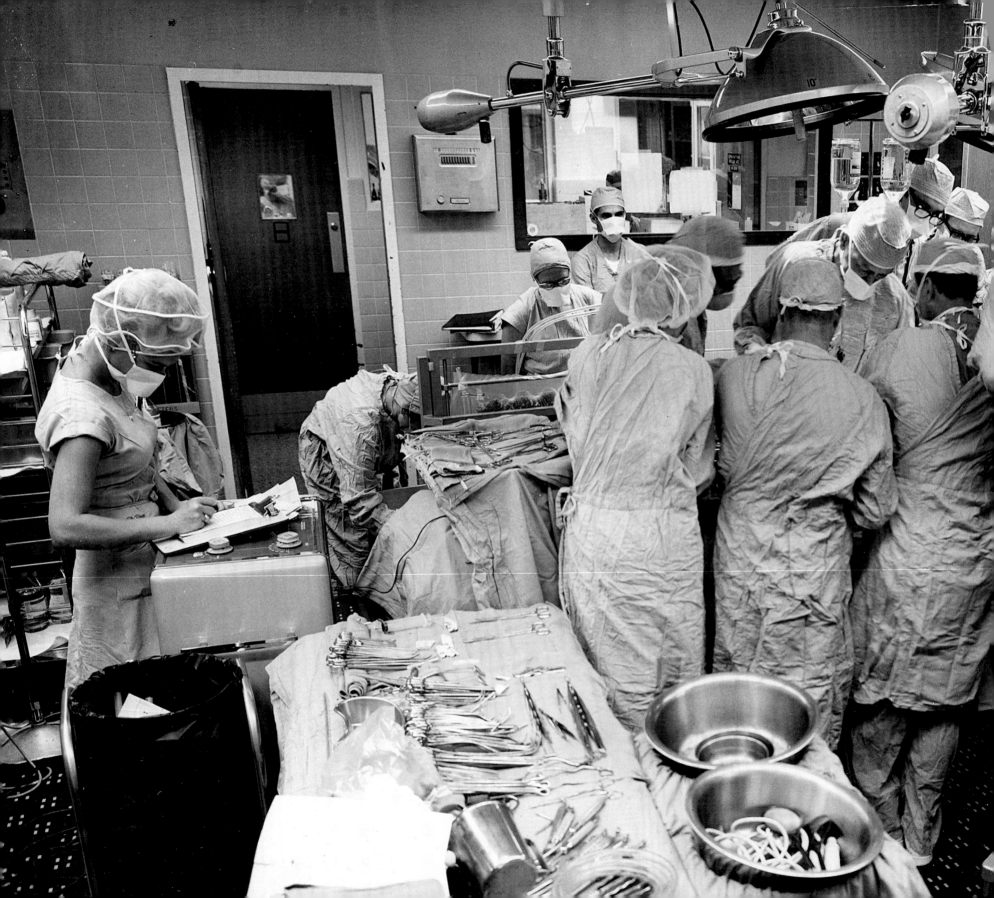

MEDICINE

Precisely how Houston became one of the world's leading medical hubs is one of those things that seems almost quirky in hindsight. The city did not have the intellectual infrastructure typically associated with medical research, and it had no hope of prying the state's leading medical school away from Galveston. What it did have was a wealthy cotton broker named Monroe Dunaway Anderson, who along with some friends decided that the growing metropolis needed more hospitals and research institutions to go along with Hermann Hospital south of downtown. In 1936, he established the M.D. Anderson Foundation with an endowment of $300,000. But the real money came when he died three years later and bequeathed it $19 million, making it — at the time — the largest charitable fund ever created in Texas.

From that the Texas Medical Center steadily grew, including the now-famous cancer hospital that bears Anderson's name and the Baylor College of Medicine, which moved here from Dallas. By 1954, the center boasted six hospitals and 11 institutions. Today, it is the world's largest concentration of medical institutions.

Although Houston boasts scores of hospitals large and small, it is the sprawling campus of 49 Medical Center institutions, all of them nonprofit, that has made the city's reputation as a leader in medical care, research and education. Two

pioneering heart surgeons, Michael DeBakey and Denton Cooley, helped spread the reputation of the city worldwide with their daring heart operations, beginning in the 1960s. But even though they claimed many of the headlines over the years, the talent across the board through the Medical Center's institutions has few rivals for breadth and depth. That talent draws patients from around the world. Some of the larger hospitals, including M.D. Anderson, have special offices and personnel to deal with international patients, who have included members of royal families, elected officials, dignitaries and tycoons of all stripes. More than 5,000 foreign students are there every year, and that doesn't include visiting scholars and researchers.

The Texas Medical Center's research spending is close to $2 billion annually, and it draws an estimated 6 million annual patient visits. The center's local economic impact in 2010 was estimated at a staggering $14 billion. It provided more than 93,000 jobs directly and supports another 120,000 indirectly. Every year seems to bring new expansion and more specialty clinics and research centers. With baby boomers entering retirement age and health care demands growing with the population, the future of the Medical Center — and Houston's place in the world of medicine — appears secure.

LEFT: Dr. Denton A. Cooley and his surgical team at St. Luke's Episcopal Hospital perform their 10th heart transplant operation, on Carl V. Bates of Amarillo, August 1968. Cooley is shown at center background directing the transplant. The 1-hour and 40-minute operation was the shortest of the 10 performed by the St. Luke's team. COURTESY HOUSTON CHRONICLE ARCHIVES

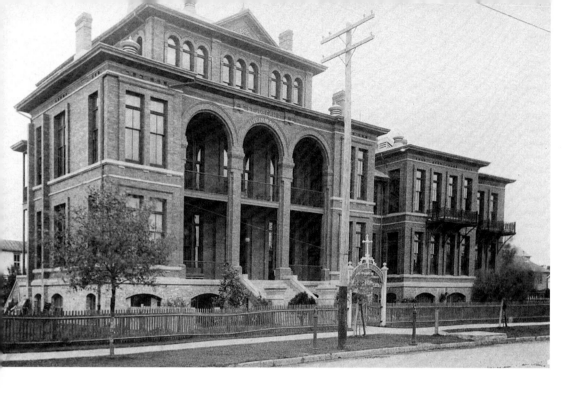

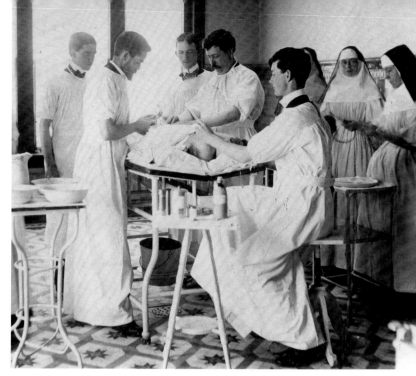

ABOVE: St. Joseph Infirmary, 1904. The hospital, located at 1910 Crawford and managed by the Sisters of Charity of the Incarnate Word, opened in 1887.
COURTESY UNIVERSITY OF HOUSTON

TOP RIGHT: St. Joseph Infirmary operating room, early 1900s.
COURTESY HOUSTON CHRONICLE ARCHIVES

RIGHT: Although Hermann Hospital stands alone in this 1920s photo, the next few decades would see other world-class medical facilities spring up around it as the Texas Medical Center took shape.
COURTESY HOUSTON CHRONICLE ARCHIVES

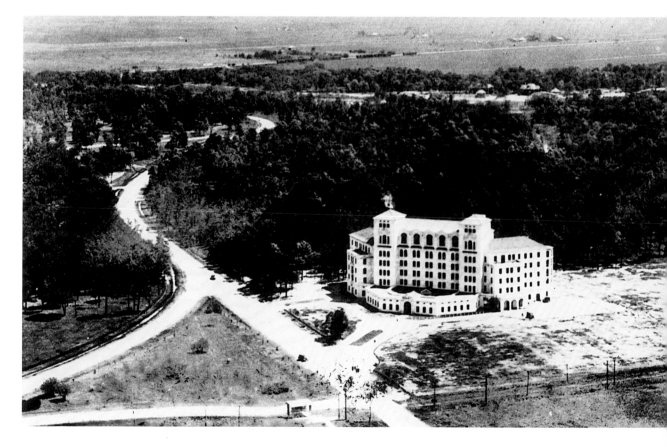

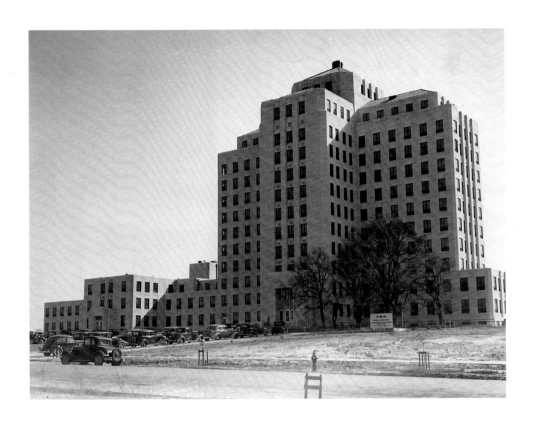

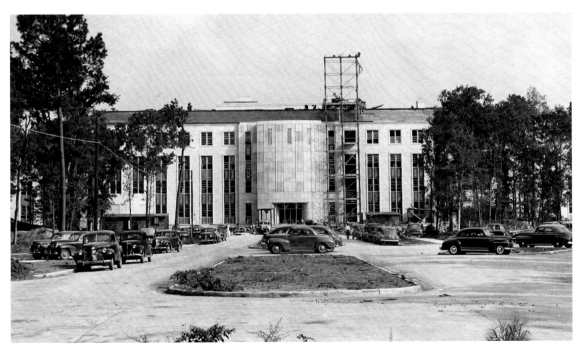

ABOVE: Before moving to the Texas Medical Center, the Methodist Hospital once sat at the corner of San Jacinto and Rosalie, as seen here in 1928.
COURTESY THE SLOANE COLLECTION

ABOVE LEFT: This Jefferson Davis Hospital was constructed on the south bank of Buffalo Bayou on Allen Parkway and completed in 1938. The hospital replaced the older Jefferson Davis Hospital on Elder Street.
COURTESY HOUSTON CHRONICLE ARCHIVES

LEFT: Baylor University College of Medicine building nears completion in 1947. The building, known as the Roy and Lillie Cullen Building, was the first to be completed in the Texas Medical Center.
COURTESY HOUSTON CHRONICLE ARCHIVES

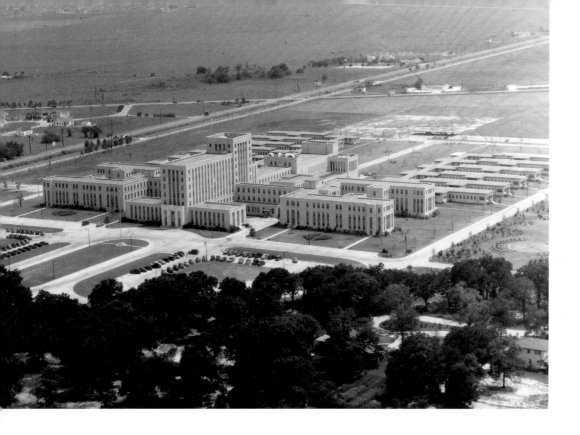

ABOVE: Veterans Administration Hospital, 1948. The site, located along Holcombe near Almeda, was purchased from the Hermann Estate by more than 300 Houston residents and donated to the federal government. On June 1, 1945, President Harry Truman designated the hospital as a permanent naval hospital and by 1949 the facility was transferred to the Veterans Administration and renamed the United States Veterans Administration Hospital.
COURTESY HOUSTON CHRONICLE ARCHIVES

ABOVE RIGHT: Houston Negro Hospital (now Riverside General Hospital), 2900 Elgin, February 1949.
COURTESY THE SLOANE COLLECTION

RIGHT: In 1951, the 300-bed Methodist Hospital became the second major facility to open in the Texas Medical Center. Over the years, the institution has been listed as one of the top hospitals in the nation.
COURTESY HOUSTON CHRONICLE ARCHIVES

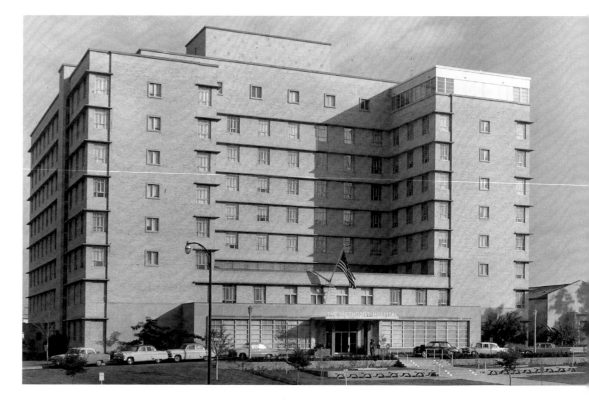

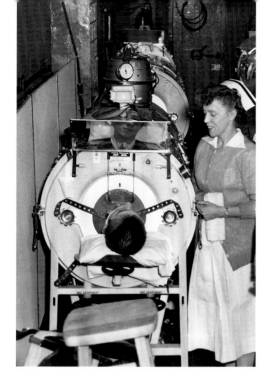

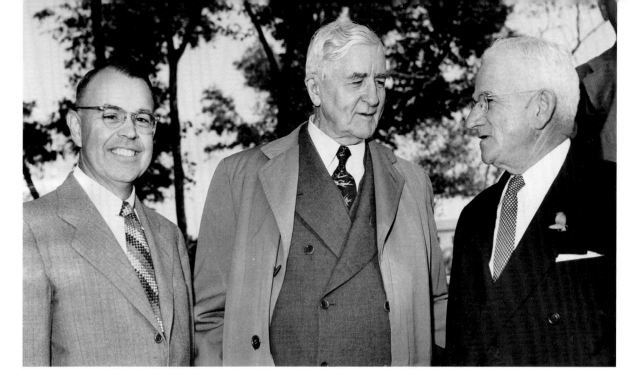

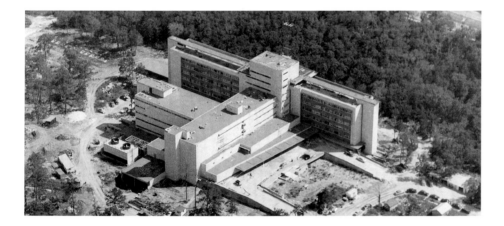

ABOVE: Three prominent Houstonians take part in groundbreaking ceremonies for the Houston Academy of Medicine–Texas Medical Center library, Oct. 15, 1952. From left are Leland Anderson, acting president of the Medical Center, Jesse H. Jones and Dr. M.D. Leavy, president of the academy. Jones and his wife donated $600,000, more than half the cost toward construction of the four-story building.

LEFT TOP: A Kentucky youth receives treatment via an iron lung at a Houston hospital, November 1953.

LEFT MIDDLE: M.D. Anderson Hospital for Cancer Research, October 1952. The hospital, a branch of the University of Texas, has grown to become one of the world's top institutions dedicated to treating and eradicating cancer.

LEFT BOTTOM: Southern Pacific Hospital, pictured here in 1949, was established in 1910 to benefit railroad company employees. Today, the facility, located at 2015 Thomas, operates under the Harris County Hospital District as the Thomas Street Health Center, an HIV/AIDS treatment facility.

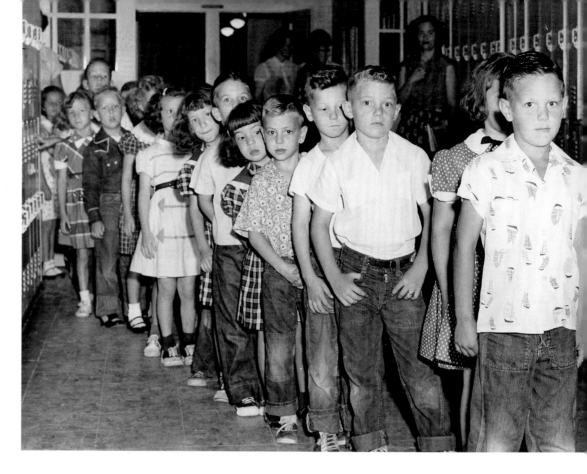

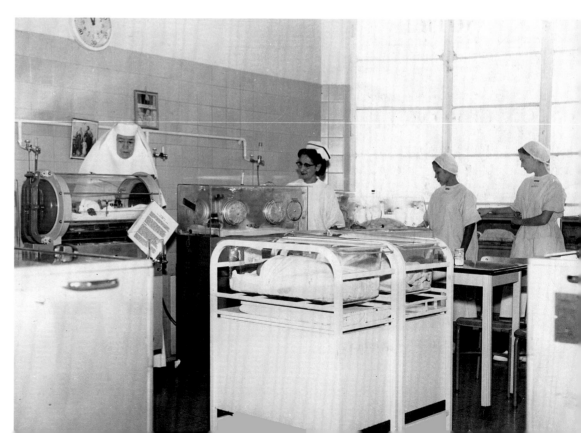

ABOVE: Dr. Katharine Hsu checks on a young patient at Jefferson Davis Hospital, July 28, 1953. A native of China, Hsu earned her medical degree there before coming to America in 1948. In Houston, Hsu established a one-room, one-nurse pediatric TB facility that later underwent expansion, and taught pediatrics at Baylor College of Medicine for four decades. COURTESY HOUSTON CHRONICLE ARCHIVES

TOP RIGHT: The first Houston-area school-children await polio vaccination injections at Henry L. Hohl Elementary School, April 1955. COURTESY HOUSTON CHRONICLE ARCHIVES

BOTTOM RIGHT: Sister May Clementine, left, walks among the air-locks and incubators which serve as cribs for premature babies at St. Joseph Hospital, August 1957. COURTESY HOUSTON CHRONICLE ARCHIVES

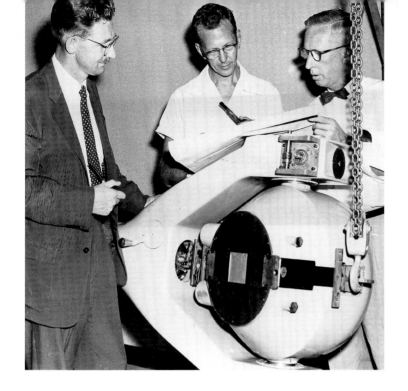

LEFT: A second cobalt-60 cancer-combating machine nears installation at the M.D. Anderson Hospital and Tumor Institute in the Texas Medical Center, 1958. Working on the project are, left to right, Warren Sinclair, a staff physicist; George Dittman, manager of the General X-ray division and, G.E. McCullum, representing the Atomic Energy Commission of Canada, which supplied the radioactive cobalt to be used in the apparatus. COURTESY HOUSTON CHRONICLE ARCHIVES

BOTTOM LEFT: This May 1957 view shows the entire Texas Medical Center complex, which includes seven hospitals, a medical and dental college, a medical library and office buildings for doctors. COURTESY HOUSTON CHRONICLE ARCHIVES

BOTTOM RIGHT: This specialized bed at St. Elizabeth's Hospital helps critically ill patients who cannot be turned over to make the bed. Demonstrating the new equipment is registered nurse Florence Stewart. This is part of the new equipment in the Catholic hospital's new $1.2 million wing, which opened in 1959. COURTESY HOUSTON CHRONICLE ARCHIVES

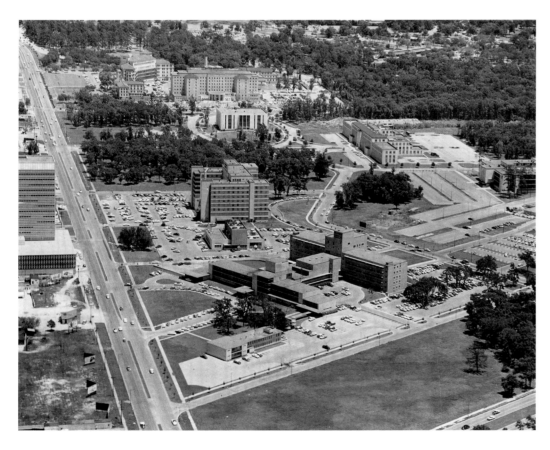

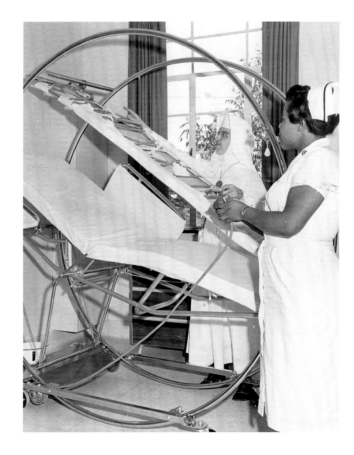

BELOW: A nurse adds a few drops of a polio vaccine to sugar cubes, 1962. COURTESY HOUSTON CHRONICLE ARCHIVES

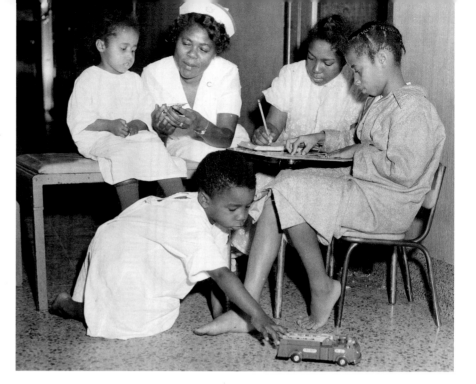

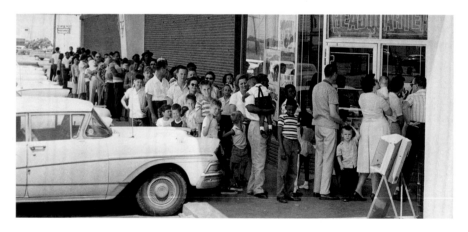

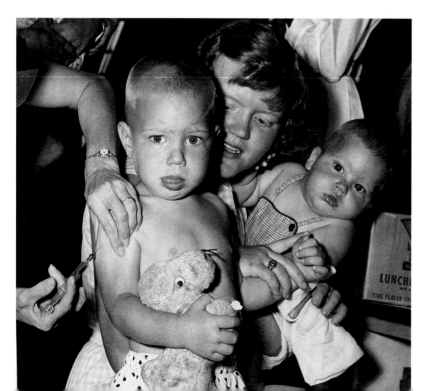

ABOVE: Houston residents wait for their free polio vaccine shots at a Minimax Store, May 1961. The special clinic was sponsored by the city health department and was manned by volunteers who gave out 50,000 inoculations in one week. COURTESY HOUSTON CHRONICLE ARCHIVES

TOP Young patients at Houston's St. Elizabeth's Hospital in the Fifth Ward, March 1959. COURTESY HOUSTON CHRONICLE ARCHIVES

LEFT: Casey Carl Vaughn holds his stuffed animal and his breath as he gets an injection of the Salk vaccine aimed to protect him from polio, May 1961. COURTESY HOUSTON CHRONICLE ARCHIVES

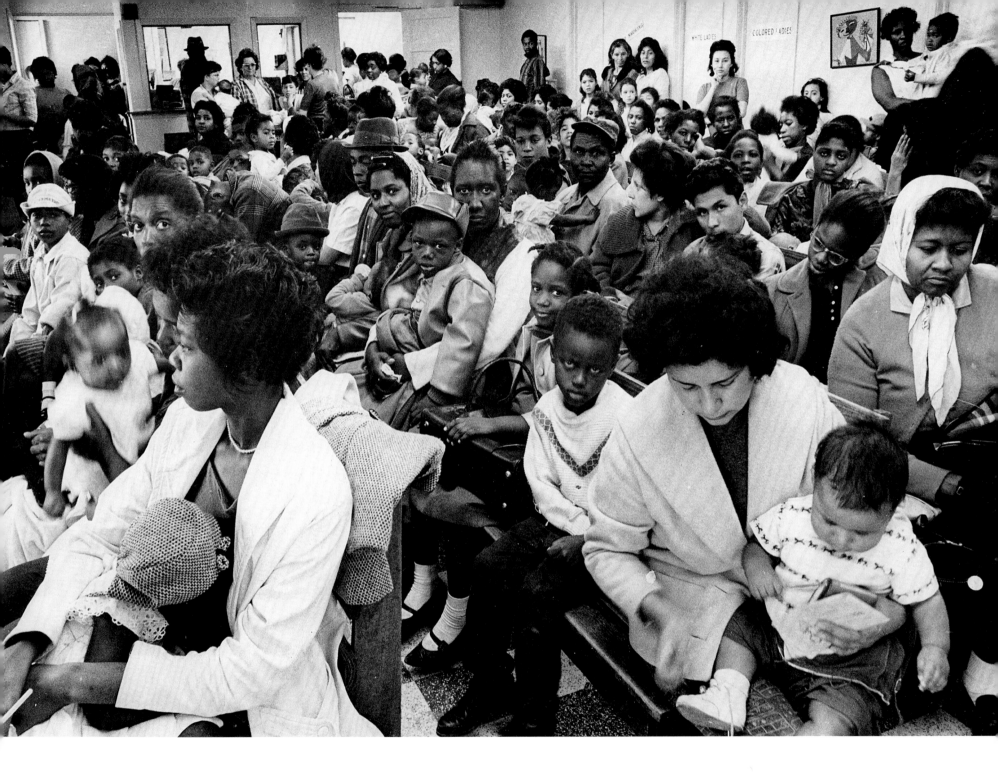

ABOVE: Children suffering from flu-like conditions swamp the pediatric clinic at Jefferson Davis Hospital, February 1963.
COURTESY HOUSTON CHRONICLE ARCHIVES

RIGHT: Dr. W.F. Blankenship and nurse Ann Harwitt of Ben Taub General Hospital make preparations before the facility gets busy with New Year's Eve mayhem, Dec. 31, 1964.
COURTESY HOUSTON CHRONICLE ARCHIVES

BOTTOM LEFT: Jorge Benzaquen, Peru's consul-general in Houston, presents the Order of the Sun award to Dr. Michael DeBakey while Dr. Denton A. Cooley waits to receive the honor, considered Peru's highest for civilians, December 1967.
COURTESY HOUSTON CHRONICLE ARCHIVES

BOTTOM RIGHT: Astros players drop by M.D. Anderson Hospital in May 1969. From left are Joe Morgan, Jim Wynn and John Edwards.
COURTESY HOUSTON CHRONICLE ARCHIVES

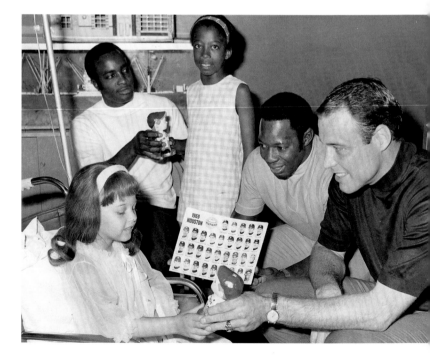

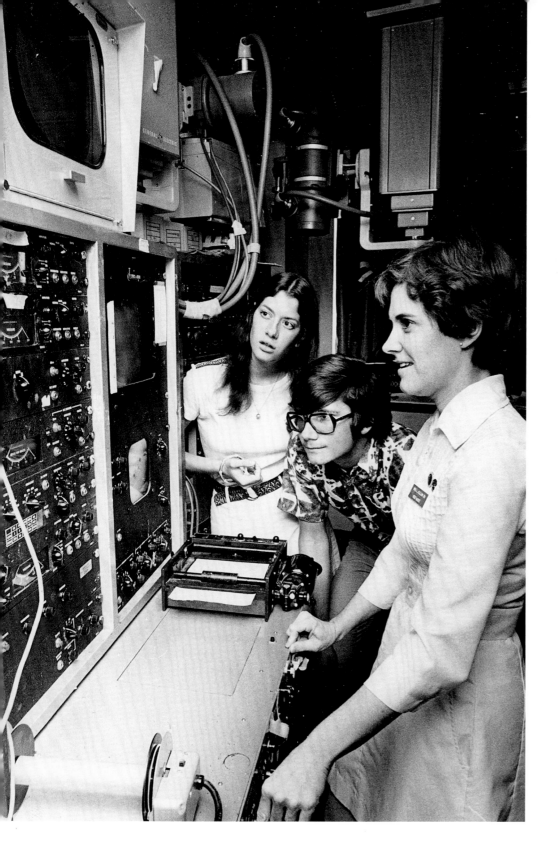

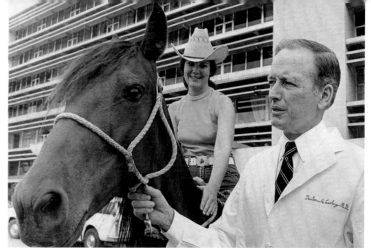

ABOVE: Dr. Denton A. Cooley shows off a Tennessee Walking Horse, his fee for open heart surgery on a 23-month-old in May 1969. Dr. Robert Westbrook, the family physician and a friend of Cooley, donated the mare when the family learned the procedure was not covered by insurance. Atop the horse is Sharon Rau, a registered nurse at St. Luke's Episcopal Hospital. COURTESY HOUSTON CHRONICLE ARCHIVES

LEFT: Linda Joullian, right, a nurse at Ben Taub General Hospital, demonstrates cardiovascular laboratory equipment to Westbury High School sophomores Susan Bullock and Bill Legler during Heart Career Day, April 1975. COURTESY HOUSTON CHRONICLE ARCHIVES

BELOW: Work progresses on the St. Luke's Episcopal Hospital and Texas Children's Hospital complex in the Texas Medical Center, September 1969. COURTESY HOUSTON CHRONICLE ARCHIVES

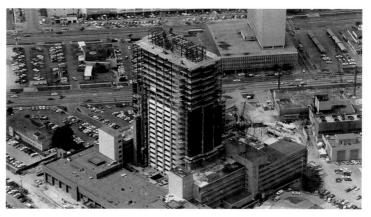

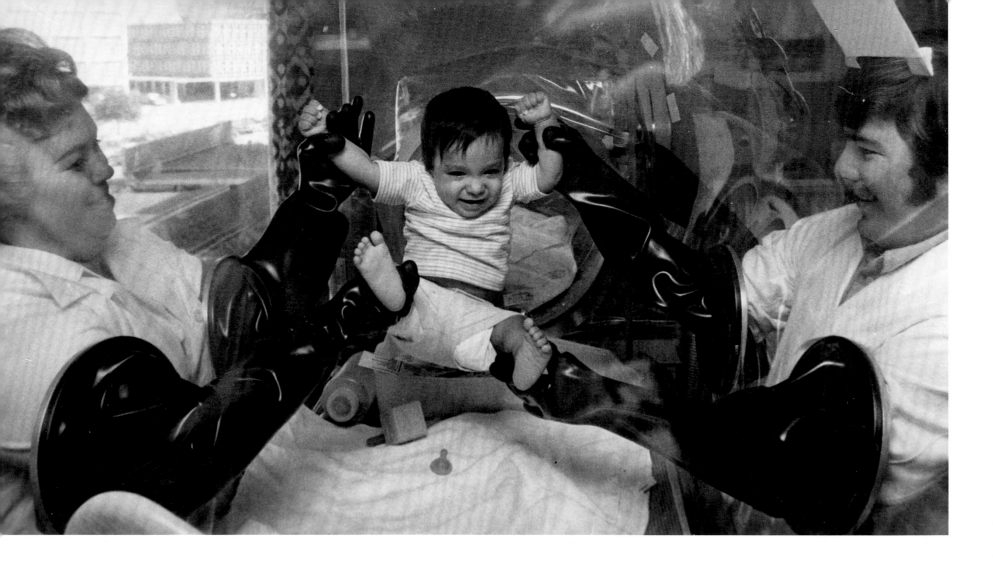

ABOVE: David Phillip Vetter, October 1972. Born with severe combined immunodeficiency, much of David's world was spent inside an isolator bubble at Texas Children's Hospital. His story captured the media's attention and was even the basis for an ABC-TV movie. Sadly, David died from lymphoma in 1984 following a bone marrow transfusion from his sister.
COURTESY HOUSTON CHRONICLE ARCHIVES

RIGHT: Connie Wharton and Jean Davis take care of newborns during an overflow of births at Jefferson Davis Hospital, July 1970.
COURTESY HOUSTON CHRONICLE ARCHIVES

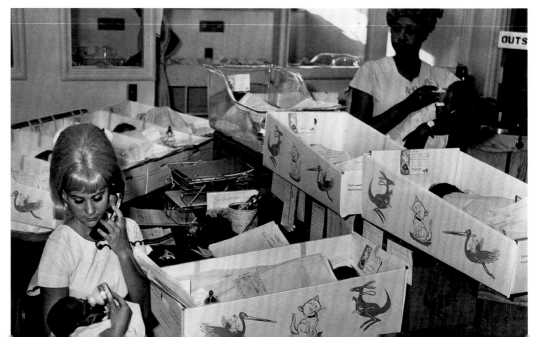

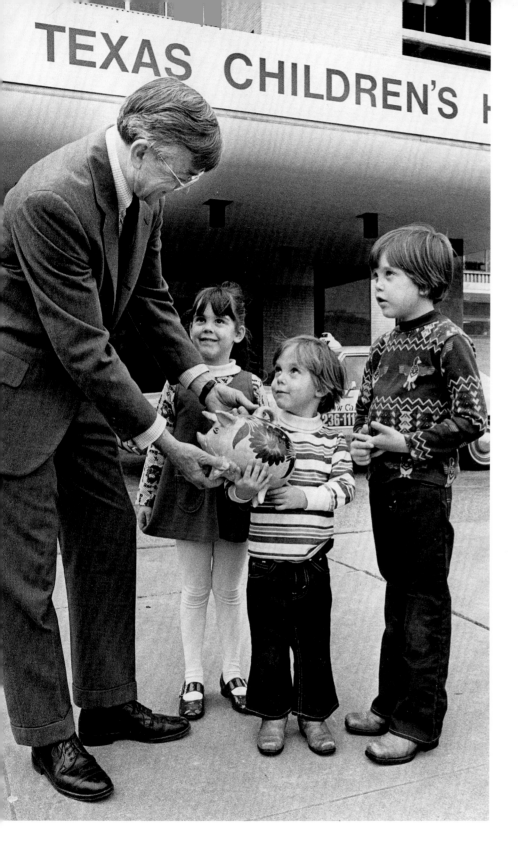

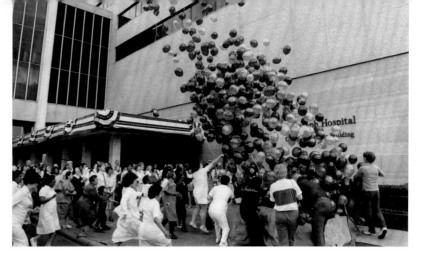

ABOVE: St. Joseph Hospital staff members release 1,000 balloons to kick off celebrations for the hospital's 100th anniversary on June 5, 1986. COURTESY HOUSTON CHRONICLE ARCHIVES

LEFT: Kathy Matthys, second from left, and her brothers, Danny and Kenny, give their piggy bank savings of about $10 to Dr. Dan McNamara at Texas Children's Hospital, December 1976. The money will go to the Danny Matthys Research Fund, which the children's parents founded as a way of helping other children who, like Danny, have inoperable heart defects. COURTESY HOUSTON CHRONICLE ARCHIVES

BELOW: Aerial view of Texas Medical Center taken from the Goodyear Blimp, 1980. COURTESY HOUSTON CHRONICLE ARCHIVES

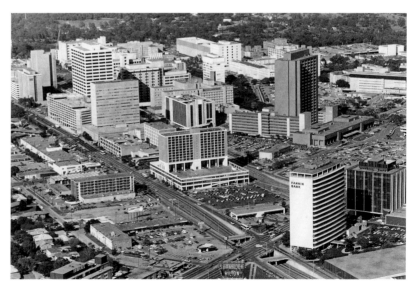

RIGHT TOP: Lyndon B. Johnson Hospital at 5656 Kelley opened on June 2, 1989.
COURTESY HOUSTON CHRONICLE ARCHIVES

RIGHT BOTTOM: Construction continues on the new VA Hospital, March 1990. In 1983, Congress approved the construction of a new $246 million facility to replace the aging VA hospital. The new facility would be named after medical pioneer Dr. Michael DeBakey, who played a crucial role in shaping the hospital's role in the medical community.
COURTESY HOUSTON CHRONICLE ARCHIVES

BELOW: Founded in 1923, the Blue Bird Circle is the oldest women's charitable organization in Houston. The money raised by the organization supports the Blue Bird Circle Clinic for Pediatric Neurology at Texas Children's Hospital, the Blue Bird Circle Developmental Neurogenetics Laboratory and the Blue Bird Circle Rett Center. COURTESY THE BLUE BIRD CIRCLE

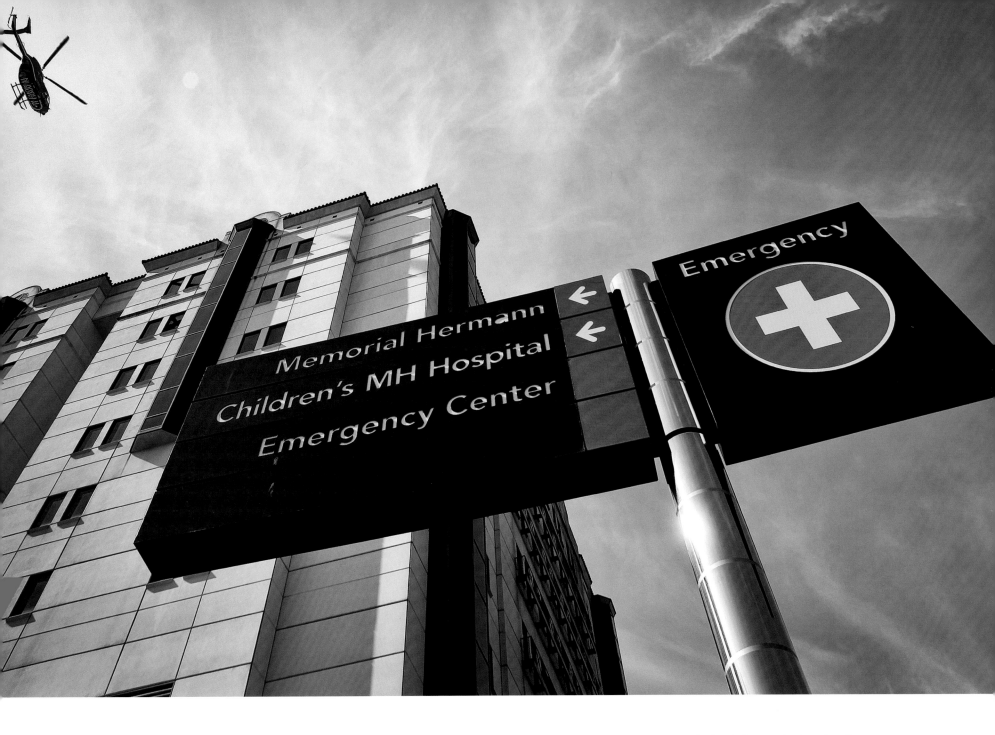

ABOVE: A helicopter carrying U.S. Rep. Gabrielle Giffords flies over Memorial Herman Hospital in the Texas Medical Center before landing on a helipad Jan. 21, 2011. Giffords would later be transferred to TIRR Memorial Hermann as she continued her recovery from a Jan. 8 shooting in Tucson, Ariz. COURTESY HOUSTON CHRONICLE ARCHIVES

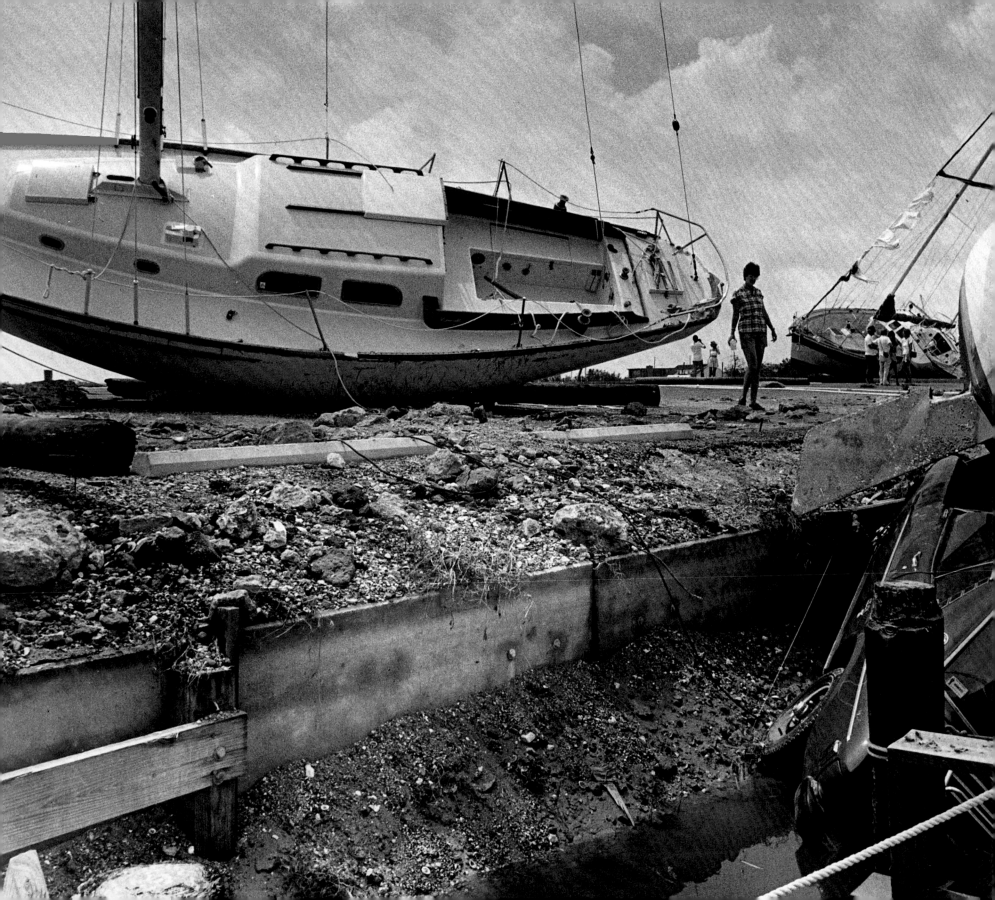

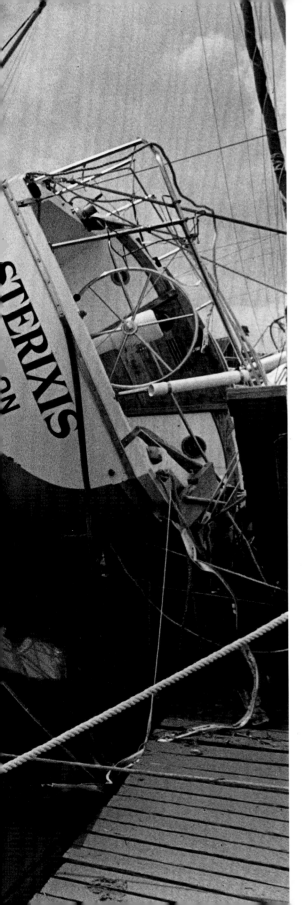

Chapter eight

WEATHER

Houston has two seasons — summer and not summer. The former is typically hot and humid, a relentless procession of wet-sauna days that begins in the spring and ends for good only with the return of October's cool breezes. As for the other season, well, that can mean just about anything — from a balmy fall day in the 70s to a pipe-freezing cold following an Arctic front.

Houston's weather has a dark side, too. Hurricanes and tropical storms are a perennial threat. In 2008, Hurricane Ike made landfall near Galveston and then slammed Houston. By the time it petered out in Canada, it had become the second-costliest storm ever to hit the United States. Ike was just the latest in a string of devastating hurricanes that includes Alicia, Audrey, Carla, Rita — and of course the unnamed monster of 1900 that flattened Galveston and claimed 8,000 lives.

One of the city's most destructive storms, however, was tame by comparison. In 2001, Tropical Storm Allison passed over the city, moved northeast, stalled and then doubled back, ultimately returning to drop more than 30 inches of rain in some areas and inundating Houston as never before. The city's flat topography meant that its bayous were quickly overwhelmed. Flooding from the storm destroyed more than 2,500 homes here and caused more than $5 billion in property damage in Texas. Allison was one more reminder that life in Houston sometimes means coping with extremes.

LEFT: Sailboats lie aground on Aug. 22, 1983, after Hurricane Alicia blew through the Houston Yacht Club on Galveston Bay in Shoreacres. COURTESY HOUSTON CHRONICLE ARCHIVES

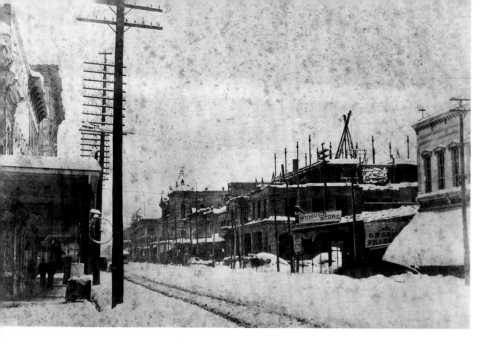

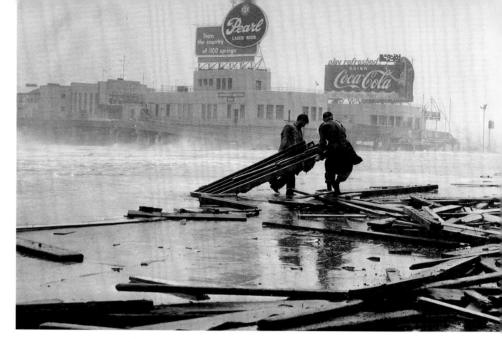

ABOVE: The most snow ever recorded in Houston – about 20 inches – fell on Valentine's Day 1895. Here, snow accumulates on Main Street looking north from Texas Avenue.
COURTESY HOUSTON CHRONICLE ARCHIVES

BELOW: Devastating floods in 1929 and 1935 spurred the creation of Addicks and Barker reservoirs to prevent the downtown flooding seen here.
COURTESY HOUSTON PUBLIC LIBRARY,
HOUSTON METROPOLITAN RESEARCH CENTER

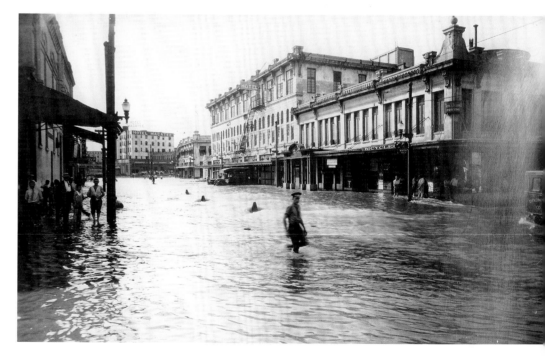

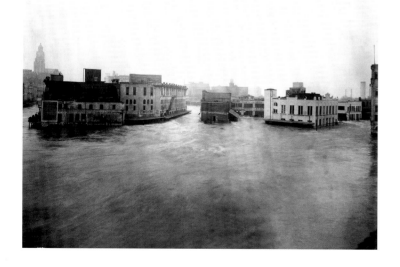

ABOVE: Floodwaters sweep through Milam at Franklin on May 31, 1929.
COURTESY HOUSTON PUBLIC LIBRARY, HOUSTON METROPOLITAN RESEARCH CENTER

TOP RIGHT: Debris washes up along the Galveston seawall as Hurricane Carla makes landfall, Sept. 11, 1961. COURTESY HOUSTON CHRONICLE ARCHIVES

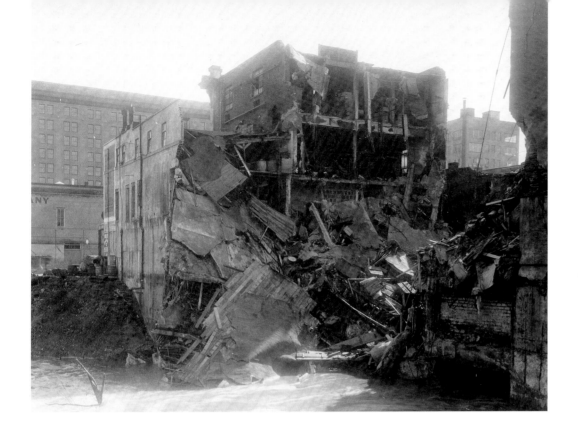

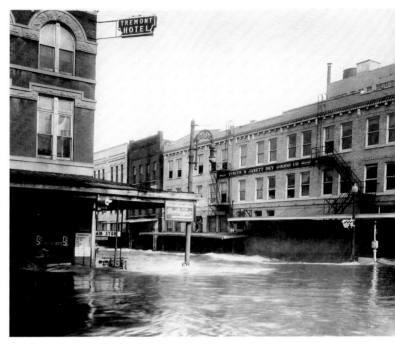

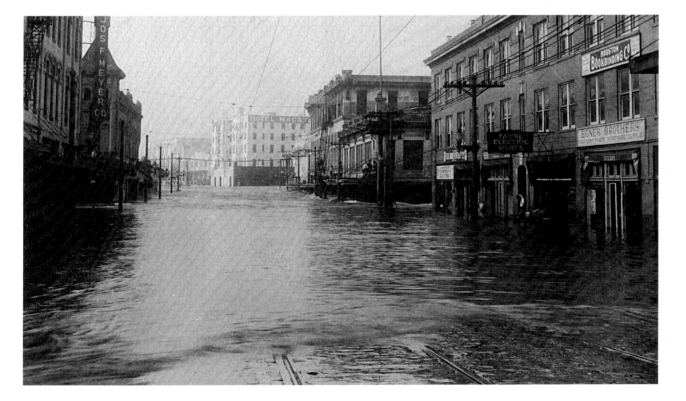

ABOVE: Flooding along Milam Street at Congress Avenue, December 1935.
COURTESY J. R. GONZALES

TOP LEFT: Buildings along Milam Street near Buffalo Bayou crumble in the wake of devastating flooding in December 1935.
COURTESY J. R. GONZALES

LEFT: Floodwaters rise on Franklin Avenue, December 1935.
COURTESY UNIVERSITY OF HOUSTON

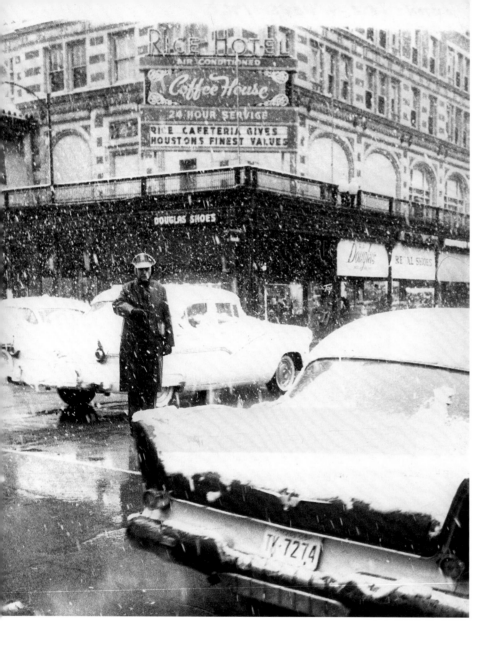

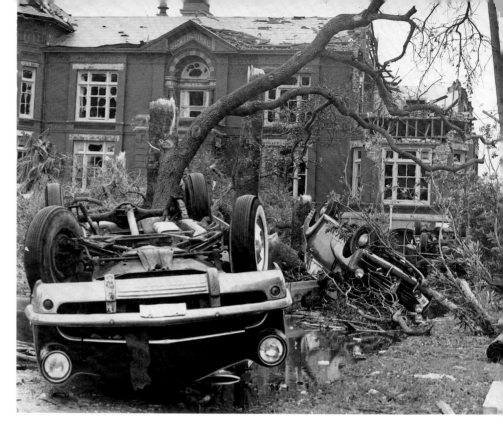

ABOVE: Snow flurries fall on Main at Texas, Feb. 12, 1960.
COURTESY HOUSTON CHRONICLE ARCHIVES

RIGHT TOP: Hurricane Carla overturned cars at St. Mary's Cathedral School in Galveston, September 1961.
COURTESY HOUSTON CHRONICLE ARCHIVES

RIGHT BOTTOM: Baker's Shoes' downtown Houston location suffered blown-out windows during Hurricane Carla, September 1961.
COURTESY HOUSTON CHRONICLE ARCHIVES

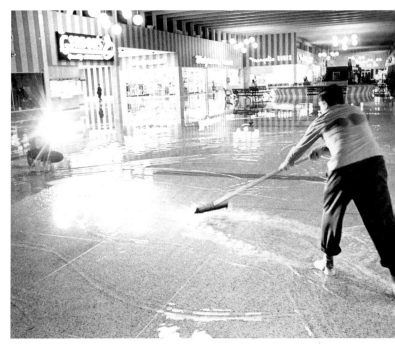

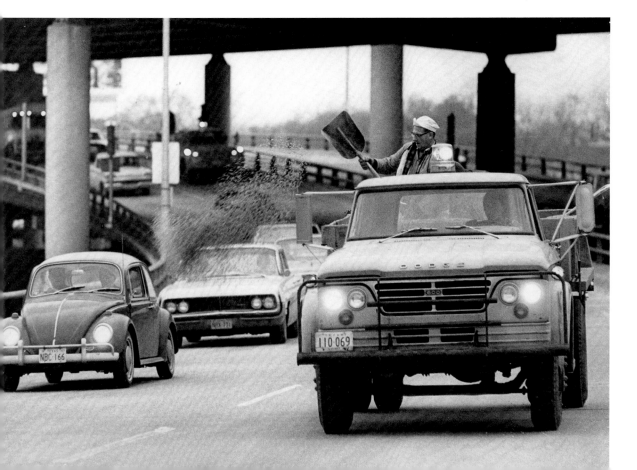

ABOVE: Employees of Northline Shopping Center worked into the night mopping up water that filled the giant air-conditioned mall after a section of its roof caved in at Britt's Department Store on April 3, 1963. COURTESY HOUSTON CHRONICLE ARCHIVES

ABOVE LEFT: Workmen clean up water and debris at Oshman's sporting goods warehouse, 2302 Maxwell Lane, in southeast Houston, August 1974. The roof collapsed under the weight of the water that accumulated in one corner. COURTESY HOUSTON CHRONICLE ARCHIVES

LEFT: A worker shovels sand on a Houston highway during a freeze in February 1968. COURTESY HOUSTON CHRONICLE ARCHIVES

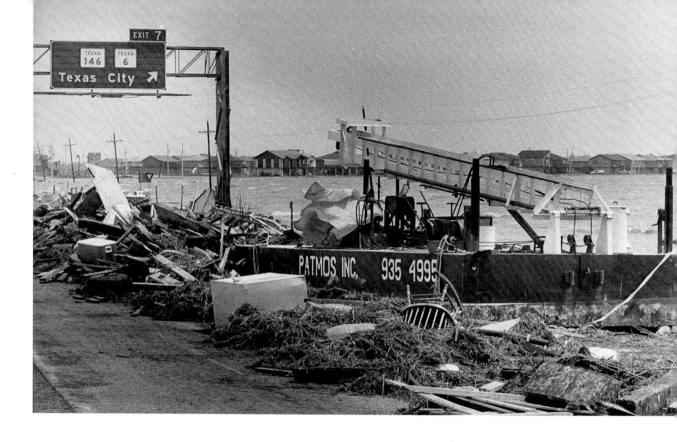

RIGHT: Debris along the Gulf Freeway piles up after Hurricane Alicia struck in late August 1983.
COURTESY HOUSTON CHRONICLE ARCHIVES

BOTTOM LEFT: Baytown residents wade in the street following Hurricane Alicia.
COURTESY HOUSTON CHRONICLE ARCHIVES

BOTTOM RIGHT: A collapsed billboard and damaged home in the 5700 block of Enid following Hurricane Alicia, August 1983.
COURTESY HOUSTON CHRONICLE ARCHIVES

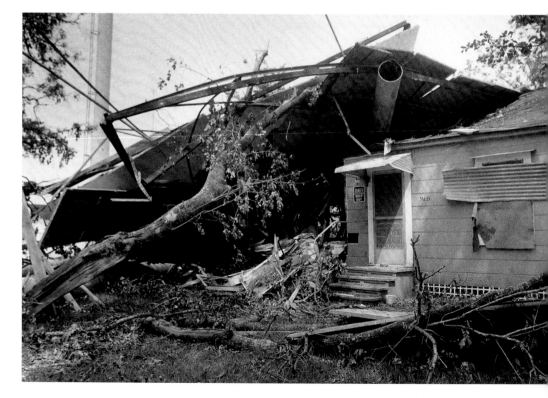

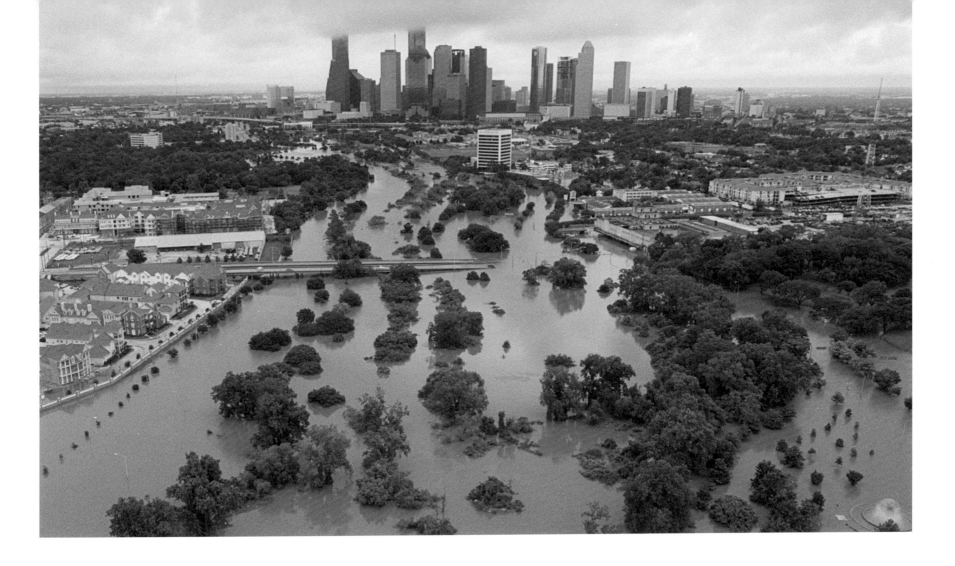

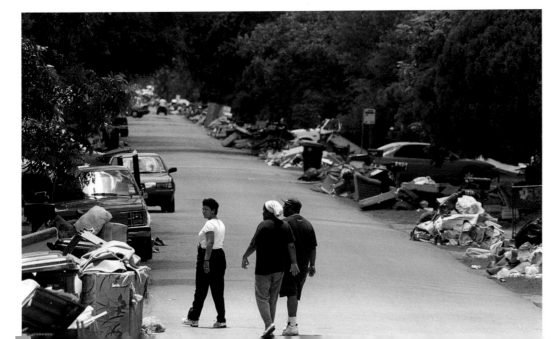

ABOVE: Treetops peek from the floodwaters along Buffalo Bayou after Tropical Storm Allison dumped more than 30 inches of rain on the city, June 2001. Twenty-two people were killed.
COURTESY HOUSTON CHRONICLE ARCHIVES

LEFT: Mounds of debris sit ready to be collected in the 8400 block of Woodlyn in northeast Houston following Tropical Storm Allison, June 13, 2001.
COURTESY HOUSTON CHRONICLE ARCHIVES

RIGHT: A historic weather occurrence provided Galveston – and much of the Texas coast – with a white Christmas in 2004.
COURTESY HOUSTON CHRONICLE ARCHIVES

BELOW: Motorists fleeing Hurricane Rita jam Interstate 45 north of Houston, Sept. 22, 2005.
COURTESY HOUSTON CHRONICLE ARCHIVES

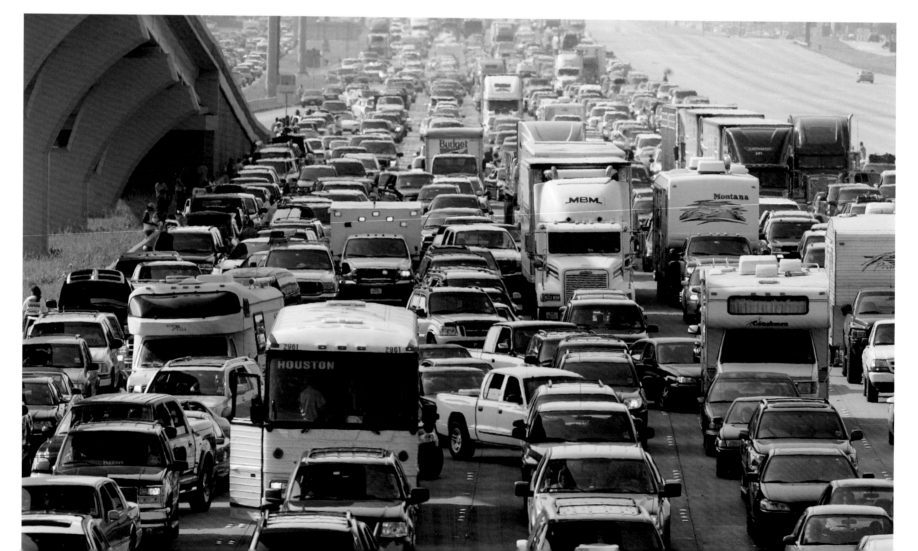

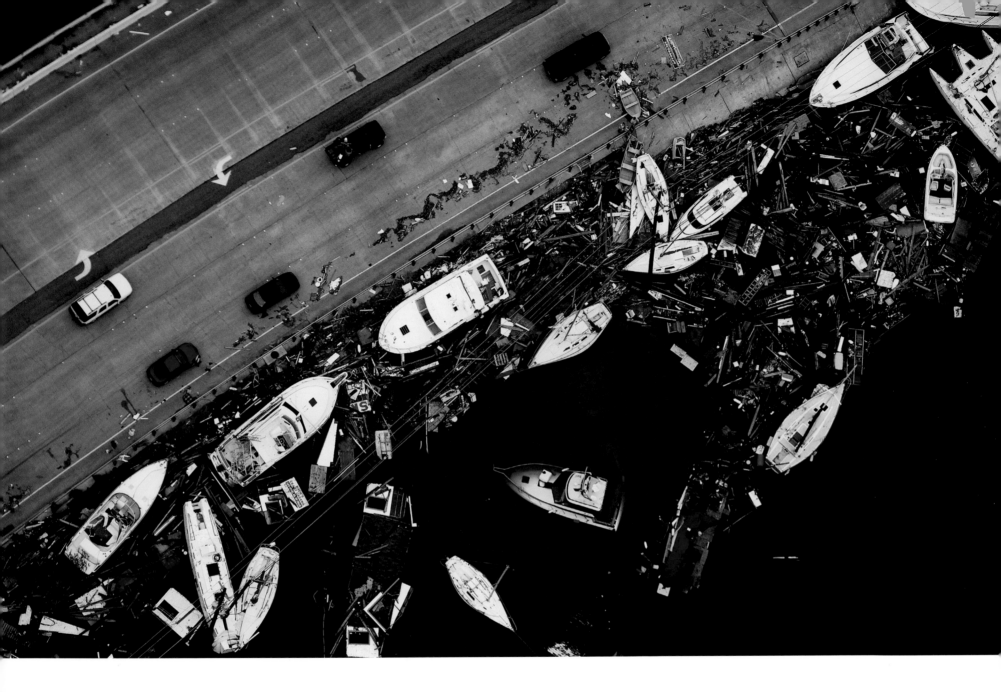

ABOVE: Boats and debris pile up against a bridge in the wake of Hurricane Ike, Sept. 13, 2008, in Clear Lake City.
COURTESY HOUSTON CHRONICLE ARCHIVES

FOLLOWING LEFT: Ships wait offshore at Galveston to enter the Houston Ship Channel following Hurricane Ike, Sept. 15, 2008.
COURTESY HOUSTON CHRONICLE ARCHIVES

FOLLOWING RIGHT: A single house is left standing amid the devastation left by Hurricane Ike, Sept. 14, 2008, in Gilchrist.
COURTESY HOUSTON CHRONICLE ARCHIVES

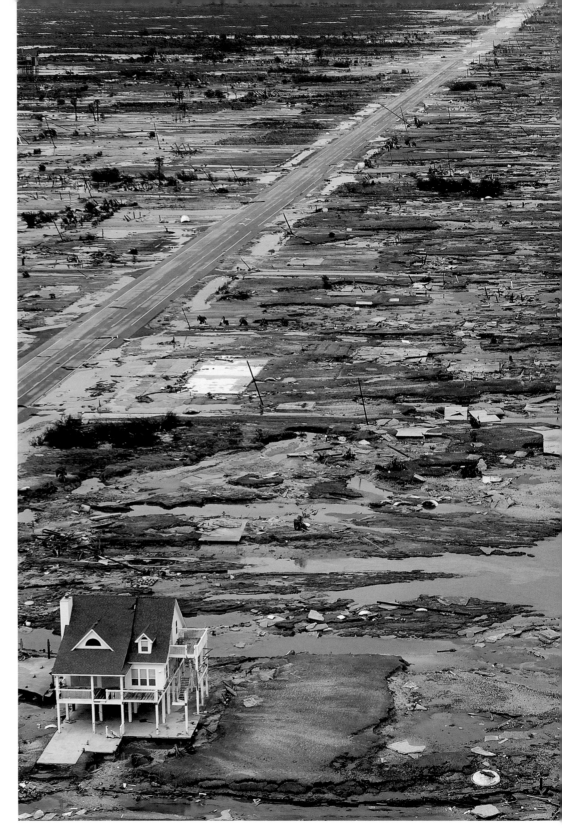

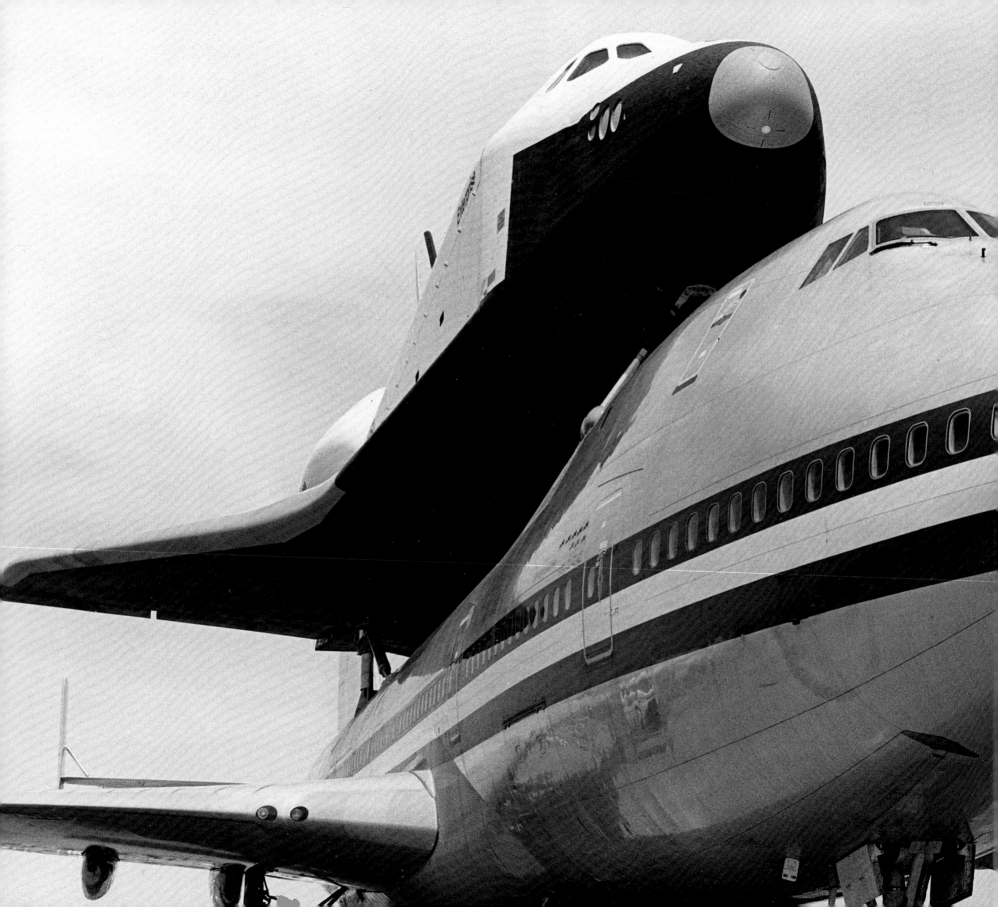

Chapter nine

SPACE EXPLORATION

Longtime residents of Houston might still remember the day when the city made its first connection to the new frontier of space. It was Sept. 12, 1962, when President John F. Kennedy stood behind a podium at Rice Stadium and announced his intention to send an American to the moon, throwing down the gauntlet at the Soviet Union, which had embarked on its own space agenda.

"We choose to go to the moon in this decade and do the other things, not because they are easy, but because they are hard," Kennedy said that day, "because that goal will serve to organize and measure the best of our energies and skills, because that challenge is one that we are willing to accept, one we are unwilling to postpone, and one which we intend to win, and the others, too."

It would take seven hard years and billions of dollars to accomplish the goal — one that Kennedy tragically would not live to see — but in the end the first word uttered from the surface of the moon was "Houston."

Kennedy's successor, Lyndon B. Johnson, made sure that Texas would get its share of the government money being spent on the space race. Houston became the center for human spaceflight operations, which meant that its astronauts would live and train here. Who can forget the strange and triumphant arrival of the first Mercury astronauts at a get-acquainted bash at downtown's Sam Houston Coliseum, each looking a bit uncomfortable beneath a new Stetson in their new hometown? Putting Houston in the middle of NASA's bold plan meant many thousands of jobs for the local economy — more than 18,000 by 2010 — and a brand new set of suburbs along the city's southern edge. It seemed only appropriate to name the center after Johnson, and his legacy lives on even in the uncertain times following the end of the space shuttle program.

Whatever the future holds, more than four decades of human spaceflight have invested the city in the space program in a way shared by only a few others. Space Center Houston, the tourist attraction outside the gates of the Johnson Space Center, will continue to draw visitors. But it is the next mission, the one that pushes the boundaries in the same way the Apollo program did in the late 1960s, that will reignite the civic passion for a next generation.

LEFT: The space shuttle orbiter Enterprise is shown atop a Boeing 747 at Ellington Field, early 1978.
COURTESY HOUSTON CHRONICLE ARCHIVES

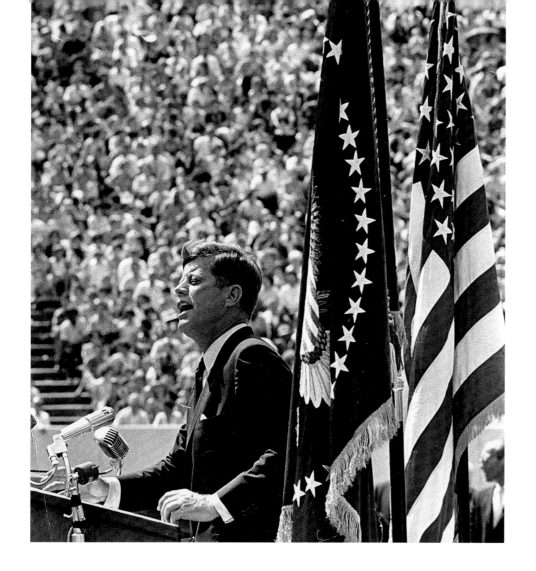

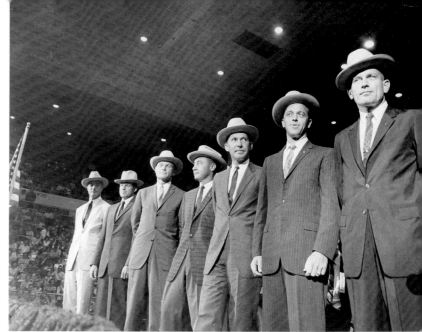

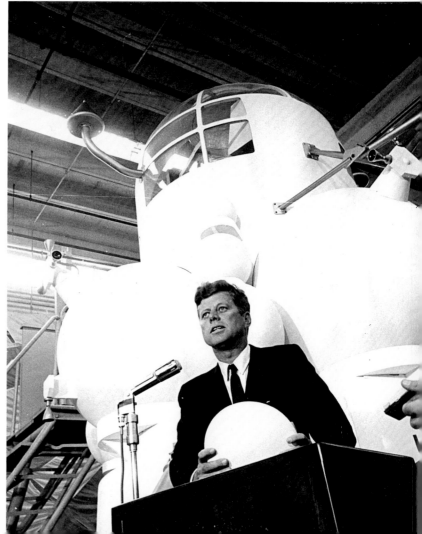

ABOVE: President John F. Kennedy addresses a crowd at Rice Stadium, Sept. 12, 1962. "We choose to go to the moon," Kennedy said. "We choose to go to the moon in this decade and do the other things, not because they are easy, but because they are hard ..." COURTESY HOUSTON CHRONICLE ARCHIVES

RIGHT TOP: The Mercury Seven astronauts receive a rousing welcome at the Sam Houston Coliseum in 1962. From left are Scott Carpenter, Gordon Cooper, John Glenn, Gus Grissom, Walter Shirra, Alan Shepard Jr. and Donald Slayton. COURTESY HOUSTON CHRONICLE ARCHIVES

RIGHT BOTTOM: During a tour of NASA's Spacecraft Research Division in September 1962, President John F. Kennedy praised the "extraordinary effort" of astronauts and engineers who will place space vehicles such as these on the moon. He climbed aboard a model of the Apollo moonship and chatted with astronaut John Glenn at the NASA briefing. COURTESY HOUSTON CHRONICLE ARCHIVES

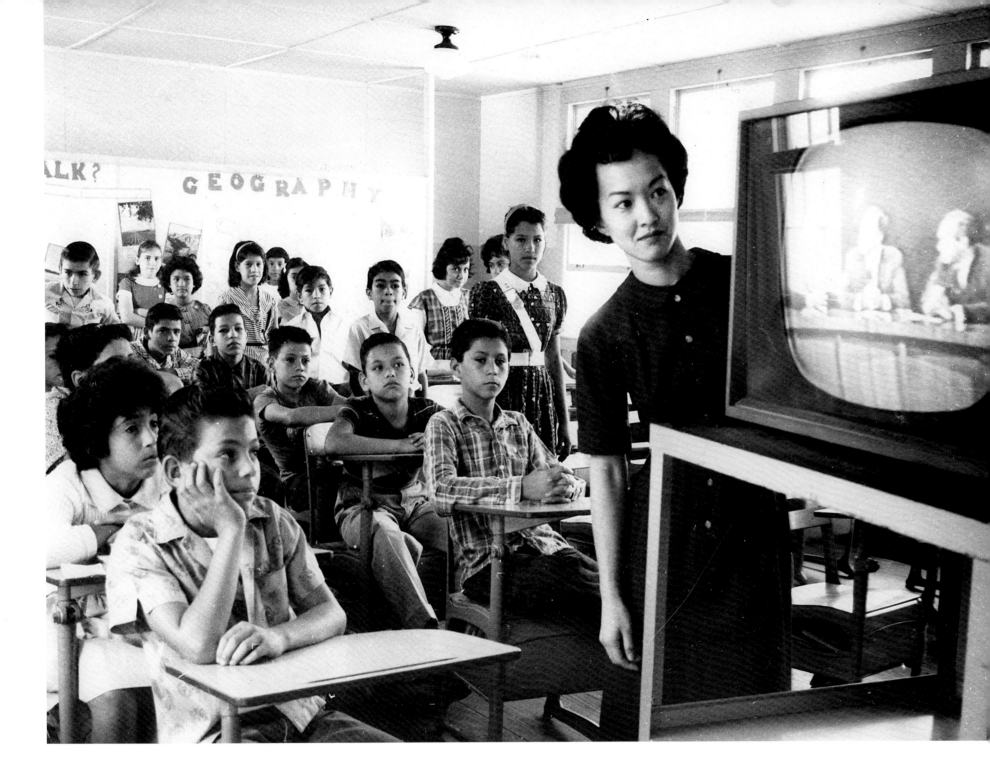

ABOVE: Rusk Elementary teacher Myrna Chun-Hoon fills in the details of Walter Schirra's orbital flight as national television networks report on the progress of the Mercury-Atlas 8 mission, Oct. 3, 1962. COURTESY HOUSTON CHRONICLE ARCHIVES

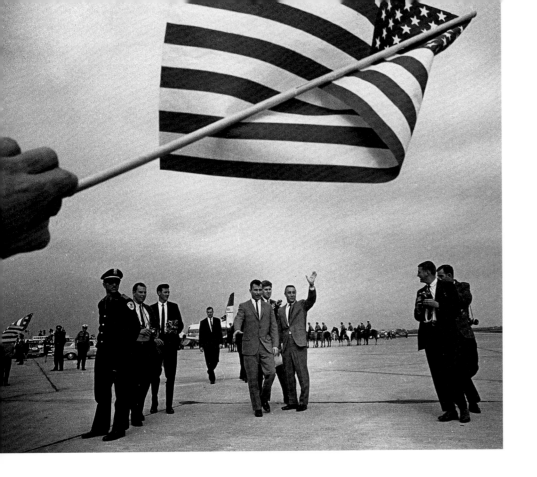

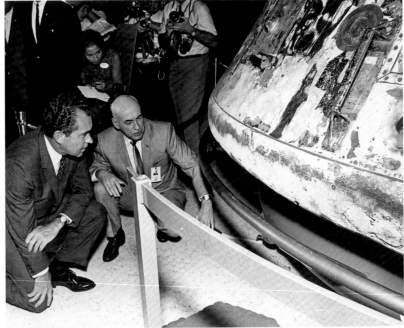

ABOVE: A crowd of nearly 12,000 people welcome astronauts John Young, at left in the center of the photo, and Gus Grissom, waving his right hand, at Houston International Airport after their successful Gemini 3 flight in 1965. COURTESY HOUSTON CHRONICLE ARCHIVES

RIGHT TOP: Actor Jay North of TV's *Dennis the Menace* greets Mercury astronaut Walter Schirra and his family, Oct. 7, 1962. Seated in the car, from left, are son Marty Schirra, 12; daughter Susanne Schirra, 5; Walter Schirra and wife, Jo Schirra. North, dressed in a replica of an astronaut spacesuit, was in Houston to film a TV program to launch a nationwide saving-stamp drive for schoolchildren. COURTESY HOUSTON CHRONICLE ARCHIVES

RIGHT MIDDLE: Manned Spacecraft Center director Dr. Robert Gilruth briefs GOP presidential candidate Richard Nixon during a tour of the center, Sept. 6, 1968. COURTESY HOUSTON CHRONICLE ARCHIVES

RIGHT BOTTOM: Carroll Bobco, left, makes a practice flight in a shuttle simulator, April 1977. With him is Houston Chronicle science writer Carlos Byars. COURTESY HOUSTON CHRONICLE ARCHIVES

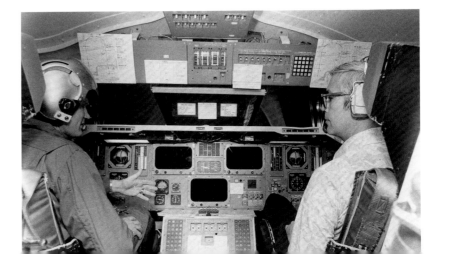

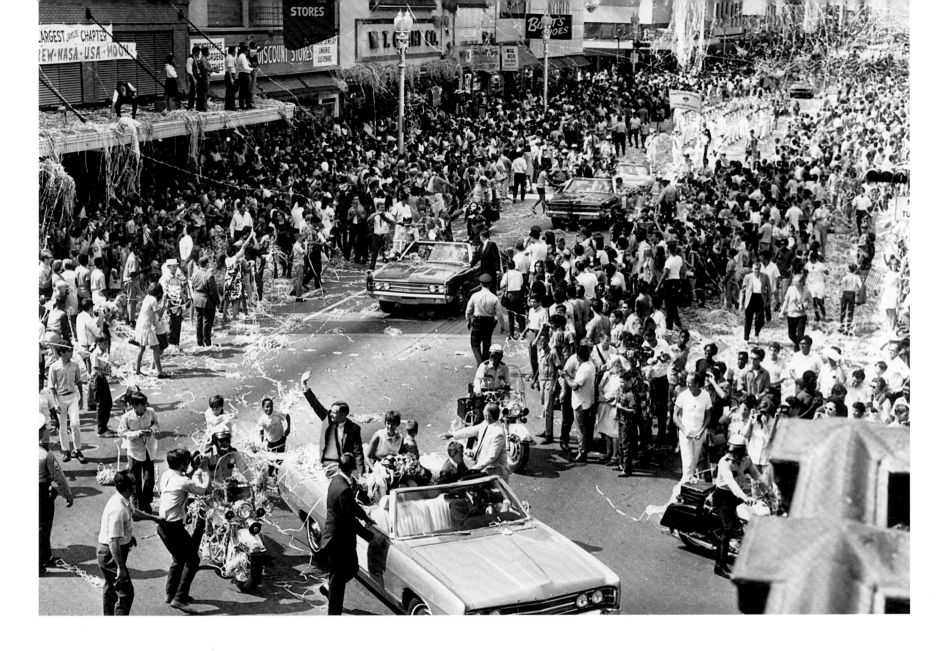

ABOVE: Apollo 11 astronauts Neil Armstrong, Buzz Aldrin and Michael Collins make their way up Main Street toward Texas Avenue during a parade honoring the men following their historic moon landing, Aug. 16, 1969.
COURTESY HOUSTON CHRONICLE ARCHIVES

LEFT: Sally Ride, the first American woman to enter space, signs autographs at the Johnson Space Center in July 1983 just days after her return from orbit.
COURTESY HOUSTON CHRONICLE ARCHIVES

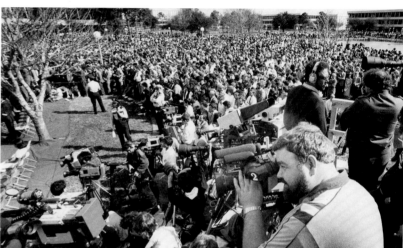

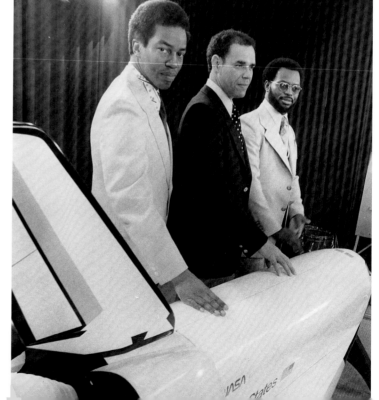

ABOVE: Space agency scientists check out a model of a space shuttle vehicle at the Johnson Space Center, January 1976. From left are chemist Robert C. Clarke; physiologist Charles S. Sawin; and astronaut-physician Story Musgrave. COURTESY HOUSTON CHRONICLE ARCHIVES

RIGHT: Astronaut candidates Guion Bluford, left, Frederick Gregory and Ronald McNair gather at the Johnson Space Center in 1978. Five years later, Bluford would become the first African-American astronaut in space, followed by McNair and Gregory. McNair would be killed aboard the space shuttle Challenger. COURTESY HOUSTON CHRONICLE ARCHIVES

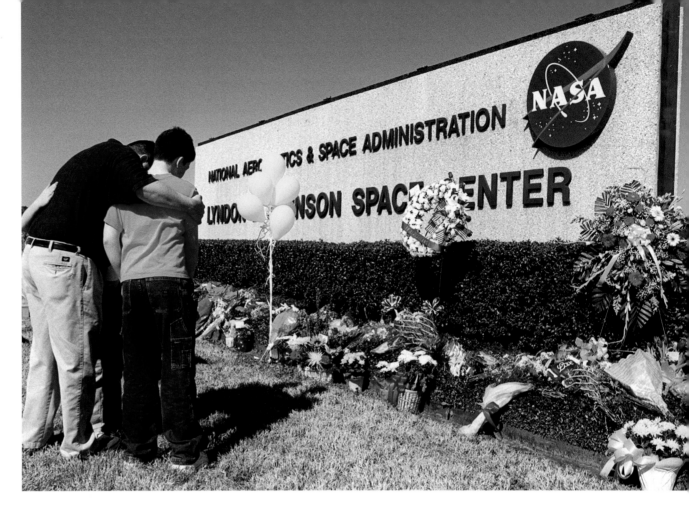

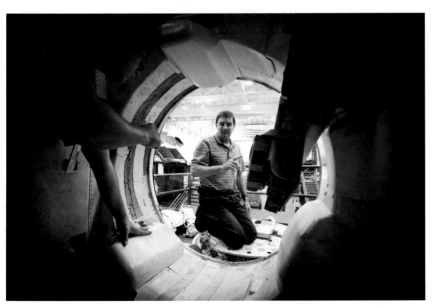

ABOVE: Adam Cole and his children, Kate and Kurth, visit an impromptu memorial outside the Johnson Space Center for the crew of the space shuttle Columbia, which disintegrated over East Texas upon re-entry on Feb. 1, 2003. COURTESY HOUSTON CHRONICLE ARCHIVES

ABOVE LEFT: NASA's Lew McDonnell shows teacher/astronaut Christa McAuliffe the cockpit area of the space shuttle mock-up at the Johnson Space Center, 1985. McAuliffe, along with six others, died on Jan. 28, 1986, aboard the space shuttle Challenger, which exploded after launch. COURTESY HOUSTON CHRONICLE ARCHIVES

LEFT: NASA astronaut Rex Walheim works on emergency egress procedures with a trainer as the crew of STS-135 trains in the Crew Compartment Trainer II mock-up at the Johnson Space Center, June 29, 2011. The training marked the crew's final scheduled training in JSC Building 9, the Space Vehicle Mockup Facility. COURTESY HOUSTON CHRONICLE ARCHIVES

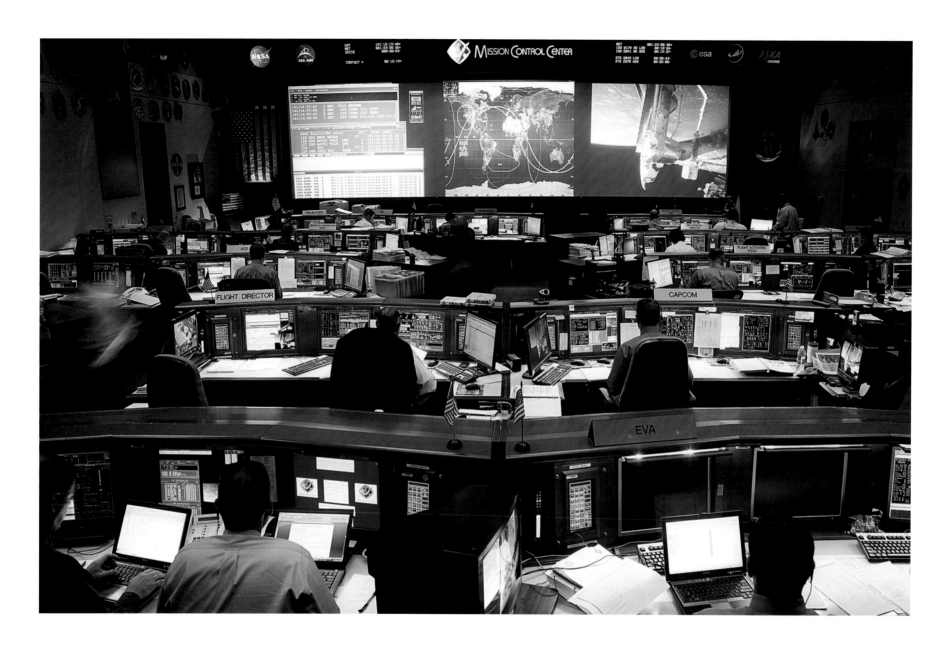

ABOVE: NASA flight controllers monitor the space shuttle Atlantis from the Johnson Space Center as the shuttle docks with the International Space Station, July 10, 2011. The crews that work at Mission Control have played a vital role in human spaceflight since Gemini IV in 1965.

COURTESY HOUSTON CHRONICLE ARCHIVES

ABOVE: The crew of STS-135, from left, Commander Chris Ferguson, pilot Doug Hurley and mission specialists Sandy Magnus and Rex Walheim stand for the national anthem during a welcome-home ceremony at Ellington Field for the crew of the space shuttle Atlantis, the final mission of the NASA shuttle program, July 22, 2011. COURTESY HOUSTON CHRONICLE ARCHIVES

INDEX